THE MACHINE IN ME

THE MACHINE IN ME

AN ANTHROPOLOGIST SITS
AMONG COMPUTER ENGINEERS

GARY LEE DOWNEY

Routledge

New York and London

Published in 1998 by
Routledge
29 West 35th Street
New York, NY 10001

Published in Great Britain by
Routledge
11 New Fetter Lane
London EC4P 4EE

Library of Congress Cataloging-in-Publication Data

Downey, Gary Lee.
The machine in me : an anthropologist sits among computer
engineers / Gary Lee Downey.
p. cm.
Includes bibliographical references and index.
ISBN 0-415-92021-3 (hardcover). — ISBN 0-415-92022-1 (pbk.)
1. Man-machine systems. 2. CAD/CAM systems. I. Title.
TA167.D69 1998
306.4'6—dc21 97-45228
CIP

The bulk of Chapter 5, "Adapting a Nation around Automation" draws from "The
World of Industry-University-Government: Reimagining R&D as America" in *Tech-
noscientific Imaginaries: Conversations, Profiles, and Memoirs,* edited by George E. Marcus,
1995. Copyright © 1995 by the University of Chicago Press. Reprinted by permission.
The following images have been reprinted by permission of the rights holders:
1.1, 2.2, 7.1, 7.2, 7.3, 7.4, 7.8, 8.1, 8.2 courtesy of the IBM Corporation
2.1 courtesy of Rich Westerfield
2.3 courtesy of Computervision
2.4 courtesy of Evolution Computing
4.1 Reprinted from Venture Capital Journal. All rights reserved by Securities Data
Publishing © 1990
4.2, 4.3 courtesy of Dataquest Incorporated
7.6, 7.7 courtesy of Addison-Wesley Publishing Company © 1991
8.3 courtesy of Steve Payne

For Marta, my partner, and
Jamie, Megan, Michael, and Leah, my children

Contents

Preface and Acknowledgments

I LOCATE THIS BOOK in the context of dramatic change taking place in academic research. I see a huge shift underway that is making pedagogy the model of and basis for research rather than the other way around. Students are no longer empty vessels waiting to be filled but have become highly developed theorists who have to be convinced. What I see happening among teachers is an increased emphasis on intervening in the dominant images with which students work to make a difference in their lives. Good teaching is becoming the cultural practice of fitting our knowledges to what they already know, displacing some parts, reorganizing others, and convincing students in the process that accepting the offer will do them good. Good research is becoming the cultural practice of formulating ideas and ways of thinking that might intervene successfully in dominant images and ways of thinking, thus helping people understand and deal with changing circumstances.

I see many researchers giving up on the dream of the academy someday attaining a state of total knowledge or understanding—giving up on the image that, inside the academy, we are all competing to attain that state and, hence, there is little to distinguish knowledge production and dissemination from, say, war. What is beginning to emerge in its place is an image of academic work in universities, colleges, and other sites of teaching and learning as producing and maintaining a collection of knowledges, a multiplicity or plurality, each with its own cultural project. It is instructive, for example, that the perceived value of high-energy physics has shifted from the foundational to the cosmological, replaced by molecular biology, genetics, as the field that asks foundational questions. Disciplines are becoming

cultural projects that need not add up to a unified whole, nor dissolve away either. I think we should celebrate this shift, for it makes the academy possibly even more important than before as a culturally specified site for imagination. But this new academy is no longer just one thing. In academic work that is a collection of cultural projects, there is still competition, there are still standards. But the competition is increasingly to make a difference outside the academy. The pressure we are all feeling to demonstrate how the work in our corners makes a difference is a healthy pressure. Some of this is about jobs and economic development, but colleges and universities are as complex as the arrays of cultural projects out there calling for new imagination.

I suspect we will never live in the absence of dominant images, but what I find encouraging and beautiful in the emergent images is an acceptance of differences and an expectation of change. Images that picture a university as a collection of valuable knowledges expect the configurations of these knowledges to shift and change as cultural projects come and go and as the academy continually repositions itself in society. I find such an academy an attractive place to work and an important place to live.

I am hoping this book will call greater attention to the problem, practices, and pathways of intervention. Focusing on the dominant image of technology, my analysis makes visible experiences of computer engineers that do not fit the assumption that technology is an external force with inherently positive effects. It seems more plausible to expect new technologies to generate new problems even when it provides helpful solutions. But through what sorts of pathways might a theoretical innovation successfully intervene in the dominant image of technology, displacing some parts, reorganizing others, and convincing people in the process that the change will do them good? The risks involved in making intervention a yardstick for measuring research are great. When, for example, is an innovation likely to be pushed aside as a celebration of the dominant image, as an entrenched opponent, or as an irrelevance not worthy of mention? Despite many important theoretical innovations in interdisciplinary science and technology studies, the dominant cultural images of both science and technology have largely remained dominant. Furthermore, since every image makes some things visible while hiding others, the dominance of an image in the sense of its widespread use is not necessarily evidence of domination. When is living with a new image better than living with the old one? This book joins traditions of intervention from science and technology studies as yet another attempt to find out.

Making visible in people's experiences what dominant images hide has been a common contribution of anthropological accounts. I count this study among those that emphasize advancing new labels to help people imagine how things might be otherwise without claiming to make authoritative pronouncements of new realities. A main feature is to acknowledge the primacy

of the peoples studied in formulating and enacting theoretical change, with the ethnographer as critical participant. Perhaps avoiding the comforts of resolute optimism or pessimism and elaborating practices of critical participation might increase the extent to which theoretical innovations do indeed make a significant difference.

While I was discussing possible subtitles for this book with Bill Germano, vice president and director of publications at Routledge, we agreed that "An Anthropologist among Computer Engineers" evoked images of the arrogant, supposedly objective observer who presumed to plop himself (*sic*) down in the midst of a primitive people and straightforwardly record their culture. Ever since James Clifford and George Marcus published *Writing Culture* (University of California Press 1986), which made more visible the agencies of writing in ethnographic practice, the objective observer has been a difficult image to sustain. Yet as subsequent debates over ethnography have affirmed, writing is also only part of the story. I suggested "An Anthropologist Sits among Computer Engineers" with self-conscious irony, using the canonical image to call attention to an attempt at an alternative. In the first place, this subtitle literally describes what I did. Most of my work involved sitting down because that is what computer engineers have to do. Second, reporting the activity of sitting highlights the central argument of the book: The dominant image of technology hides experiences that blur the boundary between humans and machines. But third and most important, the image of an anthropologist sitting among computer engineers illustrates the larger point that the main authority and responsibility for theoretical change lies beyond the researcher. In this sense, to extend Laura Nader's wonderful term, ethnographic researchers are always 'studying up,' yet with responsibilities and commitments similar to those in good pedagogy. What I am seeking here is an effort at critical participation.

Accordingly, this attempt to intervene in the dominant image of technology has depended upon gifts from many theorists, people who have given me the benefit of their interpretations and who have imagined me and my work in relation to their own. I would like to extend my thanks to the dozens of people who talked to me about their experiences with CAD/CAM technologies, both those quoted here and those who preferred their names not be used. Those willing to be quoted include Darrell Early, Paul Gelhausen, David Gossard, David Grose, Sankar Jayaram, Uma Jayaram, Robert Jones, James Parham, Steve Payne, Sandy Poliachik, Kim Repass Ceruti, Donald Riley, Eric Schardt, Syed Shariq, Dalton Sherwood, Bob West, and Sam Wilson. Special thanks to Arvid Myklebust, my host specialist throughout the project, for his willingness to take a risk with me without knowing where it would take us. I am gratified it brought us closer together.

Over the years I have learned that collegiality is far more than a purely professional phenomenon. I wish to thank many colleagues who helped me position pieces of this argument as it developed, including Madeline Akrich,

Richard Badham, Frankie Bausch, Jonathan Benthall, Wiebe Bijker, Richard Burian, Michel Callon, Amy Crumpton, Robbie Davis-Floyd, Arthur Donovan, Michael Fischer, Diana Forsythe (1947–1997), Kim Fortun, Ellsworth (Skip) Fuhrman, Mary-Jo Del Vecchio Good, Hugh Gusterson, Rob Hagendijk, David Hakken, Donna Haraway, Deborah Heath, David Hess, Maarten Heyboer, Japp Jelsma, Ron Johnston, Ann La Berge, Marianne de Laet, Bruno Latour, John Law, Linda Layne, Bill Lynch, Michael Lynch, George Marcus, Emily Martin, Kathryn Milun, Tom Misa, Fred Myers, Vinod Pavarala, Constance Perin, Trevor Pinch, Livia Polanyi, Paul Rabinow, Rayna Rapp, Arie Rip, Juan Rogers, Johan Schot, Adam Serchuk, William Snizek, Susan Leigh Star, Dirk Stemerding, Alluquere Rosanne Stone, Barbara Tedlock, Dennis Tedlock, Chris Toumey, Sharon Traweek, Steve Weiss, Robin Williams, Sarah Williams, and Brian Wynne. In particular, I thank Joseph Dumit, Richard Handler, and Juan Lucena for extended collaborations and exchanges that have helped me think about selfhood in science and technology, the complexities of theorizing and practicing intervention, and life in and around work. I also want to acknowledge the dozens of graduate students and hundreds of undergraduate students who have helped me theorize and practice intervention in the dominant image of technology through their reactions, insights, and experiences. I greatly appreciate the essential financial support I received from the National Science Foundation through grant #DIR-8721941 and for the passionate career commitment of program director Rachelle Hollander to ethics and value studies in science and technology. I thank Bill Germano for locating this work on Routledge's distinguished list and for his priceless nuggets of wisdom and advice delivered rapid-fire and with a style that makes conversations entertainment; Alexandria Giardino, assistant editor, for choosing the copy editor—herself—who produced a greatly enhanced document by combining supreme attention to detail with constant appreciation for the whole; Lai Moy, production editor, for waving the conductor's wand with patient and nurturing insistence to keep us all moving forward happily and with the highest of standards; and Amy Lee, product manager, for the hard, creative work of getting this book into your hands. Thanks to Piyush Mathur for insightful and disciplined help preparing the index.

The infrastructures of intellectual work have many dimensions. For me, this book is about hope. I want to thank family members who supported my efforts even when my accounts of what I was up to deserved raised eyebrows more than blanket endorsements. Thanks especially to my parents, Anne and Clarence (1923–1987) Downey, and my siblings, Jim and Linda Downey and Lynn and Dan Harris, for lifetimes of love and support. Thanks to the extended Downey and Zeilfelder clans for consistent encouragement. Thanks to June Kramer, who accompanied me through intellectual preparation in engineering and anthropology, and Susan Downey, who saw me through introductions to STS and this research.

Above all, I want to thank my partner and my four children. Jamie, Megan, Michael, and Leah, each day with you brings surprising and gratifying pleasures, showing me the supreme joys that come from just being there. I love parenting the choreographer, the author, the artist, and the one who is intensely alive. Marta, you shocked me with a level of trust I had never dreamed possible, teaching me how to be a healthy partner amidst shared passion, responsibility, and fun. Since 1991 I have published as Gary Lee as one small but public celebration of my permanent commitment to you. This book is for all of you, whose love has made my hope worthwhile.

CHAPTER 1 | Images Count

ONE AFTERNOON IN 1991 while trying to complete a class assignment in the CAD/CAM Lab, I ran across an illustration in my manual that vividly pictured what I had been struggling to describe—a human inside the machine and a machine inside the human. My assignment had been handed out during the second week of a senior-level undergraduate course in mechanical engineering that introduced students to the technology of computer-aided design and computer-aided manufacturing, or CAD/CAM. With this assignment, we were learning to make two-dimensional drawings with a software program named CADAM, which had been written by engineers at Lockheed, a defense contractor, and purchased by IBM, a computer company, to distribute with its engineering workstations. (See Figure 1.1.)

The illustration trained readers to see a computer display screen as one portion of a huge drawing board. In place of pencil and paper, we could draw on that board using a keyboard, keypad, and light pen. The image includes two human figures, both clean-cut white males, working with different types of machines. The man on the left is operating a video camera with directions from the man on the right, who is sitting at a computer terminal.

The main lesson in this image for students was that only one of these men was physically human, yet both were part of the CADAM system. The man sitting at the terminal could have been one of us, a human student working on the system. The man on the left, however, stood for the knowledge that Lockheed and IBM engineers had produced and written into the software. Along with the loudspeaker, camera, wiring, and, indeed, the virtual drawing board itself, this man was an integral part of the CAD/CAM

Figure 1.1 The Human in the Machine and the Machine in the Human

technology. Through this image, we could experience him as our competent, knowledgeable friend inside the machine. He was even intended to look like us students, people who were either clean-cut, white, and male, or who had accommodated themselves to a world that took these qualities for granted. In other words, we could work with the guy who lived inside this machine.

More subtly but no less important, we could work with this guy only if we adjusted our bodies appropriately: seated with one hand on the keypad and the other pointing the light pen on the screen, or with both hands on the keyboard. We real humans needed to understand that learning CAD/CAM technology involved disciplining our bodies and selves.

Have you ever felt a deep, abiding connection with a machine? I maintain we do all the time, but we struggle for the words, the concepts, to describe and understand such experiences. Last week, for example, I drove past a young man who was totally immersed in working on his car in the driveway. His arms were covered in grease up to his elbows. The car's engine had been lifted out and was hanging beside him. As I passed by, I saw a young woman leave the house and stroll tentatively his way. Did she feel herself in competition with his car? Did he feel a tension between two competing passions? In what way was this man's identity caught up with his machine?

Lourie, who cuts my hair, calls such guys "motorheads," and says her

husband is one of them. She explains his interests with evident affection as she travels around my head in no discernable pattern, taking a little here and a little there with her scissors. I can never figure out what she's doing, but I'm always delighted with the results. Admiring the virtuosity of her work, I ponder over how to think about Lourie and her scissors. The human act of cutting had somehow made it into the scissors, and Lourie had somehow fit the activities of scissors to her life and self. Furthermore, through those scissors, Lourie had established an intimate relationship with my hair that had transformed our business transaction into a genuine friendship.

The dominant image of CAD/CAM technology that I have encountered across a range of contexts is not about humans and machines living inside one another but about technology rescuing humanity or guaranteeing human progress through automation. In 1981, for example, the engineering magazine *Mechanical Engineering* ran a special issue on CAD/CAM technology. Its lead article reported that a "third Industrial Revolution is underway in which the integration of computer-based information with industrial processes and machinery will dramatically change the technological base of the country." That same year, a series of articles in *Machine Design* detailed how CAD/CAM technology now made possible the "factory of the future." The summary piece, "Automated Factories: The Ultimate Union of CAD and CAM," pointed out that the "'ultimate' factory run entirely by computers, robots, and automated machines has long been a dream of manufacturing engineers." "Automation is necessary," the author continued, "to create greater total wealth, to increase the standard of living, to reduce boredom of routine work, to avoid hazardous environments, to aid the handicapped, and to allow more opportunities for leisure and creative activities." This utopia was soon within our grasp: "Full integration of CAD and CAM technology could lead to totally automated factories by the end of this century."[1]

America loves to turn to technology or, better, the image of technology as the solution to its problems. Throughout its history, the United States has asserted in all sorts of ways that technology would step in to save the day and provide humanity with an out from whatever dilemma currently dominated the scene.[2] During the 1980s, a new way emerged for making the case: the doctrine of competitiveness. Picturing the world as a set of independent, autonomous nations competing with one another, competitiveness made economic productivity the main index of the country's global status and welfare, and new technology the main vehicle for increasing productivity. Throughout the decade, images of promising new technologies regularly appeared as sure-fire guarantees of national survival, progress, and fulfillment.

CAD/CAM was one of these technologies.[3] Developed initially for military use during the 1960s and 1970s, CAD/CAM technology became popular during the 1980s as the commercial technology that would overcome the boundary between design and manufacturing and allow the United States

to regain its status as the world's economic leader. The United States had great talent in generating new designs but was somehow less proficient in turning those ideas into competitive products. CAD/CAM technology promised to help save the nation by bringing design and manufacturing together inside the computer.

The image of automation promises control in an uncertain world. For example, at a 1991 trade show in Chicago featuring the latest in CAD/CAM technology, I watched an attractive, engaging young woman command the attention of about two dozen men as she enticed them to get involved with her software. Walking back and forth across a small stage, she worked with a microphone and two television monitors against a background of peppy music, focusing everyone's attention on the enormous capabilities of her company's newest version of its CAD/CAM software. ANVIL 5000 would make them strong, more productive, and more visible in their companies, and it would make their companies more competitive. The fantasy she performed carried an intense, albeit implicit, sexual appeal. Buying her body, I mean her technology, would put their bodies in control. "Our new version is the most innovative technology that MCS has ever devised," she said temptingly, "providing more ways to put more control where it belongs—in your hands." Sitting in a sea of white shirts and ties, I could feel the rumblings of pleasure. The men loved it.

Despite the attractiveness of the automation fantasy, it seems likely that many, if not most, people directly involved in CAD/CAM development and use never bought into it completely. During the course of this research, the most frequently used term I encountered to describe the great public and official interest in CAD/CAM technology was 'hype.'[4] Technological hype was everywhere. It was something that people had to deal with, but most everyone knew better. Just about anyone with a reasonable amount of experience could figure out that developing or using CAD/CAM technology involved more than simply automating design and manufacturing and would not serve as a simple technological fix to long-established human problems in production.

For example, in a group interview in 1990, four engineers described entanglements with ANVIL 5000 that made automation of design and manufacturing seem still an all-too-distant dream. For nearly a decade, they had worked to build CAD/CAM technologies into their work practices. Company managers had supported their efforts with major investments but were now balking at proposals to purchase further equipment until the engineers could clearly demonstrate the increases in productivity that had been obtained. The engineers knew CAD/CAM technology was worthwhile but perhaps in different terms than had been assigned to it.

Or consider a group of five confused engineering students, three men and two women, sitting in my living room to discuss the midterm exam in their CAD/CAM class. Weeks earlier, they had explained how good this

course would look on their resumes. Prospective employers would see them as people who knew CAD/CAM. However, Introduction to CAD/CAM was unlike any other course they had experienced in engineering. Rather than gaining control over some mathematical formulas by completing innumerable problem sets, students found themselves surveying topics dealing with the hardware, software, and industrial implications of computer-aided design and computer-aided manufacturing. On the exam, they actually had to define 'CAD' and 'CAM,' wisely concluding such was important after watching the instructor point the definitions out in the textbook, show them in a slide presentation, write them on the blackboard, and list them at the top of the review sheet. Each had received full credit for copying from the textbook:

> Computer-aided design can be defined as the use of computer systems to assist in the creation, modification, analysis, or optimization of a design.
> Computer-aided manufacturing can be defined as the use of computer systems to plan, manage, and control the operations of a manufacturing plant through either direct or indirect interface with the plant's production resources.

Yet these students were perplexed and uncertain. They were memorizing commands for moving around inside the computer, but exactly how was that important? Labwork was not providing them with control, and lectures seemed irrelevant.

By the early 1990s, one could reasonably assert that CAD/CAM technology would not fulfill the initial national agenda that had been set out for it. Yet the dominant image of technology as the solution to America's problems did not die. In fact, the image was not even tarnished. The industrial world simply shifted strategies from acquiring and implementing automation to adapting humans and organizations to the new technologies by whatever means necessary, including restructuring and the downsizing of labor. As CAD/CAM technology itself began to move out of the public limelight, other promising new technologies stepped in to take its place. Limitations in one technology would not undercut the image of technology in general.

This book investigates the life of the dominant image of technology by exploring its role in the doctrine of competitiveness and the development of CAD/CAM technology. My main claim is that images count. Technological hype has more than superficial effects. Every image makes some things visible while hiding other things, and dominant images establish and enforce the terms of everyday theorizing, everyday habits of imagination. By following CAD/CAM technology through the activities and lives of people involved with its development, this ethnographic study explores some effects of the dominant image of technology, investigating how the image

worked, what it emphasized, and what it made less visible as it was appropriated by the doctrine of competitiveness. By helping to make more visible how the dominant image of technology lived in the humans and machines of CAD/CAM technology, I want to raise the possibility that the greatest force of the doctrine of competitiveness lay in how it constrained the imagination rather than firing it.

In addition to showing that images count, or more specifically that technological hype has palpable effects, this book further asks: What would it take to shift the dominant cultural image to something better, to move it onto new ground? It has become commonplace, for example, to point out that new technologies not only deliver solutions but also generate new problems. Such a statement, in fact, tends to evoke shrugged shoulders or nodding heads rather than raised eyebrows. What then would it take to get to a place where every new act of technological hype also carried a responsibility to outline all the problems that were likely to develop? Imagine the dramatic shifts in discussion and debate over new technologies if the main issue at stake was not whether or not there would be problems but exactly what forms these would take. Might it be possible for people to debate the effects of new technologies without feeling they had to choose between being proponents and opponents? Although I find technological hype troubling, I happen to love new technologies. If we simply came to expect new technologies to produce problems, might we also improve the extent to which they actually provided solutions?

The experiences of computer engineers suggests that one possible pathway may be to think about each machine as a configuration of agencies—acts of positioning—that are part-human, and of each human as a configuration of agencies that are part-machine. Life with this image might expect that adding a technology to an existing web of relationships would rearrange the identities of everyone and everything involved, such that no one could just assume the effects to be uniformly positive. Would such a move make a difference? Would another direction be better? I believe it is worth participating critically to find out.

The Doctrine of Competitiveness

I first became interested in CAD/CAM technology in 1986 when I came across news stories that listed it as one of several technologies that were crucial to save America from outside threats. I found an issue of *Business Week,* for example, whose cover story, "High Tech to the Rescue," outlined efforts to integrate engineering design and manufacturing in United States industries.[5] Throughout the 1980s I had been following how official America had been retheorizing international struggle from a political to an economic idiom. That is, with its economic dominance of the world no longer

assured, America had started to theorize itself as a single economic actor maximizing a collective interest rather than a site for competition among individual interests. The national shift to economic struggle had been sudden and dramatic, embodied and epitomized in the election of Ronald Reagan as president. In this transformation, the problem of competition for individual firms had been displaced to become the national problem of economic competition with other countries. Remarkably, I think, a patriotic spirit was renewed for beating a country—Japan—that the United States had conquered before and still occupied militarily.

By contacting authors and tracing bibliographic trails of references, I identified a flurry of formal reports written by elite groups in industry, government, universities, and professional engineering societies. Each issued urgent appeals for national initiatives in technology developments such as computer-aided design and computer-aided manufacturing, directly linking their success to the nation's future welfare. These included, for example, reports by the National Commission on Excellence in Education, Business-Higher Education Forum, Congressional Task Force on High Technology Initiatives, Congressional Working Group on Economic Competitiveness, President's Commission on Industrial Competitiveness, National Research Council, Council on Competitiveness, and several professional engineering societies, such as the American Society of Mechanical Engineers and Institute of Electrical and Electronics Engineers.[6] Also, a large body of individually authored articles and books, such as *America's Technology Slip* by Simon Ramo, co-founder of TRW and a major theorist of competitiveness, and committees, such as the MIT report *Made In America,* elaborated the point. The collective goal was to produce new technologies; the primary motivation was to beat Japan.[7]

I was surprised to find in these documents a high degree of sharedness in the visions they presented. Each one characterized new technologies as ultimate saviors, picturing them as forces outside human society that would rescue America from its problems. All made use of roughly the same rhetorical doctrine, a narrative or story of national liberation in three steps.[8]

The first step established the human context of the technological problem by asserting that America was threatened by economic defeat at the hands of international competitors, particularly Japan. The importance of this step was that it restructured the meaning of the concept 'nation' by subordinating political and military content to economic content. "Our nation is at risk," announced the National Commission on Excellence in Education, for "our once unchallenged preeminence in commerce, industry, science, and technological innovation is being overtaken by competitors throughout the world."[9] In this vision, Americans were now in a race, not as individuals, but as a collective whole. "[T]oday we no longer can assume we are ahead," wrote Simon Ramo, for "[c]ontrary indications are all about us in the form of European and Japanese cars on our streets and foreign-made television

sets and tape-recorders in our homes." "Evidence is building," he continued, "that these trends are the result of some fundamental patterns that cannot be changed overnight."[10]

The second step in this narrative structure was to isolate the problem of 'productivity' as the site of weakness or failure, particularly in manufacturing industries. Although rarely defined, the concept of productivity generally referred to the amount of product produced per unit of human labor applied to produce it. Among things not counted was the labor involved in producing the tools and machines that humans used. An increase in productivity thus meant either that the same amount of product could be produced with less labor or the same amount of labor produced more product. The reports made frequent claims that "productivity has stalled" or "has now dwindled to small oscillations around zero."[11]

Most everyone turned to manufacturing, as did, for example, the Council on Competitiveness, the joint industry-university group that advised Vice President Dan Quayle during the Bush administration: "Much of the U.S. failure to exploit technology for commercial advantage lies in not adequately appreciating the importance of manufacturing. . . ."[12] Focusing on the problem of competitiveness, this report went on to claim that foreign manufacturers usually beat American companies not with low wages but with "more efficient" manufacturing processes. The Japanese were particularly good at appropriating American ideas in constantly improving their manufacturing processes. It was time for America to apply its creative energies to manufacturing, to produce more flexible forms that could respond quickly to changing market conditions.

Linking a concept of productivity to an economic interpretation of the American nation was an important move in popular theorizing, for it transformed the power of both concepts at the same time. Productivity gained national significance rather than being reserved as a purely economic category, and the nation gained a new form of technological salvation. Defining the problems of America in terms of the economic problem of productivity became a perfect setup for those who would advance utopian visions of technological approaches to flexible manufacturing.

The third step was then to call for specific developments in design and manufacturing technologies as necessary to increase productivity by making production more efficient and flexible. In other words, new 'process' technologies would have a positive impact on society because these were oriented toward improving productivity. With productivity the idiom of progress, technology became, once again, its primary vehicle. The Council on Competitiveness, for example, focused its attention on new technologies: "The effective development and deployment of technology is critical to America's ability to compete in world markets."[13] Also, as the Aerospace Industries Association of America concluded a report on the future of the industry, "In the aerospace industry, technology development is the key to

international competitiveness."[14] Similar stories routinely appeared in the trade publications of such industries as consumer electronics, semiconductors, superconductors, and pharmaceuticals. Practically every industry in the United States jumped onto the competitiveness bandwagon by spotlighting attention on flexible new manufacturing or process technologies. The idiom of competitiveness offered the outlines of a strategic plan for enhancing the power of one's industry.

At the same time, the cultural transformation of productivity into a national problem legitimized any societal adaptations or innovations necessary to improve productivity. That is, society would have to adapt flexibly and appropriately if technology were going to realize its inherently beneficial effects. In each case, societal innovations took the form of reconceptualizing organizations to fit them better to the production process. The initial move during the early and mid-1980s was to reimagine industrial research and development (R&D) in nationalist terms. Perhaps the widely dispersed organization of industrial R&D for process technologies could be coordinated by establishing cooperative R&D ventures among government, industry, and universities, as well as through new government policies for patents, anti-trust regulation, and international trade (see chapter 4 of this book). By the late 1980s, the focus had shifted to restructuring corporate bureaucracies, transforming permanent hierarchical structures of management decision making into transient horizontal structures dependent on the needs of production. Such new management movements as Total Quality Management and business process re-engineering, as well as organized efforts to build 'strong cultures,' affirmed the supreme value of productivity in everyday corporate life.[15] At the same time, higher education joined in to reconceptualize scientific and technical training as a pipeline designed to deliver sufficient supplies of flexible employees.[16] In short, organizations in government, industry, and universities all began working actively to develop new process technologies and then adapt themselves to what appeared to be the organizational imperatives of the new technologies, all justified by the desire to free America from the domination of outside competitors. By the 1990s, all these had evolved into massive restructuring and downsizing as the main strategies of adaptation.

Perhaps the most striking thing about the doctrine of competitiveness is not the force it accumulated in American cultural life during the 1980s but its rapid spread to become the dominant logic of discourse about global relations in the world today. Picturing the world as a population of autonomous individual nations competing with one another in production hides all sorts of economic, political, social, and cultural relationships within and among nations that prevent them from acting as autonomous individuals. Furthermore, the whole logic of productivity built into the doctrine of competitiveness depends upon an inflexible image of technology as an inherently progressive external force that hides and renders subordinate a variety of

other human experiences with, and hence knowledge of, particular technological developments.

The Cultural Boundary between Humans and Machines

In everyday life, Americans regularly understand and characterize technology as an external phenomenon. That is, it exists and functions outside the bounds of human society, serving as an external, nonhuman force that changes society through its effects. From this perspective, technologies typically develop according to some internal logics within specialized scientific and technical communities. The technical deliberations within these communities are opaque to outsiders and presumably free of cultural content. Much popular theorizing about technology and society treats technology as an independent variable and society as a dependent product.

It is an irony of popular theorizing that this fixed separation frequently grounds an explicit commitment to technology as the solution to social problems. Whether turning to the railroad, electricity, antibiotics, automobiles, telephone, airplanes, nuclear power, birth control pills, or, most recently, information technology and biotechnology, Americans have regularly peered outside of human society to view technology as a crucial catalyst for liberating change. Every generation in American history has made technological advancement a condition of its dreams about a utopian future, usually understood as social progress and human liberation. While the specific contents of progress and liberation have changed from period to period, the sharp boundary between the human and the machine has remained.

One effect of assuming a sharp separation between human society and technology is that it empowers technologists as creators. That is, it grants authority to those who pursue the new technological developments that produce progressive benefits and social change as technological development. The archetypal technologist is the inventor who begets a new technology through a bulb-lighting Edisonian moment of Eureka. But the boundary also gives legitimacy to engineers who systematically abstract technical problems from social problems, solve them in the rarefied realm of technical discourse according to localized considerations reserved for that realm (e.g., mathematical coherence), and then apply the technical solutions back to society. Engineers can boast that many problems have technical solutions and then complain about the barriers imposed by a purely social politics, as when they throw up their hands in frustration and say, "It's all politics."

This Basic Story of the culture-free creation of technology outside society can also include science as an internal engine for technological development.[17] Science advances truthful knowledge about the world through pure acts of discovery made by superhumans called scientists, whose brilliance

enables them to step outside of society to discover these truths. In popular theorizing about science and technology, then, science delivers the discoveries that technology applies and translates into progress. Picking up any daily newspaper, one will find several stories explaining how new developments in science and technology will deliver progressive benefits to society.

At the same time, however, by theorizing science and technology outside of society, we also disconnect technologists from the subsequent lives of their technologies. If the force that determines social change is actually the technology itself, then human participants in technology development serve only as vehicles for its realization. Humans might get credit for creating new technologies or controlling the rate of technological development, but the effects of new technologies on society belong to the technologies alone. Inquiries into the impacts of technologies rarely extend to the impacts of technologists. In short, the popular theory of technology outside of society most frequently appears in a form that academics call 'technological determinism': Technology determines the social changes that result from it.

As many academic and nonacademic theorists have pointed out, technological determinism is limited as a native theory of social change, for it offers highly simplified accounts. By confining the actions of technology to those of an external force, the language of impacts imagines only two mechanisms of technological change: Technology is either a positive or negative force. Alongside every utopian dream about a new technology lies its dystopian counterpart, which pictures the technology as leading away from social progress and human liberation toward some frightening future of social and political domination. Consider the opposed visions widely available of nuclear power, gene splicing, global warming, and information superhighways. When relying upon the standard image, people constrain themselves to regard technological development with either an irrepressible sense of optimism or an immovable sense of pessimism. The future will be wonderful, or it will be horrible. Public debates over the impacts of new technologies regularly degenerate into confrontations between proponents and opponents. To the proponents, who view the technology as a ticket to progress and liberation, anything short of support is opposition that is anti-technology, anti-progress, neo-Luddite, and, hence, maliciously anti-American. To the opponents, any show of support is a sign that one has been co-opted by a system that depends on inequality and produces domination. Middle ground becomes a dangerous position to occupy: No one trusts it.

The positive interpretation of technological change is by far the dominant one. Adopting it is usually a pretty safe strategy politically in the United States, for most everyone likes to look to new technology for solutions to current problems. Championing a new technology is often the path of least risk and hostility.

On the other hand, challenging new technology can be a highly risky enterprise. Claiming that a new technology is inherently negative is usually

also an announcement that one is willing to accept marginal status in society. That is, one is willing to risk being classified as anti-technology, anti-progress, neo-Luddite, and, hence, anti-American in order to protest the technology. Even the related, and more frequently used, strategy of pointing out negative impacts without making a judgment about the technology as a whole is dangerous. Given the dominance of positive images, any attempt to put negative images on the agenda provides evidence that one might be a closet anti-technologist, and one can find oneself sliding down the slippery slope down to marginality, irrelevance, and probable unemployment.

However, a third possible interpretation is also prevalent: Technology is neutral. In this perspective, treating technology as a force on society appears downright foolish. No technology develops without human choice and deliberation. No technology has effects without human choices to use or abuse them. Guns do not kill people. People kill people. Human society is clearly involved in every step of technological development and implementation. Some people are deeply involved in decision making to construct new technologies. A technology is nothing but a tool for humans to manipulate and use for human benefit. In fact, tools define humans. Consider evolutionary images of 'man the tool-maker,' e.g., the primate in the movie 2001 who transformed a bone into a weapon to the resounding crescendo of drums and trumpets. If humans abuse technology, certainly blame the people, but do not condemn the technology, which is simply a nonhuman object. Furthermore, public debates over technologies do indeed regularly display a range of policy positions regarding their impacts. Middle ground is a more frequent outcome than one might think, for people always search for ways of using new technologies wisely.

The third interpretation thus challenges the power of technology to change society by treating technology as nothing but a neutral, nonhuman object subject to direct human control. It tends to be aligned politically with the proponents' image of a technology as inherently positive, for characterizing a technology as neutral can be an effective way of assuring neutral people that humans are in control. The strategy is particularly useful for advocating weapons and other technologies whose effects might appear to be intrinsically negative. When this strategy works, it undercuts opponents by casting them as anthropomorphizing the technology, treating it as somehow having a life of its own, which of course must be ridiculous.

Consider, for example, the protracted battles in the United States over gun control. If guns do not kill people but people kill people, then why should a country regulate the purchase of guns? To those who resist gun control, the advocates are suggesting somehow that guns cause people to kill other people. Yet guns are simply neutral objects, tools for humans to use; they cannot cause people to do anything. When used properly, guns serve society well, such as by helping humans to regulate deer populations.

Those irrational advocates of gun control should focus their regulations more on those who abuse guns (i.e., criminals) rather than use them, and less time focusing on the actual tools the criminals happen to use. What we need in this country are more prisons and tougher laws, not attacks on our right to bear arms.

The image of neutral technology also enables participants in a range of debates about human society to ignore or take for granted all sorts of existing technologies. Consider, for example, debates over gasoline taxes in the United States. Whenever Congress considers increasing the country's low tax on gasoline, subsequent debates take for granted the presence and functioning of automotive transportation. Congressional representatives from western states tend to resist increases, citing their region's high level of dependence on automotive transportation, while representatives from eastern states tend to support increases, viewing the benefits of additional revenue as far outweighing the costs of their lower level of dependence. Perhaps automotive transportation is inherently neutral or this technology has already affected society and forced adaptations. In either case, the technology functions neutrally, and nothing more needs to be said. Roads and automobiles have become part of the furniture of the world. Since this technology stands outside of society, considering new taxes on fuel does not immediately prompt widespread discussion about how to restructure the transportation system. The image of technology as neutral object has become a key assumption in popular theorizing about taxation.

In sum, in the everyday habits of imagination that humans in North American society, and I include myself here, bring to bear through our language in describing and explaining our relations to technology, we regularly envision it or presume it to be a force that stands outside of human society. The human is separated from the machine by a sharp boundary. I have been using the term 'popular theorizing' to call attention to the habits of imagination that people regularly exercise in everyday language as activities worthy of the label 'theorizing.'[18] The dominant image of technology in popular theorizing about technology locates it as an inherently positive external force on society that is produced by a unique cadre of human creators who control its rate of progress.

CAD/CAM and Competitiveness

CAD/CAM technologists were early riders on the bandwagon of competitiveness, making full use of images of CAD/CAM as an external force. Judging from surveys of technical publications on CAD/CAM technologies as well as histories written by early developers, the nationalist reinterpretation of productivity actually may have played a significant role in constructing CAD/CAM as a distinguishable technology during the late 1970s and

early 1980s.[19] For example, prior to 1980, the term 'computer-aided design' generally referred to any use of the computer in engineering design, especially as a number cruncher to analyze possible designs in mathematical terms. Few technical papers ever used the term 'CAD/CAM,' and when it was used the term often referred generally to the rapidly developing visual technology of computer graphics, which extended far beyond engineering into such fields as architecture and entertainment. However, beginning in about 1980, commercial vendors, engineering journalists, and other advocates began to position CAD/CAM technology as the combination of these two threads, i.e., the appropriation of computer graphics for productivity in design and manufacturing. The doctrine of competitiveness gave CAD/CAM a motivating logic, a framework of meaning, a sense of place and purpose, and a moral imperative.

A key step in the public promotion of CAD/CAM technology came in 1980 when Computervision, by far the leading early CAD/CAM vendor, published *The CAD/CAM Handbook*. This handbook was a series of testimonials from satisfied customers and optimistic consultants that introduced the technology to new customers and explained how it could enhance their productivity. To the editors, CAD/CAM rode in on a white horse:

> *In the short span of ten years, a new technology has evolved which has already dramatically changed the way in which products are designed and manufactured. In the decade which lies ahead, advances to this technology will benefit all by improving mankind's standard of living and quality of life. The technology is CAD/CAM and the benefit is increased productivity.*[20]

While doing research for this project, I regularly saw this book displayed centrally on the bookshelves of engineers' offices in universities and industry. Without exception, interviewees agreed with an engineer at one company who told me, "That book really helped me get oriented." By the mid-1980s, CAD/CAM technology was widely advertised as a 'productivity tool.'

CAD/CAM proponents in industry, government, and universities found an important source of popular legitimacy and power in the doctrine of competitiveness. The great promise of CAD/CAM technologies was that they would streamline technological innovation in American industry by breaking down the so-called 'brick wall' between design and manufacturing (Figure 1.2). In the main theories of American industry held both inside and outside of industrial plants and factories, design activities had long been considered distinct from manufacturing activities, while carrying higher status.[21] Design was more important because it was the site of autonomous invention, the source of all new ideas, generated spontaneously in the persons of design engineers. Meanwhile, manufacturing was downstream, the lesser site of applied work where new ideas were put into practice. The

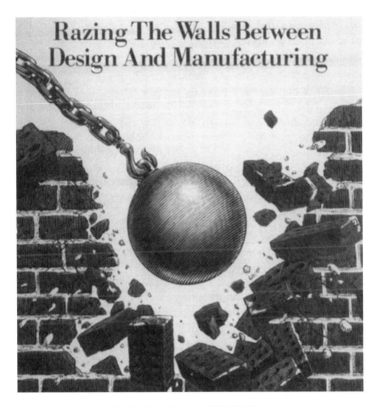

Figure 1.2 The Great Promise of CAD/CAM Technologies

image of autonomous design in technology had pushed manufacturing outside the realm of innovation.

CAD/CAM technology offered a world that would pull manufacturing back into the realm of innovation by merging manufacturing activities with design, while flexibly automating both. The two would form an integrated whole, a joint autonomous force of automation destined to produce liberating change. Merging design and manufacturing through CAD/CAM technology would increase national productivity by enabling companies to respond to changing consumer demands more quickly, effectively, and cheaply. CAD/CAM technology would lead America into a future of freedom through competitiveness, saving the nation and guaranteeing social progress by liberating Americans from dependence on foreign industry.

By the time I first arrived on the scene in 1987, the doctrine of competitiveness was well established as the primary theoretical framework for evaluating CAD/CAM technologies. That is, the nationalist story of outside economic threats, lack of innovation in manufacturing, and technological liberation established the main source of values for assessing developments

in CAD/CAM during the 1980s as the technology gained footholds in industry, education, and research. Put most simply, CAD/CAM found itself developing as a technology that would be good if it increased productivity and bad if it did not.

By thus establishing a theoretical framework for interpreting and evaluating CAD/CAM technology, the nationalist script provided a powerful motivation for CAD/CAM advocates to identify, elaborate, and advertise every bit of evidence they could muster that each new development in CAD/CAM technology enhanced productivity. Optimistic claims of productivity increases were common, despite the fact that it was difficult to measure productivity in industry for any but the most repetitive tasks. During the course of my research, I heard or read dozens of optimistic portrayals of CAD/CAM technology that pictured increases in the productivity of design activities as high as one hundred to one, or one hundred times as much output for a given amount of labor input. A standard assessment in one area of CAD work became three or four to one.

By celebrating the promises of CAD/CAM technology, a range of messages in vendor advertising, engineering journalism, and even technical articles implicitly threatened with declining competitiveness any companies that did not jump on the bandwagon. For example, working under the title "CAD/CAM System: Start of the Productivity Revolution," an early series of articles in the widely read engineering magazine, *Design News,* induced readers to continue by appealing to their fears: "In the short span of ten years, CAD/CAM systems have matured from an experimental new application of computer technology to a competitive necessity for many companies."[22] Lest readers think CAD/CAM might be a flash in the pan, the header concluded by claiming meteoric growth: "The CAD/CAM industry has grown at a rate of forty percent per year, and this growth is expected to continue into the 1980s." Clearly, CAD/CAM developments were inherently positive.

But in addition to providing legitimacy to proponents, the positive image of CAD/CAM technology throughout the 1980s also appeared to constrain the field of interpretation for potential critics. The pressure to conform to a positive assessment was great, and public debate was almost nonexistent. As far as I could tell from stories I heard as well as my own experiences, critical accounts were confined largely to private discourses, e.g., personal conversations, the hallways and corridors at professional and industry meetings, proprietary reports from industry consultants, and so forth. Those people who even considered arguing that CAD/CAM technology was less than wonderfully promising were putting their careers on the line, risking the challenge that they were anti-CAD/CAM and, hence, fundamentally anti-technology, anti-progress, and anti-American. I often felt the weight of this pressure, particularly on those occasions when I dared to inquire into potential 'negative effects' of CAD/CAM technology, e.g.,

displaced labor, the concentration of control in fewer hands, heavy reliance on mathematical modeling in engineering design, decline of hands-on skills, using limited resources on expensive equipment, and so forth. Certainly no overt conspiracy was taking place to suppress disagreement and dissent. Rather, the main framework for interpreting the technology located it as inherently progressive, which made any kind of disagreement a challenge of fundamental proportions.

Those published accounts that did begin to shade into criticism were forced to dance around for strategies that avoided the anti-technology label, for widespread acceptance of the utopian vision rendered any negative images marginal and powerless. For example, the only published account I could find by an engineer in the United States that was critical of CAD/CAM began by acknowledging that "calling attention to the dangers of computer-aided design is akin to tilting at windmills."[23] After proclaiming his faith that "[t]he gains . . . outweigh the dangers so totally that nothing is going to—or should—slow the trend," the author pointed out that he was simply identifying "unintended side-effects." The writing had a defensiveness that suggested a sense of fear. An excellent series of studies of CAD/CAM technology by academic social scientists, published in 1989, carefully avoided the anti-CAD/CAM tag by claiming only to outline the "social and organizational dimensions" of CAD/CAM use while eschewing any claims about its technical dimensions (see chapter 3 of this book).[24]

By the 1990s, however, things had changed for CAD/CAM. The technology's term of office in the nationalist spotlight had passed, and it became possible to criticize CAD/CAM. In 1992, for example, two social scientists and an engineer announced brazenly in print without having to sacrifice their consulting careers that "the technology has not lived up to its billing." "True CAD/CAM," they boldly claimed, far from being a competitive necessity and the leading edge of the productivity revolution, "is still quite rare and requires a degree of cooperation across organizational boundaries for which most companies are ill equipped."[25] One engineer involved in CAD/CAM development confided to me in a bit of corridor talk, "Not only have we not solved the problems of CAD/CAM, we haven't yet even solved the problems of CAD." Rather than breaking down the wall between design and manufacturing, CAD/CAM technology had tended to emphasize design considerations and practices, sometimes to the exclusion of manufacturing considerations and practices. In many ways, the history of CAD/CAM had become the development of CAD/cam.

But to say that CAD/CAM technology did not fulfill the nationalist agenda is not to say that the technology was a failure in some thoroughgoing sense. Although it is easy to find stories of problems and struggles (see chapter 3 of this book), it is also possible to find stories of significant successes, even taking into account perspectives from labor as well as from management. While it is clear that many companies bought these machines

as a strategy for replacing humans, the outcomes are less clear. The key point here is that no single, consistent story of either positive or negative experiences stabilized into a standard account. Human experiences with CAD/CAM technology resisted such universal reductions.

Nevertheless, from the perspective of the doctrine of competitiveness, CAD/CAM technology had shortcomings that meant it could only be part of some larger solution. The utopian image of CAD/CAM was replaced in the nationalist doctrine by a new technology, or at least a reconfigured one, called Computer-Integrated Manufacturing, or CIM (sim).[26] CIM had stepped in to become the technology that would truly merge design and manufacturing and produce the automated factory, the factory of the future.

Intervening through Technology Studies

People's experiences of technology are rarely limited to the positive, the negative, or the neutral, or even to combinations of the three. I remember vividly the first time I heard Mel Kranzberg, the witty and engaging historian of technology who was co-founder of the Society for History of Technology, provoke a popular audience with what he called Kranzberg's First Law: "Technology is not positive or negative [long pause], . . . nor is it neutral." Probably all of us could cite many examples of more complex experiences with technology.

A long history of interdisciplinary research in technology studies has challenged the dominant image of technology with its sharp boundary and simplified models of change. In fact, such challenges arguably are the defining feature of technology studies as a field of academic theorizing. In a sense, approaches to technology studies work together to make visible the many tendencies, experiences, and relationships that the dominant image has hidden or made less visible. Yet in advancing alternative images, different approaches have adopted distinct pathways to intervening in the dominant image, and the value of each pathway depends in significant part upon how it interacts with the dominant image. While calling attention to or highlighting some things, each image also omits others. Different approaches to technology studies can thus be mapped according to the specific pathways they use to intervene in the dominant image. Locating this study in the context of such approaches can help in assessing both its value and its limitations as a potential contribution to knowledge about technology and society.

The pathways researchers follow depend upon their theoretical dispositions, methodological strategies, and identities as persons. Theory matters, for it locates one in relation to the dominant mode of theorizing. Methodology matters, for it establishes the steps through which one becomes located in the field of intervention. One's identity as a person matters, for

such indicates one's initial location with respect to a field of intervention and establishes what might be helpful methodologically. To acknowledge the researchers' shared, if parallel, efforts at intervening in the dominant image, I use the present tense to discuss each pathway.

Perhaps the most traveled pathway to intervening in the dominant image has been to explore the human side of the boundary, detailing human 'impacts' of new technologies. In popular arenas, people who are concerned about the implications of technological development but do not identify themselves with anti-technology critique often couch arguments by attempting to detail the impacts of technology on society. By having conceived impacts as inherently positive, the dominant image hides occasions when they might be more complicated configurations.

For example, the engineer with whom I worked most closely on this project understood it in just such terms. My research was funded by the National Science Foundation with a small Professional Development Grant of $38,000. This grant included a training component, which required identifying a host specialist to supervise my education in CAD/CAM technology. I received a warm reception from Arvid Myklebust, then associate professor of mechanical engineering at Virginia Tech. Professor Myklebust found the project intriguing because, he said, it intersected with a major concern of his own. He had been worrying for some time that rapid changes in manufacturing technologies, such as CAD/CAM, were increasing the diversity of new products without necessarily making them better. Consumers seemed to want more and more diversity, more models every year, finer and finer distinctions. Although Myklebust said his engineering research and teaching left him little time to think through this worry in any detail, producing diversity for the sake of diversity seemed pointless. He wondered if our society was shifting to a whole new form of manufacturing that depended upon products having short life cycles. Might we somehow lose sight of what is meaningful in life by placing too much value on superficial distinctions? He asked, "How many different models of automobiles do we need? Or chairs, tennis rackets, light fixtures, bicycles?"

Myklebust seemed genuinely troubled that he was participating in a development whose effects he someday might not celebrate. He summarized these worries in a remarkable letter of support for my proposal. Voicing his concerns in a middle paragraph without questioning the assumption that automation increased productivity, he avoided the appearance and dangers of an anti-technology stance:

> Too often new technologies are rapidly exploited without consideration of their best utilization or of their impact on society. We have experienced in recent years a headlong rush into automation of design and manufacturing by industry at an ever-increasing rate. The rapid growth is to a great extent stimulated by substantially improved productivity. The best uses of this

technology in areas such as improvement of design quality are not well known. Potential side effects of this industrial transformation are not as readily apparent as they were in, for example, nuclear energy. The results of the research proposed by Dr. Downey will undoubtedly be of great benefit to both developers and users of computer-aided engineering design who are concerned about the future of this new technology.

I was delighted to have his support, flattered to gain his confidence, and sick about the burden of explaining impacts. The major problem that impact researchers faced was to identify impacts that arguably were not positive without becoming labeled as anti-technology. Myklebust's letter successfully achieved this for himself, while placing the burden upon me.

A great deal of important work has taken place under the banner of impact studies since the 1970s, when institutional support for such work increased dramatically. Academic work conceived in this way can be traced back at least to William Ogburn, an American sociologist of the 1920s, who explained "How Technology Causes Social Change" in terms of variables and constants.[27] If technology was a variable and society a constant, then technological changes could clearly be identified as the causes of subsequent social changes, whose contents one could not presume in advance.

Methodologically, intervening on the human side of the boundary involves distinguishing impacts according to different dimensions of humanness.[28] Divided up in disciplinary terms, human effects thus have, among many things, social, psychological, cultural, biological, and political contents. Researchers converge on the problem from a variety of fields, and a wide range of research strategies appear appropriate, from interviews and questionnaire surveys to psychological profiles and physiological tests, all depending upon the technology and impacts involved. The mechanisms of impact and change are diverse and not always predictable in advance. The 1989 collection of research on the social and organizational dimensions of CAD/CAM development mentioned above applied the logic of impact analysis in some respects even if not always using the concept.

The practice of making effects more visible enables researchers to participate directly in technology developments. Impact assessment gained force in the United States during the 1970s. For example, passage of the National Environmental Policy Act of 1970 required all projects with federal funding to file environmental impact statements. The 'adequacy' of an environmental impact statement became a key point of dispute between proponents and opponents of particular projects. Public debates over nuclear power and radioactive waste disposal gave rise to an industry of researchers studying the social impacts of nuclear developments and concocting strategies for 'mitigating' negative impacts and 'compensating' people who were negatively affected. Extensive assessment efforts became a regular part of federal technology initiatives through the Congressional Office of Technology

Assessment, which conducted hundreds of assessment studies beginning in 1969. By 1994, dominance of the doctrine of competitiveness had made technology assessment appear unnecessary, and Congress eliminated the whole enterprise.

The most significant danger in impact studies lies in ignoring the process of technology development itself, including the so-called 'knowledge contents' of the technology. In other words, by intervening only on the human side, they leave the machine side alone. They keep hidden the complex activities of technological development, leaving decision makers both invisible and in control. Consequently, they give the dominant image no way to adapt itself to knowledge about impacts. Impact studies can thus appear to be an afterthought, a contribution that comes too late.[29]

During the 1980s, the rise of 'constructivist' studies of technology, led by Bijker, Hughes, and Pinch's *The Social Construction of Technology,* offered an entirely new approach to intervening in the dominant image. Drawing from the sociology of scientific knowledge and the history of technology, the constructivist study of technology demystifies the machine side of the boundary. Through detailed case studies of specific technologies, constructivist studies make visible the diverse activities of individuals and groups involved in technological development, making it difficult to think of 'invention' and 'innovation' as singular events or fixed processes.[30]

By focusing on the machine side, constructivist studies commit researchers to a particular model of humanness. During the 1980s, many arenas of social research shifted their central assumptions about how to conceptualize and describe human behavior, what might crudely be called a shift from 'structure-based' to 'agency-based' accounts.[31] Impact studies are structure-based accounts, which compete to identify preexisting structural forms, e.g., social structures, cultural structures, cognitive structures, and so on, that shape the human action in question. In something of a dialectical overreaction, this form of analysis was often challenged and replaced by its polar opposite, agency-based accounts, which view human action as in a constant state of flux, always being shaped by contingent practices. The transformation of modes of analysis through this shift in assumptions is dramatic. Human actors are no longer devalued as 'dopes'[32] who apparently live only to fulfill the requirements of determining structures. They move to center stage as the source of heterogeneous, constitutive practices, often as quasi-omnipotent and omniscient beings. A single descriptive question emerged across the disciplines of social research: How do diverse human choices and judgments combine to construct or negotiate new structural forms, e.g., class interests, cultural systems, or new technologies? But just as structure-based accounts have excelled at accounting for continuities over time but struggle to account for change, the agency-based accounts are good at accounting for change but struggle to account for continuities.

Constructivist studies of technology demystify the machine side of the

dominant image by showing that society can be found there too. Constructivist analyses conceive themselves as opening the black boxes of technological development by showing how diverse choices and judgments combine to effect specific knowledge changes and technological developments. Constructivist analyses achieve their insights by postulating an initial state of disorder, or heterogeneity, and then moving to account for the achievement of order, whether in the form of established facts or stabilized technologies.[33] Any developing technology has 'interpretive flexibility,' or different meanings to different groups, and the process of technological development can be described as competing groups negotiating their differences until they eventually settle on shared interpretations.

In recasting technology from an external force to a product of contingent social judgments, constructivism democratizes the internal power relations of technological development. It asserts that everyone who participates in the negotiations, from technicians to salespersons, is a contributing technologist. Everyone becomes an inventor or an engineer. Accordingly, the constructivist pathway to intervention figures participation in technology development through a form of consultant politics, in which one helps other people and groups do a better job of negotiating their differences without presuming to interfere, assess their agendas, or design one's own agenda. At the same time, the consultant role makes dissent tricky. In a surprising way, constructivism tends to align its researchers with features of the dominant image by constraining them to either select projects with which they agree, ignore their concerns about a technology under study, or figure out how to express concerns in parts of their lives outside their research. Just as impact approaches direct researchers away from assessing technologies, so constructivist approaches direct researchers away from assessing the negotiating groups and perspectives found inside of technologies.

The main risk in adopting this pathway to intervening in the dominant image lies in potential trouble connecting life on the machine side of the boundary back to life on the human side. In a sense, although finding social action inside of technology, constructivism leaves society behind, traveling across the boundary into the realm of technology and then experiencing difficulty in getting back. To the dominant image of creation on the machine side, constructivist accounts can appear to claim that new technologies are in no way special but simply another version of a stabilized social form, since all social forms effectively become creations or inventions. The pathway could thus appear to be a thinly disguised way of pushing an anti-technology position, despite advocates' pleas to the contrary.[34] At the same time, focusing attention on the machine side of the boundary directs one away from intervening in the dominant image of impacts. Focusing on movements from disorder to order makes it difficult to articulate how a previously stabilized social order might participate in or shape subsequent negotiations, such as a stabilized technology having effects in society. Hence, although

treating technology thoroughly in social terms, constructivist studies of technology can have the effect of preserving the sharp boundary between technology and society.[35]

Perhaps the largest collection of academic work in technology studies adopts pathways to deleting the boundary between technology and society. Such approaches establish links between the analysis of technological developments and the analysis of impacts, albeit at the cost of formulating comprehensive images to account for both. So while the big goal becomes replacing the dominant image completely, the big challenge becomes convincing people to accept and live by the alternative offered.

These pathways fall, roughly speaking, into two broad categories. Members in the first category take something from the technology, or machine, side and generalize it across the boundary to the society, or human, side. For example, one might generalize a key value attributed to technological progress, such as 'rationality' and 'efficiency,' and produce models of 'technological society' driven by large-scale dynamics of rationality and efficiency, often with negative implications.[36] Or one might focus attention on the increasing velocity of technological change to generate images of 'future shock,' in which social interactions increase in velocity until finally all social bonds become unglued and society falls apart.[37]

These pathways intervene in the dominant image by showing how apparently social or purely human phenomena can have technological characteristics. In other words, if something exists on both sides of the boundary, it makes sense to analyze both sides of the boundary at the same time and in the same terms. The typical methodological strategy involves a wide-ranging search for supporting evidence, with countervailing evidence generally warranting less consideration. Because the goal often becomes completely redesigning technology and society, gaining participation in technological development appears unattractive and unlikely, for such could suggest that the researcher has been co-opted by the very system under analysis. It is difficult to structure these pathways in a way that does not approach the dominant image as an anti-technology attack.

Another approach to generalizing from the machine side to the human side involves the study of 'sociotechnical systems.' In this case, the engineering theory of systems extends to society, characterizing links between society and technology as feedback loops when all goes well and as system breakdown when all does not.[38] This pathway focuses on how things fit together, calls attention to the involvement of humans and social forms in systematic mechanisms of interaction, and explores both the technical and nontechnical dimensions of the systems analyzed. Seeking participation in technological development is largely unproblematic for the systems analyst, for the pathway leaves intact members on both sides of the boundary. However, the main risk in this approach is that it can limit analysis to elaborating the dominant image rather than critically engaging it. Systems

approaches tend to assess how well systems are functioning in relation to given objectives, making it difficult to examine critically system objectives and the systems themselves.

The second category of pathways to delete the boundary travels in the other direction, generalizing something from the society or human side over to the technology or machine side.[39] A prominent example is 'actor-network theory,' which extends a human activity involving actors and networks onto technology and other nonhumans, turning everything into both an actor and a network. It does so by generalizing a specific account of goal-directed behavior among humans (e.g., agonistic warfare) to all network participants whether human or nonhuman. Every network actor becomes a combatant seeking to expand its locus of control by enrolling others into its program or agenda, aiming for a state of total control, yet encountering resistance in the form of constraints. The theory thus commits the researcher to a uniform image of humanness that involves locating people as entities fighting it out in a heterogeneous battlefield and analysis as a process of sorting out their field tactics and strategies.[40]

Like constructivism, the actor-network pathway figures participation as a form of consultant politics, which here means that the researcher works to help actors make their way through their networks.[41] The main risk in this pathway to intervening in the dominant image is that, by seeming to reduce technology to network effects, it can appear to be anti-technology and, by seeming to reduce humans to soldiers, it can appear to be anti-human. Nevertheless, actor-network theory covers more ground and accounts for a greater range of experiences than other pathways to deleting the boundary between technology and society.

Another example that generalizes from the society side to the technology side incorporates both into models of 'technological controversies.' That is, social and technological life appear together as the social and technical dimensions of controversies whose main feature is structured conflict. For example, picturing society as structured by conflict between a 'center' and a 'periphery' produces an image of the center taking initiatives and the periphery resisting.[42] Picturing society as an array of 'competing interests' structures conflicts in patterns that are congruent with those interests.[43] Picturing competing 'ideological traditions' as a key source of conflict suggests that arguments in support of or opposition to a new technology will likely fit the social models that constitute these ideologies.[44] Finally, treating society as a 'diversity of resources' waiting to be mobilized produces images of controversies as configurations of strategies for managing and using those resources.[45]

Controversy studies intervene in the dominant image of technology in several ways, depending upon the specific theoretical perspective. For example, a study that makes subordinated perspectives more visible and places them alongside dominant perspectives can intervene in the power

relations that separate the two by helping the subordinated perspectives gain greater visibility and legitimacy. Also, accounting for activities on both sides of a controversy might put one in the position of mediating the differences between them. Finally, like constructivism, controversy studies contest the determinism of the dominant image by claiming that controversies shape technological development, thus demonstrating that a particular technological outcome could have been otherwise. Controversy studies thus put researchers in position to participate directly as advocates for particular positions, mediators across boundaries within controversies, or both at the same time.

The main risk is that controversy studies can have difficulty accounting for differences that cannot easily be characterized as conflict. For example, routine technology development and use become largely indistinguishable as phases of some more pervasive controversy, and differences among proponents or among opponents in a controversy either become sub-controversies themselves or get omitted from the account.

A final set of pathways for generalizing from society to technology involves extrapolating a specific hierarchical power relationship, particularly distinctions by class,[46] race,[47] or gender.[48] These pathways bring to technology studies the analysis of power by showing how new technologies reproduce existing power differences. In fact, the main effect of technological development becomes maintaining and expanding existing inequalities. For example, the story that provoked me most to rethink my own theorizing about technology and society was one of the low bridges on Long Island. In "Do Artifacts Have Politics?" the political philosopher of technology Langdon Winner describes how designers of the road system on Long Island purposely built bridges high enough for automobiles to pass but low enough to prevent buses.[49] The explicit goal was to prevent inner-city blacks, who could not afford automobiles and had to use buses, from disrupting the predominantly white, middle-class communities that the road system was helping to construct. With an efficiency generally reserved for mechanical devices, the completed road system helped establish and maintain racial and class divisions on Long Island and between Long Island and New York City. Equally impressive are accounts of how stereotypic gender relations can contribute to structuring new technologies, that, in turn, reproduce the gender categories ranging from the more obvious examples of the typewriter and word processor to more subtle cases involving the single-family dwelling and automobile.

These pathways intervene in the dominant image by challenging its universal dynamic of progress with images of hierarchical power and, sometimes, manifest exploitation. They structure participation as advocacy for structural change that eliminates the hierarchy, the difficulty of which depends upon the dimension chosen. For example, reordering gender relations in the United States to eliminate gender-based hierarchies may ultimately prove

more possible than eliminating hierarchies by race and, especially, class. Also, because emphasizing one dimension can make others less visible, following this sort of pathway likely requires one to figure out how to link more than one dimension together, such as race, class, and gender all at the same time.

By making the technological form directly dependent on the prior social form that structures it, this set of pathways places the greatest emphasis on technology development, leaving less analyzed the subsequent social effects of new technologies. As a result, and in parallel with impact studies, these pathways tend to leave in place the dominant image of technology as a determinate force. Although differing in how they theorize the social contents of technology, the class, racial, or gendered content generally carries over unchanged. As a result, the main risk in following these pathways lies in overlooking features of technology use that may not reproduce the power relations of primary interest.

For example, in *The Jobless Future,* Stanley Aronowitz and William DiFazio (1994) offer an excellent class analysis of CAD/CAM and other automation technologies, showing in detail how the main goal in automation has been to replace workers with machines. From this perspective, the expansion of CAD/CAM technologies during the 1980s was part of an explicit management strategy to control labor. But it is less clear whether or not such domination was actually achieved and reproduced in the purchase and use of CAD/CAM technologies. I am not sure Aronowitz and DiFazio's empirical net has been cast wide enough to warrant an overall statistical judgment, nor indeed has mine.[50] Nevertheless, I do worry that emphasizing the management objectives in CAD/CAM development may make less visible ways in which CAD/CAM use may have belied those objectives, which might lead travelers on this pathway to overlook opportunities to prevent or inhibit exploitation without requiring a wholesale transformation of society.

In sum, intervening in the dominant image by deleting the boundary between technology and society calls attention to meanings, activities, and experiences that arguably fall on both sides of the boundary. At the same time, these pathways risk construing the human, the machine, or both, in terms so narrow that replacing the dominant image remains a remote possibility. The greatest dangers they face are marginality and irrelevance. So, while many make important inroads in the evaluation of the dominant image, none has yet successfully challenged its dominance.

Another Try

This study contributes to an emerging category of alternatives that challenge the meaning and power of the boundary between technology and society without necessarily formulating a single substitute image in advance.

Drawing theoretical insight from cultural anthropology,[51] cultural studies,[52] and related fields,[53] these pathways confront people with what their images hide in order to make reevaluation a routine activity of both popular and academic theorizing. When contributing to technology studies, these pathways involve following the boundary between technology and society as people live or experience it, trying to make visible both the effects the boundary has in these lives and experiences and what the boundary hides or overlooks.[54] This shifts the problem of analysis and participation from a priori efforts at drawing or erasing the boundary between humans and machines to figuring out how such boundaries get drawn and lived in everyday experiences.

Rather than trying to convince people their mode of theorizing is wrong and advancing theoretical images that are purportedly more right, these pathways shift the burden of deliberating theoretical change to the people who must live with it, for all arguably function as theorists. Exploring how the dominant image of technology operates in everyday life becomes an important exercise to the extent that people's experiences go beyond the positive, the negative, and the neutral. The academic theorist can advocate specific directions but does not possess ultimate authority. Analysis thus merges with activism to produce critical participation.

This category of pathways thus intervenes in dominant cultural images by looking for ways to reimagine what their boundaries might mean, hence working the boundaries rather than affirming or eliminating them. The exact terms of participation vary with the choices. For example, simply making a cultural boundary visible and locating it historically can help people figure out better where they are located or positioned, understand how they got there, and perhaps establish the possibility of getting somewhere else. Such requires the researcher to travel and live on both sides of the boundary.[55] Making visible an entire mode of theorizing that a dominant image has rendered subordinate can help grant legitimacy to the alternative. It can also put the researcher in the potentially ambiguous position of spokesperson for that alternative.[56] Making visible people's distinct experiences of a boundary can mediate differences among them but also effectively requires the researcher to achieve 'membership' in each perspective.[57] Making visible how experiencing a cultural boundary contributes to the fashioning of selves can require the researcher to seek and accept deep involvement in the lives of particular people.[58]

Methodological choices in these pathways often involve participant observation, interviewing, and document analysis as these are particularly helpful for identifying meanings that dominant images overlook, but quantitative studies of meaning distributions could also prove significant. A key conceptual move is to construe experiences of self as the product of connections and relationships rather than as their essential precondition or core substance. This locates human experiences and, accordingly, personhood at

any given time and place as something to be found out through analysis rather than asserted or assumed at the outset. Also, development of a stable, coherent self over a period of time despite new encounters and interactions becomes an achievement rather than an assumption.

By locating selfhood theoretically in association with cultural position and identity, the researcher makes a methodological commitment not to draw a sharp distinction in advance between mind and body, thoughts and emotions, inside and outside, including in one's own practices of fieldwork and writing. Thus, these pathways depend upon the interpretation of meanings encountered in fieldwork through both one's reactions and observations rather than, in advance, analytically separating emotional moments of empathy and sympathy from cognitive moments of observation. The ethnographic challenge is to identify, describe, and present such meanings, including the cultural attribution of emotions and thoughts, in ways that readers who live with a cultural distinction between emotions and thoughts would find plausible and convincing.

By concentrating on making visible how this cultural boundary lives in everyday experiences, the main risks in this pathway are marginality and irrelevance, as they are in pathways to eliminate the boundary. In this case, the danger is that the account might feel implausible. To what extent might the researcher be imputing meanings that are highly local or not there at all? Is the researcher placing too much emphasis upon a small subset of meanings and experiences encountered in the field? Is the jargon too specialized or the challenges to think differently just too strange? Feeding this possibility is the concern that a study built substantially on participant observation and interviews might not be generalizable in a statistical sense, not applicable anywhere but among the people and groups studied, even if offering plausible interpretations. The problem potentially becomes particularly acute when the audience is not limited to academic theorists.

Every study adopting one of these pathways thus must organize specific strategies to achieve plausibility in the midst of such risks. For example, consider an account plausible if it contains enough data or evidence to help one identify alternate interpretations, including those drawing on established frameworks, but leads one to consider its analysis as somehow an improvement. Consider it plausible if it does an adequate job of mapping the important positions without leaving out perspectives whose inclusion would surely inflect one's interpretations in new directions. In short, measure each interpretation against other candidate interpretations rather than against any universal standards of truth.

At the suggestion of my host specialist Arvid Myklebust, I began fieldwork by attending undergraduate and graduate engineering courses in CAD/CAM and CAD, eventually participating in a total of five courses. While attending one undergraduate CAD class, I organized a focus group of five students, whom I paid to keep detailed journals describing the steps

they took to learn computer-aided design and to attend biweekly group discussions that I tape-recorded. After gaining some familiarity with the lab, I began attending and tape-recording the weekly meetings of a CAD/CAM research group.

In a search for different positions and perspectives, I soon found myself following leaks and flows from the lab. Traveling around the country, I attended four semi-annual meetings of the research group in different locations, annual meetings of two professional engineering societies interested in design research and design automation, a national trade show displaying new hardware and software for computer-aided design and computer-aided manufacturing, an annual meeting of a users' group for a new graphics standard, and an organizational meeting of researchers seeking to share software for high performance computing and communications. I toured the operations of two prominent hardware manufacturers and two prominent software developers, spent several days at industrial sites using CAD/CAM hardware and software, and was given access to the resources of a prominent market research firm following developments in CAD/CAM technology. During trips to my own professional meetings and personal vacations, I found opportunities to contact and meet with individuals somehow involved in CAD/CAM technologies in industry, government, and universities. During most all of these activities, I tape-recorded meeting sessions and individual interviews, recorded my own observations on tape, disk, and notebooks, and collected mountains of documents ranging from private correspondence to promotional materials and copies of software that sell for thousands of dollars. The editor of a monthly newsletter on computer graphics in engineering gave me a copy of every issue for a ten-year period. I accumulated approximately one hundred twenty hours of recorded cassette tapes, three hundred pages of notes, and enough documents to fill a large file cabinet.

For a time, I found myself moving happily toward full membership in the CAD/CAM Lab and possibly to adjunct faculty status in the Department of Mechanical Engineering. I accepted financial support one summer to supervise the writing of an expert system to help Virginia industries configure CAD systems. To this end, I communicated with dozens of representatives from hardware and software vendors about the capabilities of their products, soliciting copies of advertising, demos, and other promotional materials for a CAD/CAM library I was building. I was invited to teach the introductory course for senior-level undergraduates. I joined a proposal to teach continuing education courses about computer-aided design to engineers in industry. As I describe below, however, none of this lasted, for I eventually found the various challenges to selfhood less compatible than I had hoped.

When I spoke with engineers about my research, they often asked, "How large is your sample?" I responded by pointing out that, while quantity

is significant, the value of an ethnographic account lies not in the statistical significance of a sample. "Oh, then all you've got is anecdotes?" Well, in a way, yes. My goal in each case was to record how people understood and interpreted their experiences with CAD/CAM technology, and to understand the sorts of interests and commitments that people had written into the technology. Because I am presenting an interpretation of how others interpreted what they were up to, it is important that my account does a good job of mapping the cultural terrain, identifying important distinctions that make life with CAD/CAM meaningful and relationships with and within it powerful. Thus, rather than offering a single interpretation of the constitution and effects of CAD/CAM technology among humans, I map distinct interpretations with the goal of calling attention to differences among both machines and humans. The key methodological question is whether or not this account maps the range of human experiences with CAD/CAM technology sufficiently well to enable readers to identify and interpret both the similarities and the differences in different times and places. Can it help in formulating revisions of the dominant image?

The chapters in this book both follow a boundary and make visible experiences that blur it. First, I outline how the dominant image of technology has lived in and contributed to CAD/CAM development. Explicitly punning on the idea of impacts from technology, the opening chapters explore the impacts of the dominant image of technology. Chapter 2 shows how the dominant image organizes life at a trade show, emphasizing moments of pleasure and power while de-emphasizing the meaning and activities of technical support. Chapter 3 explores how engineers in a small company first benefited from the optimistic portrayals of CAD/CAM technology, then found themselves struggling to measure up to its promises. Chapter 4 examines how the dominant image helped stimulate the incredible expansion of venture capital during the 1980s, then helped drive CAD/CAM technology into commodity forms and away from its main script. Chapter 5 shows how enthusiasm for new technology justifies forcing humans to adapt by following an attempt to adapt the nation as a whole to the promises of CAD/CAM automation.

I then shift to explore experiences of humans inside the machine and experiences of the machine inside humans, both of which the dominant image has hidden. I found it most convincing to follow such experiences by concentrating on a single site—the experiences of students learning CAD/CAM technology. Chapter 6 examines the confusions of students who came to the course expecting to gain control over the technology, finding that learning CAD/CAM involved moving beyond the anticipated iterations of submission and control. Chapter 7 examines the experiences of students as they moved inside the machine, and chapter 8 explores students' struggles to locate the agencies of CAD/CAM technologies inside their own bodies.

Chapter 9 explores how the dominant image of the expert hides people's struggles to locate their expertise alongside other features of personhood.

To account for the engineers' experiences of humans and machines, I adapt the concept of 'agency' to describe acts of positioning that take place in both realms. My task is to follow human experiences with CAD/CAM technology to figure out where these attribute important agencies. Which agencies show up in humans, which in machines, and which in both? The book concludes by speculating what might have happened if subordinate experiences of CAD/CAM technology that challenged the cultural boundary between humans and machines were relocated alongside the dominant image of technology outside society. Might tracking configurations of agencies have made a difference? What does it take to imagine and build a world in which dreams of replacing humans with machines are more the exception than the rule?

CHAPTER 2 | We Put You in Control: The Trade Show

DURING THE 1980S, CAD/CAM technology grew from a $900 million industry to a $14 billion industry. The market, as they say, took off. What comprised this take-off? What drove people in large and small industries alike to lunge after this new technology? How did they understand the promises and threats of CAD/CAM technology? This chapter inquires into the attractions of CAD/CAM technologies by exploring images involved in selling and buying them, identifying both what they make visible and what they hide.

One of the companies that took off during the 1980s was Autodesk, Inc., behind its main software product, AutoCAD. Founded in 1982 by a loose collection of computer programmers, Autodesk grew in less than seven years into the world's fifth largest software developer, with $100 million in the bank, annual gross revenues of $500 million, and no debt. The human figurehead for this growth, John Walker, lent mythic status to this story with his book, *The Autodesk File,* an annotated collection of internal memos, that went through three editions between 1987 and 1989. During a visit to the company in Marin County, California (north of San Francisco), I asked Robert Palmer [pseudonym], a specialist in public relations, to describe how the company built its market. "I think," he said, "it started selling at the shows."

He meant the trade shows. In early 1990, I attended a four-day trade show, the annual Spring National Design Engineering Show, at the massive McCormick Place in Chicago. I had decided on this show because the vast majority of its twenty-five thousand attendees were engineers, male engineers, working in industry. (If they registered in advance, they paid only $10 for admission.) The most prominent show in the computer graphics

industry is the conference and exposition of the National Computer Graphics Association, which brings members of the industry together. Many CAD/CAM developers also participate in COMDEX, the trade organization of the computer industry that provides the main site for annual announcements of new hardware and software. There are dozens of other shows as well.

One of the vignettes opening this book portrayed a woman selling her company's software to an audience of men. The rumblings of pleasure were palpable as she appealed to their desire for control. The emotional contents of this interaction were actually more complex than this, for audience members had gathered in the first place out of a sense of fear, at least in part. The thrills of CAD/CAM technology also carried implicit threats, and the main images in CAD/CAM sales conveyed both.

Congruence

The show boasted the display of ten thousand products by more than eight hundred fifty exhibitors, each of whom paid $21.75 for each square foot of space for booths ranging from 200 to 10,000 square feet ($435–$217,500), plus a $100 surcharge each for access to a corner. Vertical visibility was rented as well. A small, in-line booth could not exceed 12 feet in height while a peninsula booth could rise to 20 feet and an island booth to 25 feet. CAD/CAM was one of ten categories of products exhibited at the show.

The show was a place to sell and to buy. According to survey results collected by Cahners Exposition Group, the private company that organized, promoted, and brought a staff of twenty people to the show, 84% of attendees had the authority "to recommend, specify, or purchase exhibited products"; 75% were "likely to purchase exhibited products within a year after the Show"; and 79% made "new vendor contacts at the Show." CAD/CAM technologies, along with computer-aided engineering (read mathematical engineering analysis) was the "primary product interest" by far, with 95% expressing interest. About 70% expressed interest in materials, 50–55% in mechanical and electro-mechanical components and systems and in instruments and controls, 30–40% in fluid handling/power transmission, electrical/electronic components, and joining systems and components, and fewer than 20% in quality control and testing or shapes and forms. Promotional materials to potential exhibitors promised a direct mail campaign with "over 12 million promotional pieces mailed to design engineers," advertisements in at least sixteen journals providing "almost two million exposures," a publicity program from "a major New York public relations firm," and "VIP invitations" that companies could distribute to their "hottest prospects."[1]

The most visible story in the show was a competition between two companies selling CAD/CAM software for personal computers, Autodesk

and CADKEY. Autodesk was Hertz to CADKEY's Avis. Although the Autodesk booth covered 3,000 square feet, advertising claimed more than 7,000 square feet, the difference pointing to the many software developers who built their applications on Autodesk's primary product, AutoCAD, and the many dealers who sold AutoCAD to their customers in bundled packages with other hardware and software. CADKEY claimed to offer not a sales pitch but a "Manufacturing Solutions Fair" at its booth, which covered 4,000 square feet. Both companies promoted themselves extensively in the show's daily newspaper with large news stories describing their booths, although the same stories appeared each day.

Other strong presences with major booths near the main entrance included MCS (2,500 square feet), Prime Computer (2,200 square feet), Intergraph (2,800 square feet), and McDonnell-Douglas (2,400 square feet). But nearly every major software and hardware company in the CAD/CAM business was represented somewhere. The official Show Directory listed fifty-two companies offering CAD systems, forty-two selling CAM technology, fourteen with desktop computers, twenty with workstations, and three offering mainframe computers. There was much overlap across these and other categories.

The main actors in the software booths were collections of workstations running 'demos' of the latest releases. Although demos purportedly showed products in action, generally they were simply playing back keystroke files, which were records of the keyboard strokes used to complete various tasks. Stringing these together presented moving pictures of production, visually transporting viewers directly from design to manufacturing, from idea to reality. The supporting actors in these performances were salespersons positioned in front of specific machines, ready to make sure potential customers confronted and experienced the true realities of automated production. They worked to achieve this by figuring out ways to link their machines to customers' lives and bodies. They pointed out every strength of a given product and met every concern or problem a prospect might raise. In what felt to me like trying on clothes with a salesperson watching and commenting on every move, the salespeople seemed to believe one would not buy CAD/CAM if it did not fit perfectly.

The National Design Show was loaded with powerful images overlapping on the theme of control. Engineers sometimes use the word 'congruence' to refer to a visual correspondence between distinct objects, in the sense that one can be superimposed on the other or that the two are somehow coincident throughout. For example, congruent triangles are geometric forms that can be superimposed on one another and, hence, strike the reader as the same. In similar fashion, I found many of the images at the National Design Show to be congruent with one another in the sense that their meanings overlapped. That is, these images offered their audience

the same distinctions or connections in the midst of their differences and, hence, presented people with the same sorts of challenges as persons.

For example, the show explicitly articulated the rearrangement of America's opponents in the world, displacing fears about national loss of control from a military and political idiom to an economic one. Importantly, the Soviet Union was now our friend. "Glasnost comes to National Design," boomed the full-page color ad inside the cover of the *Preview,* announcing that the female "Russian cosmonaut, world hero [*sic*]" Valentina Vladimirovna Tereshkova would address the show's visitors. "Her main topic of discussion," elaborated the daily newspaper, "centers around the need for greater cooperation between the U.S. and Soviet Union in developing new technologies and sharing information." In a second major address, the vice president of the U.S.S.R. Academy of Sciences would speak "on the benefits that U.S. companies can reap through cooperative ventures in the Soviet Union." No longer the evil empire, the Soviet Union was now repositioned as a developing country offering huge investment opportunities rather than threats. There was the Soviet Union asking for money, thus reassuring American industry.

The main drama, however, had been transported to a curious third speech, one whose appeal drew from a combination of fear and respect for America's new economic enemies, Japan and anyone else who chose to compete economically with America. The title of this address promised the knowledge that all loyal Americans desired most: "How the Japanese and Koreans are Beating Us." The curious part is that this message was more important than the identity of its speaker, Professor C. H. Suh. The accompanying story explained how Professor Suh's American-born ideas had been shunned at home but, like those of the famous W. Edwards Deming who was widely and often portrayed as the American father of Japanese economic success, had provided a key ingredient in Japanese and Korean developments.

"Once Unwanted," said the headline alongside the story about the friendly Soviets, "Suh's Advice Now Hot Ticket." During the 1970s, this "experienced consultant in the design of automobiles and components" had "approached the three top American car manufacturers with some suggestions for improving automobile design," but "each manufacturer had refused the input." Evidently this was a bad move, because Suh subsequently "helped turn the Japanese and Korean carmakers into formidable rivals, and the Americans are now approaching him." According to this native son and clear repository of expertise about competitiveness, despite the Asian name that could raise questions about the true descent of his ideas, "several areas of American design and manufacturing could use attention now—if U.S. manufacturers would simply admit it." Missing this speech would be a foolish thing to do, for "he will address many of these

during his remarks." Yet readers were told nothing else about the man. It took me three days of investigative work to find out that this icon of American competitiveness, this carrier of American essences to foreign lands, was a faculty member at a solid but not elite engineering school, the University of Colorado at Boulder. Publishing such information might very well have undercut the image of an American engineering messiah.

Professor Suh's speech was about regaining control. If Americans could demonstrate that core features of others' achievements had been fundamentally American in content, then the American belief that all technological genius originated in the United States was reaffirmed and beating the Japanese and Koreans was not aggression but simply a matter of recovering our rightful power and authority. Without this link, Japan and Korea could very well be out of our control and the United States might be doomed with no way to fight back.

Vendors at the show skillfully positioned messages about control through competitiveness in the context of other images formulated especially for the stereotypic adult male, pleasures built around experiences of power, strength, and control. Some of the force in these images was (hetero) sexual. I played nine holes of miniature golf on a Dupont course made of kevlar, accompanied the entire time by my personal caddie, a blonde wholesome-looking woman, young enough to inspire fantasy yet old enough to inhibit guilt. Dressed in a green golf sweater and khaki pants, Melanie kept the small talk going, cheered me on, and retrieved my ball from each hole, all the while reminding me of the wonders of kevlar. Some of the force was automotive: I had my picture taken in the cab of a Mack truck, parts of which had been designed with CAD/CAM software from McDonnell-Douglas, the sponsor of the event. Some of the force was athletic: After standing in a long line inside the Intergraph booth, I shook hands with Jim Everett, then quarterback for the Los Angeles Rams. Some of the force lay in controlling virtual space: I put on the famous PowerGlove and goggles and experienced the joys of flying through the Parthenon in virtual reality, although I did feel a little foolish standing there pointing all over the place with two dozen people watching me. Some of the force lay in acquiring tools: I loaded my plastic show bag with giveaways that included five pens, two mechanical pencils, a compass, two screwdrivers, four big erasers, two rulers, and a small T square. Some of the force lay in demonstrating virtuosity: I passed up an opportunity to compete for prizes in "Build a Better Mousetrap," which gave participants a bag of parts and an hour to complete the job.

That the show was about achieving control was reinforced by how life after hours was portrayed as recess, as temporary suspension, as life momentarily out of control. For example, I saw many people paging through the special issue of the *Chicago City Guide,* a popular reference for entertainment in Chicago, which had been produced specifically for this group and was available everywhere. One popular restaurant offered something akin to a

fraternity party, billing itself as "a crude eatery with too much booze (72 varieties of beer), loud and obnoxious Dixieland Jazz, surly employees, and endless partying." The most prominent advertisement was for the Baton Show Lounge, which offered "Tops in the Nation Female Impersonators," promising a "lot of laughs," something a "little bit shocking," an "evening of plain old campy fun." The *Guide*'s back cover advertised the "best steaks in the city," although with all the ambivalence of owning a Honda, Toyota, or Mazda: "When your steak knife looks like this [i.e., chopsticks], you have to serve tender steaks. Benihana: The Japanese Steakhouse." Not surprisingly, the *Guide* did not mention the popular gay clubs not far from McCormick Place, where the meaning of one's presence would have conflicted with the meaning of attendance at the show.

It's All in the Machine

The frightening dangers and exciting opportunities available in a world reimagined by competitiveness were concentrated in the show's central theme, "Design For Manufacturability (DFM)." Design for Manufacturability was a label for a new class of technological products, marking a "team approach to product design" that brought design, manufacturing, and marketing together through technology:

> *From the outset, when the marketing department identifies a new product to bring to market, the design engineer works with the marketing team to ensure that the design incorporates all features that the consumer requires. The next step in the process is to bring the manufacturing engineer into the design process. And it is at this point that traditional product design methods fall far short of 'DFM.'*

The show sold itself as "one-stop shopping" for the engineering problem solver at risk. "You need to keep up with the newest products and technology," warned the show's *Preview*, "[b]ut who has the time? The only thing tighter than your budget is your deadline." With its technology and expertise, the show would put you in control:

> *When you're looking for that specific solution and can't find it* anywhere, *when your designs are innovative but are not yet manufacturable, when you're looking for that product to spark your imagination . . . National Design delivers.*

With a photograph of a newborn child lying on top of an engineering blueprint alongside a drafting triangle, National Design stepped in with the expertise of a physician to deliver "your baby"—the "you" most likely a productive male engineer. (See Figure 2.1.) Appropriating the experience of birth

When it's "your baby" and you've got to deliver...

Figure 2.1 The Engineer's Baby

as a design and manufacturing process requiring outside expertise, delivery became not only something that men regularly do but also a problem-solving process with technological solutions. Technology gives the designer/manufacturer control over creation.[2]

CAD/CAM advertising at the show regularly used visual arguments to establish the claim that they were bridging the gap between design and manufacturing. The key was to promise and demonstrate that this took place *inside* the computer, thus freeing engineers from the burden of having to depend on unreliable human beings. Design activities and manufacturing activities are regularly located in separate departments with separate personnel who communicate with one another primarily through the medium of engineering drawings. It is still commonly said, for example, that after they have completed their work design engineers simply "throw it over the wall" to manufacturing. I regularly encountered tension between representatives of

the two sides, each finding a way to express skepticism about the value of the other. With technologies available at the show, engineers working in design would become connected to manufacturing without having to coddle to manufacturing people. CAD/CAM would mediate for them.

A main strategy in CAD/CAM advertising was to emphasize the velocity of movement from design to manufacturing. For example, an IBM ad in the daily newspaper used three computer-generated images of a bicycle to tell engineering managers to "Bring Your Design Team Up to Speed." The first panel called attention to the conceptual design process. Because the viewer cannot tell that a bicycle is coming, the vision must be in the mind of some bright design engineer, to be shared by the machine. (See Figure 2.2.) The second, central panel, a 3D wireframe model, is a bicycle broken into the pieces engineers need to analyze it thoroughly. A design team up to speed will do a solid job of engineering. The third panel is an appealingly rendered bicycle of the future, suggesting a process that carries us forward, up to speed. Consider the implications of designing a nineteenth-century high wheeler or a balloon-tired one speed from the 1950s. The appealing 'photograph' lies inside the computer.

An advertisement distributed by Computervision at the show appealed to engineers' appreciation for the one sport many of them still played, golf. Not surprisingly, given the popularity of power hitters such as John Daly, the ad called attention to the power club, the driver, which many readers had likely analyzed at some length in endless searches for more power. The five panels, titled "Five Ways to Drive Home an Idea," suggested a rapid, integrated flow from left to right, from design through manufacturing. "Nothing Gets Your Ideas to Market Faster than Personal Designer R," said the ad, moving quickly through "drafting, geometric modeling, Bezier surfaces, smooth shading, and finite element modeling." (See Figure 2.3.) An accompanying photo of the completed club, produced inside the computer, informed us that everything needed to design and build the thing took place in there. Nothing to worry about. The computer was making sure that our drives would demonstrate our true strengths.

A new CAD program calling itself the "Ultimate Speed Machine," advertised its speed with an image of a jet fighter bursting out of the screen. (See Figure 2.4.) FastCAD was fast because it was programmed directly and entirely in assembly code, which is one layer above the speedy electronic processing of computer hardware. Most CAD/CAM software was written in "higher-level" languages, which required at least one time-consuming translation before reaching assembly code. According to the ad, this strategy promised design agencies so powerful that not only do the objects live inside, but also they simply burst out at you.

My favorite example of convergence between design and manufacturing inside the machine was the Schlumberger demo of its CAD software, Medusa 3D. Demos attracted great attention at the show because these

Figure 2.2 Creation Can Be Fast with CAD/CAM

FIVE WAYS TO DRIVE HOME AN IDEA.

Figure 2.3 The Pleasures of Power

appeared to be replications of actual engineering work, concentrating in a visual experience far more activities than could be presented in print, radio, or television advertising. The CAD/CAM demo was competitiveness inside the machine, concrete testimony that the computer could blur the boundary between design and manufacturing. Human experts hidden away somewhere had empowered this technology so it could now bring you solutions all by itself. Experiencing this opportunity was the pathway to believing it, trusting it, and buying it. Only by being there could you feel it and, hence, want it.

The Schlumberger demo was accompanied by a calm, comforting masculine voice that kept informing, reminding, and reassuring us that Medusa had everything under control. Consider a small excerpt, which was presented slowly, with long pauses between sentences to help listeners feel the reassuring comfort of Medusa's presence:

> . . . We're letting the system do as much of the work as possible. We're drawing as little as possible. The system is generating as many views as we could possibly want, automatically. When it comes to assembly, we're putting things together as if we are doing it on the shop floor. If it's not going to fit, you're going to find out in Medusa on the computer, rather than when you just got done making a prototype, wasting time and money. I'm not going to say it's going to eliminate prototyping, but it's going to cut it down dramatically. It's going to allow you to get questions answered quickly. You tell me what it's made of; I'll tell you what it weighs. You might want to change the material. How is that going to affect my design? Is my center of gravity going to move? Are my moments of inertia going to change? What's going to happen? These are things Medusa can tell you right there on the computer. . . .

While most CAD/CAM advertising was pushing either software alone or a combination of software and hardware, some focused on hardware alone. In this case, the problem of fulfilling the framework of competitiveness was simpler. Computer manufacturers sold to all kinds of customers

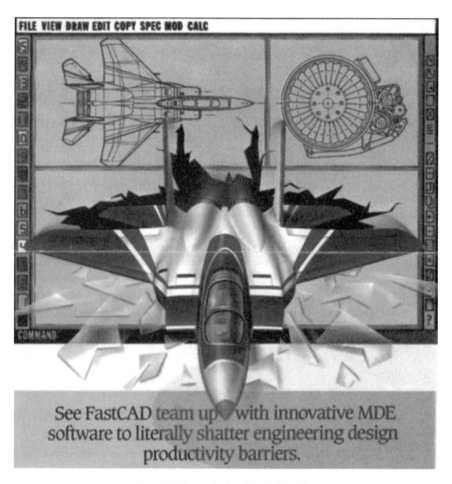

Figure 2.4 *Objects So Real They Fly Out at You*

with all kinds of desires and uses; bridging the gap between design and manufacturing was only one of many desires. But with productivity in every case calculated as a function of time, machine power could always be demonstrated through speed—a good computer was a fast computer. Just prior to the show, for example, I had joined a group of engineering graduate students in attending an IBM 'announcement' of fast new engineering workstations. Known since the mid-1960s for its mainframe computers, which serve multiple users simultaneously through 'terminals,' IBM had lost the personal computer market and had failed in introducing its first workstation, the IBM RT system, which had piled up in warehouses. The announcement presented a new class of computers that were so fast because they did the same amount of work with fewer instructions, called appealingly RISC

6000 because of the Reduced Instruction Set. IBM ads explicitly offered control to anyone willing to take the RISC. A four-page pull-out section in the show newspaper began with the full-page sentence: "IBM announced good news for those who want to seize power." In other words, the dominant computer manufacturer of the past was announcing its intent to return to that rightful position and was inviting others to come along. Its new computers were "For the Power Seeker."

The paramount importance attached to the demo for demonstrating control inside the computer first became clear to me when I saw one fail in the middle of a sales presentation. The sales rep from Manufacturing and Consulting Services (MCS) was using a demo to coax me into his primary software product, a CAD/CAM package called ANVIL 5000. I had wandered into the center of the booth after attending the main demonstration of MCS products out front, a performance that was repeated every twenty minutes. A man named Ed quickly grabbed me, seeing in my name badge, "Gary Downey, Virginia Tech," an opportunity to market his software through me to my students: "Hey Gary! Come check *this* out." Ed was standing beside a new IBM RISC 6000 workstation, which was then not yet available on the retail market. He began showing me how to start constructing a drawing on ANVIL 5000 using its brand-new user interface, whose "shallow" structure of menus reduced the number of times one had to move down and up across layers of options. The trade-off was to increase the number of options in any given layer, however, and it surprised me to see menus that were so small and crowded with huge numbers of options.

Ed: The whole idea of the new user interface is to reduce the number of menu picks you have to go through.

Gary: Have you heard any complaints that it is too small to read?

Ed: [digging quickly for counterarguments] No . . . not really. Remember you'll be sitting up close. Plus this is only a 16" monitor. That one over there is 19". I have to admit I haven't seen too many 16" monitors. IBM has a 23".

Do you want to run through this thing? [He clicks mouse to begin demo; after a few seconds, it begins.] What you're looking at is the entire part completed. We're going to take you through the whole process of building that part, a turbine blade, down to the actual machining of the part [machining is a manufacturing process]. We're going to start off by building the core of the blade. Once we're finished with one half, we'll mirror it to produce the other half. It is a 2D. . . . [pauses suddenly, because the demo has stopped, or frozen up] oops! [to Phil, another sales rep standing nearby] Has it been acting crazy on us?

Phil: It's not mine, so . . . [tries to get it restarted by moving manually through the menus].

Ed: [trying to find something interesting to say as we watch Phil] Well, this gives you an idea, too. The working of the menu structures. Actually, this way is

almost better, taking you step by step interactively rather than just watching it. [Phil gets it running again.] There you go!

Phil: [turning to explain that ANVIL 5000 was not at fault] It's just running in real time off a keystroke file. [The demo suddenly stops again, and Phil, who is evidently the more senior in rank but knows little about the keystroke file, says] Ask Jeff right there. It's *his* keystroke file.

Ed: [motioning to Jeff to get over here quick] He's just over there watching the damn video. [Evidently, it was unusual of me to hang in there so long with no demo to watch. Perhaps I genuinely might want to buy.]

Jeff: Hey Ed! Are you going through the whole demo right now?

Ed: Trying to, but it keeps hanging up! It comes back saying "There's no intersection" [ANVIL stopped while calculating an intersection between two parts]. There's no 'absolute intercept', so the system's not hung. It just keeps stopping. [Uh-oh, is it a problem with ANVIL 5000 after all?]

Jeff: [getting serious now, typing frantically, and accusing Ed] Oh, wait a minute. What'd you do, run "Surfaces" [another demo, presumably of more questionable quality]?

Ed: [a little irritated] No, I didn't! I ran "Complete Demo."

Jeff: I don't believe it.

Ed: [insistently now] Yeah, I did!

Jeff: I've been running this thing all morning without a problem.

Gary: [in a joking tone] Yeah, right. [I am wondering if I should just leave, but they are working so hard to keep me there.]

Ed: Hey, Gary saw me do it.

Jeff: I don't know what I did, Ed. I just can't explain it. So, it just went so far and then . . . ?

Gary: "No intersection exists."

Jeff: That's strange. I didn't get that at all this morning, all morning.

Unable to have me experience directly the solutions inside the computer, Ed took me instead to the only remaining authority about ANVIL 5000, a human being: "Well, let me introduce you to the boss." Without explaining ANVIL 5000 further, probably because he did not understand it fully himself, the boss pointed out that a company in my region had used ANVIL 5000 for some time. He suggested I go talk to them to get my direct experience.

The failed demo exemplified the burden on every CAD/CAM advertisement to locate the solutions inside the computer, put there by humans to be sure, but in there nonetheless. Trying to do this oneself would be foolish if all the work is already done. As the sales reps struggled to get the demo going again, blame was moving from one place to another—perhaps it was the IBM RISC 6000 hardware, or Jeff who wrote the keystroke file, or Ed

who ran the wrong keystroke file. Only by blaming someone or something else could the credibility of ANVIL 5000 and, hence, its attractiveness remain intact.

Demos do not compare products. In fact, doing so might transform a demo from a seemingly pure experience of agency inside the computer into something approaching a television advertisement, where comparative work is done all the time. While we had been waiting for Jeff to fix the ANVIL demo, I turned toward the Computervision display next door and asked, "What's so bad about CV, anyway?" Formerly the most prominent CAD/CAM vendor, Computervision had suffered major problems during the previous five years and had been bought out twice. I was interested to see how far the sales representatives would go in criticizing another product. Ed looked nervously toward Phil and asked, "Who wants to touch that?" Phil responded immediately, "Well, let's see, who owns them today?" He then laughed impishly at his cleverness in challenging the credibility of CV's products without directly trashing their specific features.

This interaction points toward a second key dimension of CAD/CAM advertising: locating the product in a competitive market. "In this world of global competition for products of all types," said the show's *Preview,* stating what it took to be the obvious, "it is no longer acceptable just to design a unique new product." The reality was a new kind of race: "The real concern is to be able to produce the design economically before your competitors beat you to the marketplace." Beyond simply solving the problems of engineers and society through wonderful new agencies inside the computer, every CAD/CAM innovation was also under attack. It was war out there. Aggression was a survival strategy and winning was everything. For potential customers threatened with the risk of economic oblivion, choosing a dying product could accelerate the decline. The best way to win was to attach oneself to a winning technology, but where in the maze of booths and demos and brochures and presentations were the winners? How was one supposed to pick a winner? CAD/CAM advertising was there to help by telling you that what you needed to want was both right here and not there.

For example, the 'news' advertisements that Autodesk, Inc., and CADKEY, Inc., published in the daily newspaper implicitly attacked and tried to outmaneuver one another without ever mentioning the other by name. Consider the following excerpts, along with my readings of their persuasive contents:

> Autodesk presents the best that the CAD/CAM industry has to offer at the Autodesk CAD/CAM Showcase.

> My reading: We want to remind you that AutoCAD completely dominates the market for low-cost (less than $5,000) 2D CAD in small companies, so do not pay attention to upstarts such as CADKEY. Although

we are aware AutoCAD is primarily a tool for engineering drawing, or drafting, in two dimensions and does not have much to do with manufacturing, we'll call our booth "CAD/CAM Showcase" anyway to make sure you do not reject AutoCAD out of hand.

Covering more than 7,000 square feet of the exhibition hall floor, the Autodesk CAD/CAM Showcase features a variety of tightly integrated, flexible system solutions developed jointly by Autodesk and some of the most prominent software and hardware developers in the industry.

You can tell we are big because we can afford all this space. We are a little worried about the future, however. We cannot keep our company growing simply by selling upgrades of AutoCAD to previous customers who want further help with drafting. We lust after the big companies who might buy hundreds or thousands of copies of AutoCAD but who also have more complex and variable design activities. Our main strategy is to get all sorts of no-name software companies to link their design software to AutoCAD. Since what they produce changes so fast and we cannot control completely the quality of their programming, we will simply assert that all are as prominent, permanent, and reliable as we are.

These integrated solutions give professionals in a wide range of MCAE [mechanical computer-aided engineering] disciplines an unequaled combination of price and performance.

We can claim tightly integrated and flexible solutions because we have linked our software to stereolithography, which makes plastic models from computer models using lasers. We know that few of you will ever use stereolithography and that manufacturing processes involve much more than making prototypes. Most of our software connections focus on automating design activities, but limiting ourselves to design is not sufficient. We need to demonstrate improved productivity from design to manufacturing.

The Showcase will also feature demonstrations of the entire Autodesk product family, including the AutoCAD Solid Modeling extension and several new Release 10 versions for the OS/2, SCO Xenix, and extended DOS 386 platforms.

We have been around long enough to have ten releases of our product, although we are hoping you do not realize we jumped last year from Release 2.7 to Release 9. We are trying to move into solid modeling because CADKEY and other upstarts are good at working in three dimensions. We are also doing our best to keep up with the incredible rate of change in computer hardware, which competitors hopefully will not be able to do.

In addition, Autodesk will hold hands-on workshops in four conference rooms.

Beyond simply having you watch demos in a crowd, we have put our demos onto computers in big rooms downstairs, which you can run by yourself. We want you to feel you are actually drawing and making things. By experiencing the pleasures of control through your hands instead of just your eyes, perhaps you will want to replicate those pleasures regularly in the comfort of your own office.

See Anderson-O'Brien, Inc., Booth 1054; Apollo Computers, Booth 654; CAD Technologies, Booth 755; CADSI, Booth 749; CYCO International, Booth 754; COMPAQ Computer Corporation, Booth 1148; Digital Equipment Corporation, Booth 648; Jagerman & Company, Inc., Booth 753; Hewlett Packard Co., Booth 618,654; ICONNEX, Booth 1049; Paradesign, Inc., Booth 1043; Plastics & Computer, Inc., Booth 750; Premise, Inc., Booth 1051; PROSOFT, Booth 756; RASNA Corporation, Booth 751; Simplified Software Applications, Booth 1053; SUN Microsystems, Inc., Booth 1054; SURFWARE, Inc., Booth 1056; Three D Systems, Booth 1055.

See all the companies associated with us. We have a cast of thousands. If you will also check out title theme of our advertising, "Design the Way It's Going to Be," you had better get yourself over to our booth now or you will find yourself forced over here later.

CADKEY divided its 'news' story into two paragraphs, owing to a marketing strategy that had two distinct parts. In fact, CADKEY tried to make it seem that two different companies were sharing one booth. One side of the booth sought to convince people that, unlike AutoCAD, CADKEY was genuinely committed to knocking down the wall between design and manufacturing:

CADKEY invites you to tour its "Manufacturing Solutions Fair" where you can experience the CAD/CAM/CAE/CIM process firsthand.

My reading: We have decided that the best way to beat out Autodesk is by convincing you that CADKEY blurs the boundary between design and manufacturing while AutoCAD does not. We even named this side of the booth the "Manufacturing Solutions Fair" to convince you that, with CADKEY, your computer will take over and solve your problems with manufacturing.

Third party links will be demonstrated for applications such as: surfacing, design analysis, networking, scanning, facilities management, sheet metal unfolding, conceptual design, plastics, stereolithography, NC-machining, quality inspection, reverse engineering, design productivity tools, and more.

Unfortunately, we too have to rely on lots of other no-name companies to achieve this, but we are trying harder than they are to reach beyond

design activities into manufacturing. Look at our long list of labels, although only some of them have anything to do with manufacturing.

In addition, "hands-on" tutorials are offered so you can actively use CADKEY and some of its third party solutions then and there. Technical experts will be available to help you solve your specific applications problems.

Like Autodesk, we are spending lots of money on interactive demos. We are doing them right here in our booth because we cannot afford all the space that Autodesk has rented downstairs for workshops. We call that intensely crowded space our Manufacturing Technology Learning Center. There you will think you are actually drawing by computer as an attractive young woman guides you through our demos.

See US First! See Anderson-O'Brien; Applied Computer Solutions, Inc.; Applied Production, Inc.; Arbor Image Corporation; Blue Chip Systems; CADNET, Inc.; COMPAQ Computer Corporation; Cubicomp Corporation; HLB Technologies; Metalsoft, Inc.; Mobay Corporation; Modern Computer Aided Engineering; N/C Systems Design, Inc.; Olmstead Engineering; PFB Concepts; PMX, Inc.; PIXAR; Plastics & Computer, Inc.; Premise, Inc.; Prototype Express; Silicon Graphics, Inc.; Surfware, Inc.; Vector Automation.

Please come here first, because we are worried you will never make it here if you go first to Autodesk. Note in our list of supporting companies the name Vector Automation, the manufacturer of the new $25,000 luxury automobile displayed at the show. The Vector was designed and built in the United States by American engineers who wanted to produce an "All American" exotic car. What better evidence is there that CADKEY designs are manufacturable and that using CADKEY helps America?

The second paragraph pointed to the other side of the CADKEY booth, oriented to those people, probably the majority, who worked in design and wondered if anything out there was better than AutoCAD.

CADKEY, Inc. will demonstrate its entire family of 3D CADD [computer-aided design and drafting] products for technical professionals. CADKEY 3 is a fully integrated 2D and 3D computer-aided design and drafting system for design, drafting, engineering, and manufacturing applications.

O.K., let us say you already know that CADKEY is really a drawing package designed to compete with AutoCAD. Because we would be thrilled even with half of AutoCAD's sales, let us focus on what makes CADKEY better than AutoCAD and ignore all those other competitors out there. Our strategy is to start three-dimensional wireframe image instead of a two-dimensional drawing. AutoCAD began by imitating drawing at a drafting board and then stretched the program into three

dimensions. We know that mechanical engineers like three-dimensional representations since they work with machines.

For conceptual design, **CADKEY SOLIDS** and **CADKEY RENDER** are available allowing users to visualize their design work and gain valuable mass property information. Quality inspection and reverse engineering tools are achieved using **CADKEY CADD** Inspector products. For AEC and facilities management applications, **CADKEY** offers its **DATACAD** product line—a full 3D design and drafting software package developed exclusively with the AEC professional in mind.

To convince you that we are keeping up with AutoCAD, we knew we had better show lots of new capabilities, so we have been buying out companies to gain control over their programs. Not only have we got some fancy programs for solid modeling and for drawing pictures that look like photographs, which help a great deal in convincing managers or customers to go ahead with a design, but we have also gone much further toward manufacturing by adding the agencies of "quality." If you are interested in quality, which you had better be, you should clearly go with us. Finally, we are also hoping to compete with AutoCAD in the areas of architecture and construction, which have relied traditionally on 2D layouts but are now moving into 3D. Look how far we've come so quickly.

Finally, they list the same twenty-three companies as if to say: Do you see all the companies associated with us? We really are here to stay. Furthermore, we too are everywhere at this show.

Gaining control through CAD/CAM technologies was both necessary and risky. As we walked out of the thirty-minute CADKEY tutorial, I asked the guy who sat next to me if his company was in the market for a CAD system. "Yeah," he said, "I'm supposed to figure out what we should get." I pointed to the mass of vendor booths around us, "How do you make sense of all this?" "I don't know," he replied with a sigh, "It's pretty confusing."

Where Control Doesn't Fit

Much gets hidden in the whirlwind of hyped claims to make a sale. The market relationship between vendor and customer is conceived so narrowly that, in principle, the autonomous vendor is freed from responsibility for the customer and the autonomous customer is freed from having to depend on or trust the vendor. The vendor's role is simply to deliver a product at the maximum possible price, while the customer compares vendors to locate the cheapest possible products. Human contribution to the sale lies entirely in bargaining over price, and the event of purchase achieves nothing more

than a pure transfer of ownership, or possession of property, from one to the other. Responsibility, dependence, and trust are not required as a condition of existence on either side, and the goods transferred contribute no agency to the sale.

The doctrine of competitiveness added the dominant image of technology to the property transfer, ostensibly without reordering the human relationships involved in the process. CAD/CAM buyers and sellers had to live in the radically circumscribed world of market encounters. When vendor technologies offered external forces that would affect customers as billiard balls, then the main issue for customers became maximizing positive impacts and minimizing negative ones. The idea is that technological capabilities would simply be transferred from vendor to customer, with customers having to figure out which vendors possessed the winning capabilities.

Yet one impact of selling and buying CAD/CAM technology in terms of the dominant image was to hide or make less visible other activities that did not fit the image, activities that belied the sharp boundary between human and machine and hence could not easily be force-fit into the narrow relationship of market exchange. These activities tended to live in the interstices of market life yet were crucial to the overall exchange.

Consider, for example, the sequence of interactions between sales rep and customer. The National Design Show felt much like a singles bar, with people hitting on one another with nice clothes, good moves, and lines that exuded the pleasures of CAD/CAM technology.[3] Remember, however, that longer-term relationships sometimes do develop out of one-night stands. Initial contacts at the show typically end with an exchange of business cards. After packing up and returning to the home office, the sales rep follows up in the next few weeks with a telephone call, which can lead to a subsequent visit on-site, and perhaps a sale. The first sale can establish a committed relationship. I asked a sales rep from Silicon Graphics what it took to be a good salesperson. He was on break from demonstrating his hardware on my campus in a fourteen-wheeled truck: "First, you have to have a good product," he said. "But you've also got to visit the customer on-site and let them get to know you. Try to keep the bullshit to a minimum. You've got to gain their confidence." This begins to sound like trust.[4]

One popular collection of businesses in the CAD/CAM industry are the 'value-added resellers,' generally small companies that carve space for themselves out of the fear people have of buying the wrong thing or not knowing what to do with it when they get it. Resellers configure packages of hardware and software that are, as one reseller told me at the show, "appropriate for our customers' needs." The word 'need' here is the tip-off that using CAD/CAM technology raises problems not only of impact but also of fit. Often located near their customers, a reseller depends for its reputation on its ability to fit together the humans and the machines. They bill themselves as 'experienced,' which means that in some important sense

they have already become unique types of persons who bring the machine and human together.

For example, I talked for a while with the engineer from ASG, a reseller that was seeking new business at the show. "We're a 'one-stop' place," he said, "that merges together the software, hardware, engineering, and furniture. We're not a software house, but we do customize interfaces." He called my attention to the risk in buying: "There's just so much out in the market right now." I should trust him, he implied, because his staff of eight to ten people had already fashioned themselves in terms of the technology: "We use the products so we know them." In other words, their knowledge of CAD/CAM was as much a bodily achievement as a cerebral one. I too could become as knowledgeable with their help: "We provide on-site training with a training tape that actually runs the product, and we follow up with technical support."

Technical support: the term is intriguing. Every CAD/CAM vendor and reseller promises technical support. In one sense, the whole idea of technical support does not fit the market relationships, for it is conceived as responsible assistance from someone you trust and to whom you are connected. In the midst of sellers and buyers maximizing self-interest by taking advantage of one another in fleeting relationships, technical support lives as a key pocket of altruism indicating longer-term responsibility and commitment. It is expertise of a special sort, from someone who has internalized totally the agencies of the technology at stake. Once located, technical support speaks for the technology. The voice of technical support is soothing, comforting advice from a body mechanic, a psychologist for the hands. Good technical support helps people into their machinery and, in the process, builds the machine into them. Consider the image in Figure 2.5 from a company offering technical support. The strong, white male holds the bridge together so people can cross and business can continue. The support is foundational.

Technical support comes from different places and in different forms. For example, the vendors of large systems offer 'maintenance contracts' as part of each package deal. The maintenance contract frequently establishes regular and long-term personal contacts between a customer and a service representative, who serves as the human figure of company expertise. Company expertise may already have arrived at one's location in the form of hardware and software, but this relationship can be fairly rigid. The service person comes to know the peculiarities of each situation, including existing arrays of people and machines, and so introduces a flexibility that extends the property relationship beyond the technology back to the vendor company as a whole. By allowing themselves to internalize the special agencies particular to a given site, service representatives deepen vendors' involvement in the identities of their customers. In other words, the presence of a service representative at a given site also marks the presence of the selling company *inside* the buying one. The idea of autonomous sellers and buyers

SOMETIMES THE DIFFERENCE BETWEEN SUCCESS AND FAILURE LIES WITH THE RIGHT SUPPORT.

Figure 2.5 What's Hidden in Technical Support

engaging in brief encounters may fit well the doctrine of competitiveness but it begins to look more like a convenience for accountants than a complete description of what takes place.

Technical support might also come through the value-added reseller. Autodesk built sales for AutoCAD through a well-organized 'dealer network.' During my visit to Autodesk, Robert Palmer explained how the system worked.

Palmer: Well, our dealers have rules. You see, one of the things the dealers have to do is provide support for the product. To the end user. In other words, the end user has a technical problem, you know. His computer's locking up or something like that. You call your dealer and then the dealer actually talks to our technical people to solve a problem.

Gary: Now why is that?

Palmer: Part of it is so Autodesk doesn't have to spend all this money on a huge support team. But there's a trade-off because the dealers then get better

margins [more room for profit]. The product can then be value-added [dealers can add features]. The dealers can charge for services and installation. It's an opportunity for them to be a vehicle that the customer can go to.

Support can also arrive through pathways outside the market exchange. Some examples include interaction with general outside expertise such as educators; interaction with independent but paid experts such as consultants; and interaction among customers such as users' groups. Seemingly the most common form of support is interaction with emerging specialists on-site, people who either voluntarily or through their job descriptions locate themselves inside the machine and the machine inside them. We all have such people around us, who have found interacting with the computer exciting enough to want to teach others, seemingly for the enjoyment and affirmation of self that comes from sharing pleasures. I once asked Darrell Early, computer systems engineer and manager of Virginia Tech's CAD Lab,[5] if he ever felt that who he was as a person ever became linked in some way to the machine. His role certainly made him the main repository of local systems knowledge and the frequent recipient of frantic requests. "Oh most definitely," he replied without hesitation and with a sweeping motion of his hand over the lab. "Sometimes out there I feel like I am the machine."

Below the show, a parallel, complementary conference was taking place in the catacombs of McCormick Place. Indeed, the full name of the trade show was the National Design Engineering Show and Conference. Whereas the show, so prominent upstairs and in outside advertising, was conceived in terms of the market and marked by the language of competitiveness, the conference, hidden below, was conceived in terms of education and marked by the language of support. Gaining access to education was more expensive than gaining access to sales. Whereas the entry fee upstairs was only $10, for the real benefits could come only later in the buying, the cost to get in downstairs was $255, for the benefits came in the hearing. The boundary between the two, however, was not all that clear.

The conference was organized by the American Society of Mechanical Engineers, a professional engineering society. A visitor could have elected to attend the conference alone, which consisted of thirteen sessions of presentations and six tutorials on various areas of design practice, from CAD/CAM to geometric dimensioning and nonlinear design optimization. For an additional $285 per day, one could earn 0.6 units of continuing education credit for attending professional development courses in project management, design and processing of plastic parts, failure mode analysis, and quality engineering. The two-hour Autodesk demos were listed in the conference brochure as free workshops. Evidently to keep things balanced, the three conference sessions on CAD/CAM technology were "presented in cooperation with the CADKEY Corporation." An engineer from CADKEY had organized and secured speakers for all three sessions.

Each session did indeed introduce attendees to the diverse capabilities of CAD/CAM technologies and the sorts of issues they were likely to face as CAD/CAM users. For example, speakers described differences between doing CAD work in DOS and in UNIX operating environments; distinguished the strengths and limitations of 2D drafting, 3D wireframe modeling, 3D surface modeling, and solid modeling; explained the benefits of high-quality rendering that produce photographic-like images of prospective designs; and explored problems in linking work in computer-aided design to activities in manufacturing. Yet the benefits of DOS were explained by the vice president of marketing from Compaq Computer, whose personal computers relied entirely on DOS, and the delights of UNIX were shared with us by a marketing representative from Silicon Graphics, which had "bet the company," as he put it, on high-end engineering workstations in a UNIX environment (see chapter 4 in this volume). The message that different forms of modeling served different purposes was conveyed by a senior manager from CADKEY, who wanted everyone to know that, despite the company's relatively recent arrival, it was actively involved in every level of CAD/CAM technology. A company representative from PIXAR, founded by George Lucas and Steven Jobs, showed slides of architectural and mechanical designs that appeared very much to be photographs of finished products. Finally, a fleet of consultants related their methods for helping companies find ways of linking together design and manufacturing.

I was often confused about whether I was hearing a lecture or a sales pitch. The exchange that is supposed to take place in a conference, let us call it 'money for knowledge,' demanded a visible focus on producing informed attendees. The speaker had to be a repository of expertise, even if also a committed advocate with pecuniary interests, for listeners were understood to be vessels seeking nourishment, even if they were already skeptical converts (not an oxymoron). What made the conference worthy of its registration fee was that conference organizers and presenters did not have to accept the dominant image of technology outside society, though they still worked within the general doctrine of competitiveness. In fact, presenters were measured by what they told us that went beyond the standard language of control. Judging from their many questions, participants clearly hoped these people would give them what they really needed to make CAD/CAM work in their companies.[6]

Our consultant-lecturers spent the majority of their time doing variations on the general theme of technology studies. That is, they were trying to disassociate us from the utopian expectations of the dominant image, dissuading us from embracing CAD/CAM technology as the solution to our problems without questioning ourselves first. In a way, the consultants functioned as shock therapists for corporate patients who had become obsessed with delusions of utopia through automation. Positioning themselves directly in opposition to salespeople, consultants emerged in the

conference as a form of technical support located entirely within people. A consultant was someone whose self had become refashioned by the technology in question and, hence, was experienced. Yet he or she lacked a direct stake or interest in the success of specific products. A consultant's career depended upon maintaining an image of expertise through experience without interest. Once paid for, it was the purest form of altruistic support.

For example, one prominent consultant in computer graphics technologies found a way to use the word "bias" as a marker of expertise. "I have definite biases in the area of CAD/CAM," he asserted proudly, "but my biases are all idiosyncratic. They are not motivated by financial considerations." Experience was an important source of knowledge in this business because "[t]here is no coherent, consistent method for doing mechanical design. It's something you don't learn in engineering school." This man worked not for customers but for clients, who found value in his advice and role as their advocate. He described his main contribution as protecting clients from impulse buying by convincing them to focus not on the capabilities promised by seductive new technologies but on the capabilities already available in place. Describing the purchase of new technology as a process of juxtaposing two sets of capabilities that might not blend, he replaced the singular event of buying with a progressive process he labeled "creeping commitment." This slower mutual accommodation of human and machine took thirteen steps:

1. Describe what you do now.
2. Postulate how you would accomplish present goals with the new system.
3. Reality check. Really?
4. Create a mapping from now until then, with minimal bloodshed at each step.
5. Assign values to any potential improvements.
6. Describe required system functionally, in terms of goals.
7. Define a pilot project with measurable goals.
8. Assemble a list of vendors who appear to meet the criteria.
9. Screen the vendors for viability.
10. Do interviews with existing users.
11. Do a demonstration of capability.
12. Now get price proposals.
13. Evaluate and select the vendor.

Supporting a client rather than a customer extended the commitment beyond the point of sale, beyond the narrow relationship of vendor and customer, to include a more pervasive sense of shared responsibility.

The consultant seemed also to be something of an ethnographer who made subordinate interpretations of things more visible in order to grant these greater legitimacy. In this respect, the doctrine of competitiveness

seemed to have been great for business, since it hid so much. For example, a team of three consultants from Anderson and Associates, a prominent consulting firm, related a detailed story in which overcoming the boundary between design and manufacturing involved convincing engineers from design and manufacturing to work together on specific products instead of establishing a technology that would organize and control both:

> From the perspective of engineers, that's very scary: "I'm used to being on the design engineering side or the manufacturing engineering side. I don't want to hear about a focused engineering group. I don't want to hear that I'm going to be in the same cubicle with a lot of operations people and finance people focused on the end product rather than their individual functions."

The main ambiguity faced by consultants concerned how they positioned themselves in hierarchical organizations: Were they simply flexible human technologies for implementing a management perspective, which paid their fee, or were they serving as clever advocates for the perspectives they helped to make visible? I myself could not tell as the Anderson consultants continued:

> The real key for all this is that people come to own this thing. As you probably already know, when you try to implement a new thing, a new process, if people feel it's their own, they're going to work harder to make it happen. So you've got to think about functional responsibilities and what will change here. A real key is WIIFM, which is the What's In It For Me syndrome. The operator's going to ask, "What's in it for me? Why am I doing this? For the good of the company is fine, but I have to know the impact on me."

As companies downsized and rebuilt themselves in terms of products and production, market concerns and logics extended more deeply into the bowels of engineering activities. Existing power relations ruptured as more and more activities came to be justified and critiqued in terms of productivity. A CAD/CAM consultant, charged with understanding and providing advice about automation, was positioned uniquely in the midst of both the fears and desires.

A final source of technical support came from other users, particularly through 'users' groups.' From one perspective, the users' group was simply an elaboration of the vendor's market strategy. Vendors typically established users' groups as a way of communicating to all customers quickly, soliciting new customers, and engaging customers in solving the problems of other customers. Through a users' group, a vendor transformed customers into a community of buyers who shared an investment and, hence, an interest in a common brand. It held them together while keeping them at a distance as customers.

At the same time, the users' group also provided additional sources of support for each user from others who occupied shared positions relative to CAD/CAM technology, and it often heightened user participation within the vendor company. I attended a three-day users' group meeting for an IBM software product known as GraPHIGS. GraPHIGS was IBM's version of the new graphics standard called PHIGS, or Programmer's Hierarchical Interface Graphics Standard.[7] The meeting provided users the opportunity to share knowledge about how they had or had not integrated this technology into their separate environments. Clearly, relationships established at the users' meetings continued through later phone calls, e-mail correspondence, and, in some cases, site visits. At the same time, consensus opinions from users in plenary discussions put pressure on IBM to incorporate a variety of new features into subsequent releases. Who here was gaining a property stake in whom?

In sum, the marketing of CAD/CAM technologies depended heavily on the dominant image of technology for its force. The language of control appeared regularly at the trade show and in CAD/CAM advertising, picturing a mass, quasi-military struggle in which only the fittest would survive. Casual interactions between vendors and customers took for granted a collective search for the technological solutions that would ensure competitive success. The risks of not getting involved were too great to resist so, one way or another, many came along and joined the movement. Standing out as unique was a threatening prospect when uniqueness meant old, out-of-date, and probably maladaptive. When instead everyone took for granted the assumptions of competitiveness, including the desirability of enhanced productivity and the claim that technologies delivered solutions, all knowledge claims about specific CAD/CAM products gained special meaning and force.

At the same time, however, the language of control through automation began to break down when one considered that the risks of buying were also great. An entire layer of consultants, conferences, users' groups, and other forms of technical support had developed to challenge and fill in the gaps around the narrowly conceived market relationship. Built into these other roles were relationships characterized by the presence of trust, commitment, and responsibility, in sharp contrast with narrow images of self-interested maximization. I could not help wondering if there might be ways of institutionalizing such altruism within the market relationship in a more prominent location, rather than simply tacked on in an ad hoc, yet well-populated, marginal space. What might it take, for example, to make technical support the most visible surface feature of market exchange? If everyone came to view altruism as a key constituent element of market capitalism, would its practice shift from the margins to the center, from the catacombs to the main floor, from the subordinate to the necessary?

CHAPTER 3 | Does Productivity Fit?

IF TECHNOLOGICAL DEVELOPMENT IS ITSELF inherently progressive, as suggested by the dominant image, then increasing human productivity through such exciting new technologies as CAD/CAM should be noncontroversial. Any short-term displacements of human labor will be far overshadowed by general improvements in the welfare of society, including the availability of pleasurable work. However, if technological development is inherently oppressive, then automation is simply another example of the exploitation of workers through technology. Increasing human productivity really means replacing some people with machines while making everyone else work harder. Both interpretations draw a sharp distinction between the human and the machine, treating human workers entirely as sources of labor and machines entirely as forces with which humans have to contend. 'Productivity' thus becomes something attributable entirely to humans, such as the output of human labor per unit of time.

But what if the people directly involved in automation experienced something different from or in addition to these two extremes, such as forms of travel within the machine or perhaps the presence of the machine as a part of self? Might the image of productivity leave out important dimensions of peoples' experiences in the workplace? Could the doctrine of competitiveness, which depends so heavily on the image of productivity, be an overly narrow account of how companies work and of how humans and machines find space within and between them? The question I want to raise is: Does the image of productivity fit people's experiences?

To explore this question I share and discuss the experiences of four

design engineers who, throughout the 1980s, had been deeply involved in promoting, installing, justifying, and using CAD/CAM technology in a small company that manufactured mechanical parts. This chapter consists primarily of excerpts from a group interview conducted in their meeting room in August 1990. Because two interviewees preferred not to be identified by name and the plant manager asked me not to identify the company by name, all the names in this chapter are pseudonyms. While I have no grounds for arguing that their company was typical in any statistical sense, their experiences do map the ambiguities of productivity that I regularly heard reported in other stories elsewhere. That is, in an important sense these engineers knew that there was more to automation than replacing humans with machines, that working with technology involved more than gaining control over it, and that productivity was a less-than-desirable metric for assessing the benefits and limitations of CAD/CAM technologies. But articulating an alternative was another thing altogether. The dominant image of technology established the terms of their struggles.

The stories told by these design engineers are limited in the sense that they do not engage the perspectives of drafters, managers, manufacturing engineers, and workers. However, because their employer made both an early and a continuing commitment to CAD/CAM technology, their assessments offer considerable insight into the unique problems of living in a world dominated by the metric of productivity. Experiencing both the benefits and the costs of the dominant image of technology, they depended on it and resisted it at the same time.

I had taken the advice of the MCS manager at the National Design Show and contacted these engineers to ask them about their experiences with ANVIL 5000. In addition, I had begun a collaborative project with my host specialist, Arvid Myklebust, to design an expert system that would help engineers in small companies choose CAD/CAM systems. I wanted to understand how expert systems worked and had decided that writing an expert system myself was probably the best way to learn (see chapter 7). I had already known that one of Myklebust's former Ph.D. students, Bill Fuhrman [pseudonym], worked for the company. I also found out during the interview that Bobby Berg [pseudonym], a staff engineer, had completed a master's degree in the CAD/CAM Lab and had plans to return to school for a Ph.D., although in a different field. The third person at the beginning of this interview was Skip Snizek [pseudonym], who was the senior person present. About an hour into the three-hour discussion, we were joined by Ron Greenwald [pseudonym], who had worked at the company longer than the other three. All four worked in the Engineering Software Development group, which was charged not only with maintaining the design software but also with writing software for a separate company product, electronic security systems. They clearly wanted to help others avoid the mistakes they felt they had made.

Tar Baby

Initially, the engineers and managers drew inspiration from the dream of automation, focusing on the many benefits that were surely to follow investment in CAD/CAM. They began by purchasing a turnkey system, which consisted of a minicomputer shared by a collection of graphics terminals [in contrast with the free-standing pc or workstation]. After buying it, however, they found themselves stuck to a tar baby.

Skip: We started like everyone else, with Computervision. It was about 1980.

Bobby: It was Christmas 1980 when it was first purchased, before any of us were working here. We got two workstations. They called them 'seats' at the time, because they were graphics terminals. So we had two seats on a Computervision CADDS3 [Computer-Aided Design and Drafting System Version 3]. It had a single disk drive, about a three megabyte disk drive, which was the size of a washing machine. At the same time we had ten to twelve drafters with a sea of drafting boards over in the drafting area. The CV system came in kind of on the side.

Gary: Who advocated buying it?

Bobby: Was that spearheaded by Bill Charlton [pseudonym]?

At the time of the interview, Charlton was the senior engineer in the company.

Skip: Probably, that had to have been the case. Very quickly, however, there was a sea of bad feelings. Not just because CAD was coming in here, but it was one of those deals where we were naive. CV seemed to be offering a great deal on its system. But what they did was dump CADDS3 in here while CADDS 4 was coming out, and we didn't know it. So that started the bad feeling with Computervision right off at the beginning.

Bobby: Within a short period of time, I don't know if it was a year or two, we spent more money and bought a third seat. By the time the system was put together, this company had spent on the order of a half a million dollars for the three graphics terminals.

Gary: Why the big move into CAD? What was the felt need?

Bill: It had to do with all the buzz words that were flying around at the time, and the salesmen were so good at playing on, you know, first-time companies. That's the main reason we bought into it. We were going to be able to replace drafters because the ones on the CAD system were going to be so much faster. At the same time, we were going to improve our designs because of the abilities of the CAD system, the inherent abilities. However, after a short period of time, two or three years, it was pretty evident that what we were doing was faster drafting, with some very limited extra help. There was a parts-list program on the system [for generating lists of parts from an engineering drawing]. We brought data from our MIS system over, and we could generate a semi-automatic parts list.

MIS, which stands for Management Information System, is a cover label for business computing, which IBM had specialized in providing since the 1960s. An MIS system generally consisted of a mainframe computer and a number of terminals for entering textual programs. Companies used MIS computing primarily for accounting and payroll purposes, as well as serving other business activities that did not involve graphics. MIS computers specialized in input-output processing rather than mathematical calculations, and were operated by computer programmers who worked with business languages such as COBOL. In contrast, Computervision had built a CAD system by modifying a minicomputer from Data General designed for 'number crunching' in FORTRAN and connecting it to some newly designed graphics terminals [see chapter 4].

Skip: There was another thing as well. I guess you might call it a dream or a fantasy that has yet to be fulfilled even today. That is the notion of 'parametric design' of parts. Everything we build is the same but it's different. The general shape or geometry is the same, but the details are different. You've got a [basic shape] and you've got a brush that sits on it and goes around. One of the things that Charlton, our chief [mechanical part] engineer, has wanted since day one is some massive program that does a [mechanical part]. You just punch in the various variables and out pops a drawing. Conceptually, it is certainly feasible. We've just never had the tools.

A main problem for the engineers was that the engineering agencies that CV had transferred to its system were incomplete, and they were powerless to transfer other agencies to the system themselves. They found themselves in an extremely vulnerable position, dependent upon the human agencies in another company, the vendor.

Skip: Picking up on Bobby's comment on CV, one problem we ran into was that the programming on the CV system was extremely primitive.

Gary: How so?

Skip: The CV computer was basically a Data General NOVA 4X, which they had modified in some fashion.

Bobby: That's a nice word to use—modify.

Skip: It was a pile of crap.

Bobby: We used other words to describe it as well.

Skip: I worked with a NOVA 4X at a previous job, so I knew it. CV had a FORTRAN compiler on it that took exception to the minimal FORTRAN standard. Most vendors will take a standard and then add to it. There's then two parts in a vendor's version of the standard: the full-blown version with all the additions, and the minimal subset. The CV system took a subset of the subset. It was a very primitive programming environment. We ended up having a whole string of people who worked as

programmers to support the CV system. There was no one in a management position who knew anything about software at the time and could have improved it in some way, so we ended up spinning our wheels a lot.

Bill: Productivity on the thing was very poor.

Bobby: There was a revolving door of programmers.

Skip: The group you have here did not come into existence until I came on board six and a half years ago. The Engineering Software Development group was formed when I came in, partly because of growth in our [new product] business. One of our members works entirely on [this new product], and there was no programming support at the time.

Bobby: One thing I want to say regarding the historical perspective on the CV system was that it was considered a turnkey proprietary system. It was a single vendor solution for both hardware and software. That experience led us in the next round in CAD acquisition to make sure we didn't buy another turnkey solution. I believe it was about 1984 when they started a new search.

Skip: Not too long after I came on board.

Gary: Would CV have ever written you an applications program to help you specifically with your [proprietary] work?

Bobby: No. They offered us an upgrade to the CADDS 4 system, which was literally buying a new system. We would have considered that, but they didn't give us any credit for all the money we had sunk into that investment. That pushed us out into the market to evaluate all these new CAD systems that were being offered. For about a three-year period, 1984 to 1986, the company was conducting a search for a new CAD system. The emphasis was to find a software package that was appropriate for us, and not to have it tied to specific hardware platform. We felt like we really got burned by CV.

Just to give you an idea of how bad it was, with a system that cost over $400,000 we were paying roughly ten percent annual maintenance fee on it. Now that ten percent is pretty much industry standard, but when your costs are so high to begin with, that makes your annual fee so high. So we were paying over forty K [$40,000] per year for maintenance. The maintenance usually came in the form of software. But I was told that the new software was so bad that they had to revert back to what they were using earlier. That was the last time we ever upgraded our system.

Gary: Who was sitting in these three seats?

Bobby: Drafters, mostly. The CV system got bogged down with three users on it, because it had less than a megabyte of RAM memory. Nowadays, that's unbelievable. So when the system was first put in, for many years they ran double shifts on the CAD system.

Gary: To justify the costs?

Bobby: Definitely. It couldn't be justified otherwise.

Skip: MIS was responsible for the programming, but MIS was geared toward a business world. They live on the other side of the plant. Once they found out that the programming environment here was a little unfriendly, they weren't too keen on coming over here. Back in 1980, about the only computer in the whole plant was in the MIS department. When the CV system came in, it was pretty intimidating to the turf of their department, which had a monopoly on the computer. Nowadays there's a computer every ten feet in the plant. I don't know what kind of friction there was. I can't imagine that it was friction-free.

Productivity as Burden and Strategy

Once a commitment was made to CAD/CAM technology, the scope and character of subsequent 'needs' took for granted the opportunities and constraints of the system in place. Because anticipated improvement in productivity had been the main justification for touching the tar baby of CAD/CAM technology in the first place, subsequent purchases depended upon demonstrating increased productivity. But this was much more difficult than anyone had expected, and calculating productivity became a dangerous game.

As my discussion with Bill, Bobby, and Skip turned further to problems with productivity expectations, Ron Greenwald, a programmer, entered the room to join us. Ron had been working for the company for twenty years, longer than the other three. Ron worked on the CAM side of things, writing software programs to drive the numerically controlled machinery out in the manufacturing plant. Our discussion quickly continued.

Skip: He asked us to tell our war stories in the CAD area.

Bobby: We've been trying to give a history of what we've been told, including the tensions with MIS.

Ron: Charlton was the one behind selecting the CV system. There were indeed major problems with MIS, because we had one group in charge of programming for the system and another group that needed the programming. We always had to justify why we needed certain programming to be done. That was a lot of pain.

Gary: Did MIS understand the questions?

Ron: Yes and no. The biggest frustration was that we had to justify everything. We couldn't get them to do even a simple little program. After a while we just stopped asking.

Bobby: Didn't we estimate what we'll call 'productivity increase' but was really just faster drafting? Did we ever estimate how much faster the drafters could work on the CV system?

Ron: If we did, it was the salesmen who estimated it for us. I remember Charlton using numbers like there was a fifty percent increase in speed.

Gary: How did he calculate it?

Bobby: I think he did like a thumbnail sketch or study.

Ron: I've heard three to one.

Bobby: On the CV system? I don't think we have it written down.

Gary: Did this become company folklore?

Bobby: Oh most of it probably is. I don't think three to one is ever what Charlton pushed.

Skip: I think the bottom line is that we really don't have very good data about productivity on the CAD system. We've never had good data.

Bobby: I'll tell you one thing, though, that makes it difficult measuring something like that, even today. It's the types of jobs that are done on the CAD systems versus the ones that were done by hand. There were certain drafting jobs that were done on the CV system that were well beyond what we had ever done before.

Gary: Like what?

Bobby: Like the job for [a customer]. It was possible we could have done it by hand, but we would have had to hire many more drafters than we had at the time, to handle all the revisions that were made over the years. It was a very complex job, probably the most complex we have ever had.

Skip: It is interesting that the [business] managers go back and try to compare productivity in terms of drawing output per person. Initially, when we needed to establish the baseline, we didn't know that we had to, so the data were lost.

Gary: There seems to be a problem of measurement. How do you measure productivity increases when you've got all these qualitative shifts in activities?

Bill: Yeah, shifts all at once. That's a good point. That's what Bobby's bringing up. The baseline might be meaningless because we're not going to do that type of design anymore. Our designs are so much more complex today than they were then, but you can't measure the complexity of a drawing.

Skip: But when a nontechnical person is holding the financial reins for advancing that, and you try to explain that to him, he doesn't want to hear that.

Gary: So how do you prove your productivity increase?

Ron: We struggled with that for years.

Skip: We basically make progress in that area by being a pain, to get additional equipment. If we want another workstation, we basically go pester the hell out of them, until they get tired of listening to us.

Bobby: We now do automatic circuit continuity, which we couldn't do before. That doesn't enhance drawing output. In fact, it probably drags it back because you're doing one more check before you release the drawing. It's a valuable function, but they only look at the bottom line: How many drawings did this one guy get out?

Gary: So how do you legitimize yourself in the middle of this?

Bobby: It's very difficult. We've been struggling with that for the past year. We are trying to justify more equipment, faster equipment, equipment with greater capacity, so we aren't forever shuffling our files around, again decreasing our productivity, because we're reaching the edges of our storage capacity.

Skip: You plan games. You decide what you want, and then figure out the right way to pressure them into getting it. Catch them in the right mood.

Living with the Machine

As they gained greater understanding of available CAD/CAM technologies, they formulated strategies to reduce the vulnerability they had experienced with Computervision. Although there were vulnerabilities in transition, the stories suggest a departure from sole reliance on the dominant image and its promises of control and progress. The engineers were coping with alternative strategies designed to enable life within the machine and to integrate the machine into their lives.

Bobby: I want to jump ahead for a minute. The CV system was here until 1987. In 1986, we got our first Apollo workstations here in the plant. We purchased eight workstations. They were the new ones based on Motorola's new chip, the sixty-eight-oh-twenty [68020]. Each one had seventy megabyte hard drives. We expanded them so they all had four megabytes of RAM memory and fifteen-inch color monitors. They were pretty nice workstations for 1986. The software we bought to run on them was ANVIL 5000, made by MCS.

Skip: Yeah, we've been getting more and more away from the proprietary hardware and software and going more and more toward generic solutions, first with the workstation solution, and now with ANVIL. We are starting to look at Auto-CAD, because ANVIL is a difficult program to interface with when you have a custom program or application that you want to develop for it.

Bobby: Such as trying to develop parametric programs. We found out very early that ANVIL had limitations on program size. When you're trying to develop a parametric program, you are anticipating a very large program, so when you run into a two-hundred-line limitation on a program . . .

Skip: That's absurd.

Ron: [mockingly] You could have lots of subroutines.

Skip: Yes, you could do that, but there is also a point about maintenance.

Bobby: Also, in ANVIL you're writing in a custom programming language that gets changed and updated every time they upgrade their package. It's different from FORTRAN where, if it ran ten years ago, it still runs today. With ANVIL, when you get next year's release you might have to go back and maintain every program in your database. That's not acceptable, and it's why we're starting to look at things

like AutoCAD. While the package itself isn't that powerful on first view, the interfacing is so easy and you can do it with standard languages. It's too attractive not to investigate.

Gary: Now wait a minute. Tell me again how things are so different today?

Ron: In 1980, CV was the only realistic game in town. For a company this size, it seemed good because you could bring it in and fire it up. The existing drafting supervisor could be put in charge of it, and CV could tell the supervisor to do this and this, and then call us when you have major problems. It was very attractive, something that was just a complete box.

Today it's not CV but some reseller pushing a prepackaged pc-based solution. Maybe they'll put AutoCAD on their favorite pc, grab their favorite plotter, monitor, graphics controller, the whole nine yards, and put one price on it, including training. They'll come in, dump it in there, and then it's "See you guys later."

Skip: One thing that's different is that there's a lot more computer literacy in 1990 than in 1980. Back in 1980, in order to become a decent programmer, you needed access to decent equipment. What we now routinely purchase for twenty or thirty thousand, such as DEC's Microvax, would have cost you a quarter of a million dollars. Not that many people had that. There were not many programmers.

Gary: Don't people still look for the turnkey solution?

Ron: Yes, but anyone getting into it today should be very aware of the fact that they might want to do something on their own with it in the future. Back then, everyone was ignorant. CAD was CAD. Who knew how it was going to grow?

Bobby: CV was going to do everything for us. They would be wonderful, for it was all above us. It is not above us anymore, the people that are getting into it. The interfaces on some systems are so good that people are going to want to write their own applications, like the parametric program, and they need to anticipate the limitations that a turnkey system might put on them. They are running a very real risk if they go with a proprietary system, because if the company does not support them, they cannot go to anyone else.

Skip: We are very wary of turnkey systems. True, it is hard getting started, and recruiting programmers is not easy. There are lots of people out there who call themselves programmers or computer experts who aren't worth a dime. A small company runs the risk of getting some charlatan in there.

Ron: The turnkey solution is very dependent upon the company that supports the turnkey. If they make a sale and go away, then the company will have some problems in the near future. But if they make a sale and then keep their finger on the pulse of the company, and are ready to help them with modest expansions and small upgrades when it's appropriate, then things can work O.K. It can't be that the salesmen just return and say, "Well, that whole system is now outdated and outmoded. You have to buy a completely new one." Then you have to go retrain your whole staff.

That's what we experienced with Computervision when we bought their CADDS 3. Some sales rep went off to Hawaii for Christmas, and we're left thinking

that we just sent that sales rep to Hawaii. Then the next time he shows up, it's like, "Oh, we have CADDS 4 now and that's the only way to upgrade your system. All the hardware and software you have is outdated, and you have to upgrade the whole system."

Bobby: Salesmen don't make a lot from selling small upgrades.

Ron: I want to go back to how we justified bringing in more equipment. Right now we have seventeen workstations. In 1986 we had eight.

Gary: Why Apollos?

Skip: At the time we decided to drop CV, we were looking at other vendors. Ron and I were going to other customers' sites and doing benchmarks [taking along their own drawing tests]. Ron designed the benchmarks, and I was going along to look at the solid modeling capability. We finally narrowed it down to Applicon and ANVIL. We threw out fourteen different systems because they wouldn't benchmark the system, such as CALMA, Autotrol, AutoCAD, Prime Medusa, Euclid, and a bunch of others. At CALMA, they screwed up on the benchmark. AutoCAD was too primitive. Medusa couldn't do something simple like a fillet [a rounded corner]. Prime had what seemed to be half of their company there. We had a simple little part: a gasket, two circles, and fillets. I used to do this one. You'd be surprised how many systems had trouble with filleting. They called their headquarters trying to find out how to do them.

Gary: That's a lot of company investment in the search process.

Bobby: It was not that difficult to justify.

Skip: I'm not sure how we got away with all that time benchmarking.

Ron: Well, after a half-million dollars on the previous CAD station, they wanted to be careful about the next decision.

Skip: Yeah, you're probably right. Some caution there. It finally boiled down to a choice between Applicon and ANVIL. I was advocating Applicon because I liked their solids package a little better. Also, their parametric programming capability consisted of extensions to PL1, a standard programming language which is not bad to program. There were some other folks that were advocating ANVIL because ANVIL had a few more capabilities.

Ron: One of the reasons I didn't like Applicon was I felt we were getting back into the same thing we had with Computervision [a turnkey system]. For $500,000 we would have had two or three terminals. The ANVIL system passed the benchmarks; in fact, a lot of things it did faster than the other software. We also found out that it would run on the Apollos.

Skip: You're missing a step there. I've got another story. Originally, we were going to go with ANVIL running on a Microvax II [DEC's new minicomputer serving terminals]. Then connected to that would be IBM pc's running terminal emulation software that emulated some flavor of Tektronix terminal. I don't remember which, something beyond the 4010 series but I don't remember. So anyway, because of the reasons that Ron mentioned, the bias was toward ANVIL. It did some things

better, and we got more seats for a given amount of money. . . . There were two other factors: one swing factor and something that turned out to be just plain wrong from ANVIL. They supposedly had a program that was in the public domain that would convert CADDS 3 drawings [from Computervision] to ANVIL drawings. We were assured by MCS that this program was available in the public domain, and as soon as we bought the system we would be given a copy of it, a translator. Once we bought the system we found out that the program was not in the public domain, and it was never completed. It was written by an aerospace company on the West Coast, Rockwell. I'm not sure the thing would actually compile [run]. They had started to do it for internal use and planned to release it at an ANVIL users' meeting. They suddenly got cold feet about getting sued by Computervision. You had to know proprietary details about the Computervision database in order to write the thing. So they got cold feet and decided not to put the thing out. The ANVIL salesman got a pirated copy of the source code and gave it to us—a lot of integrity in this business. Some subroutines would not have compiled.

Ron: Another kicker is that the first copy we got was missing the bottom line on every page. Anyway, that was the thing, the existence of the translator that put Harry over pushing for the ANVIL solution, Harry Miller [pseudonym], our vice president of research and development, Skip's boss.

Skip: We got all this stuff in here and all of a sudden we had no way to convert all our old drawings. We finally ended up going to a company up in West Virginia, Bendix, now part of Combustion Engineering. They had a CADDS 4 system and a converter from CADDS 3 to CADDS 4. So we sent a CADDS 3 tape to West Virginia, got it converted to CADDS 4 and then to IGES, and then brought it back.

Ron: CADDS 3 wouldn't generate IGES output.

IGES is an international standard for translating information for two-dimensional drawings from one CAD program to another. Because it is a bare-bones set of features, much information is lost in the process and must be reentered through the new program.

Skip: We had an ongoing, informal relationship with them for several years, because they had a CADDS 3 system at one time. So we helped each other out.

Gary: Was there much communication among CADDS 3 owners?

Ron: We did have a list of about seven companies in Virginia that had CADDS 3. We probably got it at a users' meeting.

Skip: Anyway, we had worked up this scheme for running a Microvax II and pc's running terminal emulation software. Meanwhile, I had been talking to the Apollo salesman out of Vienna, Virginia, originally about some of the applications. But he called up one day just as we were getting ready to sign off on this arrangement. He asked what we were doing on CAD. When I told him, he said, "You guys are stupid!" Those were his exact words. [Turning to Ron] You remember Paul Shelley [pseudonym] don't you?

Ron: Oh yeah, he was pretty straight.

Skip: He told me that for roughly the same dollars we could get low-end Apollos and get more seats. He stepped in at the last minute. That's why we have ANVIL and Apollo.

Ron: It was a last-minute switch. We got eight workstations for $250,000. The Applicon system with three seats would have been $500,000.

Bobby: Applicon had pieced together their own system. They had taken a DEC Microvax with a big screen terminal that looked a whole lot like Computervision with the names and faces different. They had added a few little gizmos. But only Applicon could service the computer. Digital couldn't. There was some fear that it was a unique box, because it was a turnkey solution.

Ron: It was a leap into the unknown with Apollo. They had been the first workstation vendor, so it was a fairly radical move.

The point here is that they were switching from a system that had one computer processor shared by several terminals to a set of processors, each called a workstation, that could be linked together in a way that each could access the storage from all the others. They got more seats for the same price but had to worry about long-term implications.

Skip: I had been to Apollo headquarters and met their president. I was fairly impressed with the company. I was not as uncomfortable as I would have been otherwise. We ended up getting workstations before anyone else was thinking about them. Apollo's problem was marketing. They didn't do a good job of marketing, but, of course, they're part of Hewlett Packard now. The workstations they made and sold were excellent. They have not just tooted their horn. Unfortunately, you have companies with ho-hum products that are very good at marketing, and companies that concentrate on the product itself and assume that it will sell itself.

Bobby: The key was Skip's previous experience with Apollo. With CV it was totally a sales job. We had nothing to fall back on. Here we did.

Gary: You were trusting your judgment and experience.

Skip: There's an old saying: In the land of the blind, the one-eyed man is king. That's basically the situation we were in.

Ron: The choice of the Apollo workstations was the highlight of the current CAD system we have now. Since investing in ANVIL 5000, we've gotten a second CAD package from Infinite Graphics, NGI 2100. We use that for specialized circuit tape design. They are a small company, and their software is a CV lookalike. They put it on pc's, so it was easy for us to use when we first got it, and it did a specialized CAD job that we needed. Actually that turned out to be the last thing we needed to do on the Apollo system before we could get rid of the CV system because we were still doing circuit tape design on the CV systems. By finding the Infinite Graphics software and getting it on our Apollo workstations, we were able to cut our last tie with the CV system.

Bobby: It was a subtle point, but it enabled you to establish line-width tapers and things like that you could feed into a photo-plotting machine and make artwork. You couldn't do that on ANVIL.

Skip: Also we got the Interleaf software.

Ron: That's software for technical publishing, charts and stuff, that is used quite extensively now on the CAD system by our engineers and product management. We've got people from manufacturing who come over, quality control. Sometimes I'll walk around the plant, and go into personnel, and I'll see a diagram that came off of our Interleaf. I don't know how it got down there.

Gary: But how did you get from eight to seventeen workstations?

Ron: We selected the Apollo hardware with the software in 1986. At that point, we had eight Apollo workstations, running ANVIL 5000.

Gary: Who's working on them?

Ron: Mostly drafters. At first, we had thirty-some people trained all at once on-site, including drafters and engineers. The first two or three months, it took time for the transition. For the first few months, not all eight were in use. Sometimes only three were even being used, but during that time the CV seats were constantly being used. At some point we went from two shifts to one on the CV system and progressed to the point where we had eight Apollos workstations and three CV seats all at once. There was a drastic reduction in the number of drafting boards in the area. Then about a year later, we justified four more Apollo workstations and some disk-drive upgrades.

Gary: Were all the old files converted by then?

Ron: No. We weren't converting. We were starting new jobs on Apollos.

Bobby: As we received an order for one of those exiting jobs, then we went through the conversion process. So we were doing that step by step.

Ron: Many times we had both systems going at the same time. We still had some old jobs. At some point we decided to move things over.

Gary: Were there any unusual stresses then?

Bobby: Definitely. Not only were some drafters working on translations, but you had some drafters who were really good on the CV system. As we filtered over to ANVIL 5000 on the Apollos, you had one or two drafters over here who I'm sure were feeling kind of left behind. Everyone else is over there doing that, you know.

Gary: So does everyone use it?

Bobby: That's on an engineer-by-engineer basis. Even now we have engineers who don't use the CAD system at all. On the other hand, we've had engineers do all their drawing on the CAD system.

Ron: Actually the engineering managers are the only three who don't use the system. The rest of the engineers do. The older managers . . .

Skip: . . . say "I'm too old to learn that."

Ron: Yeah.

Bobby: So here we had this mixed system. I sat down one day and realized we were paying over forty thousand a year on maintaining these three CV seats. I essentially justified four more Apollo workstations against dropping the CV system, and we did that. We dropped maintenance on the CV over here. The usage on the CV system then dribbled off. It went from three to two to one, till finally we just turned it off.

Gary: What about archiving old files?

Bobby: We had a tape library on the CV system. What we do even today if we need an old drawing is send the tape out to Combustion Engineering. They can bring it up on their CADDS 4 system and give us IGES. Only very rarely.

Gary: Do they do it for free?

Bobby: We pay someone a couple dollars a file to do it on his own time. He got permission to do it after hours. Now, how did we get from twelve to seventeen workstations? We bought two more used workstations from a company down in Lynchburg. This company had bought two workstations with ANVIL, but for whatever reason, they didn't like that setup and wanted to buy SUN workstations. So we got a pretty good deal on buying their workstations. That's two more, gets us to fourteen. The fifteenth was an administrative monochrome graphics workstation that's now in my office. Basically I was finding I had to do administration after hours or bump someone else off the system. Now we do a lot of Interleaf [technical publishing, reports], and Interleaf works well with monochrome. About two years ago, Apollo offered some newer DN 4000, faster with larger screens and larger disk drives. We got a good deal because they were demo workstations. That's the last we've purchased. For the past two years, the engineering staff has been kinda frustrated because the investment in the CAD system has been stopped.

Boxed in by Productivity

Although now experienced at combining the agencies of human engineers with the agencies of machines, these engineers could find no way of translating such knowledge and understanding into the language and rigid financial calculus of productivity. Accepting CAD had shifted existing activities and relationships rather than simply substituting machines for humans. Productivity became a box rebuffing their efforts to progress further.

Gary: What are the problems now?

Ron: Running out of disk space.

Bobby: The reason we're running out of disk space is that we keep all of our drawings active on the system. The reason why is that, with the CV system, you didn't have a choice. Whenever you saved, you had to write it onto a tape and store it. Then whenever you wanted a drawing you had to reload it. That took a lot of Ron's time, and the time of the drafter who's waiting for it. It just doesn't make sense. If you keep it available online, the drafter can go find it.

Skip: Also there was a time when we had trouble with Apollo tapes.

Bobby: Even now it's risky with Apollo tapes. If we made a tape that seemed valid, we've had problems restoring and we've yet to understand why.

Gary: So there's a concern about loss.

Bobby: Yeah. We make backups. We're very faithful about making backups.

Ron: That is another problem. I back up the stuff daily, weekly, and then every month do a full backup. But that's strung out over twenty-five cartridge tapes. With a newer system we could back everything up on one tape. We could back up the entire system every night.

Bobby: We've been advocating some newer technology in the system, because the workstations today are much faster. Again, the backup capabilities for eight millimeter tapes are a lot higher capacity. On and on. Faster graphics. The whole works, but we can't get that without the capital expense.

Ron: We've been hoping that the technology and just the size of the system will grow so that our file space would increase. We want to continue having everything online all the time.

Gary: At the risk of getting into politically sensitive issues, what's the problem?

Skip: The real problem we run into is that the final decision makers we run into are not technical people, engineers. Now my boss has a Ph.D. in materials science.

Gary: I will turn off the tape if you want.

Skip: No, everyone around here is a loudmouth. We've gotten into trouble before. You can go to my boss and make the technical arguments, and they make sense to him.

Ron: He'll say, "Yeah, I agree."

Skip: But when he has to go down to the front office to his boss, it's lost, because the upper powers here are financial people. They are not technical people.

Gary: But certainly they can understand the difference between keeping things online and doing tape storage. So what does it come down to, "Keep doing the tape storage"?

Ron: I think we've even heard, "Take some files off the system."

Gary: That's what I'm getting at. You guys are just greedy. You just want everything there in front of you.

Ron: The reason we do it is because we know. There are certain things you do because you've been there before, and you have the experience. You can't quantitatively justify it all the time, but we know it's a savings to the operation here to do it the way were doing it. That just doesn't fly down there. You have to put it in terms of dollars and cents. It's hard to do. Going back to the measure of quality: How do we show that we have more complex drawings and more complex work today? That even if we are producing drawings at the same pace, we've got a higher level of productivity?

Skip: It's almost like there's a penalty to pay for developing a new test because that new test will not show up with more productivity. Even though you're cranking out a higher-tech design, perhaps in shorter time, the project is still finished in about the same time.

Bobby: Now one thing that has happened, that doesn't seem to get us very far is—how many drafters do we have now?

Ron: Six.

Bobby: O.K., six. We had about twelve drafters in 1980, B.C., Before CAD. I asked our vice president of finance to estimate the difference in business between 1980 and 1988, taking into account inflation. He estimated that the amount of business dollars this company does in the [main product] area has essentially doubled. At the same time, the number of drafters supporting [main product] development has been cut in half. Now that's a very outside view of productivity increases, but to me that looks like four to one.

But then when we sit down and ask, "How much faster are they drawing?" it's more difficult. We've done drawing tests. They are maybe fifty percent faster on the CAD systems than on the manual drawing, but that's all we can show. So obviously they aren't just drawing faster, but there are other factors. For instance, it's easier to modify an existing drawing. When we're starting a new job, maybe there are some drawings on a different job that are very similar. You can just copy them over, make some modifications, and "ta dah," there you have it, a whole new package of drawings. There must be a lot of other factors, but we've tried to document these in a quantitative fashion, and we can't.

Skip: If you want to be clever, you can bias the test so that manual drawing is faster. All you have to do here on this CAD system, or any other CAD system I've seen, is do a lot of text modification. CAD systems are notoriously bad at handling textual material, and that's half the drawing. It's half the solution that people don't want to pay a lot of attention to, because it's not glamorous.

Bobby: But we can also turn it around and bias it the other way. We can make the CAD system do something in fifteen minutes that another person would spend all day drawing by hand.

Skip: When we did this last test, in which we concluded that people were fifty percent faster on the CAD system, we were very careful to bias it in favor of the manual drafting.

Gary: When did you do that test?

Skip: Last year. In fact, we did all that as ammunition to get more equipment. I think we never finished it. Bill Charlton still has a part he never finished.

Gary: What keeps you from going into the pc big-time?

Skip: The workstation prices are going down. We are looking at Vaxstation 100s that are almost down to the point where they cost the same as a high-end pc. Why go to a pc with a primitive operating system when you can get a Vaxstation? The Apollo also has an honest-to-god operating system [non-standard, proprietary].

Bobby: One real nice feature of the workstation is the networking. It is totally transparent. You don't have to know a lot of special DOS commands to go out and access and activate sites, log them into the system. When you turn this thing on, you're there, in every workstation. It looks and feels like one big mainframe.

Ron: When you log onto a workstation, it's like you've logged onto a single computer. All the files on all the drives on all the workstations are available to you as if they were on your workstation. The pc networks aren't that transparent now. Another thing, I've seen comparisons a few years ago between an engineering workstation and a pc that had been expanded with graphics accelerators and memory boards to make it equivalent. They found that in many instances the pc was more expensive, so we don't view going to the pc as a way of making money.

Skip: The way I see the pc in this whole thing is that it's a cheap way to get started. But if you're into some serious work, probably you want something else.

Bill: You need more disk space even than you get in a workstation.

Bobby: And not just disk space. We probably ought to get into stories about solid modeling.

Return of the Dominant Image

In a world built on the dominant image of technology outside society, the only reliable maps depend on its terms. Despite having experiences that extended beyond this narrow image, the engineers returned to it and the image of automation as they looked ahead wistfully to the opportunities that lay just beyond their reach: Could the engineers' dream be fulfilled, perhaps, through the next CAD/CAM technology, 'solid modeling'? People just didn't realize that it was technology and the engineers behind it that made a company go. Productivity was an outsider's concept, an accountant's whip.

Gary: It surprised me that you were looking for solid modeling in '86. No, '84!

Skip: We don't have it yet. We bought a package but we don't have it yet.

Bobby: We bought one copy. That was probably the most intelligent thing we did, buying only one copy.

Skip: We got burned for what, eight to ten thousand dollars? This was another case where it just wasn't true.

Bobby: This was MCS with their Omnisolids.

Bill: Look in the MCS literature. Omnisolids is featured again and again and again. I even tried to use some of it for my dissertation. Some of the guys had gone through the training, and some of the examples weren't that clear. I came in and said, "Maybe the documentation was a little funny." I got in, and all the examples in the documentation worked. But nothing outside of that set of examples worked.

Skip: I worked through all the examples twice, and got different results.

Gary: Really?

Skip: Yes, and I never did figure out what was wrong.

Bill: I found out there was a subtle fact where you wanted to do a calculation about a planar surface. If the surface you chose crossed a margin, you got slightly different results than if it didn't. They didn't make any mention of the fact that this would happen, in their literature. So it was real easy to misinterpret what was going on. After that, I started trying to do things like models of mechanisms. It was real simple stuff. If you said "Take a cylinder, then take a sphere and put it on the end of the cylinder," you would watch the thing blow up 'cause it couldn't do that. It can't do it today. I will give you a simple test. If you want to go into any ANVIL demonstration and bring them to their knees, just say, "Create this cylinder and create this sphere of the same diameter, and then put them together so the center of the sphere is at the endpoint of the cylinder. Perform the union operation." It won't do it. It will crash.

Skip: Also, let me get my two cents' worth in here. I had once written a solids modeler, so I had some sense of what has to go on inside. I have no idea what in the hell they're doing in Omnisolids. I cannot understand it, and I know the underlying principles.

Bill: In an act of desperation, to try and get some response from ANVIL I decided to send them an error report every week. On the fifth week, I called them up and said, "Did you get that last error report?" The guy got me on the phone and said, "I sure hope you're not using this for any kind of design applications." Well, we had paid $10,000, so we kinda wanted to use it for something like that. He said, "We're not there yet."

Bobby: About three years ago, we approached MCS formally with this problem. When we requested a refund or a credit, they said they can't do that, but they would suspend maintenance costs for Omnisolids until they "fixed" it. So here it is, it's August of 1990 and we first got Omnisolids in 1986, and we're still not paying maintenance on Omnisolids because they haven't fixed it yet.

Gary: Why is solids so important to you?

Skip: Visualization. Some of our parts are fairly complex. When you do the layout on some of the more complex parts, it's difficult to see just how everything fits together. The option of the solids modeler gives you a way to visualize how everything comes together. Also weight calculations are important, because of the different uses [our product] can have.

Bill: Weight and surface calculations are pretty common around here. We've got a lot of operations where we want to know exactly what the surface area is.

Bobby: Although ANVIL 5000 is a 3D CAD package, we use it for 2D drafting. My assessment of that is because most of the parts we have are cylindrical. They revolve. They're not boxy. They're not conditioned to a nice wireframe. It's very hard to draw a wireframe of a rounded smooth surface, a sphere or a cylinder. For us to use a 3D modeler, it would need to be a solid modeler so we could show that

surface. A solid modeler works better if what you want to say is "I want a cylinder with a hole in it." With a surface modeler, you've got to make sure . . .

Skip: . . . that you don't have any holes in the thing or all your calculations will be off.

Bill: For me, a surface modeler is totally inadequate in a production environment because you don't have people who understand the mathematics. It's O.K. for someone in graduate study who understands the mathematics involved and can keep all the special references clear. But for someone who doesn't have that training in the mathematics of geometric modeling to try and grasp what a surface model is doing, trying to keep track of what's inside and what's outside, that's just not clear. There are ambiguities. The solid modeler is not ambiguous.

Ron: I can still remember trying to put surfaces together to produce a completely enclosed volume to make a complete piece. Phew!

Bobby: At least conceptually a solid modeler will take care of a lot of the bookkeeping for you, such as where the pieces come together. A lot of people don't care to know how to knit the pieces together.

Bill: Also, solid modeling is getting better and better. We are looking at a couple now that have two-way associativity between the drawing and the solid model, which means that if you update the drawing it updates the features on the solid.

Bobby: In this example I did of a [part] with a shaft, I never did see the shaft. I was given two drawings. I went over to the Virginia Tech CAD/CAM Lab, and in three days came back with a solid model of the shaft. It was pretty revealing for me, to be able to work on those drawings and really figure out how it was shaped.

Also, Charlton, our chief parts engineer, told me that solid models were very helpful to the Air Force people who came in here to see that shaft on the screen, because we could do cross sections and show them what was inside.

Gary: I was expecting you to say something about manufacturing, that the big value of the solid model was to communicate better with people who manufacture the [parts].

Bobby: No, it had to do more with demonstrating to the contractors. We are subcontractors with [a major defense contractor] on [our main product], and they wanted to be able to see it. We could have purchased another solid modeler and run it on the Apollo hardware, but we have had the problem of justifying the expense.

Gary: How about that the move enhances communication between the group and other groups?

Skip: You can't put a price tag on that.

Bobby: If I could go downstairs and say, "Here's a three-hundred-hour drafting job and two-hundred-hour engineering job for which we've quoted X dollars. If we add this solid modeler here, I could reduce that by seventy-five percent." Then they run the calculations and go, "Sure, I'll buy this for you. It'll save us a lot." But we can't do that.

Ron: We also can't use all the time lost when we do things wrong. Lots gets lost everyday. We end up doing a lot of things over again.

Bobby: They always assume that next time we're going to do it perfect. So for the past two years, we have not been able to figure out a new way to justify significant expense on the CAD system. We have run out of ways.

Ron: We've been trying to approach it from the point of view of stereolithography, where we could make the ultimate hard copy out of a solid model. That's been getting some raised eyebrows, but we never seem to hit the wave when it's cresting.

Bobby: There's definite expense involved. It's a shame because, although there is money involved, this group has the sort of expertise to support that kind of operation here. Other companies in this area couldn't do that. They couldn't go out and buy a solid modeler and actually get a lot out of using it. Skip has actually developed a solid modeler. Bill and I have got a lot of experience through the University in solid modeling. I've done projects with solid modeling.

Bill: Solid modeling is the wave of the future. With two-way associativity, you can build the model, peel your drawings off, make changes on your drawings, update your model, and make your hard copy. You can check form, fit, and function and then use it in a presentation tool when the customer comes in, without ever having to go to tooling. You can also take this stereolithography piece and create some tooling off of it. There are people doing lost-wax operations, with the little plastic figures coming off. There are people making power metallurgy molds.

There's a limitation on the solid model on the CAM side as far as machining is concerned, because the mathematical surfaces that you can peel off the solid model are not necessarily the mathematical surfaces you want for machining. For example, a lot of times in manufacturing they want a tool to come down and sweep off the edge, continuing to surface in the same vein, but the solid model stops right there at the edge. That's a very sticky interface right now. They don't have a good NC [machining] program that works with a solid model right now.

Gary: So now you folks in design produce hard copy of drawings and then they re-enter the information over in manufacturing?

Bobby: Right now, it goes down to the floor, and it's entered at the machine tools. They program from drawings onto the NC machine tools.

Gary: So to you the solid model seems to hold the potential of everyone working with the same computer program?

Bobby: What we've advocated here for months and months is: Give us one new workstation to support one new solid modeler so we can demonstrate its usefulness. But we've been unable to get that. I wish there was some magic way.

Bill: At least this time we have done the research. We know there are solid models out there that work.

Gary: Which ones?

Bill: Pro-engineer, SDRC.

Bobby: Those are the two we have really keyed in on.

Bill: Pro-engineer was the buzz word for the past two years because of their parametric approach. They had filleting features that blew everybody away—automatic filleting. SDRC just caught up with them using a variational geometry approach where you could leave some ambiguity in the model and it will do a best guess approximation of intent [see chapter 8]. Those two guys are running neck and neck. There's also ARIES for a pc system, a pc-based conceptual modeler.

We know this because we have talked with 3D Systems, who makes the stereolithography equipment. These are the people they recommend. We have also seen the demonstrations. We have talked to a number of people who are using the equipment. There's a company down in North Carolina that does prototyping and conceptual design based on Pro-Engineer and stereolithography equipment.

Bobby: I bet over these past four years I have spent probably two months of my time traveling to see demonstrations and sales contacts, being on the phone, and day-to-day stuff. Bill too, just evaluating something we have yet to buy.

Skip: I think there's one conclusion here if one makes the assumption that the management mindset in many small companies is the same as what you got here. It's that in order to get anywhere in the CAD areas, you need to have somebody who's going to be aggressive in pursuing the technology.

Gary: A champion within?

Skip: Exactly. Because if you're just going to pursue the old-boy network of sales contacts, you're not going to get it. You need someone to keep up with the technology, to pursue it very aggressively.

Gary: Someone who is in both engineering and computer science?

Skip: Right. Someone who's going to be a pain in the neck.

Bobby: Thank you, Skip. But that's not enough. What I'm saying is that, over the past year or two, they are not listening. They don't see it.

Gary: I never thought about not being able to justify a solid modeler in terms of productivity. It appears to be qualitatively different, visually appealing. There's a bunch more information but you don't know how to describe it. Yet customers now go, "Oh, now I understand."

Bobby: What is the dollar value of "Oh, now I understand," instead of them calling you up on the phone two weeks later and saying, "Oh, now I finally understand"?

Bill: Stereolithography has finally opened a small door because it looks like we might be able to cut tooling times in half. There's the justification in terms of productivity. We might be able to hit them through that window.

Bobby: We are still trying all possible angles.

Skip: It helps to be a little bit of a snake oil salesman.

Gary: Do you think there's a trend in the country where engineers are percolating upwards more, without needing the MBA [master's in business administration]?

Bobby: I think that is happening because the ones with the accountants and

the businessmen at the top are not staying in business. The ones that are lasting are the ones where the engineers have got more say.

Gary: Why is that?

Bobby: They have intimate knowledge of the technology that makes the company go.

Bill: If you come down to a pivotal decision on technology, the engineer can make a better decision on that.

Gary: [with irony] But I thought engineers couldn't make such decisions because they don't understand the bottom line?

Bobby: But the bottom line is not the right measure. You look at the Japanese. Do they always make decisions based on the bottom line? No, and it's obvious that over the past few years they've been passing us up quite completely.

Skip: We are talking into your Japanese tape recorder [Sony].

Bill: We went through a period where the short paybacks worked, you know, the 1950s and 1960s. General Motors could get a complete payback on a new automobile setup in five years, so they said, "We don't need to look at this long-term stuff. Just give me my payback."

Gary: So the new factors are judgments of quality, which are not 'bottom line' judgments?

Bobby: I know you've seen the comparisons of what American managers usually use to make their decisions and then what Japanese managers use. It's like quantity versus quality, the long term versus the short term. It's night and day. What I think you're seeing today in American companies is that the ones who are adopting more of what we associate with the Japanese company are more successful. They are lasting longer.

Gary: How about the big technology shifts in the United States versus the incremental changes?

Bill: We could go off into a whole quality discussion here. We teach a course in quality to our folks here. It seems like the American view of quality is, "Set a benchmark. When you meet it, ok, you're there." The Japanese start higher, "We're not going to set any benchmarks. Let's see how well we can do." They are always looking at their process, the variation on that process, and they're looking to improve it, wherever they start.

Bobby: The word you used, 'incremental,' brought something to my mind. We're going to make the little adjustment anywhere in the process, and we realize that things are eventually going to add up and be significant. The way I've seen things around here is, and Skip talks about it all the time, what management wants is some big technology pill, some piece of technology that is magical. You buy it and it's going to solve all your problems.

Bill: You've probably heard about the study done with IBM where they decided to automate making computer parts. They found that they had to redesign some of the parts for the robots and the robots indeed made the parts faster. So

everybody patted themselves on the back and said, "What a wonderful thing." Then one day they had to take the robots offline, and they brought the people back in. Lo and behold, the people put the parts together faster than the robots. The critical factor was that they had found an employee so stupid, the robot, that they had to simplify the process. They couldn't bargain with or bully the robots into doing it faster, but they had also made it simpler for everyone.

Bobby: In the meantime, you have the Japanese over there, instead of putting a robot in there, saying, "How can we make it simpler for the average worker?" When they're at the point of introducing the robot, it's for a different reason that may actually speed up the process. The robot is doing something that the human can't do, while back here we're thinking the robot is going to replace the human. We've missed the whole boat, because the robot is not a human. It is never going to be a replacement for a human. It is going to perform some task that a human cannot.

Gary: Are engineers percolating upward here?

Bobby: Not here. We would have to talk about the structure of management here. [turning to Skip] You want me to give him my view of who works at the company?

Skip: The path to the top here is through accounting and finance. That's been true here for twenty or some years. Engineering is simply not the way to the top. Our current president has a financial background. His heir apparent is vice president of finance. His heir apparent is coming out of accounting.

Bobby: They've had to sign off on all the money flow outside the company, but they don't sign off on anything in the technology flow.

Bill: Seems to me that the financial attitude on computers is: "I want to have a one-time purchase, and I want that thing to last forever," instead of looking at short-term depreciations so you can upgrade to the next system and maintain your stand with technology.

Bobby: Keep in mind that the CV system was on an eight-year depreciation. We actually gave that computer system to a company in return for their services before it was written off our books. Only in the last year or two have we finally scratched it off our books. Eight years to write it off. Now they are doing it for five years. That's still long. I advocate four years if you want to be really long, or three years if you want to be more realistic.

Skip: Bobby and I went to a Digital presentation down in Roanoke. Their plan is to make a given product obsolete in eighteen months. Training would not be an issue, because all our machines run Digital's VMS operating system.

Bobby: That affects what we do with our product line. It's like a new revelation to management every time we tell them. They say, "What are we going to do? I can't believe it just happened again."

Bill: There have been instances where we got new software only because the vendor told us they would not write a maintenance contract on the old version.

When you reach that wall consistently, it's scary, because that wall can bring down the whole operation. After that point we would be floating on our own. Not only would maintenance not be there, but they won't give you the source code to modify yourself. We're coming close to this.

Gary: Thanks very much for giving so much of your time.

Bill: We're glad to do it. If we can save anyone the pain and agony that we've gone through, then we feel good.

Bobby: Other companies will have different experiences, but we've heard stories of companies that bought a big CAD system and it just sat over in the corner. At least we've used ours here. That's one saving grace. We've used the equipment that we have had. One problem we have now is we don't have enough. We've got more people who would use it if it were available. We have reached a saturation point. Saturation is reached when one person walks up to a system and it's not available. If you have ever had that happen, then you have reached saturation. You can't get that across to management.

One company told everyone at a users' group meeting that their measure of saturation is sixty percent of capacity. That's sixty percent of the workstations for a full day or all of the workstations sixty percent of the day, or whatever falls in between. When they reached that, they bought more equipment. They didn't sit around and have twenty-five meetings on "Wow, what should we do now?" They were always below sixty percent utilization. We probably run eighty-five or ninety percent.

Gary: [in executive voice] Hey, there's a lot of seats out there, guys. Go sit in them.

Skip: I've heard that before. A couple of guys come up to me and say, "I saw an empty seat over there. We must have plenty of equipment."

Bobby: What I want to do is make some sarcastic comment like, "You have a phone in your office. Are you using it right now? You have a chair in your office. Are you sitting in it right now? So why does a measure of a computer workstation mean that you have to sit in front of it eight hours of day?"

Skip: You could even argue that running all those pieces of equipment is not the most efficient way of doing it.

Ron: What are you going to do with all this information?

Skip: He's going to blackmail the hell out of us.

CHAPTER 4 | Seducing Money

THE BIGGEST PLEASURES I OBSERVED around CAD/CAM technology lay neither in the engineering experience of control, nor in the utopian vision of a machine arriving, knocking down the barrier between design and manufacturing, and streamlining the production process. Rather, they lay in a derivative vision, a vision that depended for its fulfillment upon hordes of people and companies ardently pursuing the dream of competitiveness through technology. It was the image of making lots of money from investments in the CAD/CAM industry itself.

This chapter explores the rapid expansion of the CAD/CAM industry during the 1980s by following the dominant image of technology outside society into the realm of investment and finance. Although I do not provide detailed accounts of specific companies or even attempt a comprehensive survey, I do describe a general transformation in the industry as a whole from collective pursuit of a technological system that would eliminate conflict and distance between design and manufacturing to cut-throat competition among a maze of companies edging one another out with specific bits of hardware and software. What emerged was an expanding maze of attractive yet limited commodities whose connections with one another were often problematic, as well as a flurry of failures, mergers, and acquisitions among vendor companies forced above all else to show profit increases on quarterly reports.

After a brief review of a technological fantasy called venture capital, I follow expansion of the CAD/CAM industry in three phases, marked by the years 1983, 1987, and 1990. The first phase was dominated by utopian images of a new technological solution, the second by a growing emphasis

on the price and performance of specific commodities, and the third by the shake-out of companies unable to keep up with the rapid pace of change. Throughout this period, the belief that CAD/CAM technology was going to have a glorious future was so compelling to investors that it guaranteed an increasing supply of capital investment and an ever-present optimism about the benefits of powerful new equipment. Practically everyone involved in the CAD/CAM industry was certain these technologies were good; however, exactly how was less clear. The inability of CAD/CAM technologies to fulfill the original dream presented buyers with the problem of figuring out what to do with them and how to make them fit. In the context of great enthusiasm, any evidence challenging or undermining the promise for CAD/CAM technology barely gained notice. It would have been next to impossible for anyone to articulate alternative visions of human experiences with CAD/CAM technology. Yet as the hardware got faster and faster and the software more and more powerful, the one objective that kept getting postponed was the original vision.

Quick Bucks

Much of the funding for expansion in the CAD/CAM industry came from venture capital. "The whole idea of venture capital," wrote Roy Helsing in *Venture Capital Inside Out: An Entrepreneur's Guide to How the System Works,* "is to invest in the stock of a young company for as little as possible and sell it for as much as possible, meanwhile owning the stock for as short a time as possible. A neat trick." The venture capitalist is usually a professional money manager who invests other people's money for both a fee of two and a half to three percent and roughly twenty percent of the gain when the stock is sold. But actually, continued the guidebook, "a venture capitalist is a gambler. The good ones have the nerves of a riverboat sharpie calmly calling for one card to fill a straight, inside." Everything revolves around the return on investment. "Neither venture capitalists nor the money-providing partners are interested in being eleemosynary [charitable] institutions. Profits count." The exchange is clean and simple: money for money.[1]

The 1980s marked a dramatic increase in the availability of venture capital. Figure 4.1 displays a year-by-year summary of the amounts invested. Prior to World War II, only the rich had significant involvement in venture investments. Through its Small Business Investment Act of 1958, Congress provided for the creation of Small Business Investment Companies, which could borrow from the federal government up to four times their invested capital and at interest rates several points below the prime rates of banks. The Revenue Act of 1978 and the Economic Recovery Act of 1981 offered further incentives by reducing the capital gains tax from forty-nine to twenty percent.

Venture Capital Investment by Year, 1979–1989

	1979	1980	1981	1982	1983	1984	1985	1986	1987	1988	1989
Number of companies	375	504	797	918	1,320	1,469	1,377	1,504	1,729	1,472	1,355
Follow-on	0.16	0.28	0.51	0.90	1.54	1.760	1.71	1.89	2.41	2.19	2.09
First capital	0.30	0.33	0.65	0.55	1.04	1.004	0.97	1.34	1.53	1.47	1.17

■ First capital ▨ Follow-on ●— Number of companies

Source: Venture Capital Journal (July 1990), p. 14.

Figure 4.1 Take-off of the Venture Capital Industry

New technologies had already become the special beneficiary of venture capital funds. As the guidebook put it:

> *During the late 1960s and early 1970s, the space program made technology popular. Americans went to the Moon. Technology could do anything. It could do everything! Invest in technology!*[2]

Another resource book, written by three finance professors from the University of Texas, put the point in straightforward terms: "Venture capital has been used primarily to fund entrepreneurs interested in high technology ventures."[3] According to them, roughly sixty percent of venture capital during the early 1980s went to computer industries, with the rest divided up among energy, communications, genetic engineering, and medical and health technologies. A researcher at the American Enterprise Institute elaborated how the seductions of high technology helped structure this new system of investment:

> *The industry grew out of the need in the postwar period to finance high-tech startups and to cover the substantial risks associated with breakthrough innovations. Banks and other traditional lending institutions were not set up to handle the risks of startups, which need financing up front but often do*

not offer any prospect of a payment for five to seven years versus the one to three years it may take a mature company to produce a product at a profit. With banks unable to wait, the market for venture capital emerged to fill the gap.[4]

We have all probably encountered one way or another what the guide-book called SVF, or the Silicon Valley Fantasy. "There seems to be a vague national understanding that venture capital is risk capital," the guidebook asserted. Risk capital is about strength and power, for it "is invested by strong, bold men into small, weak, struggling companies which, overnight, become giants in their industries spawning dozens of millionaires in the process." Note the birth image of strong, bold men spawning dozens more strong, bold men. "This," it concluded, "is the Silicon Valley Fantasy (SVF) at its highest peak."[5]

Mythical stories abound. Alongside Autodesk's phenomenal rise during the mid-1980s on the strength of AutoCAD was Sun Microsystems, which built its fortune on the emerging engineering workstation. In their book on venture capital, two Harvard professors celebrated the rise of Sun in Mountain View, California, who "true to its name—is the brightest of them all."[6] Founded in 1983 by three men with venture capital, its sales reached $3.2 billion by 1991.

Just as achieving success meant producing a technology that promised to substitute for humans and human agency, so failures in upstart ventures were understood as misguided attempts to achieve this goal. For example, shortly after beginning this research, I visited the headquarters of Stardent, a new company developing what it called "graphics supercomputers" for visualizing scientific data and running sophisticated simulations. As the Harvard professors tell the story, in 1985 Bill Poduska "raise[d] $50 million of venture capital to start his high-end graphics workstation company, Stellar." Poduska was one of the founders first of Data General, the company popularized by Tracy Kidder in *Soul of a New Machine,* and later of Apollo, widely known as the "pioneer" of the workstation industry. However, things never worked out and the $50 million produced no return:

> *Faced with mounting development costs and disappointing sales, it subsequently merged with Ardent, a competitor with woes similar to its own. Unfortunately the merged company, Stardent, with Poduska as CEO and Bell—another veteran of venture-backed companies as its chief scientist, was unable to survive. The venture capital industry suffered one of its biggest financial losses when Stardent closed down in 1991.*[7]

Accepting risk in CAD/CAM development seemed to promise two alternatives: the blissful pleasure of incredible profits or the anguished desperation of debt and lost credibility.

1983: A Glorious Future

In 1983, the past, present, and future of CAD/CAM technology all looked extremely bright. Dataquest, a prominent market research firm in San Jose, California, had recently completed its second annual conference for clients analyzing the present and future of the CAD/CAM market. Dataquest had initiated its "CAD/CAM Industry Source" in early 1981, a publication designed "to help CAD/CAM professionals make sense out of this often-times confusing world."[8] The marketing service now had one hundred eight clients, all of whom attended the conference, and had built files on more than three hundred fifty companies.

People and companies were rushing to buy this technology, and the outlook appeared good all around. Worldwide revenues for the U.S. CAD/CAM industry not only would top $2 billion for the year but would also likely reach $9 billion by 1987, an expected annual growth of more than forty percent. Dataquest divided the industry into five categories, corresponding with five major areas of industrial production: mechanical—everything from the local tool and die company to the aerospace industry; architecture, engineering, and construction—all areas of civil engineering and building construction; printed circuit—any industry making electrical products; integrated circuit—primarily the computer industry itself; and mapping—everything from street maps to astronomical maps. The industry had already installed a total of seventeen thousand machines, expecting this number to increase by more than sixty percent per year.

It was widely understood that the technology was born in military research and development. Nearly all the major early developments in what became known as 'interactive computer graphics' had taken place in the aerospace industry and universities with support from defense funds. One key area of hardware development had been display technology, which converted digital information to produce pictures on a screen. Also, key advances in programming the drawing process had been made at Lockheed-Georgia and McDonnell in St. Louis, as the increasing geometric complexity of military aircraft had multiplied blueprints until the sheer mass had become overwhelming. General Motors was one exception to this military heritage as it sought to automate the drawing process for automobiles, which is another geometrically complex technology.

But in 1983 this military stuff was old news.[9] For the previous three years, concern about declining industrial productivity in the United States accompanied by enthusiasm for the prospects of automation had driven hopes sky high for commercialized CAD/CAM technology. Dataquest clients were likely relieved when a staff member completed a fact-finding trip to the Far East with the conclusion, "Japan is effectively five to six years behind the United States in implementing CAD." However, a Department of Commerce group had already drafted a report asserting that "Japanese efforts are

particularly intense in the areas of licensing U.S. leading edge CAD/CAM technologies," which meant they were buying it to take a closer look. "Once these technologies are mastered and reduced to routinized production," the group continued, "many fear that the Japanese will develop a productivity advantage, allowing them to undercut U.S. manufacturers." In other words, "[w]hile there is not yet a significant threat to U.S. manufacturers, it is clear that Japan recognizes the potential for CAD/CAM, and is aggressively moving toward a significant position in the future market."[10] Clearly, Americans had better get going fast.

As most engineering magazines gushed about the opportunities presented by CAD/CAM technologies, only the industrial engineers, who worked primarily in manufacturing, appeared not to share the enthusiasm. For example, one set of pronouncements in *Industrial Engineer* amounted to a wake-up call to industrial engineers to get involved before the technology passed them by: "The role that industrial engineers will play in the development of CAD/CAM will be largely up to them, individually and collectively. The potential for involvement and leadership, however, is essentially unlimited if IE's awoke to the opportunities available." Another set asserted that blurring the boundary between design and manufacturing could only come through the participation of industrial engineers:

> *It has often been said that someday someone will take the slash from between the two titles. It is my belief industrial engineers will probably be the ones to destroy that slash. If removing it will also symbolize the removal of the political and communicative barriers presently found between designers and drafters on one side and industrial engineers and manufacturing personnel on the other, then its elimination will be significant. The productivity of all manufacturing requires it.*[11]

During this period, there were two main types of CAD/CAM systems, both significant in retrospect for how they did not separate sharply the concepts and agencies of hardware and software. In each case, a CAD/CAM system consisted of a computer processor and an operating system so intertwined as to appear to be a single unit. The 'turnkey' system drew its name from the nuclear power industry, where customers worried about switching to this new technology were regularly promised they would need nothing more than a key to start up and run a newly built plant. The core of a turnkey system consisted of a minicomputer, most frequently the VAX made by Digital Equipment Corporation, attached to two or three display terminals. The word 'terminal' indicated that the device had no computer processor but simply transmitted commands from the main computer to the screen. By 1981, more than ninety percent of the CAD/CAM business was in turnkey companies.

By contrast, the mainframe computer was a huge machine designed for

the many information processing needs of businesses. Mainframe users did more than turn a key because they had to share the computer with others already using the system. Mainframe manufacturers such as IBM, Prime Computer, Digital Equipment Corporation, Control Data Corporation, Sperry Rand, and Perkins Elmer had begun offering display terminals for mainframe machines. During 1982 and 1983, these companies increased their share of the CAD/CAM market to more than thirty percent. Both turnkey and mainframe vendors followed sales with maintenance contracts at a cost of roughly ten percent of the purchase price per year.

By all accounts, the leading company in the CAD/CAM industry was Computervision, whose $224 million in 1980 sales had been a seventy percent increase in one year. Founded in 1969, the company had grown to employ thirty-five hundred people with two large plants in Massachusetts and New Hampshire. Manufacturing its own computers in-house with a proprietary operating system (CADDS—Computer-Automated Design and Drafting System, see chapter 3), the company claimed that its first system had logged twenty-eight thousand hours with less than three percent down time.[12] A key marketing strategy was publication and distribution of *The CAD/CAM Handbook,* a detailed three-hundred-page volume outlining the features, benefits, terminology, and future of CAD/CAM. In the introduction, a prominent CAD/CAM consultant, Carl Machover, offered a snapshot of the glorious future ahead:

> *Depending on the particular applications, 5:1 productivity improvements in the product development cycle are typical of Computervision customers. However, these ratios can range as high as 20:1 improvement over traditional methods of design, drafting, etc. The primary benefit from the use of CAD/CAM is the substantial cost savings realized throughout many of the steps from initial design to production startup. These savings are often enough to allow the user to fully recover initial system costs in about one year—typically from $200,000 to $500,000.[13]*

During this period, the *Anderson Report* was impressed with Computervision's aggressiveness, especially its large, direct sales force with overseas distributors in Japan, Taiwan, and Argentina:

> *The management team of Computervision are real pros and consciously work at preserving the entrepreneurial spirit that has contributed to the company's success. . . . The morale and esprit de corps at Computervision are the highest we have seen in this industry. Will they pass the billion dollar figure by the mid-eighties? We'll bet on it.[14]*

At Dataquest's 1983 conference, the president of Spectrographics, a new startup company funded with venture capital, presented what he called

CAD/CAM TREE

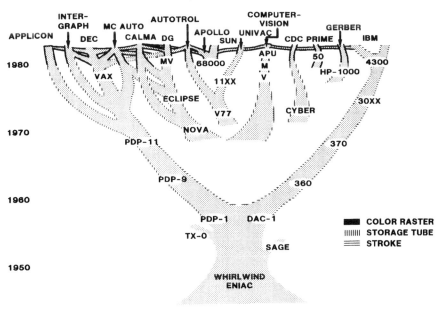

Figure 4.2 A Genealogy of CAD/CAM Systems

the "CAD/CAM TREE," which mapped all the major computer and turn-key companies according to technological progress in computer hardware, which forms the tree's branches. (See Figure 4.2.) Springing from the trunk formed by the post-World War II research into data processing were the two main branches developed during the 1960s, the series of IBM business mainframe technologies on the right—360, 370, 30xx, 4300—and the DEC engineering minicomputer technologies on the left—PDP-1, PDP-9, PDP-11, VAX. Moving upward, note how the tree represented the interesting mix of new inventions during the 1970s, including, from right to left, the Hewlett Packard minicomputer HP-1000; Prime's 50 series of mainframes; Control Data Corporation's Cyber series; Univac's V, M, and APU minicomputers; the V77, 11xx, and Motorola 68000 microprocessors that were just beginning to have some effect; and Data General's NOVA, ECLIPSE, and MV minicomputer.

Edward Busick's tree also portrayed the competition that had been developing among three types of display devices, the vector refresh, storage tube, and new, exciting color raster displays. On a home television, the display is a raster scan device. An electron beam moves continuously in a fixed pattern, lighting up individual points, or pixels, tracing one horizontal line at a time left to right and top to bottom, thirty times per second. The main

difficulty in adapting these devices for design purposes had been getting high enough resolution, or pixels per inch, to be able to see detailed drawings clearly. Denser pixels meant sharper images. Storage tube technologies had been the favorite until recently because they provided the clearest image, painting an entire drawing onto the screen one line at a time and then keeping it there. However, every change required one to wait for the whole image to be repainted again. The vector refresh technology lit up only those lines that had actually been drawn, painting the bits of line, or vectors, over and over again so they looked stable on the screen. The problem with this approach was that, as the drawing became complex, painting the whole drawing could take so long that the screen began to flicker. By 1983, color raster devices clearly appeared to be the wave of the future.

Of the turnkey vendors in the industry, a new CAD/CAM directory listed forty-four of them in the mechanical area alone. However, only Computervision, Applicon, CALMA, Intergraph, and Auto-trol had been around for more than a couple of years. Applicon, also located in Massachusetts, had been purchased for $222 million in 1981 by Schlumberger, a cash-rich company that had made its mark in the oilfield service business. Moving to gain a strong position in CAD/CAM technology, Schlumberger had also purchased another turnkey company, MDSI. Intergraph was originally an Alabama consulting firm for hardware and operating systems at NASA, founded by five former employees of IBM under the name M&S Computing. They changed the name in January 1981 to acknowledge its main focus in turnkey CAD/CAM systems. Auto-trol was originally a manufacturer of input and output devices, from keyboards to plotters, but turning to turnkey CAD/CAM systems had quickly made it a $50 million company.

CALMA was a noteworthy case, for the little company from Sunnyvale, California, had recently become part of a grand plan by General Electric to develop a "a 'one-stop shopping center' for the factory of the future." Purchasing two CAD/CAM companies and acquiring a major interest in a third, GE planned to invest more than one billion dollars in the business. Although wondering if GE would "screw up an entrepreneurial company like CALMA," the *Anderson Report* was "confident GE will be the dominant force in factory automation during the 1980s" since it "is one of the few companies that can compete head on with IBM in terms of resources and clout."[15]

Everyone was afraid of IBM, which had dominated the computer industry since the 1960s with annual revenues approaching $26 billion. IBM had been slow to move to the engineering marketplace from its bread-and-butter market in business systems, and its first vector refresh system in the 1960s, the 2250, had not worked out. But with so many business systems installed, merely serving existing customers with a new vector refresh device, the 3250, put it in second place behind Computervision in total CAD/CAM sales. Rather than writing its own software, IBM included products that defense contractors for military aircraft had written on IBM computers.

Originally written by engineers at Lockheed as a 2D drafting system, CADAM had recently become the main product in a separate division of the company. CATIA was a 3D surface modeling system developed by Dassault Aircraft Company of France. Other mainframe companies were all trying to move quickly into CAD/CAM systems before IBM established a position of market dominance, overtaking even Computervision.

The ready availability of venture capital was evident at the second annual meeting of the new industry association, the National Computer Graphics Association. Among the many companies appearing for the first time were Avera, Graphic Technology, Bruning, Loral, Aztek, Computool, Sigmagraphics, Cascade Graphics, Tricad, Jupiter Systems, Mentor Graphics, Valid Logic, and Florida Computer Graphics. Florida Computer Graphics seemed particularly promising, having been founded in 1981 with $7 million from The Hillman Company to develop a CAD/CAM system using color raster displays. They were considered by many to be the "'darlings' of the venture capital community," with a "beautiful facility," "astute management team," and "viable products."[16]

Curiosity on Wall Street about the CAD/CAM industry had become so great that three hundred security analysts attended a 1981 seminar on CAD/CAM technology sponsored by the New York Society of Security Analysts. Only a few years earlier, most security analysts had never heard of CAD/CAM or computer graphics. Every presentation at the seminar glowed about future prospects with most companies expected to average growth rates of thirty to one hundred percent per year and no slow down in sight. The president of Intergraph actually said that one of the biggest challenges in the industry was "management of growth," by which he meant "funding and training people and being sure the dollars are available for continued expansion."[17] Further evidence of the growing interest was that First Boston, a top U.S. banker, began issuing quarterly reports on the CAD/CAM industry. During 1983, $55 million of new capital was invested in the industry, up from $33 million a year earlier.

The all-out optimism about CAD/CAM technology made it difficult to identify other sorts of effects, let alone judge their significance. For example, the rapid establishment and expansion of new CAD/CAM companies involved the flight of large numbers of people from older companies. One respected manufacturer of display systems, Tektronix, lost so many technical personnel that it became known as Tek University. Yet aside from individual announcements of high-profile moves, little was said in public about such changes.

The biggest potential issue concerned the loss of jobs for workers in industries buying CAD/CAM equipment, particularly since replacing humans with machines was often the explicit goal. As The CAD/CAM Handbook illustrated, however, optimists could respond fairly easily by picturing a world with more jobs:

A typical objection to CAD/CAM is that its introduction may eliminate jobs. Certainly that is possible. However, in the United States as in many industrialized nations, a greater problem right now is the inability to locate and hire enough properly trained qualified engineers and designers. For many companies, the only way to meet productivity requirements is by using CAD/CAM techniques to enhance the capability of the people already available. A major aerospace company concluded that if it was going to continue creating products in the same way as in the past—manually—it would need to hire all the parts programmers available in the world.[18]

A reassuring report from Daratech, a consulting firm specializing in CAD/CAM technology, outlined how "proper planning can ease resistance by employees, unions." Elaborating the importance of good training, it pointed out with evident pleasure that "union experiences with CAD/CAM have been good and no discernable, nationwide union opposition has emerged." CAD/CAM had "not been a job threat" and "not resulted in layoffs." Yet one of the reasons why such dislocations had not occurred raised as many questions as it answered because "gains in productivity have been moderate and slow in coming, overall."[19] In other words, was CAD/CAM automation involving or producing something other than the replacement of humans by machines?

A Dataquest survey of users indicated that 92% were using CAD/CAM primarily for design functions, 60% of which to automate drafting, 27% for "design and modeling, and 5% "analysis," while only 8% used it primarily to connect design with manufacturing. At a Dataquest conference on the topic "Linking CAD/CAM with Integrated Manufacturing," one researcher illustrated the problem with an image of a rainbow connected to separate two pots of gold. Could the rainbow become real? (See Figure 4.3.) The *Anderson Report* claimed that "buyers were pushing suppliers to move beyond automating drafting to include data base management, analysis, and manu-

CLOSING THE GAP

INTEGRATION

ENGINEERING AND DESIGN

MANUFACTURING

Figure 4.3 The Fantasy

facturing support, and that turnkey vendors appeared to be responding with a move to faster 32-bit computers and some better software." At the same time, however, "*the total solution is still missing*" (emphasis in original).[20]

The *Anderson Report*'s own analysis of the problem likely missed the point by suggesting implicitly that perhaps manufacturing engineers were not educated enough to understand. After all, manufacturing tended to have lower status and visibility than design:

> [B]ringing focus to the CAM area . . . is important and necessary if facto-
> ries of the future are to be automated. One of the keys is to bring the manu-
> facturing engineers up to speed about what CAD/CAM can do for them.
> Vendors tend to complicate the education process with complex model num-
> bers and memories for their products. The manufacturing engineer is not as
> comfortable with computers and associated technology as design engineers.
> Manufacturing engineers must stay current on rapidly changing machine
> tool technology, robotics, and now learn CAD/CAM. Complicated model
> numbers are confusing and hard to remember.[21]

Another market research firm in San Jose, California, Creative Strate-
gies International, was probably much closer to the point in a 1983 report:
"One major obstacle to market growth is the classic marketing myopia
exhibited by a number of vendors in their orientation to technology-based
marketing strategies rather than user-applications oriented strategies."[22] That
is, too many companies focused on building fast drawing systems without
thinking too much about how these would actually fit into working envi-
ronments. Fast drawing systems would sell.

One candid speaker at the Dataquest conference outlined in remarkably
simple terms the magnitude of the gap in practices that CAD/CAM technol-
ogy was supposed to bridge. Michael Sterling, vice president of a new
startup called CADLINC, Inc., acknowledged that "[i]t is a shock to buyers
of $100,000 per seat CAD/CAM systems when they realize that they are
not saving money." The reasons, he said, "are complex" and "our industry
must be blamed, not so much for over-sell as for lack of understanding of
the mechanical CAD/CAM problem set itself." Design systems, Sterling
said, were concerned primarily with "visual completeness," which is to say
that, in their drawings and models, they attributed importance to such
things as "clear geometry," "precision," and "making ideas clear." Manufac-
turing systems, by contrast, were concerned primarily with "topological
integrity," which meant that they attributed importance to proper "tooling,"
"mating surfaces" such as corners, and "removing excess material." The
problem, he said, was that "very few [CAD drawings] hang together topo-
logically."

Sterling illustrated his point by contrasting the problem of drawing a
rectangular object with rounded corners with the problem of making one.

Drawing the object involved drawing long lines to make the sides, drawing 'fillets' to round the corners, and then trimming the unneeded lines that extended beyond the fillets. Because directing a computer to draw a line gave it a direction as well as a magnitude, translating a drawing into directions for a cutting tool could be tricky, if not impossible. The efficient cutting tool for a rectangular object would move smoothly from side to side while a drawn line might end abruptly by running into another line coming from a different direction. The CAD image may have appeared visually complete but it lacked topological integrity. Drafters, Sterling pointed out, "are responsible for drawings (visuals)" but "sketching things together [to achieve] data integrity is not their job." In other words, "[m]anufacturing has been left out" of CAD/CAM development thus far, and "manufacturing problems are too little understood."[23]

Despite such pockets of skepticism, most people seemed to share the continuing optimism expressed by Richard Clayton, a vice president at Digital Equipment Company, in an article titled "CAD/CAM Integration: $2 + 2 = 5$":

The trend is toward integrated CAD/CAM systems. . . . In the coming five years, this sort of integration will become commonplace for successful manufacturers. By getting on with the integration of our CAD/CAM systems, we will get a richer flow of information between manufacturing and design. This will significantly help us reach the level of creativity we need as a nation to ensure long-term productivity growth.[24]

1987: From System to Commodities

Now jump ahead four years to 1987. It was a perplexing time for the CAD/CAM industry, for the previous few years had witnessed a stunning rate of transformation in computer hardware. At the beginning of the decade, it had appeared that hardware developments were actually slowing down, with the focus on enhancing mainframes and minicomputers rather than replacing them. But now the great worry was that buyers might be confused by the incredible rate of change. Growing competition in the computer industry had each manufacturer out searching for reductions in price combined with increases in performance, with performance defined as sheer speed in processing commands. The rapid changes in hardware separated hardware development from software development, making CAD/CAM software increasingly important.

The big story was the increased use of personal computers, for sales of IBM pc's and pc compatibles had skyrocketed by 1984. Even as revenue growth in the CAD/CAM industry as a whole was slowing, down from fifty percent in 1984 to twenty-four percent in 1985, the number of CAD/

SEDUCING MONEY | 95

CAM systems in operation had increased to more than forty thousand. The president of Daratech, the CAD/CAM consulting firm, asserted in 1985 that pc users received "70% of the capability of large systems at 20% of the cost" and predicted that "by 1990, 90% of the CAD systems will be personal computer-based."[25]

The *Anderson Report* followed this change with evident concern. For example, in 1984 it reported that the CAD/CAM market was splitting:

> *Personal computers are taking an increasing share of the market from graphics suppliers. . . . The future of the low/medium end of the graphics terminal market will belong to high-volume producers.*[26]

A 1986 article elaborated how "PC-based vendors are enjoying a heyday" by offering "lower budget solutions." This was appealing to working engineers because "approval level is within a department in most cases." Yet it concluded by trying to make light of the change, "Keep the PC-CAD revolution in perspective, [for] one week's revenue at a top CAD company is an entire year for most PC-based suppliers."[27]

Autodesk was the main reason for all the excitement, or the concern, depending on where one stood: "[W]ho would have predicted that little Autodesk would have over 30,000 AutoCAD workstations in less than three years?"[28] John Walker's book-length compilation of internal memos covering this period describes how the company started in 1982 with thirteen founder/programmers contributing a total of $59,000 in start-up funds. None had significant expertise in CAD/CAM technology and all worked part-time evenings and weekends, yet they began with a plan to develop five software products. One of these was AutoCAD, a "basic CAD package" for 2D drafting to be sold at the bargain-basement price of $1,000. When AutoCAD attracted great attention at COMDEX '82, company members put all remaining resources into that one program. Yearly sales shot up from $15,000 in 1983 to $30 million in 1986, and employment grew to more than two hundred people.[29]

Key to this expansion was a decision to separate Autodesk from the responsibility for providing technical support. The company designed and nurtured a network of independent dealers who both sold AutoCAD and provided technical support to their customers. By 1986, the company was referring more than two hundred calls per hour to local dealers, contributing to an order rate of about twenty-five hundred orders per month. Training was then provided both by the dealers and by an additional collection of twenty-five new companies operating 'independent authorized training centers.'

While separating Autodesk from technical support left it free to focus on enhancing features of the software, this step also made visible a developing tendency to transform the lower-priced versions of both software and

hardware into consumer 'commodities,' akin to furniture or toothpaste. An individual CAD/CAM commodity differed from a CAD/CAM system as a whole in that it consisted of a narrower band of technological forces. The commodity was there for a buyer to purchase, use, discard, and replace as appropriate, in contrast with a whole system, which one evidently had to engage in some sort of relationship. The cultural status of the CAD/CAM commodity was thus much clearer than that of the CAD/CAM system because the commodity was much more limited in function. Breaking up CAD/CAM systems into collections of CAD/CAM commodities also fit them better to the dominant image of markets as temporary, narrow exchanges between buyers and sellers rather than as the initiation of longer-term commitments. Where competitions among CAD/CAM systems involved races to identify and establish relationships with clients, competitions among CAD/CAM commodities were much simpler, and more brutal, competitions to reduce prices while increasing performance.

As the *Anderson Report* recounted, "[the] initial response of high-end CAD suppliers was to downplay or ignore Autodesk." But "momentum increased" as the edge in price and performance increased to "80% of the functionality of a high end CAD system at 10% of the cost." At the 1985 meeting of the National Computer Graphics Association, the dominant theme was "personal computers applied to engineering, business graphics, and graphics art." The busiest booths were Lucasfilm, which had developed software for making, or rendering, computer images that approached photographic images in quality, and Autodesk. "[T]here is little doubt," the newsletter concluded, "this small company is redefining the CAD business."[30]

Adding to the challenge was another new technology, the engineering workstation, which moved into the middle of the CAD/CAM market as pc's were taking over the lower, cheaper end. Although similar to a big, powerful pc because, unlike mainframes and minicomputers, it was a one-person machine, the workstation was distinguished by its higher price. As Daratech put it:

> The main difference between a 'work-station' and a 'personal computer' is price: If a complete system with disk drive can be had for under $4,000 to $8,000, the product qualifies as a personal computer. If the price of a single-user computer is $15,000 to $50,000, the product is a workstation.[31]

To engineers, however, other differences were just as important. Workstations could be linked together in small networks so each machine could access and use files stored on different machines. Workstations used faster, more expensive computer processors, 32-bit instead of 16-bit, for making the complex calculations and mathematical translations necessary in engineering drawings. Finally, they employed a variety of techniques for

separating the translations necessary to produce images on display screens, called graphics operations, from the detailed mathematical calculations in the main computer processors, called floating point operations. Because the processing of underlying equations had to take place one step at a time, these were handled by the normal serial, or sequential, processing in the main computer. However, many vendors had begun moving graphics processing from the computer box to the display box, turning television-like 'dumb terminals' into active 'graphics display devices.' Since different parts of an image could be thrown onto the screen at different times, graphics operations could be completed more quickly if they took place in tandem with the main floating point operations. Vendors chose all sorts of ways to make this move as they searched for the decisive edge in price and performance. While all these capabilities reorganized relationships among the people who made use of them, none contributed significantly to blurring the boundary between design and manufacturing.

Not surprisingly, venture capital invested heavily in workstation companies, which promised especially large returns rather quickly. The big winners so far had been Sun Microsystems and Silicon Graphics. Sun's revenues grew from $86,000 in 1982, its first year, to more than $180 million in 1986. When it became a public company in 1986, it raised $45 million more in its initial public offering of stock. Founded in 1981, Silicon Graphics received more than $30 million in venture capital before it turned profitable, achieving sales of $80 million in 1987. While Sun went after the low-cost engineering workstation with as high resolution and as high digital performance as possible, Silicon Graphics focused on the higher-end problem of complex 3D graphics, developing a special computer chip to process graphical operations in parallel with the main processors.

Powered by venture capital, a staggering number of companies charged into the workstation market, e.g., Ardent, Cadimation, Cadnetix, Edge, Evans and Sutherland, Hewlett Packard, Stellar, and Tektronix. The risks were particularly high, for it was becoming common for companies to introduce a new product line every twelve to eighteen months and not everyone could keep up with this pace of change. For example, the company that had first developed the engineering workstation in 1980, Apollo Computer, had been experiencing problems. After growing rapidly at first, Apollo lost $18 million in 1985 and laid off three hundred people from its workforce. According to the market analysts, its main problem was that its network operating system would not work on other machines besides its own. Following the pattern established by mainframe and turnkey companies, Apollo had made the operating system proprietary as a strategy to keep customers coming back for more. By contrast, Sun had become quite popular through the commodity route, making its specifications readily available to software developers and committing itself to using a new, publicly available operating system called UNIX. Written by engineers at AT&T, UNIX enabled

workstations to run multiple tasks concurrently, unlike mainframes and minicomputers, and without imposing any limits on how much memory a given machine could allocate to these tasks, unlike DOS for the IBM pc. In other words, Sun became more attractive than Apollo because it was, in principle, compatible with a greater variety of other software and hardware. Its strategy was better suited to the commodity-style market, where mass sales were the goal and vendors limited their relationships with buyers to the sales encounter.

Mainframe companies were forced to begin manufacturing workstations. In 1985, DEC introduced its contribution, the microVAX, with "aggressive pricing and performance."[32] It then suspended the sale of computer processors to CAD/CAM companies and entered the CAD/CAM market by selling systems itself. From 1984 to 1986, industry publications worried openly about what IBM would do, because the company appeared to have finally shifted away from an exclusive focus on business computing and begun pursuing the engineering marketplace. Everyone wondered if IBM would introduce a machine that would simply blow everyone else away. However, the workstation that was finally introduced in April 1986, the RT, was nowhere near fast enough in processing graphics. In fact, IBM tried calling it a personal computer. As the *Anderson Report* observed, "with $50 billion in sales and $6.5 billion in profits, it would be a bit arrogant to suggest IBM is in trouble" but "[t]he IBM name is no longer enough to win sales in the face of aggressive competition from the likes of Apollo, SUN, HP and others."[33] Meanwhile, other mainframe companies struggled to keep up.

The turnkey market built on 16-bit microprocessors and long-term relationships with customers was simply dissolving away, along with the fortunes of its leaders. Computervision tried to expand into the pc market with new products in 1983 and 1985, but could not keep up with the rapid change. Slow at first to move into workstations, Computervision had by 1985 lost money for six straight quarters, laid off nine hundred fifty employees, and begun offering deep discounts on its older CADDS IV systems: "The dethroned king of CAD/CAM has been plagued by loss of market share, negative earnings, and loss of investor confidence. . . . Over half the personnel in Metheus-Computervision [a joint venture with Metheus], were terminated this month."[34]

The headlong drive into faster workstations at cheaper prices drove out anyone who could not continue expanding sales at the rate everyone had come to expect. Venture capital stopped supporting newer companies and shifted to keep alive best bets. For example, Bausch and Lomb shut down its CAD/CAM business after only thirty months, selling off its Houston Instrument Division to Ametek. MAGI sold its SynthaVision Division to CADAM, Inc. BruningCAD sold its product line to Holguin Corporation. After a two-year foray into the workstation market, Tektronix dropped out, generating no return on its investment of $40–50 million. "It was difficult,"

admitted a Tek executive, "to stay up with the learning curve in both hardware and software in the face to such rapidly changing technology."[35] Schlumberger merged Applicon with MDSI, reducing employment from thirteen hundred to six hundred in the process.[36]

The so-called 'realignments' were particularly devastating at smaller companies, where "changes in management are being forced by venture capital controlled boards of directors who are looking for the quick fix or magic formula for winning." Telesco changed presidents three times in six months. Other companies with new presidents included VIA systems, SKOK Systems, Racal-Redac, Auto-trol, Lundy Electronics, Qubix Graphics, Silicon Solutions, and Graphic Software Systems. After spending $22 million, the prestigious Florida Computer Graphics split into two smaller companies, both of which relocated to "more modest facilities."[37] And a new startup, Syte Information Technology, shut down because second-round financing failed to materialize, shortly after the magazine *Mini-Micro Systems* had featured it in a cover story. Its president told an oft-repeated story: "We just got caught in the venture capital squeeze. Our backers have more mature companies that need money because of the poor public market for technology stocks . . . and we lost." In January 1986, one anonymous vendor summed up the growing sense of desperation in the CAD/CAM industry by saying, "Life's a bitch, then you die."

The commodification of CAD/CAM, indeed the computer industry in general, sharpened the problem of compatibility among commodities. Emphasizing performance inside a given box tended to deemphasize connections between boxes: "The good news about unbundling is lower cost and user-paced expansion. However, the integration between packages is limited." IBM, for example, was offering separate packages for design and drafting (CADAM); engineering analysis (CATIA); and solid modeling (ISD). Yet the different packages represented data in different ways. In the absence of integration, IBM touted 'connectivity,' which really meant that it intended to keep the separate packages separate. In 1985, engineering managers from General Motors and Boeing brought together more than three hundred representatives from twenty-one vendors to propose standards for communicating engineering data across different kinds of equipment, because "[b]asically these two industry giants are tired of buying equipment that does not communicate with each other."[38] Since together these two companies were spending more than $2.5 billion per year for automation equipment, the vendors took notice. But since they also had to compete with one another in commodity markets, the meeting did not have the desired effect.

As the CAD/CAM industry came to depend increasingly on CAD/CAM commodities, the original dream of bringing together design and manufacturing appeared to be losing legitimacy as a key objective. General Electric's massive plan to develop the factory of the future was a case in point. In the face of reduced orders, it cut three hundred fifty jobs from its

CALMA division 1984 and another one hundred twenty in 1985. "General Electric has suffered its share of humility in the CAD/CAM market since the acquisition of CALMA in 1981," observed the *Anderson Report,* for GE "clearly over-estimated the market for the 'factory of the future.'" The risks of automation were too great: "Buyers were not willing to risk major changes that could cripple production lines if the changes did not work." GE had treated CAD/CAM as a "traditional manufacturing operation" where "if you throw more money in, more product comes out." But this is "[n]ot so in high tech." Although a "leading high technology company," General Electric "did not understand the CAD/CAM business."[39]

The dominant use of CAD/CAM systems was still for drafting, 53% in one survey, with 30% using it most for conceptual design, 10% for manufacturing, and 7% for engineering analysis. The industry fretted over the fact that buyers were still struggling with such "basic issues" as training and "how to change corporate structures to get the most out of CAD/CAM." Perhaps the question of fitting technology to people was not so basic.[40]

1990: Living for the Quarterly Report

Fast-forward to the end of 1990. If you can believe it, the pace of change in the CAD/CAM industry during the previous three years actually increased, as both technologies and vendor organizations continued to undergo significant transformations. The world market grew from roughly $8 billion in 1987 to more than $14 billion in 1990. The mechanical market was still the largest by far, accounting for $7.7 billion of the total, with AEC/Mapping and Electronic Data Automation each accounting for about $3.3 billion. Nearly $8 billion was spent on technical workstations, $3.8 billion on turnkey and mainframe systems, and $2.5 billion on personal computer systems, leading Dataquest to cheer warmly, "We believe such strong growth in the force of industry instability is clear evidence of vitality as well as the market's insatiable demand for leading edge CAD/CAM/CAE products."[41] In other words, the lust for automation appeared to continue unabated.

The big story of the past three years was the accelerated development of workstations. Performance levels doubled every year at equal or lower prices, particularly due to technology changes in three areas. All vendors moved to a new kind of computer chip design called the Reduced Instruction Set Computer, or RISC, because it performed the same functions as conventional chips with fewer instructions. Most vendors obtained faster display speeds by shifting graphical calculations from central processors to graphical processors in the display box. And many vendors began designing their own processors to find an optimal mix of graphical and arithmetic computations rather than going to semiconductor companies for processors that might not be best for CAD/CAM purposes.

The warfare among workstation vendors had been intense. For example, in a special newsletter titled, "Workstations: The Battleground for the 1990's," Dataquest asserted that "[w]orkstation vendors are still fighting the price/performance battle, keeping the workstation industry constantly on the move. Vendors are in the never-ending stages of price slashing and performance enhancements."[42] Another report elaborated the point:

> *Increasing workstation performance and fierce price competition among computer vendors continued to be a driving force behind the CAD/CAM/CAE market's strong growth. In 1989, there was a continuation of the MIPS/MFLOPS war [millions of instructions per second/millions of floating point operations per second, two crude measures of performance] at the high end and eroding prices at the low end, both of which have become hallmarks of the workstation hardware industry. These extraordinary price/performance characteristics continue to fuel demand for CAD/CAM/CAE applications as users continue to swap older hardware in favor of faster and more functional workstations.*[43]

The competition to provide high performance at low prices focused each company's attention on the financial bottom line, the quarterly report of profits and losses. As Dataquest put it, "[s]uccess in the CAD/CAM marketplace over the long term hinges upon how well the marketplace perceives a company is performing in the near term."[44] Sun was still the leader, but its "quest to increase market share by using aggressive pricing as a strategy" had run into problems.[45] In the fourth quarter of fiscal year 1989, Sun had finally stumbled, posting a $20 million loss. Note that the word "loss" in this case did not mean that company lost money but that its net profits were lower than during the previous quarter, down to $60 million from $80 million. Their's was a loss of growth. Sun's stumble "set the tone of quarter by quarter earnings as the key in this business," according to Dataquest.

One outcome was a reordering of company priorities. Sun had established a reputation as an "open" company in its relationships with its employees as well as through its products. Open access to management, for example, had translated into "super high morale and low employee turnover."[46] Posting a loss meant that the company had to shift more resources to sales and marketing to reestablish a record of growth, and management's role became more visible. The *Anderson Report* noted the change with an air of resignation: "At some point just about all companies must make a transition from people-dependence to organization-dependence. Perhaps this is where Sun is now."[47]

The pressure waves of price/performance thus rippled heavily through the industry. For example, in order to survive in the workstation market, Digital, for the first time in its history, had to go outside the company for new processors. Other companies, including Apollo, Hewlett Packard,

Silicon Graphics, and Sun all had made inroads with Digital's customers, "reveal[ing] Digital's seeming inability to develop and deliver competitive midrange and high-performance workstations."[48] Despite its long-standing reputation as talented developer of the PDP, VAX, and MicroVAX II computers, Digital turned to MIPS, a new semiconductor company, for its new workstation, the decSTATION 3100.

Other companies experienced similar pressures. Because Digital had canceled its license agreements with CAD/CAM turnkey and software companies, Intergraph turned to a new processor, the Clipper chip from Fairchild Semiconductor, then found itself having to buy Fairchild in order to guarantee timely delivery. Apollo attempted to follow Sun's footsteps by putting its specifications in the public domain, but sales continued to decline. Hewlett Packard took over the company in 1989. Hoping to rebound from its unsuccessful RT workstation, IBM licensed Silicon Graphics's graphics processor for its RISC 6000 machines (see chapter 3). Meanwhile, on the strength of its huge pool of venture capital, Silicon Graphics continue to improve 3D graphics processing for the high end of the engineering market while also producing less expensive machines to compete with Sun.

In the language of market researchers, the CAD/CAM market was 'maturing.' A market is something akin to a growing child, who, if all goes well, grows steadily for a significant number of years before leveling off in a state of mature adulthood. In this case, however, maturity was scary because the internal organs of this body cannot function in a state of organismic equilibrium with one another. Dataquest reported in 1989 that

> *too many companies are chasing too few dollars. . . . The CAD/CAM revenue pie is just not growing as fast as the number of vendors lining up for slices. A vendor must either settle for a smaller piece of the pie or combine with another vendor or vendors.*[49]

In other words, the companies manufacturing and selling CAD/CAM products had to continue to grow, or die. It was as if developing organs were cancerous masses that had to keep spreading, taking over an entire body or reaching out to inhabit new bodies. Invading a mature body is difficult, but possible. There were two ways to "penetrate the installed base of a competing incumbent vendor," counseled Dataquest: One can disguise oneself as an existing inhabitant by building and selling "compatible systems," or force oneself in with money and "buy customers through strategic acquisitions."[50]

Maturity thus also meant 'shake-out' and 'mergers.' The fifteen mergers that took place in 1988 increased to twenty-four in 1989 before decreasing to eleven in 1990. "Without a doubt," reported Dataquest in 1989, "the outstanding issue of 1988 was the firestorm of CAD/CAM related mergers and acquisitions. We view this as a clear sign that the CAD/CAM industry is

now entering the market maturity stage."[51] In addition to outright mergers, CAD/CAM companies announced in 1989 more than one hundred agreements of joint developments in products and sales.

Mainframe and turnkey vendors took a beating because they could not keep up with the pace of workstation development. Control Data Corporation, for example, was one of the first to reduce its CAD/CAM business after sales declined from $3.7 billion in 1984 to $2.7 billion in 1987. After the company's founder retired, a new president refocused the company's attention on quarterly earnings, cutting employment by twenty-five percent and eliminating a range of 'social projects' that the founder had established. Meanwhile, Prime Computer fought off a hostile takeover from a European financier by selling itself to a Boston venture capital firm for $1.25 billion. It was trying to stay in the CAD/CAM business by acquiring software companies and then selling their products not only on its own minicomputers but also on Sun workstations and IBM pc's. After acquiring Versacad to compete at the pc level, Prime bought both Computervision and CALMA, whose sales had continued to decline. CALMA had already surrendered to the workstation vendors by transforming itself from a turnkey company to a software company, reducing employment from two thousand to nine hundred in the process. A big question at the 1990 Design Engineering Show and Conference was whether or not Prime was up to the "challenges of integrating and paring down its disparate product offerings" so it would be able to "stave off the focused niche [commodity] suppliers that continue to assault its customer base."[52]

By the late 1980s, the distinction between CAD/CAM hardware and software had become fairly stabilized and, hence, "natural."[53] The early 1980s interest in integrated CAD/CAM systems had shifted to a question of 'support' relationships between independent hardware and software. 'Porting' came to be seen as the process of fine-tuning software to make sure it ran on specific hardware, after which one could say that the software and hardware each supported the other. Because software did not develop as rapidly as hardware, naturalizing the distinction between the two promised to escalate the problem of compatibility between them.

The solution lay in shifting the most stable point in the interaction from hardware to software. Where specific machines, such as IBM mainframes or DEC minicomputers, had served earlier as platforms on top of which software ran, vendors were now turning to an operating system for networked workstations as a predictable link between changing hardware and software. Initially developed and sold by AT&T, UNIX enabled users to access files on different workstations and to do multiple tasks simultaneously. Widespread acceptance of UNIX as a software platform permitted rapid developments in workstation hardware to continue unabated below, secure in the knowledge that maintaining continued compatibility with UNIX was sufficient access to other software.[54] Meanwhile applications software

running above UNIX could continue to develop at a slower pace. Any system relying on proprietary operating systems was effectively dead.

As the cost of hardware decreased, the cost of software increased. Software vendors able to keep up with the change continued to prosper. MCS's ANVIL 5000 remained popular while McDonnell-Douglas "achieved a reputation as a steady, reliable CAD/CAM, CAE supplier" in significant part because it was "not encumbered with a hardware legacy."[55] It successfully ported UNIGRAPHICS II, its design, drafting, and manufacturing software, to UNIX-based workstations. IBM acquired CADAM in 1989 as part of its strategy to shift engineering customers from mainframes to RISC 6000 workstations.

The pc portion of the market was the only area that seemingly had not reached maturity, in which optimistic images of the future still reigned supreme. As workstations were pushing down into the commodity market, pc hardware vendors were relentlessly pushing upwards with increases in speed. Also, as Dataquest reported in 1990, "the Autodesk phenomenon continues unabated." Dataquest further noted that it occupied "approximately one out of every four legally installed CAD seats worldwide."[56] Although more than two hundred companies worldwide offered drafting software for personal computers, Autodesk continued to drive growth at this level, which still exceeded twenty-five percent per year. Autodesk had earned $300 million in five years. "This was an amazing story of the entrepreneurial spirit," cheered the *Anderson Report.* Not only had "the founders all bec[o]me wealthy," but "more important they did a 'Henry Ford' and brought CAD/CAM to the common man." With a profit margin of twenty percent after tax, it had "not only been one of the fastest growing CAD/CAM vendors but also one of the most profitable."[57] For two years in a row, *Business Week* magazine ranked Autodesk first in its list of one hundred best-run small companies, a clear indication that CAD/CAM was still booming.

In the midst of such rapid growth, however, major questions persisted about how CAD/CAM technologies actually worked within the organizations that used them. Blurring the boundary between design and manufacturing was as distant an objective in 1990 as it was in 1980. The majority of software developments, by far, had fallen on the design side, inundating practitioners with complex mixes of design, drafting, analysis, and rendering capabilities involving 2D drawing, 3D wireframes, 3D surfaces, and 3D solids. It is instructive, for example, that the theme of the 1990 National Design Engineering Show and Conference was "Design for Manufacturability." The technologies highlighted there for their promise in linking design and manufacturing, such as stereolithography, parametric design tools, and programs for including tolerances on printed drawings, fit at best a limited set of manufacturing processes. Furthermore, even the dreams of automating the design side alone had fallen short. As industry consultants pointed

out regularly, improvements were never consistent from one company to another or even from one area of a company to another.

But this is not to say that the dominant image of technology as a positive outside force promising a bright future somehow lost its effect and propelled everyone into a search for new images. Rather the locus of the larger problem of competitiveness shifted from the world of machines to the world of humans, to wit: CAD/CAM technology was clearly great. The developments of the past decade were proof. Look how fast the hardware had become and how much the software could do. If automation was not working, i.e., not producing dramatic increases in productivity, the fault must lay with the companies who bought and used it. For CAD/CAM to guarantee competitiveness and progress, companies had to adapt themselves to the strengths of the technology. The problem, therefore, had to do with humans. It was a case of poor adaptation.

In June 1990 Dataquest announced this conclusion as something of a discovery. Because virtually all companies have now bought into the technology, the report began by asserting that "CAD/CAM/CAE is no longer a luxury," for there was "widespread agreement that CAD/CAM/CAE is mandatory." However, market researchers had "uncovered a symptom of a basic problem that began to emerge in 1989," namely that "some companies are realizing tremendous gains from the tools, while others are experiencing only marginal results." Its main finding, then, was that "large segments of the market are ineffectively applying the tools to the design problem." The failures lay in three areas reserved for human action:

- Inefficient organizational structure;
- Failure of users to update procedures to utilize fully later software releases; and
- Inefficiency in sharing design information between applications and workgroups. Basically, many companies are simply not being aggressive enough in organizational changes or procedures to exploit the power of CAD/CAM/CAE technology fully.[58]

A forthcoming issue of *Computer-Aided Design,* another industry observer, came to the same conclusion:

> *Our associate, Ray Wysach, is fond of saying "There is no waste greater than doing a job well that shouldn't be done at all." In that spirit, there is no waste greater than automating an inefficient design process. Unfortunately, that is what many CAD system buyers have done. They've used CAD systems like automated drafting tables without rethinking their design processes.*

Most companies had located CAD/CAM technologies in the drafting department, or its equivalent. However,

> *fitting CAD into the traditional drafting process rarely produced the big productivity gains needed to justify expensive systems. . . . CAD can deliver major productivity gains when it is coupled with more efficient product development processes. In order to improve your companies' processes, workers and managers must study them to discover activities which can be made more efficient. Such study should precede CAD systems specification so that tools can be selected to aid the new, streamlined design processes, not the old inefficient ones.*[59]

During the 1980s, the desire for automation in design and manufacturing had generated a complementary desire for 'restructuring' industrial corporations. The automation by autopilot that had seemed possible in the early dreams of competitiveness evidently had not worked. The emerging technology must stay, but now organizations must change to ensure increased productivity. Corporate organizations must dismantle their vertically structured bureaucracies and replace these with more sleek, horizontal structures that are shrunk and laminated onto specific and changing production technologies. The desire of automation was not wrong or misguided, only incomplete. Productivity and competitiveness will surely come when organizations have adapted themselves properly. The people involved will just have to cope.

At the same time, however, a glimmer of hope for automation still remained. A new technology was emerging that promised to integrate the activities of manufacturing and design, this time working from the manufacturing side to the design side. The industry leader, IBM, had been putting all its resources into developing this new technology, appropriately called 'computer-integrated manufacturing,' or CIM. Everyone involved was optimistic that CIM would bring manufacturing and design together in a single database.

CHAPTER 5 | Adapting a Nation Around Automation

IN 1991, THE NATIONAL RESEARCH COUNCIL LAMENTED, "Unfortunately, the overall quality of engineering design in the United States is poor. . . . Partnership and interaction among the three key players involved in this endeavor—industries, universities, and government—have diminished to the point that none serves the needs of the others. . . . This state of affairs virtually guarantees the continued decline of U.S. competitiveness." During that same year, the ACSYNT Institute, a new joint venture between industry, university, and government, was struggling to share research and development activities in the conceptual design of aircraft, particularly in developing and using the ACSYNT computer program. Originally written by engineers at the Ames Research Center of the National Aeronautical and Space Administration (NASA-Ames), the computer program had new capabilities in computer-aided design written by faculty and students from Virginia Tech.

As we saw in the last chapter, the dominant image of technology, as an external force affecting human society, limited the ways people could think easily about how to make CAD/CAM and other automation technologies work. In other words, if automation did not simply produce positive outcomes by itself, people would have to adapt in appropriate ways to realize the progress that surely must be inherent in the new technologies. However, restructuring individual corporations was not the only pathway available to adapting humans to CAD/CAM and other automation technologies for the purposes of competitiveness. Because competitiveness was a nationalist doctrine, appropriating the dominant image of technology introduced an entirely new way people could adapt to CAD/CAM: They could adapt together, as a nation. In other words, rather than locating adaptation solely

inside of individual human or corporate persons, adaptation could be a process involving the collectivity of persons as a whole. Restructuring could be a national process.

For a brief period beginning in the mid-1980s, the emerging doctrine of competitiveness thus made possible a set of ambitious experiments in rethinking institutional relations in American economic life or, more specifically, in the organization of industrial research and development. The main motivation was the belief that America had to do a better job of coordinating its R&D activities, for duplicating these activities in different areas of industry, academy, and government made no sense when assessed in national terms. Proponents of the doctrine of competitiveness were acutely aware that the Japanese Ministry of International Trade and Industry had long coordinated industrial development in the private sector, while governments in many European countries and most postcolonial countries played active roles in managing industrial development, if not directing it entirely. If America were going to rely on new technologies to beat Japan and other budding competitors, it would somehow have to transform relations among the corporations, universities, and government agencies that contributed to a maze of overlapping activities in R&D.

While maximizing the interests of the nation was logically only one step removed from maximizing the interests of individual people and corporations, taking this step potentially involved a huge shift in priorities and everyday habits of imagination for Americans. It meant building commitments to others into one's routine economic practices. It meant encouraging people to look beyond private or local interests to address concerns on a wider, national level. Even if chauvinistic because nation-centered, collaborating for the national interest in economic terms introduced an opportunity for participants to look beyond the individual person, whether human or corporate, and make altruism an integral part of the R&D process. Could the same attitude eventually be extended across national boundaries as well? The tone was hopeful; the possibilities for new forms of cooperation were real.

Because the doctrine of competitiveness provided the conceptual framework for formulating and interpreting new possibilities, these experiments in cooperation focused on improving the nation's production process. This meant an emphasis on manufacturing, which was purportedly the weak link in the American production system. Since it was taken for granted that technology stood outside of society, going out there together to work on new technology would not advance the interests of one group at the expense of another as long as the resulting technology did indeed serve everyone equally. Cooperating in R&D for manufacturing processes thus appeared the most palatable and promising site for new experiments, since presumably everyone could make use of whatever new technologies emerged. Joining companies together in actual product development would likely have raised all sorts of concerns about trusts and monopolies and,

hence, would have appeared to be self-interest on a large scale rather than a shift of interests to a national level. Two of the most prominent experiments in collaboration across institutional boundaries were Sematech and the Microelectronics Research Corporation, collaborations on manufacturing processes for computer chips and on advanced chip design, respectively.[1] This chapter reports a case involving CAD/CAM technology that was less publicized but still encountered all the main issues.

While the dominant image of technology figured in the optimism for an adaptation that was national in scope and content, for theoretically the new technologies would promote progress for all by affecting everyone equally, this image also structured the principal barrier to change by hiding or making less visible significant differences among participating humans and institutions. By focusing attention on the relationship between machines and humans rather than among machines or among humans, the dominant image of technology carried an implicit assumption that all humans were alike. Accordingly, participants in the ACSYNT Institute concentrated the majority of their efforts and attention on developing and improving the ACSYNT technology, yet their greatest difficulties lay in articulating, addressing, and resolving the differing problems and expectations they experienced depending upon where they were located relative to one another. Negotiations of these differences were forced to take place through debates over the specific features of the technology itself. As David Grose, an engineer from Boeing, put it at one of the early meetings, "We're trying to do with the computer what we cannot do with our organizations."[2]

Hybrid Humans

The ACSYNT Institute was founded as a joint venture to transfer from government to industry a computer code for the conceptual design of aircraft. During the two years I followed the Institute (1990–1992), its membership consisted of eight aircraft companies, Virginia Tech, and NASA-Ames, with four other NASA and Navy research organizations participating in minor roles. Each participating company had committed $30,000 per year for a period of five years to support R&D on the code, which was conducted primarily by researchers at Virginia Tech and NASA-Ames.

ACSYNT, standing for AirCraft SYNThesis, had been written during a twenty-year period by engineers at NASA-Ames. During the middle to late 1960s, a number of aircraft companies, including Boeing, Grumman Aerospace, Lockheed California, McDonnell Aircraft, and North American Rockwell, had developed all sorts of computer programs to aid in the various stages of design. These programs and their successors were proprietary and therefore not open to public scrutiny. Yet NASA's statutory responsibilities in aerodynamics required it to research advanced aircraft technologies and

evaluate proposed designs for military aircraft that contractors submitted to the Department of Defense. NASA evaluation teams were minuscule compared to the engineering staffs of defense contractors. Hence, during the 1970s engineers at NASA-Ames initially developed ACSYNT as a resource to give themselves greater independence and control in examining technologies and comparing proposals. By the 1990s, this tool had become attractive to companies faced with restructuring themselves for a post-Cold War economy.

Engineers participating in the Institute categorized ACSYNT as an exercise in conceptual design, a phase of design activities that had stabilized in the aircraft industry after World War II alongside the phases of preliminary design and detailed design. Conceptual design practices specified a vehicle's initial geometric configuration, size, weight, and performance characteristics. During this phase engineers considered a much wider range of alternative vehicle concepts than during later points in aircraft development. Groups responsible for conceptual design in the aircraft industry were typically small and did not carry a great deal of power and authority in company decisions to develop particular designs.

In contrast, the leaders of preliminary design groups typically held the greatest power by far in configuring a design. As both aircraft company and NASA engineers explained in interviews, the industry subdivided the activities of preliminary design in knowledge terms according to the major subdisciplines of aeronautical engineering, including aerodynamics, propulsion, and structures, as well as combinations of organization-specific considerations. Each subdisciplinary area had teams of engineers that could number in the hundreds. Starting with a small set of alternative concepts negotiated with conceptual design groups, these teams conducted computer-intensive analyses of expected vehicle performance in each area and then negotiated among themselves a narrowing of alternatives down to a feasible design that group leaders found most acceptable.

By the time the phase of detailed design was reached, the design concept was well entrenched and extremely difficult to influence. Company engineers regularly joked about the build-up of momentum behind a design as something that departed from engineering rationality and problem solving. Activities in this phase provided detailed specifications of all vehicle components, planned and scheduled construction activities, and set up relationships with contractors. Evaluations of the design shifted from computer simulations to experimental efforts and wind-tunnel testing with mock-up prototypes.

The ACSYNT Institute included fifteen to twenty regular participants from industry, all engineers working in conceptual design. A primary goal of these engineers, both individually and collectively, was to increase the influence that conceptual design had on company decision making by appropriating into conceptual design some of the activities of preliminary design.

Among the capabilities that ACSYNT promised was an improved ability to communicate a proposed design both visually and with authority. The conceptual designers were especially interested because in 1987 and 1988 CAD/CAM researchers at Virginia Tech had written a program for representing aircraft visually (see Figure 5.1).[3] With this CAD/CAM 'interface' or 'front-end' conceptual designers could input a specific geometric configuration, ask what additions or changes might be necessary for the vehicle to meet some specified mission requirements, and then view a three-dimensional shaded image of that vehicle on the screen. Prior to having access to CAD/CAM visualization, engineers in both conceptual and preliminary design had to analyze large amounts of numerical data from each computer run in order to draw manually the visual representations. Participants in the ACSYNT Institute believed that having the capability to analyze and visualize quickly alternative designs would enable them to enhance their decision-making authority.

The original ACSYNT program itself consisted of approximately fifty thousand lines of commands, or 'code,' that divided calculations along disciplinary lines into modules. For example, the aerodynamics module determined the minimum drag on the vehicle, while the propulsion module calculated the performance of different types of engines on the vehicle, and the trajectory module used data from both the aerodynamics and propulsion modules to calculate the fuel weights needed during each phase of specified missions. Other modules included geometry, weights, stability, takeoff, cost, advanced aeromethods, and sonic boom. Each module consisted

Figure 5.1 Iconic Representation of the ACSYNT Institute

of detailed mathematical routines whose outputs varied with a limited set of input variables, or parameters. Running the ACSYNT program brought several modules together, hence the name AirCraft SYNTthesis.

NASA was the main motivating organization behind the Institute. A legal provision of the 1958 Space Act founding NASA had permitted it to enter into jointly sponsored research arrangements with nongovernmental organizations, something that few other federal organizations could do. In 1987, NASA provided staff to establish an independent, nonprofit organization called American Technology Initiative, Inc. (AmTech), with a mandate to establish joint R&D projects to transfer NASA technologies to private industry. In the wake of the Challenger accident and the spreading doctrine of competitiveness, NASA needed additional sources of legitimacy. The ACSYNT Institute was the second joint venture founded under the auspices of AmTech, although the first to be funded under the broad authority of the Space Act. Figure 5.2 presents a visual image of these relations.

A notable feature of the ACSYNT Institute experiment was that its human participants were people whose careers had taken them across the borders separating industry, university, and government. In a sense, participants were all hybrids. Not only did these people have some understanding and respect for the perspectives that colleagues from other arenas brought to the Institute, but their individual biographies also contained some significant features or events that demonstrated a commitment to working for more than the maximization of self-interest. After all, because the whole idea of maximizing self-interest depended upon the image of a coherent self, it posed a real challenge to people who experienced multiple identities or selves. Many participants saw in the ACSYNT code an opportunity to

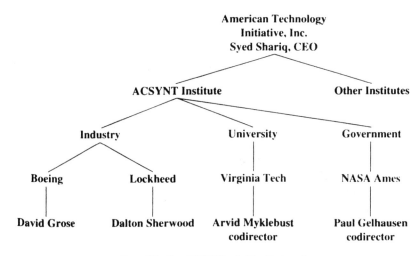

Figure 5.2 How ACSYNT People Were Positioned

help an industry shift from military to commercial enterprise and some wanted to introduce a wider range of design considerations, such as environmental specifications, into the mechanism of aircraft design. I was surprised at the high level of commitment to find new ways of working together.

One of these individuals was forty-two-year-old Syed Shariq, CEO of American Technology Initiative, Inc., located in Menlo Park, California, and the parent organization of the ACSYNT Institute. At the time of our interview, Shariq was working full time on leave from NASA-Ames Research Center in Moffett Field, California.

Downey: You were at Ames at the time this started?

Shariq: I had just joined Ames. What brought me to Ames was a very long and circuitous path. I graduated from Virginia Tech back in 1974, where I got my Ph.D. in operations research in the industrial engineering department. I taught at Oklahoma State for a couple of years, and then got very interested in the decision sciences area. I went to Duke and was responsible for starting and heading up their program in societal risk assessment. How does society make the social decisions of risk, and how do you value human life? All those questions concerning the socioeconomic impact of technology were the focus. Also questions of ozone depletion and whether or not there's enough risk there to worry about, in terms of cancers and other ecological effects and so on. So I did that until about 1980, 1981, when I decided that I wanted to leave academics to pursue a career with more direct relevance and immediate impact on the world we live in—the real world.

Downey: Did that business become boring around '80 or '81 because of the Reagan election?

Shariq: President Reagan came into office, so I realized that the environmental agenda of the nation is going to be on ice for awhile. It was also a good time to really do something different. I joined the Stanford Research Institute [prominent consulting firm, primarily on defense matters], and spent about four years working for companies as a consultant in strategic planning and diversification/acquisition of technologies. Just looking at how technology is developed and commercialized in large and small corporations. What does it take for these big companies to acquire little companies? How are they thinking about future products and how does technology play a role? How do you price knowledge work and technologies, and so on? I did a lot of economic, financial, strategic thinking for several companies, and I also helped SRI to do their own investments in high technology areas, like biotech, VLSI, advanced materials, A.I., et cetera. I was internal consultant to the office of the president of SRI.

After doing that for three and a half years, I felt I should really take my knowledge and ideas and apply them to real world, high-tech investments, so I joined the venture capital business. I spent two years at a premier investment banking company in the Bay Area. I became part of a team of four senior people who were managing a portfolio of over sixty-seven companies, with $100+ million dollars in

investments. And for about a year and a half, I developed a system for them for managing portfolios of companies and monitored investments in the artificial intelligence area.

I spent about two years in venture capital doing that, working on portfolio selection and investment decision-making methodology in the A.I./software area. So after being there, I realized that most of the venture investments, with over $110 million, had been made in the '83, '84 time frame. Those portfolio companies, over half of them, were doing so poorly that the fund would eventually collapse. There's no way anybody would be able to raise funds again, so I looked at the cards and decided that's just not gonna work out. I wanted to take some time out for personal reasons, just slow down, because venture capital had gotten to be more than two full time jobs and then some more.

Downey: I bet it was stressful.

Shariq: So I came to NASA to head their program in artificial intelligence, with no intention of doing what I am doing now at AmTech. But the director of Ames who hired me and a couple of other people thought that this idea of bringing NASA-industry-university joint ventures together is an interesting one. . . .

The legal people at Ames had done some research on the idea of using NASA's Space Act authority for carrying out joint R&D projects, and decided it was a nifty idea. They wanted to ask somebody who is well versed in the private sector and also understood academia to implement it. And so, I happened to be in the right place at the right time. When I reviewed the concept, I felt that I could do it and believed it would be a valuable innovation in our economy.

Downey: And government. So you've got it all. You got it all.

Paul Gelhausen, 31, was co-director of the ACSYNT Institute with Arvid Myklebust, and an aeronautical engineer working full time at NASA-Ames.

Downey: Could you give me a sketch of your own history and involvement in ACSYNT and what you're doing currently? You're often characterized as someone who really has become a champion for the code.

Gelhausen: I don't really consider myself a champion. I've always considered myself more of a—see I'm of German descent and I think that Germans are the guys that are paid to fight for you. So I kind of consider myself more of a technical mercenary. I always find something technically challenging no matter what the job.

Downey: You're a soldier. You're a soldier rather than a champion.

Gelhausen: I think so. I hope; that's what I'd like to be. Yeah, I am enthusiastic. I started as a co-op student working here on ACSYNT. [A co-op student alternates between school and work, taking more time to get a degree in order to gain experience and income.]

January of 1980 is when I started. Boy my boss, George, hated me because I was a terrible typist and all we had were punch cards for writing programs. I kept screwing up the cards. I'm surprised he hired me back, except I work hard. But I thought ACSYNT was a great thing. I thought it was the way things ought to be done.

Downey: George told me in an interview that you were an excellent student out of Michigan. In aeronautical engineering?

Gelhausen: Yeah. Aerospace is what the degree is, but I studied mostly aeronautics. But I came and I worked for George and we were doing research on the VSTOL airplane [vertical or short take-off and landing]. It was more in the line of advocacy. [Gelhausen elaborated in some detail how he did design research for several different types of aircraft while maintaining an interest in ACSYNT.]

Downey: It sounds like you didn't want to limit your identity to any particular type of airplane but wanted to focus on the more general engineering issues.

Gelhausen: Yeah, I think it's all aerodynamics, when it all comes down to it. They all fly, so they're all flown. The other thing is that I would like to think that I'm making things that are most efficient. I'm interested in making the most efficient use of resources, getting the job done most efficiently.

Downey: Where efficiency includes cost?

Gelhausen: Cost and minimum fuel use and things like that. I grew up in the '70s with the fuel crisis and things like that. It probably affected me more than, say, the folks who work on the National Aerospace Plane [NASP, a long-distance aircraft that will fly into space], which will really suck up gobs of fuel. One thing that I hope to be able to do is to look at alternate energy sources. Methanol, those kind of things, that have less impact, maybe more replenishable and clean energy sources.

Downey: [skeptically] There might be money for that someday.

Gelhausen: [sighs] Someday.

Downey: Not right now, though, not in the last ten years, not since Reagan beat Carter.

Gelhausen: Yes, that was '80. Well anyway, the way that I ended up getting involved with ACSYNT is that I always knew that we could do a better job with it.

Gelhausen then described a three-year design competition between the United States and United Kingdom, in which he used ACSYNT successfully to compare and evaluate the proposed designs. By this point, his own identity as an engineer at Ames had merged with the code, and he became principally responsible for managing its further development. In a subsequent interview, he explained how he wanted to incorporate environmental considerations into ACSYNT calculations. For example, at the time he was trying to figure out ways of incorporating concerns about sonic boom into the prospective design of a new supersonic aircraft.[4]

David Grose, 43, was the leader of a design research group at Boeing Commercial Airplane Company.

Downey: Could you give me a little background on your career?

Grose: I got my bachelor's degree at the University of Kansas in engineering.

I was in that first draft lottery. It was the only thing in my life that I have ever won. I got drafted out of college and spent two years as a prison guard at Levenworth. I had a chance, because of the duty hours, to take a couple courses each semester at Kansas, it was only an hour drive away. So when I got out of the Army, I went back to graduate school. By that time, I just had a few courses to finish my master's and then I started on my thesis. While I was there I got a lot of good advice from professors that "if you want to go farther, do it now because it's so tough to do later on."

So I went in and I started on a Ph.D. program in control sciences. Then I shifted to a doctor of engineering program, which NASA partly sponsored, that was design-oriented as opposed to basic research-oriented. It was more of a systems, system design, system analysis, that type of thing, the bigger picture. So I got a fellowship grant and went to NASA-Dryden and did my research in active controls of flutter suppression, which had an interdisciplinary flavor. So when I finished up there I went to Gates Lear Jet in Wichita, where I headed an engineering group in flutter and vibration. I was there about three and a half years, I guess.

Downey: When did you finish your doctor of engineering degree?

Grose: I finished at NASA in '78, with the degree effective in '79, and I stayed at Gates for a little less than four years. I had the responsibility for the flutter certification of the Lear 55.

Then I got the courage to start a small company with some other guys trying to apply aerospace technology to alternative energy. Kansas was primarily oriented at that time to energy storage and wind energy because the wind blows all the time. We built a large prototype of the system and tested it until it was damaged in a wind storm, which are also common in Kansas. I guess I was in that a little over two years. Unfortunately the timing was bad in the sense that when we started there was a lot of interest in alternative energy and after two years Reagan was president now and the interest in funding for those type of things went downhill rather fast.

For monetary reasons I went to Boeing at that point. The first job I had there was program manager of an Air Force program on artificial intelligence. What they were trying to do was apply A.I. techniques to automate aircraft manufacturing.

Downey: They were doing that ten years ago?

Grose: Really wasn't what I wanted. I went there to actually apply some of the control background in robotics, which was kind of an emerging field at the time. I was there three days and literally got shanghaied on a proposal effort [seeking a defense contract], and when it was over I was hoping they wouldn't win it but they did. Well I did that for about a year. The technology was not anywhere close to the point that the expectations were. And I actually recommended to the Air Force that they terminate that program and focus on some of the areas that needed to be matured before they try it. They cut the funding but they kept the same objectives [laughs]. It started to focus in an area that I really had no interest in, integrated data base management and things like that. So I got 'em on schedule, under budget, and we got a deputy program manager that had a background in that to take it over. I went and took advantage of an opportunity to lead the flight controls research group at Boeing Military in Wichita.

Tweaking Boundaries

Building a new approach to R&D required establishing a new form of organization to nurture and perform it. Could hybrid people relocate, redesign, or otherwise tweak institutional boundaries to make working together a genuine option? The lives and activities of institutions tended to presume that human employees had unitary selves located entirely within the boundaries of a given institution. In other words, a human normally did not live in industry, government, and the academy at the same time but really was just one thing. Since the boundaries around these human institutions were organized and policed in terms of existing categories of law, establishing a new form of organization was no easy matter. It would have to be theorized in terms of these categories. A collaboration in R&D that could not be described in legal terms could not exist, at least not for long.

Syed Shariq: The idea of AmTech as such didn't come out of any of the congressional activities or any mandates from the executive office of the president or from higher-ups at NASA. The Space Act has been around since 1958, when NASA was created. At the time, we were under the fear of Sputnik and there was tremendous pressure to build technology and compete head-on with the Soviets. The law was and is one of the strongest legislations, providing unprecedented authority for the agency to deploy resources and do things that other civilian agencies could not do.

Strangely, the way NASA chose to do most of its business was different than any other agency. So NASA really does business an old-fashioned way, even though [the] Space Act allows the agency broad authority to be innovative and pursue alternative strategies. The common mode is to use grants and procurement mechanisms [purchases]. NASA does distinguish activity outside of grants and procurement as Space Act agreements.

During the past thirty-two years, the Space Act agreements have been used only when NASA entered into an agreement without committing any agency or federal funds. Because they felt there was a clear boundary—that, if you used money, you used grants and procurement. But for doing novel things—leasing a facility, using a wind tunnel, or letting McDonnell Douglas or Boeing or 3M use microgravity time on the shuttle—you can do Joint Endeavor Agreements. But in all of these agreements, federal funds are never involved.

So when I took on the challenge of developing the joint venture program in the fall of 1987, it was just an idea. We needed the Space Act to fund joint ventures, for the Space Act had never been used to pursue such a program.

Recall that in chapter 4 I explored how the notion of venture normally described investments that were risky but promised big payoffs. A joint venture, then, would spread the risks and benefits.

Shariq: During the early years (1987–88), we built a body of knowledge on intellectual property law, procurement law, laws on policies and procedures

governing transactions among companies and universities and government. And all that led to a unique and unprecedented set of policies, guidelines, [and] procedures for joint ventures.

After two years of work, back in last fall [1989], we realized that there is just a tremendous potential. The country needs this kind of transaction mechanism for R&D, joint ventures among government, industry, and university. And the idea we were bringing to it, which is the market-based transaction mechanism, became stronger and stronger. The more I talked with people, the more I got support for it: "Good idea. This country needs it."

So what you see here is a market mechanism for doing three-way joint ventures, sharing property rights and resources for common R&D goals but different end uses for the resulting technologies. Nothing is new, but collecting them all in one package is new.

Downey: Wait! How does it work, if you're going to be a venture capitalist in a joint venture? A joint venture capitalist, that's what you are!

Shariq: That's what we've become. Nonprofit, too. We realized nobody would know us at first, so what I did was I used my contacts in business, industry, and within NASA to pull together a joint R&D project. The first joint R&D project came into being because I knew a colleague at Ames. She was the one who really wanted to do it. I said, "Hey, why are you spending $200K a year on a grant? Why don't you multiply that through the joint venture process?" And so the whole thing got started. The second Institute, the ACSYNT institute, is pretty much the same way. I talked to a few selected people I know.

We said to these people, "We're not open for business right now, because we're still trying to work the bugs out of the system." But we want to have some enterprising souls to work with. We can provide benefits for them, because AmTech offers a lot of free services: legal and financial research, dealmaking negotiations, et cetera. All of the contract negotiation and the entire deal package was put together by AmTech staff at no cost to Virginia Tech or other participants.

What we are doing now is marketing. I looked at the NASA budget for 1991 and made presentations to people in Washington at NASA headquarters whose money eventually winds up at the NASA research centers: Ames, Langley, Lewis, Goddard, et cetera. We're not looking for lots of projects, three or four this year at the most. Each joint venture package is currently done in a customized way. We are still learning from these experiences.

People who are in the Council on Competitiveness, on the Quayle Council, or in the White House I talked to, they'd like to use this as a prototype.

Downey: To keep it small, but make sure it's good, so you can show it as a example, a successful example?

This interview was the first time I had heard of the Council on Competitiveness, an advisory group legislated by Congress and with members from

industry and universities appointed by the president. As I read the council's reports, I began to worry about building economic nationalism into AmTech, for the Quayle Council had already established a reputation for conceptualizing national issues entirely in business terms. Rather than transforming the image of the corporate person to fit the interests of the nation, might we be transforming the nation to fit the interests of the individual corporation? The influence of the Council on Competitiveness during the Bush administration became an issue during the 1992 presidential campaign. No formal connections between AmTech and the council were ever established.

Shariq: So the idea of establishing a nonprofit came because when I was talking to many, many people, it was very obvious that this organization must be a contractual party to the whole agreement. I found through a year's worth of legwork, many trips to Washington, that a group of trustees would help establish this organization only if it was a nonprofit. These people were very enthusiastic, and they would say, "Okay, if you are going to build a nonprofit, we'll be happy to serve as trustees."

At the time I asked them, I had known each of them for about two years, and had maybe five or six meetings and phone conversations. And I said, "Look, we're moving towards a problem here. We need to create a new organization so it can have it's own destiny. Its destiny cannot be tied to NASA, nor can it be tied to the university or to industry." I asked them to work with me to create a fourth sector of the economy.

Downey: Yeah, that's what's happening here. That's why I'm interested.

Shariq: It's not so different. There are lots of nonprofits. In fact, the independent sector in Washington, it's been there for a while. Probably you know, you were there. But what's not there is the market orientation.

Downey: The market orientation, no. A nonprofit, market-oriented sector. [hesitating] A national concern that is realized through the maximization of private interests.

The implications of conceptualizing an organization as market-oriented but nonprofit were potentially dramatic. If because of the doctrine of competitiveness nationhood became reconceptualized totally in economic terms as economic competition among nations rather than military or political competition, AmTech and other similar experiments could actually become more representative of America than the federal government. For while government necessarily had all sorts of dimensions and functions, e.g., political, military, police, and so forth, AmTech would function solely as a national economic actor, nothing more. It would be a nonprofit economic actor, maximizing the interests of the whole rather than the individual parts.

Shariq: AmTech combines the public and private interests.

Downey: You are trying to encourage private interests to pursue a public benefit, and you need to have a vehicle. . . . It has to be, this I hadn't thought of before, a nonprofit organization. If it were a profit-making organization, then there would be some distrust of its activities.

Shariq: Absolutely. I couldn't go into Washington. I couldn't go to the White House. My trustees wouldn't donate their time.

At the same time, however, I have difficulty attracting staff members to a nonprofit organization. Because there's no bonus pools, no personal wealth to be made. This is not venture capital. This is not shared ownership. This is a privately managed nonprofit, and there is no membership. It is very much of an anomaly. There's no precedent that I know of for it. I looked high and low at nonprofits and congressionally chartered corporations. I looked at the institutional arrangements that we have in our society, the corporation, the idea of agency, beginning from the late eighteenth century down to today. There is no place for something quite like this.

As we proceed down this path, I am trying to figure out, "What are we really trying to do and innovate?" And what I'm following is an instinct, which says that there's a need for an organizational contract that can make the area of public-private R&D transaction efficient. And nothing makes it efficient unless it's market-oriented.

Downey: I'm fascinated by this ideology, by this institutional innovation whose justification is very much particular to our historical circumstances. If we didn't have the Japanese out there, this would not exist.

Shariq: Yes, I'd have no reason to do it. There would be no market for my idea, or for that matter, I would be told, "We don't need it. We are doing everything fine."

Downey: Also, if the Soviet Union had been competing against us successfully, there wouldn't have been a need for you either, because we would have seen the battle as one between capitalism and communism. But Americans tend to perceive the Japanese as beating us at our own game: "If they're beating us at our own game, then we need to change our game."

Shariq: Or some way for us to do better.

Downey: But there's still anti-trust law. I mean there's still the whole American cultural tradition of market competition among separate property-holders that you have to confront, as we saw in the ACSYNT Institute meeting earlier today. I mean, the industry guys didn't want to share their data with one another. One guy choked on naming the computer program his design engineers use. He couldn't say it because there are still proprietary issues. And that's why I was thinking about the problems that you must run into structuring legal contracts, because you've got a mess of cultural issues that have to be resolved in formal language.

Shariq: Absolutely. You are quite right.

Negotiating Inside the Code

Building a novel collaboration around the ACSYNT program depended ultimately on convincing industry participants to integrate the code into their design practices. At the same time, the government and industry participants had distinct constraints and objectives. Semi-annual meetings of the ACSYNT Institute brought the three groups together to review progress in rewriting the code, primarily through visual demonstrations on computer workstations, and to define objectives for future versions, or releases. Observers from other companies were permitted to attend during the first day of each meeting. Communication and competition across institutional boundaries took place in negotiations about technical developments in the code. While everyone was able to see and understand the contrasting interests and desires at stake, no language for making these visible and negotiating them explicitly was readily available. Building a novel collaboration had to go *through* the ACSYNT program itself.

At the third meeting, held at Ames Research Center in the heart of Silicon Valley, Paul Gelhausen and Arvid Myklebust, co-directors of the Institute, were hoping both to get industry members to commit themselves to use the code and to attract some new members.

Gelhausen: [opening the meeting] Let me first say, "Welcome." We're waiting for software to show up for our workstations so we can show the demos here this afternoon. We were supposed to have that all here yesterday and, you know, everything had to go bad, and that's where I was this morning. It will be here at noon. I think I'll skip lunch, and we'll get it up and running for the afternoon demos.

The objectives of this meeting, my overall objective, is to try to get industry participants to really come together and start giving us more feedback, I guess, on what we've got going. We spent the first year kinda like our grant years, where we just have been going off a little bit unguided, I guess. [When NASA gives a grant rather than a contract, it is not permitted to direct the research.] I'd like to get more guidance in from the industry people. It's healthier if there's more industry participation, because it will help ACSYNT to become more useful to all of us. So one of our main objectives, I guess, is to get more dialogue going with the industry folks.

This morning Arvid's going to talk about the technical accomplishments and show off in viewgraphs and words what we have done with an overview of the upcoming release. Then this afternoon, we'll get to see a demonstration of the upcoming release and some of the tools that are now available. Then we're going to have time for member input, which will include myself, and then we have a special guest, Boeing Commercial, I hope, has got a little bit to say, maybe, and then anything else from other members that are here.

Engineers at Boeing Military and Commercial working under David Grose had done a great deal of work improving the code in order to use it. But all the Boeing work on the code was proprietary. Would they be willing to

share it with other companies? Gelhausen was hoping that Grose's interest in ACSYNT would influence other members and prospective members to get more involved themselves. In addition, perhaps moving into a position with greater visibility might encourage Grose himself to find ways of convincing his superiors to let him share Boeing's work with other conceptual design engineers.

Gelhausen: Tomorrow morning, at our meeting for members only, we will have a discussion of upcoming research and new ideas for research. I think we really need to spend some time together to generate some communication, to generate dialogue between the different members. So hopefully that will happen during the demos this afternoon, during the cocktail hour at dinner tonight, and then tomorrow afternoon. There's a lot of open space in this agenda that I think is mostly for kind of getting the input. With that, I'll introduce Arvid.

Myklebust: All right, I guess the central concept here is to improve computer-aided conceptual design. There have been many objectives, but I'll just list three here that we've concentrated on for some time. First, we want to have a highly interactive graphics interface for conceptual design of aircraft. That should be obvious.

Note how Myklebust announced right up front that his main goal was to advance the technology apart from anyone's specific interests in it. The purpose of a graphics interface was to make it possible to generate visual images of proposed designs no matter what sorts of analysis were conducted. Making the interface highly interactive meant that engineers could make changes to the design and then view the results quickly and easily. Virtually everyone I talked to emphasized the importance of being able to visualize prospective designs. Visualizing made it possible to locate a proposed design in the context of existing designs, to judge the extent to which it extended existing concepts or promoted more radical, hence riskier, changes. Managers might have removed themselves from the mathematical details but they were acutely interested in the overall identity question for each new design. For conceptual design engineers, a key benefit of visualizing the output from ACSYNT runs was that it enabled them to locate a new design for superiors while keeping control over the detailed mathematical specifications. Few people understood how ACSYNT calculations and imaging really worked in mathematical terms.

Myklebust: The second objective is that we want to enhance the analysis and design capabilities of ACSYNT. So that the kinds of things we do on the screen, graphically and geometrically, can immediately be analyzed and, likewise, the kinds of things that come out of an analysis will be immediately represented as a geometric aircraft model without all the intermediate steps of putting in points, lines, curves, and surfaces, and all that activity that takes so long. Of course, the reason for that is, we want to be able to have very rapid design cycles, and to give the best possible design feedback we can have by doing that.

In addition to having the computer draw aircraft images automatically with data taken from the analysis process, industry members also wanted additional forms of analysis. Unlike NASA, the companies actually built airplanes. Since ACSYNT was originally a research code used by a small group of engineers, it did not include some forms of analysis important to engineers working in preliminary design. In addition, ACSYNT's authors had not always followed rigorous standards for programming, much to the consternation of industry members for whom liability issues were a constant concern.

> Myklebust: The third item, right here, is that you'd like device-independent computer graphics. As a result of that, we now have one version of code that runs on all our workstations, the only differences being a MAKE file at the beginning of it. The code is all the same.

The concept of device-independent computer graphics was crucial here to all users, not only to legitimize the work of researchers but also to make it possible for everyone to use the code. Writing a program that was device independent meant that it should run on everybody's computers. Industry engineers indeed used many different kinds of computers and, as the previous chapter described, the market had become flooded with all sorts of new engineering workstations. Without device independence, building lasting collaborations across institutional boundaries would likely have been impossible. In particular, this meant not only writing all new code in UNIX but drawing on newly published graphics standards as well.

After giving his introduction, Myklebust launched into a half-hour lecture about how his university group was using the latest concepts in computer-aided design. These concepts included representing complex curves and surfaces, intersections between surfaces, various forms of color, shading, and lighting, and complex aircraft shapes. He also described changes that students had made so the code might be easier for industry people to use. Aside from Myklebust's colleagues and students, the audience of forty people knew little about computer-aided design and, therefore, likely did not understand much of the presentation, but they loved being able to see visual images of aircraft designs. Myklebust then turned his attention to the half-dozen prospective members present.

> Myklebust: All right, for those of you that are new, let me review a few words about the ACSYNT Institute. The intent, of course, is collaboration between NASA, industry, and the academic world in improving aircraft conceptual design. The participants share the technology developed by the Institute and the source code is distributed under license to the participants. That's a rare occurrence these days, and it's a bit of an experiment here to see how well this works out. We're very strongly committed to supporting this. Not only supporting what we're doing but

supporting the source code itself. We need feedback, to know how we can help you, help the companies to be able to benefit by this.

His last statement revealed much about the technical strategy for producing a collaboration across institutional boundaries that might permit members to be both inside and outside of their particular worlds at the same time. First, by providing maintenance support and assistance for the ACSYNT software, Ames researchers and university faculty and graduate students were blurring the boundary around their activities and status as researchers in government and the academy. In exchange for accepting a new type of task, one that was normally an industry activity, the government researchers gained the claim of relevance for their work and the academic researchers received substantial financial support. This arrangement was not without its costs, for AmTech took ten percent off the top of everything; however, both groups found the compromises an acceptable way of continuing to improve the code.

Second, industry participants received everything they needed to modify the code for their own purposes because they got 'source code.' Normally when one buys software, such as the WordPerfect I am using now, one can only use the code, not rewrite it. Giving the source code to all members transformed the relationship between writers and users from one implicitly between sellers and buyers into an explicit collaboration among co-writers. Industry participants would be able both to receive code from the Institute and to add to it privately or otherwise fit it to existing software and design practices. While this step enabled code development to be a shared and a private activity at the same time, only the government and university participants would be working for the group as a whole. Industry participants would likely have to go along with developing some features in which they had little interest, but they were still getting a large return on their $30,000-per-year investment. Industry participants could thus comfortably maintain a primary focus on maximizing their individual interests.

Myklebust: By forming this Institute, we do get a great deal better leverage, a better return on your investment, than you would yourself in the companies. If you doubt that, you should talk to David Grose at the Boeing Commercial Airplane now. He can talk to you about the advantages of doing it this way. We get support from the Commonwealth of Virginia, and we have much lower research and development rates at the university than you do in companies. All three of us working together can make significant strides at a much faster rate than companies can, I believe.

At present, it's open to U.S. businesses, universities, and government agencies only. We've had a lot of inquiries from people outside, but that's currently the policy.

Rolls Royce, for example, sought membership for some time but was denied on the grounds that it is based in Great Britain. I never heard any discussion about how to define the nationality of a multinational corporation.

Integrating ACSYNT into aircraft companies would require blurring some established internal boundaries, in addition to the external ones. Conceptual designers generally were good candidates for pulling this off, for they already saw themselves as having one foot inside the company and one foot outside it. Conceptual designers were nonconformists, "cowboys" lost in the world of aircraft design, people who just wanted a place to do neat design work. But how could they convince powerful groups in preliminary and detailed design to accept ACSYNT? During the Institute meeting, I interviewed David Grose about this issue.

Grose: They asked me to head up a concept development group in advance product development and the biggest fundamental problem we had was what they wanted to do Boeing did not have tools to do it within a timely manner. I was familiar with ACSYNT from when I was with NASA from the early '70s and stuff. We started to get into it and that's when we started to see how scrambled the code was. You know it was originally never really intended to be anything but an analysis tool at NASA and so there was really no configuration control or those type of things involved. The programming was representative of the era of fifteen years ago. So we bit the bullet and fixed it to the point that we could maintain it and work from there. I guess we started on it right about the first part of 1988.

I think it was around September of 1989 that Boeing made the decision to reduce the military part of the company. They had just finished about a ten-year, two billion dollar expansion of the headquarters for military R&D in Wichita, facilities and everything, laboratories, the whole bit. It is not being utilized in the way it was intended. You hate to see that kind of an effort and then just kind of walk away from it, but the realities, I guess, for Boeing were that wasn't the place to invest their money—in the military side. They had about a fifty-fifty balance five or six years ago between military and commercial, and now it's ninety-three percent commercial, seven percent military.

Downey: Could you give me a quick sense of the organizational structure that you're in?

Grose: It's configuration development and engineering analysis for airplane design, and the conceptual design work is scattered all over the place. Each airplane project really does things totally different from every other project. When you have people spread out, you know, they are unfamiliar with how it gets done in different projects. So Boeing Commercial decided to create configuration development and engineering analysis as a group in its own right in the engineering technology staff.

Downey: How big is the configuration development and engineering analysis group?

Grose: It's got about a hundred and fifty people in it.

Downey: How big is the whole engineering technology staff?

Grose: Oh boy. Let's see, what's the population of Seattle? I would guess

probably four to five thousand are involved in R&D work. Aerodynamics, propulsion, avionics [electronics and flight systems], and structures are the largest of the specialist R&D groups.

Now, they started a core group, which is supposed to focus not on what's going on now but on what we anticipate in the future. We're trying to find a way of not only doing a better job of that initial definition of the design, which all the disciplines now work with and analyze, but also trying to find a way of integrating all those disciplines to where the work that's done is consistent.

A few minutes earlier, the head of a conceptual design group at Lockheed, Dalton Sherwood, had walked into the room and was listening to my interview with Grose. He jumped in to explain the major barrier that conceptual design faces in seeking a higher profile and greater authority in the design process.

> **Sherwood:** This requires a culture change because each of these technology specialist groups are all used to keeping control of their numbers very closely, saying, "You tell me what you want, I'll work on it and give you the numbers back." They did not want you to know how they did their study and what their assumptions were and they could care less what the impact was on the overall study.
>
> **Grose:** I would say that very thing right there is the thing that hampers trying to do what we're doing more than anything. Because one thing computer-aided design or analysis has done is that it's integrating the data. The trouble is some disciplines want to avoid that because they feel they're losing control of their own destiny. For example, in Wichita, [the] propulsion [group] was really opposed to what we were doing with ACSYNT, and yet in Seattle, they're one of the biggest supporters of it.
>
> Some want to get their software activity integrated into this thing. Some don't, they are not going to give you their software. You know, you just tell them what you want and they'll give you the data type of thing, and that's not the way to design.
>
> **Sherwood:** I've had guys curse me because I was taking their job.
>
> **Grose:** In reality, he was making it better, they just didn't realize it.

The ACSYNT code was uniquely suited to the exercise of collaboration across boundaries because it was divided into large building blocks of subprograms, called modules. Each module was roughly independent of other modules and could be used or ignored in particular projects. The interests and desires of radically differing perspectives could thus co-exist inside the technology simultaneously, for each group could decide which modules to use and which to avoid. Furthermore, individual members could write, maintain, and use their own proprietary modules while the Institute produced modules for all members to share. This structure protected the industry members, once again, from having to admit altruism into their calculations of costs and benefits for participating in the ACSYNT Institute. They could

work for the benefit of the collective whole without ever having to give to their competitors.

Grose: [in a presentation at the Institute meeting] The work that was being done at Boeing Military was trying to look at restructuring ACSYNT so it could be integrated into a larger setting in our system. The primary issue there was to identify explicitly what was in it [general laughter, since ACSYNT contained many mysteries], and provide some kind of rigor and structure so we'll be able to add to the software in more of an automatic sense.

We have basically gone through the program line by line [laughter again, because the original code had sixty thousand lines]. What we tried to do is, in every case where there's equations, through conversations with Paul Gelhausen, we found out the reference and got a copy. Cases where an equation showed up, that it was not in a referenceable document, we then derived it to ensure its correctness. And we're embedding all these comments in the code so that people can look at a section of code and see the reference material. We'll have a set of reference materials that then they can go look at if they want more details on the issues there.

Again, we're trying to deal with the fact that, when engineers get involved in a design project, they may have a pet way of calculating a particular parameter, and they'll say, "Well, how's this doing it?" And it's not an issue that you're trying to promote the one over any other, but you can simply now readily show them what is in there.

Now the key to the whole thing is that we have to decompose the analysis modules to where you have fundamental building blocks of code and then pull the appropriate one in at the appropriate time. I think with the realm of problems we can envision with lots of people in the company trying to work with this, what we were trying to do is add as much flexibility as possible to it at the conceptual design stage.

And this will help us to try and integrate this into other software systems downstream in the design process, to start to pick up the information in them and couple better with their models. So this is the direction we're trying to go now, so we don't find ourselves spending all our time trying to get the program to work the way we want to get the answers, but we have the opportunity to do the fun part and that's actually to work the design problem.

Other conceptual design codes frequently did not distinguish so clearly among the disciplines. Without the modular design in the ACSYNT code, then, the ACSYNT Institute and its attempt at collaborating across institutional boundaries would likely have been impossible from the start.

Gelhausen: Well I think that's one of the real key features of ACSYNT now, its modular design. Nobody else has done that.

Downey: How do others do it?

Gelhausen: I think it's like one guy that sits down and kind of puts things together, pulling together different types of methods.

Downey: Puts the modules together?

Gelhausen: No, there's no code that's as modular as ACSYNT overall. From what I've seen, my experience is in helicopter codes. You know, the guy is going along and he's thinking about aerodynamics [airflow over wings and other surfaces] and then he sizes his engine in the middle of his aerodynamics for some reason, you know, it's not as well organized.

Downey: It's not subdivided by discipline.

Gelhausen: Those codes tend to be very inflexible or if they're flexible it's because you gotta have the guy who wrote the code with you to be able to modify it. I think my generation is always saddled with somebody else's code.

Downey: Well, I watched the guy from Boeing, David Grose, paint kind of a nasty picture of the structure of the code and its documentations.

Gelhausen: Well, it's true. I mean ACSYNT's documentation is pretty thin, I think because it's research code, but it's easier to justify ACSYNT than probably any of these other codes, except that the other codes were developed in-house in the companies. You've got, you know, people who say, "I know that the results of this code predict this and I trust that because we've done this before and it's been right." ACSYNT, on the other hand, was never in Boeing before so they're trying to justify it.

As modular computer software, ACSYNT was thus an unusually flexible technology. How many other technologies would have been able to incorporate the interests of industry, university, and government simultaneously?

Resistance from Industry

By participating in the ACSYNT Institute, NASA-Ames engineers gained the opportunity to direct university research, which they could not do in a grant relationship, while university researchers accepted the burden of delivering products. All this was in the name of adapting organizations to pursue a greater good. Industry participants, however, had no way to theorize adaptation in the national interest.

Downey: At what time did NASA-Ames people say, "Hey it would be nice to have a graphical interface [get visual images]?" How did that come into the picture?

Gelhausen: We had always been playing around with graphics and doing graphical things and trying to make pictures of what our airplanes looked like. We've got some interesting pictures of airplanes with the tail flying alongside the airplane because of something the optimization code did or some other bit of code that somebody put in, that kind of thing. So we, we'd been working on doing the graphics stuff.

At one time ACSYNT actually did have graphics in it. Sometime after '75, they lost the punchcards that the graphics routines were on.

Downey: Really?

Gelhausen: Yeah. So that was kind of depressing. I kept seeing all these great three-dimensional pictures of airplanes that came from ACSYNT but weren't there anymore.

Gelhausen described the initial encounter between his boss, Sam Wilson, and Arvid Myklebust, which led to a grant to write the graphical interface for ACSYNT. This technical work, including an initial collaboration between NASA and Virginia Tech, took place before AmTech and the ACSYNT Institute were founded.

Gelhausen: I was skeptical at first because I didn't know, but I'm generally skeptical because no one knows ACSYNT as well as I do. Or me or George, or Gregory down the hall. But anyway, I think I was really pleased with the professionalism of Arvid's students in putting together that first version of the graphics code.

We need now to get more interaction with Virginia Tech. Mark, my assistant, and I need to get in the middle of the graphics development somehow so that we can make the aerodynamics be fully interactive.

Downey: Boy I see! See, this is what I was talking about. If you look at the actual development of the code over the past several years, you can see the various groups in it. In the newest versions, for example, there's Gelhausen in there, for your interests are making their way into the code.

Gelhausen: Yeah, because the earlier work was all grant.

Downey: All grant?

Gelhausen: See, a grant is where I'm not supposed to interact too heavily. I went back to Virginia Tech and gave talks about what I'd like to see and where I'd like to go, but it wasn't until the ACSYNT Institute came along that I could go back and say this is what we have got to do.

In contrast with Gelhausen's technical vision of more interaction, Syed Shariq understood problems and formulated solutions through a legal discourse.

Shariq: We learned some things that we didn't know before we wrote the contract between these three parties. Like, for instance, that technology rights issues come up when a federal employee spends time at a commercial company. What happens is a joint invention can have two authors, one a federal employee, the other a company. What happens to those rights? How do you negotiate a priori the disposition of those rights? There are certain federal laws covering federal inventions. But what about a joint invention? We are coming into some things that are fascinating, where we can make some contributions.

One thing that's happening is that there's more management on the projects we do, because joint ventures are managed differently than grants. In government,

the idea of grants means you give the money and hopefully something comes out of it. You may not get anything.

Downey: You cannot ask for 'deliverables.'

Shariq: In a joint venture it's not the same thing. It is an obligation on the part of industry to join hands with government to co-manage the project. And the university has to take direction and be managed somewhat more than is customary.

Downey: Which can raise a lot of tension within a university. I think Arvid Myklebust regularly has to justify how his work on the ACSYNT code and in the Institute make legitimate contributions to engineering research. There always seems to be a tension there. Of course, it's a tension that most of his colleagues face in their own way by taking industry money. So it's not an unusual thing. This tension has been around in a big way at least since World War II.

Shariq: The industry investors in the ACSYNT Institute do get to manage the research somewhat. Also, students get exposed to real company people. They will probably have better jobs/contacts because of the Institute. Plus, Virginia Tech gets rights to royalties that come out of commercializing this software. So, for the university, the benefit from accepting some outside management is there. In addition to normal teaching, research, publications, promotion, and tenure, it can expect to place its students quickly and can look forward to royalty revenues down the road.

Downey: Will you be able to solve all these problems?

Shariq: See, we have taken a very basic approach. We say, "We really will not solve the ultimate question of ideology. We cannot solve even the many questions of law and policy." I think if I was standing today in front of Congress, I'm sure we would be shut down by somebody or other, for some reason or other. So we really needed to take a more pragmatic attitude: "Let's just hide and do it under the legal banner of the national authority that exists already. Let's get it to a point where it's working well enough. Let people come and kick tires and look at it. And then they can decide whether they want to do it or not."

Downey: I see.

Shariq: Rather than trying to publicize it prematurely, or before its time, we're just doing it, in a real world, with real projects. On the other hand, it's an opportunity. In the many studies that have been put together on U.S. competitiveness, written by bright, competent people at MIT or Stanford Research Institute or wherever, the big question is always implementation. Who's implementing these great ideas? What's being done? Not enough ever gets into implementation. In 1980, legislation came along that gave universities and nonprofits the rights to retain federal technology developed under federal grants. Then the Technology Transfer Act came in 1986, which gave some impetus for government to transfer technology to the commercial sector. But the mandate for implementation and specifically through the market orientation, the incentives that could really bring these parties together, are not there.

Downey: So how do you define success?

Shariq: As yet, there is no clear indication of how you measure success in

technology transfer. Where's the benefit? How do you quantify it? Meanwhile, in our system of doing things, we have located success in the sharing of resources. We have build indicators of success into the design of the joint venture: The commitment of resources by industry in return for technology is a fundamental requirement for successful commercialization, assuming that the joint project produces good technologies.

Consider how a project looks at the beginning. From the government's point of view, a project is doubled in scope because the industry commitment ensures that twice the resources have been invested. So just by having additional parties in the deal means that the accomplishments will be much bigger than any one party could do by itself. So there's efficiency built in here, in the sense that, why duplicate the same research separately in a corporate lab and a federal lab? Why waste the R&D resources of the country? It's actually a triplication here, because the university is involved too. So this way R&D resources can be conserved and dedicated for something else that is important. So this in a sense is a justification for joint R&D and at the same time a built-in or designed-in implementation of the philosophy that ensures success at the start. That is where we measure it, not at the end.

The confidence in this measure comes from the fact that the companies are putting their own earned income on these joint projects. We don't allow them to put in federal money they might receive from work on government contracts. They cannot subcontract this either. None of the government money can flow right back into these joint projects. This is one of the essential requirements. So, as long as industry is putting their own hard-earned money on the table, they clearly would not do these joint projects unless they saw opportunities for profits. Each joint project, therefore, becomes successful by definition, through a commitment to a transaction mechanism that is based minimally on the needs of parties to fulfill their specific self-interests—thereby creating a market-based collaboration between government, industry, and university.

Shariq and I continued our discussion via correspondence:

Downey: [in a written inquiry] Why not let it get really big? Why not allow membership from other countries and make this collaboration a place where conceptual designers work together to improve the tools for reducing costs, reducing fuel use, and reducing emissions into the environment? The step to a global world of collaboration is not that much harder to conceive than the step already taken.

Shariq: [written reply] You are right, that's where we need to get to, eventually. However, given the enormity of this challenge, it really comes down to the fact that we don't know how to make giant strides. All we know is how to take modest steps: A journey of a thousand miles must begin with a first step. Socioeconomic innovations and the creation of market mechanisms are complex problems, as the struggles of countries in the former Soviet Union and Soviet bloc demonstrate. Reimagining R&D in America's future is a problem of the same complexity. Nevertheless, while we think of better ways to resolve these complex problems, we need

to proceed with and encourage responsible innovation and experimentation to foster solutions through experience. AmTech is one small effort in that direction.

Was the ACSYNT Institute's definition of success sufficient? Was it enough if the R&D projects were well supported financially and the participating companies saw the opportunity for profit? One could see how economic returns constituted a minimum condition of existence for these organizations. But if success had to be limited entirely to an economic idiom, then the ACSYNT Institute and other similar experiments were serving as little more than a mechanism for enlisting government and the academy in the pursuits of industry, justified by industry money. The underlying sense of citizenship that also motivated participants in the first place and the boundary-blurring vision they attempted to build both into their organization and their code were not successful in repositioning industry identities in national terms, not even a little bit. The clearest evidence was that Boeing was never willing to share the work it had done on the ACSYNT code.

In the end, experiments such as this one to adapt a nation to new automation technologies by blurring the boundaries among three constituent institutions never became a larger social movement because not everyone was able to adapt and relatively few technologies are likely flexible enough to pursue three distinct sets of objectives simultaneously. Although participants from government and the academy were able to build industry interests into their activities somewhat by couching their contributions to the whole in economic terms, industry participants were unable to push the envelope that defined them.

Perhaps the most important contribution of these experiments was to highlight the narrowness and rigidity of the corporation as a person. Unlike humans, a corporation lives in one dimension. It is a person without citizenship, defined wholly as a maximizer of self-interest, thus rendering problematic possible links between the corporation, especially the multinational corporation, and the nation. The dominant image of technology played a significant role by focusing everyone's attention on developing new technology rather than on how each participant related differently to the technology. Taking the dominant image for granted thus prevented participants from confronting and addressing directly the main problem that was limiting their attempts at collaboration, the narrow, inflexible definition of the corporate person.

After following experiments such as the ACSYNT Institute, it becomes easier to understand how, by the 1990s, the restructuring of industrial corporations to reduce labor costs had become the order of the day and the major indicator of national success in competitiveness had become the state of the stock market, especially the S&P 500. The dream of automation through CAD/CAM and other technologies that appeared so promising during the early 1980s had not been fulfilled, and efforts to adapt the entire

nation around new technologies had encountered an insurmountable barrier. Short of reimagining in fundamental terms the dominant image of technology that sharply separated humans and machines, the only remaining strategy for fulfilling the nationalist doctrine of competitiveness involved adapting humans inside of individual corporations, where adaptation meant defining people entirely in terms of the specific production tasks they completed, eliminating people associated with tasks no longer needed, and challenging those left to become malleable bodies who could adapt as needed to new technologies and the changing demands of production.

But must reimagining the relationship between humans and machines be as difficult or as foolish as it sounds? Perhaps it could involve nothing more than making more visible a range of human experiences that the dominant image of technology outside of society has hidden systematically.

CHAPTER 6 | Beyond Control and Submission

THE FIRST PATHWAY I HAD CHOSEN into CAD/CAM technology for this project was to follow undergraduate students through their learning experiences with the technology. The dominant image of technology outside society provides for a special breed of person who produces and controls technology. The ideal type is the inventor who departs from human society to become the creative genius behind the technological force of progress. Today the figure of design engineer most closely approximates this ideal. I was interested in how prospective design engineers might move into positions of control over CAD/CAM technology, and was surprised at the extent to which such movement involved simultaneous acts of submission.

At Dr. Myklebust's suggestion, I sought out Introduction to CAD/CAM, a senior-level course designed for novices. I approached its instructor, Anne Zeilfelder [pseudonym], for permission to attend her class as an observer. I already knew from my own training that engineering students and faculty tended to understand learning as a cognitive process that takes place entirely inside the head. I wondered to what extent they might also see it as involving some sort of transformation of personal identity, involving the body as well as the mind. My first lesson was that none of us in Introduction to CAD/CAM were novices in the sense of having no knowledge, for everyone was already positioned with respect to the technology in some significant way. Indeed, more than half of the forty-eight engineering students in the class, six of them first-year graduate students and the rest senior undergraduates, did have little prior experience with CAD/CAM technology. Yet, every one had been through an intensive learning experience in

engineering. All of us arrived not so much as empty vessels to fill with knowledge but as differently positioned students loaded with expectations and desires about the course and the technology.

In this chapter, I follow students as they embarked on the process of coming to know CAD/CAM. I sat through Introduction to CAD/CAM twice, once with Ms. Zeilfelder and once with Dr. Robert West, a newly hired assistant professor.[1] I could have followed users on the job or drafters in training at a community college. But based both on my experiences and on testimony from others, I think my findings would have been similar. That is, the dominant image of technology outside society, which draws a sharp boundary between humans and machines, made invisible all sorts of human experiences that did not fit its terms, leaving people in ambiguous relationships with CAD/CAM technologies beyond control and submission.

Who Is the Slave?

Machines are slaves—they're dumb, they're stupid. They don't know any-thing other than what you put into them. Sometimes we tend to give them human characteristics and give them some semblance of intelligence, but that is absolutely false. They are there to offload your workload. They work for you.

Confidently presenting the last lecture of his course, Dr. West summarized what students had learned. His image of slavery said it all: The course's pri-mary achievement had been to provide students with control over CAD/CAM machines. At the end of a long, difficult semester, West seemed sat-isfied that the business of teaching was done. The only thing left before the final exam was for students to present their group design projects in the CAD/CAM Lab. These projects aimed to demonstrate the control students had achieved over CAD/CAM software and hardware, which they would put to use in future employment.

Whenever they had wanted to give students a pep talk, maybe to help students feel good about the course or to justify taking it in the first place, both Zeilfelder and West portrayed learning CAD/CAM in control terms. For example, Zeilfelder pointed out early in her course, "By learning CAD/CAM you can improve your productivity as a designer because you can manipulate more parameters at once." West argued repeatedly that CAD/CAM technology was "nothing but a tool out there to help you." "CAD/CAM does not exist for itself," he said at one point, "but is there to support a higher function . . . the design function." Several times he championed the image of combat, promising students that, if they were willing to put in the

necessary time and effort to learn CAD/CAM, they would eventually be able "to bring the technology to its knees."

The course met for fifty-minute lectures twice a week and then divided into four groups for lab sessions, since the CAD/CAM Lab did not have enough workstations for everyone to use at the same time. Lectures were just that, monologues by the instructor built around daily presentations through viewgraphs. Attending lecture was not required, and roughly a third of the students were missing on any given day. In addition to labwork and a semester-long design project, students turned in six lengthy home-work assignments and completed midterm and final exams.

Each instructor established a fast-paced routine, and I quickly found myself overburdened by the time commitments involved. Laboratory as-signments piled on rapidly, each requiring the total three-hour lab period and up to six or seven hours more work outside of class. Struggling to build fieldwork into an already full daily schedule, I looked for shortcuts to expe-riencing the sense of an assignment without fighting through all its details. I arranged to pay three students, Kim Repass, Jim Parham, and Sandy Poli-achik, $100 each to participate in a series of group interviews about the course and to keep journals of their activities. I recruited two other students, George Rickley [pseudonym] and Eric Schardt, as research assistants to the project and participants in the group by gaining permission for them to enroll in a humanities course in undergraduate research, which I supervised. I turned to Eric for tutoring and tours through lab assignments when I began to drop behind the pack.

These students all described their goals and pleasures in control terms. For example, Sandy explained that she took her time and learned slowly so she could "manipulate the system" without difficulty:

> What I try to do in Lab is learn the procedure as I do it. This takes more time than just doing it, and I know some people just fly through as fast as they can, but I'm taking this class to learn CAD/CAM, not just to get a grade. So my strategy for learning is to go as slowly as I need to, 'playing' with the graphics as I go so that I learn how to manipulate the system. I want to be able to make it do what I want to do without a lot of hassle, look-ing things up, etc.

I distributed two survey questionnaires in class, the first of which included the question: What did you like most about the first laboratory session? Many students alluded to the pleasures of control. One wrote, "getting the computer to finally draw what I wanted," while another wrote "learning to operate the system." Eric wrote generally that it was "wonderful fun." Sandy wrote in her journal, "Got passwords, ID's. Learned to draw points, lines, and circles. Pretty exciting. Also learned functions for line manipula-tion and the window functions. So many instructions to remember. Stayed through dinner till 7:00 P.M."

Just five days after lecturing students that machines were slaves, however, West's message to his students had turned upside down. Now speaking with a gentle, consoling voice, as he summarized the project experience and prepared students for the final exam, he said:

> *You are also a slave to the computer. You can only work as fast as the computer can work. You have to tell the computer exactly what you want done. If you have a conceptual outline of what you want done, you have to translate that into the format of the commands that the CAD/CAM system recognizes. If the system is not user-friendly, then you can run into difficulties.*

West was trying to reassure a group of civil engineering students who had just presented their CAD/CAM design project, a visual model of a small bridge. The project was woefully incomplete. Like other groups in the class, this one had encountered a series of huge, frustrating problems trying to use CAD/CAM tools to produce their designs. By this point in the semester, I had observed much frustration and heard many complaints that the CAD/CAM system on the mainframe computer could not produce the solid shapes they wanted, could not handle enough complexity, demanded endless hours of tedious work, and took forever to process files, particularly when several groups were competing for its attention. Having stayed up all night trying to finish, many students were both exhausted and angry. The image of slavery, its poles now inverted, marked what many students felt.

Learning CAD/CAM thus seemed to carry with it a second image that directly contradicted the first. For West, helping students accept submission to the CAD/CAM system as a normal state of affairs rather than an exceptional circumstance was a pedagogical responsibility. Submission was as routine as control and possession. When I questioned him about the exchange during a brief break between presentations, he said, "I feel like sometimes I'm badmouthing [the CAD/CAM system]. But sometimes you have to say look guys, it doesn't work like that. You've got to. That's the whole concept of this design project." The design project, the ultimate objective and experience in the course, was supposed to help them understand they were, in part, slaves to the computer.

I realized then that, throughout their courses, Zeilfelder and West had routinely argued that an important strategy for learning CAD/CAM technology was to submit to it. For example, Zeilfelder said that while the most common technology for making solid models of three-dimensional objects was "hard to adapt to," one also had "no choice" but to adapt. Or, in responding to a student concern in class that the CAD/CAM system was unpredictable, she cautioned everyone about the vagaries of a "sensitive system":

Student: Yesterday, a couple of the functions we tried were bumping people out of the system. The lab instructors didn't know why.

Zeilfelder: I don't know why either. CADAM [the IBM software used in the course] is sensitive and it will throw you out. You have to try different things. If it fails three times in a row, then you have a problem. We often send problems back [to the vendor]. They will send us a 'fix' tape.

West warned that the command ASSEMBLY[2] produced responses that were difficult to predict because of unusual relationships with other commands:

> *You cannot use SUBASSEMBLIES within an ASSEMBLY. An ASSEMBLY can only be made of PARTS, not SUBASSEMBLIES. I know, sometimes it looks as though you can do it and sometimes it blows you out of the water. These are land mines we're trying to keep you out of.*

Or in explaining why the software in one laboratory exercise had failed so miserably, he emphasized that gaining control over CAD/CAM was by no means automatic:

> *It illustrates the problems one can have in integrating CAD/CAM and engineering analysis—it's not all that straightforward. There's a lesson to be learned with that. It shows you that if you accidentally mess up somewhere, it's tough to get back. Even though it is interactive, it is not exactly made so anyone could come in and use it.*

Neither instructors nor students used the word "submission" directly, as far as I can remember. Perhaps the word was too strong, too direct, too submissive. Yet even though students may not have acquired the label, I do maintain they acquired both the practice of submission as the inverse of control and a language for theorizing submission, whether as "run[ning] into difficulties" or getting "blown out of the water."

In representing CAD/CAM technology both as a slave to control and a master demanding submission, the instructors appeared themselves to be experiencing not contradiction but some sort of internal dialogue. As students focused on gaining control and measured themselves against the achievement of control, I watched as instructors both encouraged students forward and cautioned them about the technological constraints they would have to accept. In a world dominated by the image of technology outside society, the only resource easily available to imagine constraints through technology was the inverse of control. Learning CAD/CAM was supposed to consist of some sort of movement between submission and control, or acceptance of life in the middle. The product was somehow different than a pure relationship of control. "A great way to learn CAD/CAM," West often said in a way that suggested there was no other, is to "get black and blue" with it.

Was This Iteration?

Engineers students were, in fact, ready to accept an iteration between submission and control as integral to the learning process. Undergraduate curricula in engineering regularly construct struggles between students and mathematical representations of machines so students can master the techniques of 'engineering problem solving.' Through an endless barrage of problem-solving exercises in calculus and the engineering sciences, students learn to value the techniques for properly manipulating mathematical equations or computer codes and algorithms. The process seems to call for a repeated iteration of powerlessness and control as each class challenges students to compete for knowledge through grades.

Several times during my fieldwork, students found ways of asking me if I was taking the course for a grade. My presence was anomalous not because I was generally twice their age, for they were used to seeing older students, nor because I was a professor, for they were used to professors visiting classes, but because I was both not enrolled and always there. I was not a student but behaved as one.[3] Once as we emerged from an exam in a FORTRAN class for first-year students, one student asked me with great interest, "Did you get both programs to run?" FORTRAN (FORmula TRANslator) is a computer program for solving mathematical equations that is widely used in engineering education and practice. I joined the class partly to improve my understanding of the software programs in CAD/CAM, many of which were written in FORTRAN. We had been asked in the exam to write two short programs on small notebook computers that our instructor had brought to class. Although I had never interacted with this student before, his tone of voice told me he had been sizing me up, and now we had shared the experience of an exam. I was embarrassed to respond that, while I did indeed have a working knowledge of FORTRAN (and should therefore have some value as a human being), I had not been doing the homeworks nor even tried the new software, and had spent the entire class period practicing FORTRAN commands rather than taking the exam. As I anticipated, and regretted, he immediately lost interest in me. My high status as professor gracing the class with my presence and willingness to participate as a student dissolved completely. Any control over FORTRAN I might have achieved became irrelevant, for he now knew that, unlike him, I was not putting my body on the line and taking the course for a grade.

Students in engineering had more daily homework than in any other curriculum, for they practiced problem solving through repeated exercises. Getting the right answer was crucial because it established new relations between the student and the material manipulated. Consider the power dimensions in the experiences a senior engineering student had writing computer programs:

Gary: Can you describe how you feel when you get a program to run, that you haven't been able to get to run?

Steve Payne: I probably got my first C program to work last week. It was just a little thing, an inverted matrix, inverting an 'n by n' matrix. There's tons of formulas and routines to do it, you know, but I had a kind of pseudocode to do it, something that's just written out [on paper]. So I wanted to implement it. But learning how to get the variables in there, and change it around, and debugging, you know, is eighty percent of the program.

When I got it to run, got the right answers, I was [snaps fingers and slaps leg] "That's it!!!" I jumped out of my chair, I just raised my arms up in the air [demonstrates], and [screams] "I'm King!!!" [then sitting down, suddenly quiet] That's how I feel.

Steve positioned himself in control as someone who knew the material, and the material became transformed into a tool for him to use, a subject in his [*sic*]⁴ realm. Yet as students moved from course to course pursuing the ever-present goal of getting the right answer, the sense of control repeatedly iterated with the absence of control.

A key characteristic of engineering knowledge presented in the curriculum was that it appeared as an aggregate of discrete bits and pieces. These bits and pieces accumulated in students one at a time, with each serving as a prerequisite for the next. "It is like a pyramid," a professor once told me, "courses in [freshman engineering] establish the base of the pyramid and other courses build on top." A single national organization, the Accreditation Board for Engineering and Technology, regulated the curricula at the vast majority of engineering colleges and universities, making sure that each built roughly the same pyramid.

The endpoint of this aggregation of knowledge was the supreme act of control, the ability to construct technology, to undertake the creative process of translating one's knowledge into technological form; in short, to design. Engineering educators regularly pointed to engineering design as the pot of gold students will receive at the end. For example, one department brochure summarized its curriculum with the words:

Engineers design things—that is what engineering is all about. It is the nature of the things that are designed that distinguishes one branch of engineering from another.

Usually only seniors got to practice design. In the senior CAD/CAM class, the project group I followed most closely was designing and building components for a solar-powered car they later raced against cars from other universities. The College of Engineering regularly advertised itself with photographs of solar cars designed and built each year by students. In this image, the manufacturing process appeared to be incidental to the design.

Learning to submit to the authority of the curriculum necessarily started

early. At freshman orientation, for example, an associate dean of engineering told incoming students and their parents that "engineers have to learn how to have fun . . . efficiently." He was warning them that the engineering curriculum was demanding. I later repeated it to a Ph.D. student in mechanical engineering on whose dissertation committee I served. After laughing heartily himself for a minute or so, he stopped suddenly and said, "You know, he's right."

The core practice that students acquired was a strict, uncompromising methodology for both identifying engineering problems and then solving them in mathematical terms. Every homework assignment, for example, had to begin with the student's name, course number, and date lettered properly at the top of a sheet of engineering paper.[5] The problem-solving sequence divided neatly into five steps: given, find, equations, diagram, and solution. One started with 'given' data and was charged with 'finding' a 'solution,' which one calculated mathematically by drawing on established 'equations' and producing an idealized visual 'diagram.' If a student wrote a numerical solution without any units of measurement, e.g., feet, meters/second, pounds per square inch, the answer had no meaning and frequently received no credit. Throughout their undergraduate careers, CAD/CAM students had solved thousands of problems in this fashion, drawing sharp boundaries around problems they took as given, abstracting out their mathematical content, solving them in mathematical terms, and then applying the numbers back to the original problem.

In this context, however, the CAD/CAM class became something of a surprise. Students happily experienced the joys of control over CAD/CAM technology, but they were less willing to shift submission from universal standards of mathematical knowledge to the historically and locally specific demands of novel computer technologies. This was different.

Authorized Personnel

I was sitting in the CAD/CAM Lab when they came in, first two or three students, then a few more. Making their initial trip into the laboratory, the CAD/CAM students appeared hesitant and unsure, not knowing where to go or what to do. They congregated in the small space available at the end of the room between the rack of open computer manuals and the door. The area was safe somehow, inside the room but outside the working space of the lab, although I doubt anyone reflected consciously on the social significance of this space. More likely, they were wondering what kind of work they were going to have to do to get through this course.

A group of five students told me later in an interview that going into the lab for the first time is, as George Rickley put it, "like entering a different world." He found it "exciting," while Jim Parham found it "disorienting."

Kim Repass jotted down in her journal, "new lab—intimidating but with many people I know, so okay." The noisy hallway outside the lab, at the center of a middle-aged university building, had the more comfortable feel of established, routine activity in engineering education. The beige tile and concrete floors, concrete-block walls displaying the class pictures of graduates over a fifty-year period, and bust of William Rankine, a nineteenth-century theorist of engineering thermodynamics, donated by the class of 1902 with the inscription, "Master of scientific engineering and chief among its founders . . . ," all conveyed a sense of productive, yet changeless, tradition.

Everything changed, however, when one passed through the door that read:

CAD/CAM LABORATORY
Authorized Personnel Only
A Key or Pass is Required for Entry

Like entering a different world indeed, it felt as though one were becoming part of a closed environment, constructed by some faceless authorities looking to the future rather than to the past or present. But while severing one's physical connection to the rest of the building, one also gained the opportunity to establish a multitude of new relationships that extended far beyond the physical space of the building. Students enrolled in the class had heard repeatedly, both from the instructor and from other students and faculty, that the laboratory sessions were the most important part of the course. Everyone believed that it was in the laboratory sessions, with the instructor's guidance and the help of teaching assistants (TAs), that students would "learn CAD/CAM."

Shortly after his arrival at the school in the early 1980s, Dr. Myklebust had been asked to build a university CAD/CAM laboratory to serve as home for developing research and education programs in CAD/CAM. The university was one of twenty-two schools that had received $2 million gifts of computer hardware and software from IBM for CAD/CAM research and education. These schools had formed a consortium, the IBM CAD/CAM Grantee Schools, that met every two years until 1988 to report on progress and build solidarity. Although building CAD/CAM training into his own department's curriculum became a matter of considerable internal debate, Myklebust served actively in the consortium, including its executive committee, and worked feverishly to expand academic activities in CAD/CAM. His prospects for gaining tenure as an engineering faculty member depended on it.

To IBM, giving equipment and software to institutes and universities was a strategy for pursuing three goals simultaneously. As an IBM representative explained to me, helping schools to train large numbers of engineering students on IBM hardware and software was a way of expanding its

pool of potential customers. Graduates would understand IBM better than its competitors in hardware and software. Also, supporting academic research would not only help develop new technologies but also provide a steady supply of potential employees in research and development. Finally, since gifts were tax deductible, IBM could write off older equipment that could no longer be sold on the open market. In short, $44 million in hardware and software aimed at building a network of relations with twenty-two schools was part of a more general business strategy that would build allegiances and help channel customers, employees, and tax breaks to IBM. However, according to Myklebust, explaining IBM's actions purely in terms of the maximization of self-interest would be insufficient. "I have seen IBM people do incredible things," he said one day, "such as channeling all sorts of resources to disadvantaged schools, for which they would clearly not get a matching return."

For the schools, the equipment gifts were both a necessity and a windfall. Institutes and universities accustomed to investing in physical plant for the long term and providing funds for current operating costs were not prepared to pay for expensive, yet rapidly obsolescent, computer technologies. Large gifts from IBM and other computer manufacturers became significant feathers in the caps of those departments that solicited and received them. I once overheard a department head proudly display the CAD/CAM Lab to a touring visitor:

> We have over $5 million worth of equipment in here. IBM donated most of the hardware and software [including a later gift], and a state agency gave us a half-million to renovate the space. The university cannot afford to buy hardware and software. IBM gives it older models.

This administrator was more than happy to accept leftovers from industry.

Within the CAD/CAM Lab, one's sense of time had to change. There the past was measured in terms of months rather than years, and the future arrived as a ceaseless succession of new equipment, new software, new students, new funding, new deliverables (research products), and new deadlines. All the relationships established within this 22-by-44-foot room involved in some way the array of twenty-four computer terminals positioned on either side of a central aisle where students and faculty engaged in quiet, but intense, individual struggles with computer hardware and software.

The most notable features of these terminals were the display devices, which presented both text and engineering drawings on large screens ranging in size from 16 by 16 inches to 18 by 18 inches. While display devices exhibited great activity in bright colors, the rest of the room served as background, with features in muted colors, designed for their functional connection to these displays. The displays were connected to humans through

input devices, such as keyboards, and output devices, such as the printers that generally produced text and the plotters that produced drawings. The displays were connected through a maze of wiring to computer processors, sometimes one to a display, sometimes shared on a network within the lab, and sometimes shared on a network extending outside the lab through a university mainframe computer. The room was also cold, although it took a while to feel it, because the computers preferred the temperature regulated at a constant sixty-eight degrees. Most talk was low, often virtually inaudible beneath the constant hum produced by the computer equipment.

Within a few minutes, fifteen students, including nine white men, two white women, two Hispanic men, and two Asian men, had packed themselves into the safety zone at the front of the room, effectively blocking the doorway for another man attempting to step out for a break. Finally, an Asian graduate student, a Taiwanese man, looked up from the terminal at which he was working and motioned for everyone to come in. The students dutifully filed down the aisle and congregated around the terminal and the graduate student. "My name is Wong Yin Tao," he said too fast for anyone to understand, "but you can call me Wong." Wong was our lab TA. As he had learned only the previous week, Wong and three other lab TAs, a Taiwanese woman and two white men, would direct and evaluate the laboratory activities of the nearly sixty students in the class, dividing them into four groups.

As we waited for Wong to signal the beginning of class, some students took the opportunity to renew old acquaintances or establish new ones. When students met for the first time, they worked to place one another. Depending on where and when the conversation took place, they questioned one another's major, year of study, place of residence, hometown, daily schedule of classes, career plans, and so forth. "It's a pretty standard set of questions" for getting to know someone, said George Rickley in a group interview. The strategy is to piece together pictures of who people are, i.e., how others are positioned in relation to oneself. "We do it to find a connection," said Kim Repass. The connection was some sort of shareable position, which established the possibility of and terms for shareable understanding and initiated the relationship that became the basis for further conversation and interaction.

For CAD/CAM students, getting to know someone before class seemingly produced a different type of knowledge than the knowledge that produced control over technology. Figuring out how someone else was positioned was itself an act of positioning that located both the other and the self. One's position only acquired meaning and power through its relations to other positions. Positioning someone thus established a relationship that transformed the identities of both people, if only through slight positional adjustments, for identity was relative to positioning. The practices involved in getting to know someone were not those whose

success provided control or in which learning demanded submission, as in the practices engineering students applied to the engineering sciences. The students chatting before class most certainly understood the knowledge they gained in building new acquaintances as something other than engineering knowledge. Demanding control and submission was more likely to end a relationship than stimulate further interaction. Students did not theorize this sort of learning as part of the educational process itself.

Or did they? During my fieldwork, I watched many engineering students get to know CAD/CAM technology. In every case, getting to know CAD/CAM also seemed to involve a repositioning of person and technology in ways that transformed both. Yet in contrast with the human conversations before class, the first interactions did not begin with participants finding a connection or shareable position. Rather the humans had to give themselves over to the machine and accept the task of becoming part of a technological system.

Passions Inside

The first homework assignment in the CAD/CAM course was odd for an engineering class because it asked students to define 'CAD,' 'CAM,' 'CAD/CAM,' 'computer graphics,' 'interactive computer graphics,' and the 'relationship between CAD/CAM and interactive computer graphics.' The students I talked to resisted this type of question as a useless activity that demanded the most irrelevant form of knowledge, knowledge that filled one's head but lacked any value, i.e., memorization. Consider reactions from Eric and George:

Eric: I mean, I'm looking at this as complete memorization. I'll never have to know it again.

George: Exactly, regurgitation. That does not mean anything to me.

Eric: [In other classes,] you're doing numerical methods. You have to memorize formulas and stuff like that. This is just mass memorization garbage. I hate it.

Memorization was not control, and the quiz was irrelevant. Well, not quite. The last question on the assignment was both strange and provocative: "What is the most important element in a CAD/CAM system?" The answer was supposed to be the user. A human's first step in getting to know CAD/CAM technology was to become or, better, produce a user.[6] "The user is the most important element in a CAD/CAM system," West asserted in class with some enthusiasm. "We tend to look at CAD/CAM as able to operate without a user," he continued, appealing to the image of external technology, "[but] if you cannot understand the problem, the CAD/CAM

system will not help you." The human being makes a critical contribution: "The human sits down with a preconceived notion of what's going on in the design. He's [sic] going to use all his insights." At the same time, by becoming a user the human being somehow transcended mere humanness. "User is a general label," West said, meaning that it somehow referred to more than the human being alone but lacking the theoretical resources to say so explicitly. Just as the machine did not run by itself—"Interactive graphics is just a support layer"—so the human needed the machine—"it allows the user to be more productive." The human became more productive by creating or transforming itself into a user.

For West and Zeilfelder, asking what was the most important element in a CAD/CAM system helped students start down the pathway toward understanding this technology and how to use it by discarding popular images of CAD/CAM technology as an instance of automation, the replacement of humans by machines. "This is not automation," said West, "I hope we never design without the human component." Understanding the concept of user was thus supposed to be the students' first way of theorizing a relationship with CAD/CAM technology that somehow moved beyond control and submission while involving both.

In the first of the two survey questionnaires I distributed in class, I asked students, "Were you confused by the question: What is the most important component of a CAD/CAM system? Why or why not?" In a class of forty-eight students, thirty-one students completed the questionnaire, seventeen of whom answered "yes" and fourteen "no." What I found most interesting is that reasoning on both sides relied on the same assumption— humans were not part of the technology—unless they found out otherwise by looking in the textbook. Most of those who answered yes said explicitly that they had not considered humans as part of a CAD/CAM system: I misunderstood the question. I only thought that it was referring to the computer, i.e., What is the most important component in the computer system?; Was thinking in terms of the computer component; Did not think of person as part of 'system'; I was not confused. The instructor was. Of course, computers are tools, but when we talk about 'systems' we talk about technical characteristics; First, I thought of an element belonging to the system. Although I thought of the user, the Graphical System seemed quite logical; I was unclear about what the question was asking, whether it meant machine hardware, applications of CAD/CAM, etc.; I think the computer is the most important part, otherwise it's not CAD/CAM. AD/AM?; I was, because it was too vague. For example, the computer could be the most important element because without it there would be no system, and the same thing could be said about the other elements of the system; At first I was not sure if it was a trick question or not. I guessed and said the 'user'; The word on the question was 'element,' which has a vague meaning; I was confused for some time. But later on, after going through the text, it was

evident." Others answering yes were surprised that the instructor had not prepared them in lecture for this way of thinking, while only one offered no explanation.

Of those who answered "no," some had figured out that something unusual was happening: "It was a silly question in my opinion; not a standard engineering question. So I figured it was a 'trick' and I picked up on it immediately. Also, in ME 4624, we were always required to check results from the computer with engineering calculations/estimates; I understood what he meant (meaning that he was looking for something other than hardware, but I answered the flexibility of the system to be adaptable to a company); Read books and guessed it; I got it wrong, but I looked it up in the book. Where I worked, one of the drafters didn't even know how to use trigonometry [but the computer evidently did]. I don't believe it [the user] is the most important component; I was unsure at first, but it's kind of obvious a computer system isn't really any good without a competent user."

While four offered no explanation, a few might have already learned to theorize computer users as part of the system: "The answer seemed obvious; It was straightforward; Because it was an easy question; Because I am bright."

Throughout the course, West and Zeilfelder repeated the lesson that CAD/CAM technology did not run by itself, nothing worked without the user inside, and inappropriate use would get you nowhere. As West put it toward the end of the course:

> There are companies that have gone under because of MRP [manufacturing resource planning, an extension of CAM technologies]. I worked for a company that encountered some financial difficulties because of MRP. The reason why they encountered problems was because they were not religiously maintaining the database. As a result they were making decisions based on poor data.

The qualified CAD/CAM user thus seemed to be managing two different sets of relationships at the same time. On the one side was the iteration of control and submission familiar to engineering students. From this perspective, the CAD/CAM user was simply an active, intentional human gaining control over an inert machine, appropriating it as a tool for human purposes. One just had to suffer through learning to be a user as a step to gaining control of the system.

On the other side, however, was a much less articulated relationship, one in which the boundary between human and machine had possibly become blurred. I found students generally reluctant to describe any sense of intimacy with CAD/CAM technology. When I ventured to ask people directly if they ever felt themselves merged with the machine, the reaction was often a smile signifying the silliness of the question, followed by something that denied the legitimacy of the question. The smile sometimes carried a

searching look of suspicion. "What kind of anti-humanistic anthropomorphist or other sort of weirdo might this guy be?" To someone accustomed to assuming a distinction between humans and machines as a key habit of imagination, questioning the boundary could sound like a perverse desire to equate members on opposite sides. Did I think they were stupid, or perhaps possessed a crazed masculinist desire to get inside and copulate with a robot? Or, at least as bad, were they fearful of being labeled a 'geek,' the well-established label for someone who had indeed merged totally with the machine? Admitting to feelings of convergence with the machine could be an admission that one was a geek, someone who was largely uncomfortable in human worlds but appeared to thrive with pleasure in technical worlds. Generally men, people labeled geeks were humans only in terms of bodily needs and functions; their key agencies and passions resided elsewhere.

Sometimes, however, the question elicited some story that did indeed convey an intimate feeling of connection with the technology. A student in computer engineering once told me that he sometimes pictured himself as an orchestra conductor inside the computer, managing the harmonies among dozens of processors. "I even had a dream that I was part of the computer," he continued. "I had to go somewhere but couldn't leave my place because an Interrupt was coming along that I was supposed to process. I woke up in a sweat." Steve Payne, the student above who associated getting a difficult program to run with feeling like a king, was an attractive, sociable character whom fellow students would not normally characterize as a geek. Yet Steve had no trouble expressing his intimacy with CAD/CAM and other computer technologies:

> Gary: The reason I am asking about this kind of stuff is because the stereotype of engineers is that they are emotionless people.
>
> Steve: Yeah. You're right.
>
> Gary: And engineers with computers, that's about as emotionless as you can possibly get.
>
> Steve: That's true. That's true.
>
> Gary: But I don't agree. I think there's all kinds of passion going in there.
>
> Steve: Yeah. I, for one, I'm a computer geek at heart. I'm all into this thing. That's why I was excited about taking the [CAD/CAM] class. . . . I've always been a computer person.
>
> Gary: Well, when you say that, what do you mean? See, I'm talking about the passions here, and you say, "I'm a computer geek at heart."
>
> Steve: I turn on my computer every day, at least every day. Whether it's just to write letters, which is some of the time. But usually it's for something like, I keep track of my expenses, I keep track of . . . I have a program I wrote to, when it's . . . I run like every week to see whose birthday is coming up when, and do I have any birthdays I need to be alerted about in the next two weeks. So I type, "Birthday" and

it comes out, O.K., "Steve's going to be twenty-three in four days," or something like that. It sounds out of control, but it works!

Gary: And you wrote it?

Steve: Yeah, I wrote that my freshman year. I wrote it in BASIC. . . . Stuff like that, I have all my albums, all my cassettes, CD's, stuff like that, I have a spreadsheet file I use for that. I entered all that stuff in.

Gary: So that you know what you got?

Steve: Yeah. 'Cause I got plenty. I got like a thousand tapes or something like that. I'm a big music person. So I get a new CD, I run home, I turn on my computer, and I enter the title, what the time length of it is, I enter all the songs in, things like that.

I'm addicted to it after a while. Say you want to know what kind of music I listen to. I could say, "Well, I listen to heavy metal." "What do you got?" "Well, I have all kinds of heavy metal. Here's my list, or if you want to listen to a couple of certain groups," I could say, "Well here's what I got." I don't even remember what the names of some of the albums are. So I'll say, "Oh, yeah, I do have that one." Or something like that.

Gary: Now how about your relations to the computer here? Is there a sense of, I mean, do you climb in the computer? When you get it to run, like how . . . ?

Steve: It's like, I've got a sense of control.

Gary: You said, "King." King. A king is a powerful person. He has a realm.

Steve: Well, people like to say that a computer does only what you tell it to do. Sometimes it does more: it doesn't do what you want it to do, or it does something you don't tell it to do. The computer maybe assumed something. It had a default value or something. If you don't declare a variable, it's always going to be zero. If you don't declare it as a number, it's going to be zero. I didn't tell it to be zero. It assumes it's zero. It's not really an artificial intelligence, but that's the way it's preprogrammed, how the memory's preprogrammed, I guess.

I don't know if I could say this, but I'd probably say that I'm one with the computer. I'll be bold and say that, I guess. 'Cause I've been working with computers since seventh grade or something like that. I can do a lot of things with a computer besides. . . . I think I'm a real computer person. I got four pretty solid program languages down: PASCAL, FORTRAN, BASIC, and I'm getting C. A little bit of assembly in there somewhere. I use these things for my own use, not just classes. I use a lot of software, I've used TK Solver, I've used word processors, things like that. But besides that, I sort of go above and beyond the call of duty, and I turn my computer on everyday, and it's hard for me to live without it.

The depth of Steve's involvement with his computer was likely more the exception than the rule. After completing his senior year, he returned to the CAD/CAM Lab as a graduate assistant. Yet precisely because of his personal commitment to computer technology, Steve illustrated a form of relation between the human and the computer that I believe I saw other students enact but not necessarily articulate. Might we all be geeks in a way?

Configurations of Agency

Boundary-blurring activities appeared quickly in the course. When the first laboratory period began, our initial act as users was to give away our human names. We handed them over to Wong on signed agreement forms to be shuffled off and stored in the lab manager's office at the far end of the room. In exchange for our names, each of us received a 'userid' (user-eye-dee), the name for one's electronic personhood. In order to have the opportunity to extend one's personhood into the machine, one had to agree to constrain oneself to the role of new user: "I have read and understood the CAD/CAM Lab Guidelines. I understand that . . . consulting work is not allowed . . . and that violation of this rule will result in suspension of my privileges. . . ." I found my user located in relation to other users in the class through my individual userid 'CAD347,' and my course in relation to other courses through the group userid 'CAD5.' The course designation made it possible to delimit the range of activities available to us.

We humans also received individual and group passwords. The password was an ingenious practice for ensuring a one-to-one correspondence between a user and a human. By memorizing 'EOTHIA' and 'CLASS' and then typing them without being able to see them on the screen, I informed the computer each time I used it that user CAD347 was an extension of the human named Gary Downey.

Reading to us from the Lab Staff Notebook he had received in a one-day orientation with West, Wong explained the computer's rules for our participation as users. We were going to become users on a mainframe computer. The mainframe was an especially authoritative device because we knew to identify it with the organization as a whole, the university, and it operated at some distant location across campus. All CAD/CAM students had previous computer experience because they had been required to buy personal computers as entering freshmen, but the mainframe presented a whole new experience because one could not possess it in the same way one possessed a personal computer. Instead, one had to share it and, in order to share, obey its commands.

Gaining access to the screen (the graphics display device, monitor, or scope), was no straightforward appropriation. Wong told us we would have to "borrow the screen" from some other authority. This experience was my first direct evidence that other users had been there before us. Those users had left behind many different configurations of agency that were now structuring our participation. As indicated in chapter 1, I use the term 'configurations of agency' to refer generally to acts of positioning regardless of whether the positioning was undertaken by humans or by nonhumans. For example, the activities of hardware and software in a graphics display device could be described from this perspective as configurations of agency that might very well be found elsewhere in the activities of humans alone.

In this usage, agency is neutral with respect to humanity. Also, the existence of a meaningful boundary between human and machine, as well as the precise location of the boundary, becomes something to discover and analyze rather than to assume at the outset.

The authority in control of our actions resided somewhere within the mainframe computer. "All of the IBM graphics display devices," Wong read, "are controlled by the Graphics Task Monitor (GTM)." I pictured a hall monitor in junior high school telling us not to run. Usually this authority could be seen, for "[w]hen GTM takes control of the graphics device, it will display the GTM logo on the screen, but after 15 seconds GTM blanks the screen to save the phosphors." I guessed we were already supposed to know that the screen had a metallic coating on the inside made of phosphors that lit up when bombarded by beams of electrons, but no one really seemed to care how this worked.

Even when borrowing the screen, however, a user would not gain complete control over the display device. Rather the user entered into exchange with some other configuration of agency also located somewhere in the mainframe computer, known as the 'application program.' For present purposes, let me describe an application program simply as a bit of software that puts computer hardware to work, saving for the next chapter a more developed exploration of agencies in software and hardware. GTM would grant an application program control over the screen only for a brief period, as our instructions put it, "Applications programs may 'borrow' the scope from GTM, but must return it when they terminate."

Any student who wanted to produce a CAD/CAM user by extending agency into the computer had to use an enormously constraining device, the keyboard. "All entries should be made from the keyboard," said the instructions on borrowing the screen from GTM. If we bracket for a moment our knowledge that a human and a computer are clearly different sorts of things, we can perhaps begin to make visible a simultaneous understanding or knowledge of the keyboard as a translator of agency that transforms the physical movements of human digits, or fingers, into machine digits, the ones and zeros of the binary number system. Most readers have probably felt both the joy of getting something to work inside a computer and the frustration of being chained for hours to a seat and a keyboard. The computer program interpreting a keyboard translates mathematical signals in linear terms, as the sequential production of discrete events. To produce a CAD/CAM user through the keyboard, I and other students had to reduce all significant bodily movements to linear terms. In sharp contrast with, say, riding a bicycle, driving a car, wielding a hammer, or fixing the plumbing, all of which required variable movement and involvement of my body, transforming myself into a CAD/CAM user reduced my body to an analog of the computer. My body input data by sight and sound, performed calculations, and then output data all in a sequence of discrete events. I also learned to

use the mouse, or puck, by bringing two-dimensional movements of my arm into play, but all interactions still took place in a strictly linear sequence.

For each CAD/CAM student, borrowing the screen from GTM established a connection between the student's user and the machine, a connection that had more features than relations of control or submission. In order for these users to exert agency inside the computer, they had to interact with another authority and then translate its agency into the format or terms of an application program. Without following these steps, the user's agency could not exist, nor would the user itself. In other words, just as these novice humans were beginning to extend their agencies inside the computer to participate in an electronic exchange, so the computer was extending its agencies into their bodies, producing a significant bodily interaction and exchange.

Our final preliminary step in establishing CAD/CAM users was to initiate a relationship with a specific applications program. The strategy was to log on—to join up, sign in, and begin a record of one's performance. In this case, students logged onto CADAM, a computer program for making engineering drawings that had been written by aeronautical engineers at Lockheed and marketed by IBM for use on its mainframe computers. Logging on to CADAM was a critical step because it did more than just establish a connection between user and computer. It began to intertwine the agencies of both by transporting the agencies of the user into the agencies of the software, which lived inside the machine. When I logged on, I experienced the sensation of traveling.

Wong steered us away from the written instructions for logging onto CADAM, "I will bring you step by step through these instructions and tell you how to access CADAM so you can work on your exercises." Indeed, the instructions did look confusing, and we already knew we were supposed to complete the first three exercises before the end of the class. Wong was our leader, our guide. He would show us the way in. But what do you do when your guide gets lost?

The first step was to ask GTM, the hall monitor, if CADAM could borrow the display screen. The screen was blank. Was GTM in control? The instructions said, "Make sure the device is powered on [and] the screen intensity is all the way up." "Press 'Reset,' then 'Enter.'" The GTM logo appeared on the screen, telling us GTM was in control. So far, so good.

GTM wanted to know if a legitimate user was requesting entry. "ENTER USER IDENTIFICATION" appeared on the screen below the logo. Wong then typed his userid, 'CAD313,' then moved the cursor down to the command, "ENTER PASSWORD." GTM wanted to be sure the proper human was claiming to be CAD313. Wong very quickly typed six characters that did not show up on the screen. When GTM inquired which application program wanted to borrow the scope, Wong typed "CADAM" and pressed ENTER. "In about five seconds," he said, "a menu screen for CADAM will pop up."

It did not. We waited. After thirty seconds, Wong said, "There's some-

thing wrong here." We had no idea where to go. "Could I have somebody's userid and password?" he asked us. Perhaps GTM did not recognize CAD313. Getting nervous, he said, "It's a good idea to show you another time, anyway." Some other student let Wong use his userid and password, enabling Wong to lie to GTM about his human identity. Still nothing. "I'm afraid the system is not functioning right," he finally announced. "Let me try and find another terminal." We all moved to another display device, where he repeated the procedure again. This time he was a little less optimistic, "In about ten to fifteen seconds the big character 'C' should pop up." Much to his relief, it did.

We never found out what the problem had been, for it was of little relevance to us. It was a 'system problem.' Higher human authorities engaged system problems, interacting with system agencies. We were not there to learn how to control the mainframe computer, which was the province of a vague network of graduate students, faculty, and technical support staff from the University Computing Center. Our task was simply to enter into one configuration of engineering agencies within the system, a program for computer-aided design and computer-aided manufacturing. We would find out later, however, that this distinction was not an easy one to practice.

One last step remained before Wong was logged onto CADAM. The screen asked us, "Cold Start" or "Warm Start"? Evidently, this configuration of agencies thought it was an engine of some sort. "We use Warm Start," Wong said, "only if you have a hardware problem such as the system crashing before you can save your file, so you use Warm Start to bring you back to the place where you were." "In the normal case," he said, "you will use Cold Start." In addition to selecting COLD START, Wong had to convince CADAM that he was a legitimate user, so he entered 'CAD5,' his group userid for CADAM, another six-character password, and then the ENTER key. After a few seconds, at the bottom of the screen a complicated string of words appeared, separated by slashes: "/START/CALL/FILE/DATA-M/ GRPUSER/SPLIT." Although we had no idea exactly where we were and what to do next, we knew we were in.

Mapping Positions

Few students, it appeared, enjoyed the lectures in this course. Zeilfelder and West were introducing them to a new engineering world in industry but not in a way they easily recognized as worthwhile. In contrast with familiar courses in the engineering sciences, lecture material did not arrive as a systematic, step-by-step presentation of mathematics-based knowledge to be tested through problem sets. Rather it consisted of a series of maps to guide students through the industrial worlds in which CAD/CAM technologies were to function as an increasingly routine participant. How strange.

Demonstrating an understanding of these relationships posed challenges to students that differed from the normal structure of engineering problem solving. The lectures aimed to help students through an interpretive bind, but no one, not even the faculty, had a vocabulary for routinely describing the location of CAD/CAM in industry as an activity that humans experienced as blurring the boundary between the agencies of humans and the agencies of machines.

Consider, for example, the outline of major topics in Zeilfelder's course, which took students on a tour of design and manufacturing. She began with the mainframe computer, familiarization with VM/CMS (the mainframe). The next seven topics walked students through phases of engineering design: capabilities of current CAD/CAM systems; CADAM capability overview; interfacing applications programs to CADAM; hierarchic decomposition (computer programming technique); descriptive geometry (CAD technique); design analysis with CADAM; and solid modeling methods. The final two topics gave students a cursory introduction to manufacturing processes: NC part programming and computer-aided manufacturing.

Students found the requirement to understand the positioning of CAD/CAM technologies in industry intensely boring, for this demand did not fit their well-honed practices of gaining control over mathematical material through engineering problem solving. The only alternative to seeking control was memorization, a worthless endeavor. Three weeks into class, for example, Sandy Poliachik, a graduate student and one of the most motivated students in the class, began to complain in her journal that lectures were nothing but "lists":

Jan 31: Continued spiel on software engineering. There's a lot to it, but no one seems too interested. Just a lot of lists on the board.

Feb 7: Handed in FORTRAN programs. More lists for notes. Lecture seems pretty worthless. The lab is the only thing worthwhile for this class. At least so far.

Feb 12: Another dull class. I underlined things in my Kinko's notes. That's about as thrilling as it got.

In a group interview, students elaborated differences between working engineering problems and memorizing definitions and lists in the CAD/CAM class:

Gary: Is it more fun to work problems based on formulas?
Eric: More interesting.
George: Yeah.
Eric: 'Cause you're doing something constructive.

Kim: It's something you can think about, not just sit there and memorize.

Eric: You can analyze it.

Kim: 'Cause you can kinda understand it. Memorizing formulas is a lot easier than memorizing . . .

Sandy: Lists.

Eric: Put it on the simple side. When you're calculating the velocity of a car, let's say, you're starting with some things, like time and distance, and you end up with how fast the car is going. You start with something. You finish with something. And there's a means through which you can go back and check it. Here, you don't start with anything. . . .

On one of my tests in statistics, which I hated, we had to derive the least squares fit for the natural log of y equals ax + b. Then we had to fit data to it. I hated it. I had no clue how to do it, but I sat there and figured it out, and I got it perfectly right. The only reason I got it perfectly right is that I sat there and I could reason through how I would have to fit my data to that. And I knew another way of fitting data, so I made the two similar and kinda worked through it, and it worked.

It's one of those things where you didn't have to memorize it. You could figure it out. I think that's what engineering is. Engineering is not memorization, engineering is figuring things out.

Sandy: You can always go look a definition up in a book.

Kim: Exactly.

The main label CAD/CAM faculty had available to characterize this mapping exercise was 'survey course,' precisely the sort of course that traded depth for breadth. "My attitude in general is that this is a survey course," said West, "so we can't get into detail on each of these topics." Teaching a survey course in engineering could be as distressing for faculty as it was for students, and for the same reason: "One of the most frustrating elements of this class is that we never have time to explore and understand any element of CAD/CAM technology." Or in describing attempts to develop CAD/CAM standards, he said, "We don't have time, as usual, to get into really what these standards stand for, what their capabilities are . . . but we can talk about why they were developed."

In a survey course, rapid transit was the goal, for this geographical sort of knowledge was incomplete if the entire landscape were not traversed. I was somewhat relieved, for example, when students complained they were having difficulty taking notes in class, for I was leaving every class exhausted from the strain of keeping up. Sandy wrote in her journal:

Trying to take notes FAST. Nothing seems any more important than anything else. Tried to write everything. This worked for a while. Finally gave up. Too much. Frustrated. Tried just listening.

At more than one point, West apologized for the pace, "We go awfully fast over this material and don't ever put it in one place. [In the future,] we've got to do something a little different so we can spend time on some of the more important topics." He even vented his own frustration one day by mocking himself: He flashed viewgraphs on an overhead projector so quickly that students could not even begin to read what was on them.

One outcome for students was that they saw little connection between labs and lectures, with no reason for the latter. Eric wrote in his journal, "It seems like class and lab are two completely different courses, nothing relevant about the other is mentioned in either one." Students also displayed this conclusion in responding to two questions on the second questionnaire, by which time fewer than forty students were attending regularly. The first asked, "Have the class lectures helped you in the lab?" Among thirty-three responses, eighteen selected "not at all," thirteen "a little," and two "somewhat." No one selected "very much." The second question was open-ended, "What connections do you see between the lectures and the labs?" Twenty-two of the responses offered variations of none or very little: "I have very little interest in lecture because the information doesn't seem to be practical; To be honest, no connections, however, the information given for interactive computer graphics helped a little to understand how the system works; Not much, both deal with CAD/CAM though each explores different elements of it." Even the three responses that suggested some connection did not claim that knowledge gained in lecture was integrated strongly with knowledge gained in lab: "Lectures supplement the theoretical part of Lab; In class we get assignments that require techniques learned in the Lab; Lectures tell us what is possible with CAD/CAM; the labs let us know how little *we* can do now." Although eight people did not respond, all selected "very little" when asked if lectures helped in the lab.

Eric wrote the initial draft of the questionnaire. He was one of the students earning humanities credit by helping me with the project, and I thought his questions might tell me something about how he viewed things. As he later described it to other students in an interview, Eric used the opportunity to vent:

> *See, I wrote up the questionnaire and then Gary had to change some of the stuff because I was a little biased, the way I asked some of the questions. Remember the question that said, "Do you feel that lectures help you in the lab?" The question after that said, "Do you feel that lectures are* any help at all?" *[his emphasis]*

Certainly, Eric felt they were not.

To faculty committed to helping students learn how to live with and use CAD/CAM technology, fitting CAD/CAM into its industrial context was an important, necessary step. Students needed to understand that CAD/CAM

would not perform magic through automation. However, for students oriented to manifesting knowledge through control, tasks that involved memorization appeared to be the opposite of learning. Lists seemed unconnected to the problem solving that had to take place in the creative act of design. Survey knowledge, positioning knowledge, getting to know CAD/CAM by figuring out how it fit into design and manufacturing processes in industry, all of these carried less weight with engineering students than the core exercises in engineering problem solving with which they were familiar.

All this suggests that both students and faculty were caught in an interpretive bind. Might the force of competitiveness, with its dominant image of technology outside society, have contributed to structuring a systematic ambiguity in this course? In other words, in an important sense, CAD/CAM faculty knew that human interactions with CAD/CAM technology involved more than iterations of submission and control, yet no language was available for making these other interactions a visible and explicit part of instruction in the course. In fact, the widely publicized image of CAD/CAM technology smashing the boundary between design and manufacturing made it even more difficult for teachers to counsel otherwise.

In taking this course, students were looking ahead to future employment. They wanted to get jobs and thought recruiters would value the course in CAD/CAM. For example, in responding to the question, "Why did you enroll in this course?" twenty-two student highlighted employment: "I think CAD experience will make me more marketable; A lot of companies like for you to have experience with CAD/CAM; To gain an understanding of CAD/CAM systems since their use is growing rapidly in industry and government; Knowledge of CAD/CAM systems will, it seems, be virtually required in the future; Because I have been told that a knowledge of how to use CAD/CAM would be helpful in future jobs; CAD/CAM will be a valuable tool in the 'real world'; As I talked to employer representatives and last year's seniors, they all recommended taking CAD/CAM to get experience." Four simply said they were interested in computers, five said it fit their schedule, and one did not answer.

Yet what kinds of knowledge were important for students to get jobs in companies rushing into CAD/CAM technology and worrying about competitiveness? Because students were accustomed to iterations of submission and control, they were willing to submit themselves to the demands of CADAM and the Graphics Task Monitor if the promised outcome was a position of control. If something more was taking place in the lab that might involve merging together the agencies of human and machine, such was more a private curiosity, a matter of personal experience, than an issue for public discussion and debate. Lectures thus appeared to be inappropriate, matter out of place. I usually got only silence when I asked if perhaps similar things were happening in the classroom and the lab: They were positioning themselves both outside and inside of CAD/CAM technologies. The

theoretical shift required to accept this interpretation meant questioning the whole content of engineering knowledge as repeated iterations of submission and control.

Teaching CAD/CAM was thus a difficult challenge. Zeilfelder and West spent a great deal of time covering material that students found uninteresting or irrelevant. However, not wanting students to accept without question utopian images of automation, in which humans were replaced completely by machines, the instructors often interpreted their pedagogical task as revealing the limitations of CAD/CAM technologies. They wanted students to be excited and enjoy their courses, yet their higher responsibility was to make sure that students would understand where they were and what they were doing when they encountered CAD/CAM technologies on the job. Somehow this meant putting together a collection of activities that moved students beyond an iteration of submission and control.

CHAPTER 7 | Locating Me Inside It: Coding

DRAWING STORIES FROM HIS EXPERIENCES, Dr. Jayaram was explaining to CAD/CAM students how difficult it could be to read someone else's computer programs, or even one's own programs after a period of time. Substituting for West while he attended a professional meeting out of town, Jayaram was raising a common problem in engineering programming. "At the beginning of my master's program," Jayaram told the class, "I wrote a piece of code about six hundred to seven hundred lines long. . . . Certain things needed to be done, and they just had to go into the code." He was clearly proud that his code was still in use: "Even now that piece of code is being used by others working in the same field." The problem, however, is that people have trouble reading it when they try to take it apart:

> They come and ask me, you know, what did you do here? I cannot tell them what happened. I do not know what I did there. . . . I could not understand the code after a few years, and I doubt if anybody else could.

How could a computer program produce a lasting configuration of agencies if no one, not even the author, could read it? Jayaram joined the class to introduce us to a rapidly expanding field called 'software engineering,' which aimed, in part, to solve this problem. Software engineering sought to reduce the practices of programming to a set of principles that would constrain writers and readers equally. Its theoretical vision imagined a world in which all users had access to the agencies of all programs by, in effect, having every program configure the same, principled user. But

individual idiosyncrasies in writing and reading practices somehow always seemed to slip through the cracks.

Following students' introduction to CAD/CAM in the last chapter suggested that sometimes they experienced the technology in quasi-human terms or, to use the language of agencies, as somehow possessing configurations of human agencies. If they placed greater emphasis on these experiences, CAD/CAM development could potentially be seen, at least in part, as a process of transferring and transcribing human agencies into machine terms. Computer technologies did some things really fast, but these generally were things that humans told the computers to do. The activity of coding, or writing computer programs, serves as an excellent site for exploring this transcription of agencies from humans to machines precisely because it involved explicit activities of writing.

This chapter thus follows student users in the CAD/CAM course as they sought to gain control by learning how to code. The practices of writing code and using computer programs varied widely across the terrain of engineering, computer science, software manufacturing, and general computer use. The coding practices I followed in the CAD/CAM course focused on transcribing human practices of engineering drawing and design into configurations of mathematical agencies or, more crudely, making pictures on the screen. The idea was that inserting CAD/CAM technology into established practices of drawing and design could increase their productivity in dramatic ways by providing humans with greatly enhanced control. However, each transcription of practices from one form to another also transformed them, and each transformation introduced a new world of constraints.

The forms of power that CAD/CAM users achieved and exercised was thus not so much power over CAD/CAM but power inside it. That is, what one was able to do with CAD/CAM technology varied enormously depending upon how and where one went. Following students' activities reveals ways in which mathematics functioned by no means as a uniform configuration of agencies but had distinct fields endowed with variable agencies that might or might not link with one another. The identities of users and, hence, of the students associated with these users depended upon how they moved within the machine through specific mathematical transcriptions. What students were able to do with CAD/CAM technology, which they characterized as degrees of knowing CAD/CAM, depended upon which configurations of agencies their users were successful in engaging. While Jim Parham just wanted to make it through the course and get on with his life, Eric Schardt, George Rickley, and Kim Repass all wanted to secure important jobs, and Sandy Poliachik was preparing for a career in research. The extent of their travels through CAD/CAM software and hardware, all conducted in mathematical terms, varied accordingly.[1]

First Transcriptions

Early on in the project, I naively asked Anne Zeilfelder if CAD had been derived from CAM. From my experiences in summer jobs during the 1970s and David Noble's *Forces of Production* (1984), I was familiar with how numerical control (NC) machinery had been used for cutting operations in manufacturing since the 1950s. NC machinery used punched tape generated by computer to direct the cutting operations. I pictured CAD, computer-aided design, as having developed somehow as an extension of CAM into the realm of design. Zeilfelder corrected me, "No. CAD had developed because the airplane developers simply had too much paper to deal with. In order to make the Boeing 747, they needed ten football fields of E-size drawings. So CAD developed as a way of simplifying the drawing process."

When I first took my seat in front of a terminal in the CAD/CAM Lab and logged on, I could have made any one of several moves into the CADAM system. The "I" here refers to my machine alterego, CAD347, which I produced when logging on. CADAM presented me with a set of optional moves on a menu, each of which would have initiated a pathway to other moves. I could have returned to an old drawing I had worked on earlier by using any one of the three input devices I had before me. I could have turned to the 'keypad' and pressed FILE, used my mouse to select CALL from the bottom of the screen, or used the keyboard to type in the name I gave to the drawing and then pressed ENTER. I could have left by pressing FILE, selecting LOGOFF, and pressing ENTER. Because I had no earlier drawings and was simply following directions in my student text, *Basic Operator Course,* I selected START to move to a new drawing. (See Figure 7.1.)

Students routinely talked about interacting with CADAM in spatial terms, moving through space as if they were traveling. "Where are you?" is a question I often overheard in the lab, followed by "How did you get there?" It was the electronic version of the user who was moving around inside a system or, as sometimes occurred, made a quick, involuntary exit. One was something of a guest in this location. "We had so many components [in our drawing] we got bumped out of the system . . . ," complained Eric one day. "It just kept kicking us out. It would have been nice to have some warning." Sometimes, however, the electronic version of the user produced movement elsewhere. Calling up an old drawing, for example, moved it from some remote position in storage to the screen where the human user could read it.

The sense of spatial movement was made possible by making time strictly linear. The digital computer reduced time to a linear string of events. Every action one took stood in single file, which meant that the passage of time could be represented as linear movement. Time became the medium

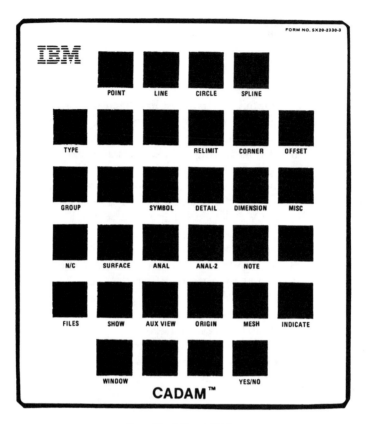

Figure 7.1 Buttons to Get In

for spatial practices, and space had a temporal dimension. For example, every CAD/CAM program I encountered included some sort of 'history line,' which displayed in a visual map on the screen the sequence of choices, or movements, the user had made from different menus. History, in effect, mapped where the user was and how it got there.

For engineering students, working on a CAD/CAM system transformed the physical practice of producing an engineering drawing, or drafting, into the computer practice of entering. Engineering drafting was a complex, yet finely honed, body of practices for communicating with other people through pencil and paper. Every engineering student received some training in drafting, and practically every engineering firm employed a complement of drafters. Although national and international standards governed everything from how to make points, lines, and circles to the ways one added dimensions or wrote notes, such standards did not specify the sequences through which lines should be drawn or words written on a particular drawing. In the world of hands-on drawing, it made no difference, for example,

whether one drew lines before or after circles or whether one drew circles clockwise or counterclockwise. There were also no standards for how to erase.

In contrast, drawing by entering was a strictly linear sequence of events. Empowering the computer to make drawings meant that every drawing activity had to be converted to linear sets of actions. Whether a circle was drawn clockwise or counterclockwise by a CAD/CAM program could be very important to subsequent practices of cutting and editing, for erasures that traced lines backward in time involved different steps and produced different outcomes than erasures that moved forward in time. Likewise, computer commands for erasing had to be tied neatly to computer commands for drawing, otherwise one could lose parts of drawings or have different parts stuck together in unexpected ways.

Producing good transcriptions was an important goal for CAD/CAM developers. Think, for example, about the process of transcribing a conversation from a cassette tape onto paper. A good transcription transforms one sort of order into another sort of order in a way that preserves the key relations valued by the reader, such as the grammatical structure of the conversation and contextual information about its tone. What constitutes a good transcription depends upon where it is supposed to fit, such as preserving an ethnographic interview versus conducting linguistic research. Although shifting the activity of drawing from paper to the computer, good CAD/CAM systems somehow preserved, reproduced, or transcribed the relations among points, lines, circles, and so forth, that drafters produced according to conventional standards of representation. In one sense, then, all CAD/CAM systems were the same.

In another sense, however, they were all different. Transcription also included transfer, movement, or spatial translation.[2] In this case, converting drawing practices to linear terms presented CAD/CAM developers with an enormous opportunity to enable users to reach out and engage all sorts of mathematical engines for producing their drawings. That is, rather than hand drawing every line or shape, as did the drafter working with pencil and paper, the computer user could jump-start and link together a variety of engines that could be structured in linear terms, initiating a series of mathematical translations that culminated in events of drawing. The names of these engines included geometry, algebra, trigonometry, and so on. CAD/CAM systems varied widely in how they engaged these engines.

After I entered START and then assigned a name to the drawing, CADAM sent back a reassuring picture of two arrows in the middle of the screen. Intersecting at right angles, or 90 degrees, the two arrows informed me that I was positioned. I had place. Through my user, I had entered a new kind of space, a space quite unlike entering and walking around in the lab or leaving the lab to enter the outside hallway. Unlike those physical spaces, the features of this space were completely bound and determined, including

both a finite set of objects that were permitted to exist and a set of possible interactions that could occur among them. I was familiar with the space and did not find it forbidding or unfriendly. I already had some idea how to move around within it without using a map to identify position and a compass to specify direction.

This space was a world of mathematical agencies. Given the intensive experiences engineering students had with mathematics in their engineering science courses, I was not surprised that movement in CADAM would confront me with configurations of mathematical agencies and, accordingly, a sense of moving through different kinds of mathematical space. But how did moving through mathematical space transform the linear activity of entering events into graphical representations on the screen?

The first, and possibly most important, mathematical practice built into the arrows was routine, and students barely noticed. Where I felt a sense of drama, they likely felt the comfort of control. The arrows had identified the famous X-axis and Y-axis of a two-dimensional coordinate system. Not only was I, as user, now in mathematical space, but I was also oriented. (See Figure 7.2.) I had a right and a left, an up and a down. Any shapes I might build in this space would now occupy positions in relation to one another.

Then, just as quickly as I entered mathematical space, I was asked to make a second, equally dramatic, move. "Now that we're oriented," the text told us, "let's get rid of the arrows, and draw a point at the origin (X=0, Y=0)." All I had to do was press the fourth button on my puck, the YES/NO button, and the arrows were replaced by a point at the center of the screen and the notation (0,0) slightly below and to the right. Pressing the YES/NO button moved me back and forth between the two options, the absent member of the pair remaining implied by the other's presence. 'Toggling,' as this action was called, differed very much from erasing and rewriting, for I was moving, shifting frames of reference, jumping across worlds.

CADAM was informing me of its ability to transform graphical representations into numerical ones. The activity of drawing shapes on a coordinate system could be rewritten as the manipulation of numbers through equations. Engineering students were evidently not impressed because the

Figure 7.2 Reassuring Axes

practice was not unique to CADAM. They did it all the time. Understanding the two-dimensional coordinate system, i.e., converting shapes and numbers back and forth into one another, was a key early component in the education of every engineer. I asked Eric Schardt whether he had started his first lab by reading the basic, introductory matter in the manual about computer hardware and the coordinate systems:

> Gary: When you started doing this, how did you do it? Did you read the front matter first?
> Eric: No. Well I read this kinda junk here, but I skimmed through it pretty fast.
> Gary: This is the introduction?
> Eric: Yeah. It explains the system and the buttons and all. . . .
> Gary: The two-dimensional coordinate system you already understood?
> Eric: Yeah.

By poring over the introductory manuals and trying things out for myself, I identified five different configurations of mathematical practices translating mathematical forms back and forth to model basic drawing. These included arithmetic, algebra, plane analytic geometry, trigonometry, and descriptive geometry. Following these engines into CAD/CAM systems illustrates both how users achieved power and how problems of compatibility became paramount.[3]

The first four were taught in primary and secondary schools, and all engineering students were required to take an exam soon after entering college to test their knowledge in these areas. The first, arithmetic, uses equations to translate relations between numbers into other numbers. For example, the equation $9 \times 8 = 72$ rewrites the relation 9×8 as 72. Focusing entirely on the equality itself as a fact drawn from the multiplication table would deemphasize the additional implication that the translation achieves a movement that transforms old relations into new relations. Locating 9×8 in the multiplication table situates it between 9×7 and 9×9, while 72 is located differently, between 71 and 73. Translating one into the other becomes a significant exercise to the extent that they connect different sets of meanings in valuable ways. For example, for someone wondering how much to pay a friend for driving her to work, knowing they made nine trips of eight miles each might not be helpful until she recalculates this as seventy-two miles total. This puts the traveler in closer relation to the expense of driving a car that gets, say, twenty-four miles to the gallon. Ah, she might share the cost of three gallons.

As middle-school students and their parents could readily attest, algebra takes a big step past arithmetic, introducing variables to rewrite complex relations in the numbering system into simpler relations. For example, $x^2 + 3x + 2 = 0$ is known as a second-order equation because it includes the variable x raised to the second power. This equation can be converted into

(x + 2)(x + 1) = 0, and then solved as x = –2 or x = –1. Although students tend to worry most about solving such equations properly, getting them right, implicit in each solution is a transcription whose value lies in preserving original relations while introducing new ones.

Introducing the X and Y axes brings plane analytic geometry into play for transforming arithmetic or algebraic equations into geometric shapes. For example, one could transform a graphical image of a line into the slope-intercept algebraic form of a line, y = mx + b, where m is a number that represents the slope of the line and b represents where the line intercepts the Y-axis. At the same time, movement in the other direction, from arithmetic or algebra to geometry, gives an equation location or place, for it enters a coordinate system. The CADAM system likely started by orienting us in a two-dimensional coordinate system because, with analytic geometry, we were getting closer to drawing with pencil and paper.

Moving into analytic geometry enables one to begin to work with trigonometry, which offers a special class of practices for moving back and forth between graphical forms and numerical forms. The configuration of agencies in trigonometry translate the graphical properties of circles, e.g., radius, chord, and circumference, into the numerical properties of angles, e.g., sine, cosine, tangent, and cotangent.

Students in the lab began drawing by constructing points, lines, and circles in two dimensions. Starting with points, lines, and circles was important in a CAD/CAM system because these were the fundamental 'entities,' or basic building blocks, in engineering drafting. The CADAM developers had evidently labored hard to reproduce the activity of pencil-mediated drafting in computer-mediated entering, thus preserving the sense that one was drawing with tools. That is, pencils were replaced by input devices and the reading of engineering drawings was replaced by the reading of display screens. As students reported to me and I indeed experienced myself, making points, lines, and circles on the screen using the keyboard "felt like drawing." The physical 'I' did it and saw it, even though enlisting the help of the electronic user and a pile of agencies already invested in the machine.

Yet achieving this equivalence depended upon a transformation that located human agencies inside the machine. Students were supposed to imagine that a huge drawing board was present somewhere inside the computer. In other words, they were to view the screen as if they were actually looking through the screen to an engineering drawing board located behind it. I often heard instructors and lab assistants tell students to "think about the screen as a window looking out onto a drawing board." CAD/CAM developers were often quite explicit about this objective. For example, one described in a magazine interview how he had sat for hours watching people draw before writing his software: "With a [two-dimensional] program, we start off looking at it as a model of a draftsman at a board."[4]

Our manual also tried to help. Remember Figure 1.1 (see p. 2) featuring

the friendly engineer behind the camera? This image showed up at a crucial time to rescue students who might have trouble experiencing this complex software as a simple tool they could control. Note the blank screen with the label "20,000 × 20,000" DRAWING BOARD. "Imagine," said the manual, "a 20,000 by 20,000 unit piece of paper on a drawing board to make a drawing on." Making this move meant appreciating the man on the left, the virtual guy, as standing for all the intelligent configurations of mathematical agencies that CADAM's developers had transcribed into the software. Representing these configurations of agency with a human figure reassured us that bright people were somehow still living inside the CADAM program. Because they were still there doing things for us, we could spend our time on other things and possibly accomplish what we could not have done previously. The image assured us that humans were still in control, albeit inside of the machine. CAD/CAM students thus learned to see the geometric shapes they produced on their screens as simply curtailed, limited images painted onto a great canvas.

Once students made this shift in seeing, the display screen became a looking glass onto a whole new world out there. The passionless activity of drawing points, lines, and circles became a jump through the looking glass into mathematical worlds with all sorts of possibilities in which nothing was as it seemed, until, that is, one figured it out. The jump became a leap of great proportions once sitting for hours at a computer motionless except for furious fingers became an opportunity for adventure. I asked students in the first questionnaire, "What did you enjoy most about the first lab?" Although four did not answer, one liked "turning off the computer," one enjoyed the department's doughnut break in the outside hallway, and three simply wrote "finishing," twenty-one connected pleasure and control: "Making my first sketch without the manual; Getting the computer to finally draw what I wanted; Seeing how a few simple commands can do complex operations; Doing the 3rd lesson (playing with the color function); Making fill color on screen; Drawing parts like exercise 7; Seeing the pictures being drawn on the screen, knowing I was doing it; Seeing some sort of useful results (i.e. drawing object models); When you get the results; the idea of all the capabilities that this system offers; Creating the pictures, using colors, being able to do the job competently!; It helps to visualize the objects, in a way improving our imagination; Just learning to use the system, completing the assignment correctly; Everything!"

Yet many of the agencies we engaged were configured in ways that were specific to the CADAM program and with links that were far more fragile than one might otherwise have guessed. For example, the reference manual told us that we could follow fourteen different pathways to produce a line and forty-seven to produce a circle. Different pathways were useful for different purposes and probably no other CAD/CAM system offered precisely the same configuration.

CADAM included dozens of pathways for erasing, including some unique strategies that doubled as both erasing and drawing. Following the RELIMIT command not only erased by trimming away parts of lines or circles but also enabled one to extend a line or close a partial circle. CORNER offered the alternatives of producing corners by trimming away unwanted portions of lines that intersected, transforming square corners into rounded corners, or adding lines and circles to modify intersections of other lines and circles. Furthermore, some pathways formalized parts of the drawing parts that have previously been done informally. For example, we used TYPE to change the thicknesses of lines, substitute dotted lines, or otherwise modify the visual presentation of lines. SPLINE allowed one to draw wavy curves through sets of points. NOTE enabled us to add text to the image while DIMENSION had pathways for presenting the dimensions of an object. In sum, whoever had coded CADAM had to decide how to combine and transcribe diverse arrays of existing practices into mathematically coherent actions on points, and whoever sought power through the program had to follow the pathways that had been coded into the system.

We also had to remember that CADAM was written for the computer. The complicated mathematical agencies of CADAM had to intersect somehow with the calculational practices of digital processing, which followed a binary logic of on-off switches. Every action in a digital computer, even apparently fixed graphical representations, had to be converted somehow to moving binary activities of 1's and 0's. CADAM achieved this goal by transcribing everything that appeared on the display screen into huge lists of points and actions on points. CADAM's images of lines and circles were thus actions on points. A line became the extension of one point to another point and a circle the rotation of one point around another point.

An implicit warning in Figure 1.1 was that the complexity of a CADAM drawing was limited by the number of points the program could handle: $20,000 \times 20,000$ points, or four billion (4,000,000,000,000) points in two dimensions. Four billion may sound like a lot of points, but a complicated engineering drawing, particularly an assembly with component pieces, could easily require more. In contrast with a paper drawing, whose constraints on size and complexity were set by informal visual conventions, a computer drawing was constrained by the mathematical density of its interior structure. No drawing could have more than twenty thousand points in any direction.

By understanding that the screen's image consisted of data about points sent selectively and repeatedly, to the screen, students could appreciate the screen's constant state of motion. The mathematical agencies of drawing had to intersect somehow with the machinery of display (see chapter 9). Where a paper drawing exhibited a fixed set of internal relations among its features, CADAM images represented translations from graphical representations to binary 1's and 0's to electronic on-off switches and back so quickly

that the process was measured by the nanosecond, or one-thousandth of a billionth of a second. The changes may have been frequent enough to give the appearance of visual stability, but students who had sat powerless watching a screen flicker because the drawing was too complex or whose demands on the system had caused them to be 'booted out' knew better. A user's control over the lives of four billion points was not wholly secure.

One way or another, CAD/CAM students had to appreciate that the several links represented in Figure 1.1 could be quite tenuous. Moving from function keypad to the virtual drawing board and back combined the inside human engineer with the wiring, loudspeaker, and camera in a series of geometric translations. The user's commands from the function keypad translated into the request, "MOVE THE CAMERA PLEASE," which, in turn, modified the graphical image on the drawing board that got sent back to the screen for the human user to read. Every step depended upon a fragile combination of human and nonhuman agencies written into and performed by the machine and the user, enacting a drama whose endpoint was by no means guaranteed. It all depended on what was possible mathematically and how programmers chose to transcribe. It was as if, in transcribing audio tapes, each transcriber had the option of creating the language in which the transcription would be written. It was difficult, if not impossible, to understand CAD/CAM technology without locating human agencies inside it.

One implication of the fact that no rules existed for how to transcribe drawing agencies into mathematical agencies was that learning a CAD/CAM system involved traveling down the many pathways it provided. The key theoretical term for CAD/CAM students was 'play.'

"I am a strong believer that someone learns through experimentation and playing around with something. How do you think most people learn how to make love and get good at it? I'll bet they don't learn it at school or from their parents. Trial and error sometimes is the best learning technique." Eric was complaining to me in an interview that laboratory exercises introduced too many new things too quickly. He was offering advice I later often received from both students and faculty in the CAD/CAM Lab, i.e., that the only way to get good on a CAD/CAM system was to "play with it." Sandy elaborated the point in a conversation with other students:

Gary: Did you folks read this lab manual?

Eric: Yeah, we had to or you couldn't do anything.

Jim: We looked at the block instructions.

Sandy: I just went into each menu item on the screen and looked.

Gary: So you just played with it?

Sandy: Just played around with it. Just put the cursor on the item and press select and it pulls the item up onto your screen. I think I spent a lot more time than a lot of people on some of those labs, trying things out. I played around a lot.

George: It says in the book, "Do a couple of examples on your own."

Sandy: I spent fifteen minutes playing around, changing the colors.

Gary: I skipped over that.

George: I did it once and then moved on.

Eric: When it said to practice, I skipped that and moved on.

Linda: I did a little bit. I didn't stay there forever, but I played around with it a little bit.

Sandy: I figured the best way to learn it is to play with it. The more you use it the more you know it.

Jim also made the point. Although far less impressed with the content of play as knowledge than other students were, he was still thinking in terms of following pathways:

Jim: I've gotten most of my experience by trying to figure out what the computer's doing. When we select a particular menu item, another menu comes up on the screen. It's like three or four different choices. You don't have to be a genius to figure out what each of the menu items that comes up on the screen tells you to do, so by trying to think and do it sequentially you can like predict what you should be doing.

For students accustomed to engineering problem solving, playing with the CAD/CAM system was both fun and also something more. The word 'fun' itself functioned as a way of explaining the importance of moving beyond iterations of submission and control to understand other possible relationships in CAD/CAM technology. Because courses built on mathematical problem solving specifically excluded play as an activity bearing value in favor of innumerable practice exercises, the language of play distinguished the human-like familiarity students were gaining with CAD/CAM systems from standard engineering knowledge.

I heard more about the value of play implicitly than explicitly, through complaints that labs never left time for sustained periods of play. Moving ahead quickly, the course appeared to place highest value on that dreaded cranial activity that produced the absence of learning—memorization. "Another problem," wrote Eric in his journal, "is that they ran us through the 2D CADAM book in 3 lab periods. We never had time to sit down and play with CADAM and try to experiment." In the first nine hours of lab sessions, students followed exercises that used all thirty-two keys on the function keypad, each of which had offered between four and seven options that sometimes included still other options. It was exhausting to become familiar with the thirty or forty pathways traversed in the lab manual, let alone the two hundred or more possible. The only strategy left for completing lab assignments, Eric argued, was memorization: "If we were not sitting

in lab for three hours and up to five hours outside of lab, then we might have the time to sit and learn how to use the functions better and not just memorize what the different keys did." Memorization was degenerate because it did not last: "By the time lab was over the I might have retained a fourth of what I went through that lab period." In the second questionnaire distributed in class, I asked, "Do you play with the system as a learning strategy?" Although only one answered "Very much," only four answered "Not at all." Like Eric, most were in between, with fourteen responding "Somewhat" and thirteen responding "A Little."

I never heard students or faculty explain just how one gained knowledge through play, e.g., what sort of content it had, how it might relate to other forms of engineering knowledge, whether it could be pyramidal in structure. It was always simply a statement of the sort: "There's no other way to learn." I myself experienced play as something of an adventure inside the computer, taking different turns to see where they would lead me. It was not that going somewhere was all that difficult, but you could not say you knew the place until you had been there. Students were emerging with something akin to geographical knowledge, the satisfying sense of place and orientation that comes from knowing where things are on the map.

The fact that each CAD/CAM program had innumerable program-specific strategies for transcribing drawing practices had a larger implication. This was not simple automation, the replacement of human by machine. When I compared the commands in different CAD/CAM programs, amidst large areas of overlap I found equally large areas that did not come close to intersecting. A human using a CAD/CAM system might eventually achieve a sense of control but only by structuring all interactions to fit the specific configurations of agencies that had been built into the machine. The question to ask is what configurations of agencies had been transcribed into the CAD/CAM system and how might those agencies fit the agencies of design and/or manufacturing in my workplace?

We concluded our first lab session by constructing step by step the messy two-dimensional image depicted in Figure 7.3. All we needed were the function keys POINT, LINE, and CIRCLE. We were to imagine ourselves looking through a window out onto a world of activity involving points, lines, and circles. Everything was in motion. The points on the screen stood for movement back and forth between the visual image of a dot and point data stored as numbers. Lines that began and ended entirely on the screen stood for points that moved to other points, while other lines reached out beyond the screen to the limits of the drawing board. The circles were also all moving points, some confined to the screen and some traveling beyond it. At this moment, the word "CIRCLE" appeared on the history line at the top, left-hand corner of the screen, indicating that only three options were currently available to us in this radically circumscribed world of mathematical activity, options that involved actions on circles. We humans had

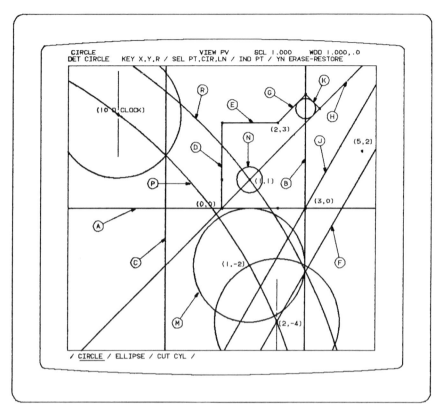

Figure 7.3 Looking Out onto Another World

traveled inside the computer through our users, participating in the production of a drawing, and entering what had become the Grand Central Station of engineering activity.

Putting Objects into the Machine

Producing two-dimensional images of points, lines, and circles was not sufficient for the engineering user. Budding engineering designers had to build objects. They needed to be able to climb into the system, design an object, and then send that object off to manufacturing to produce. Figure 7.3 above includes no objects. For CAD/CAM developers, this meant figuring out how to make the technology work in three dimensions. CAD/CAM instructors presented strategies for representing three dimensions in two-dimensional space as the key pathway to engineering control. The only cost was that one had to give one's eyes over to the system as well as one's fingers.

Halfway through the semester, students took an exam to test their practical skills in CADAM, i.e., their abilities to move around in CADAM quickly enough to produce engineering drawings in a reasonable amount of time. Students took their seats one to a display terminal, and Wong handed each a small battery clamp, the kind used on car batteries. The photograph in Figure 7.5 below presents a three-dimensional image of the clamp, but this would not be particularly useful as an engineering representation since it offers no easy way to transcribe features of the object into mathematical form. The students' assignment was to produce such a mathematical representation. "Work in inches," said the exam's directions. "Start a new drawing called EXAM1," and then "[c]onstruct the front and side 2D views . . . of the given part." Students were tense and worried going into the exam.

Even to get to the point of taking this exam, students first had to master a series of important reading practices, all clustered around the problem of seeing objects in engineering drawings. An ideal engineering drawing permitted no variation in reader response, no diversity, no contingency, no interpretive flexibility. That is, an engineering drawing differed from other sorts of drawings, sketchings, or paintings in that every human viewer was supposed to stand in the same relationship to it and interact with it in the same way. Whereas a work of art might purposely seek differing reactions from its viewers, such that it fit each person's life in a distinctive way, the engineering drawing sharply constrained the position of the viewer. For the engineering drawing to achieve a one-to-one relation with some present or future object in the world, eyes had to be disciplined to position it in predictable, indeed invariable, ways.[5]

The second lab assignment had taken us on our first journey toward transforming 2D drawings into 3D representations of objects. Our task was to construct a simple image of a familiar object, a house, and then manipulate this object in various ways to produce what the manual called a "village of houses" (Figure 7.4). A tedious way of producing this drawing would have been to draw each house separately using only the procedures for constructing points and lines. Instead, through the function key GROUP, we found ourselves taking one such house and then moving, rotating, resizing, mirroring, and stretching it through activities called 'geometric transformations.' Points and lines had become an object with different versions.

The crowning achievement in engineering graphics for constructing 3D images in 2D space lay in the practice of presenting 'views.' A view implied an object by presenting a perspective of that object, following along a line of sight, as in a point of view. All the houses in Figure 7.4, for example, presented us with the same view of the house, its front. Each house presupposed a viewing eye at some distance from the screen and in a direction perpendicular to the flat surface of the screen. All these eyes had the same perspective because they viewed their houses along the same lines of sight. In effect, one eye viewed every house from the same perspective. The trick

Figure 7.4 From Lines to Objects

in jamming three dimensions in two-dimensional space was to have the lines of sight for different views converge in one eye, the trained eye of a visualizing user. Although each view was two-dimensional, the whole could be read in three dimensions through the reading practices of 'orthographic projection.'

Figure 7.5 reproduces the grading sheet lab instructors used to evaluate students' drawings on the practical. In class prior to the exam, West had briefly explained how precise the final drawings would have to be:

> *You ought to be caught up on all your 2D work and well on your way to 3D. . . . Make sure you're on time and sitting at a workstation ahead of time. The lab TAs are going to hand you a part and a ruler. We are asking you to incorporate only the major features of the part and get down to the last half division on the rulers. If the ruler goes to 1/16", go to half of that. Most engineers can read to half a division easily. Sit down and look at the part before you start to draw and measure it.*

Because students had been producing three views of objects in laboratory exercises, having to do only two views either meant that the exam would be easy or that the job would be so complicated that doing three

GRADING SHEET FOR ME 4634 MIDTERM PRACTICAL EXAM

FEATURE (TWO PTS. EACH)

NAME/DATE 2
5 DIMENSIONS 1 EACH
OUT-OF-SCALE 1
HIDDEN LINES SHOWING 1 EACH
INCH UNITS 2
POINTS ERASED 2
RELIMIT ERRORS 1 EACH

Figure 7.5 Putting a Battery Clamp into the Computer

views within the 90 minute time limit would have been impossible. It turned out to be the latter. "I was expecting some type of object, not too easy, not too hard," Eric later wrote. "I almost died when Adam, my TA, handed us battery clamps. These things were a nightmare."

About three years earlier, students had encountered the practices of orthographic projection in a freshman course on engineering graphics. The main objective in that course, as listed on its syllabus, was "to ensure an understanding of the theory of orthographic projection." The only way to do this was to discipline one's body, to train one's eyes to position themselves in a way dictated by a mathematical model of views. Or, as written in the syllabus for a class I observed and emphasized repeatedly by its instructor, Professor Dennis Edwards [pseudonym], learning orthographic projection required every student "to develop 3D visualization and interpretation skills."

In the first instance, multiple views required multiple lines of sight, or multiple eyes. For example, as illustrated in a figure drawn from our

textbook in engineering graphics, the first step involved theorizing three lines of sight emanating from three different imagined eyes. These eyes occupied different positions, viewing the object from the front, right side, and top. Step 2 then described the procedure for getting to Step 3, a two-dimensional image of the front view only. The front view was thus a two-dimensional mathematical image of a three-dimensional object. The mathematical relation between a view and an imagined eye was supposed to reproduce for engineers a physical relation between a drawing and a human viewer.[6] (See Figure 7.6.)

Multiple views came together through the glass-box theory, which completed the trick of reading in three dimensions by disciplining the person to see all the views at the same time. It formalized the process of producing a three-dimensional object in two dimensions by converging together the multiple eyes of distinct views. Professor Edwards found the glass-box theory so important that he introduced it to us with a stern warning: "Pay close attention, because if I lose you today, you're going to be in trouble for a long time." Using an overhead projector in class, he put a visual image of the glass box on a large screen at the front of the class, keeping it there for the entire seventy-five-minute class period, as well as for part of the next class period. (See Figure 7.7.) "Don't think of the front view just as a 2D plane," Edwards said. "You always want to be thinking in 3D terms."

The glass-box theory provided a strategy for positioning the front view in relation to other views, typically the right side and top views. The first move, reproduced in Figure 7.7, projected views of the object onto three sides of a transparent box enclosing the object, the glass box. "Imagine," said the caption to step 1, "that the object has been placed inside a box . . ." The second move performed the magic, unfolding the sides of the box to bring all three views in one plane, the plane of the drawing board. The term orthographic projection derived from the fact that the three sides of the box were all perpendicular, or orthogonal, to one another.[7]

The beauty and force in geometrically transcribing three dimensions into two thus lay in the convergence of three imagined eyes into one for, as

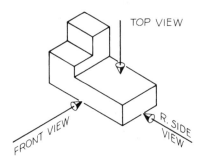

Figure 7.6 Seeing through Three Different Eyes

Figure 7.7 Seeing from All Sides at Once

the box was opened, the lines of sight became parallel to one another. A disciplined user looked at three views and saw a three-dimensional object. A single physical relationship between a drawing and a person incorporated three distinct sets of mathematical relationships between views and imagined eyes.

In the lab practical, students had to draw the front view and side view of the battery clamp. Instructors expected students to use a powerfully dense configuration of agencies in CADAM called AUX-VIEW, which embedded many of the agencies of orthographic projection by helping one use one view to construct other, auxiliary, views. After drawing the front view of the clamp, for example, students could have used AUX-VIEW to project many of its features onto a side view, thus avoiding drawing the side view entirely from scratch. It was one thing to understand the practices of orthographic projection and quite another to be able to follow the pathways opened up by the AUX-VIEW key. No student I talked to dared risking it during the ninety-minute exam. Three weeks prior to the lab practical, Sandy had described in her journal her difficulties in learning AUX-VIEW: "Went to lab and drew pictures. Tried to master the AUX-VIEW procedure. All those different views are confusing—changing origins and all." Then after the exam, she reported her decision to avoid the AUX-VIEW completely: "I was considering using AUX-VIEW, which in a more relaxed atmosphere would have been the way to do it, but I chickened out because I always screw up AUX-VIEW." Along with everyone else, she chose a more tedious but certain path: "So, for the side view I projected lines on my own [using the LINE function key] and filled in the rest."

Although CAD/CAM students had difficulty describing the knowledge they were gaining from learning CADAM, they could claim they had it after completing the lab practical. For example, immediately after taking the exam, Kim Repass went directly to a job interview. How to show knowledge or

control of CADAM was clearly a concern for her since she had not yet completed the CAD/CAM course, so she asked for help in the job placement center. "Saw someone in placement," she wrote in her journal. "Had been wondering if CADAM could go on resume. This other person in our class had it on his so felt better about showing it on mine." A defining moment for a job candidate in engineering was when some form of knowledge made it onto the resume, for the resume defined, or positioned, the person in a world of engineering knowledge. By constructing and manipulating three-dimensional representations of objects on imaginary drawing boards within the computer, CAD/CAM students could report themselves as CADAM users, people with knowledge. But to get there, they had to accept not only the long-standardized constraints of engineering drawing but also unique choices and judgments built into the CADAM software itself. They had become participants in the movement of objects inside the computer, but only by giving up much of the flexibility in the world of human action and accepting the rigid mathematical constraints that had been built into that world of objects. In the pursuit of control and mastery, they had given up freedom and become members.

Engines of Analysis

Perhaps the greatest opportunity engineering students encountered by climbing into CAD/CAM systems was not drawing on the computer but linking drawing to forms of engineering analysis. The engineer who wanted to design and build something, say a battery clamp, likely faced a variety of questions. What shape and size should it be? How strong should it be? How much should it weigh? How long should it last? How much should it cost? Should there be only one size or different sizes for different batteries? Where were the major stresses and likely sources of wear? A battery clamp that cost $50 yet lasted fifty hours was likely not going to be especially desirable, so the engineer researched not only the size and shape but other potential properties as well, such as strength. One common strategy was to make and test a thousand different prototypes in order to find the best one at each size. CAD/CAM technologies made it significantly easier to do much of the testing, or 'engineering analysis,' on the computer. Innumerable computer programs were available for calculating all sorts of engineering properties, such as mass, weight, centers of gravity, stresses, and heat flow, yet each one of these included distinctive mathematical practices. CAD/CAM technologies made geometry, the agencies of drawing, the point of contact among distinct engines of analysis since many forms of analysis included assumptions about geometry. The CAD/CAM user could thus travel quickly across but, once again, at the cost of committing oneself

to engines of mathematical agency that almost never intersected with one another without significant adjustments.

At this point, students had a problem. They had achieved some sense of how to make 3D representations of objects in the CADAM system, but their abilities to engage even the simplest programs of engineering analysis were limited by the fact that each drawing they made had a unique mathematical representation in the computer. Since they had built each drawing as a linear accumulation of data about points, two drawings that appeared identical visually could have different accumulations of points. The only way to make two drawings identical mathematically was to follow exactly the same sequence of steps in entering commands. Since the activities of analysis depended upon the geometric information they received, the engines of analysis could be confused by an engine of geometry that was not consistent in communicating what it saw.

One way of making drawings consistent with one another mathematically was to shift from coding them through data about points, lines, and circles to coding them through equations. For CAD/CAM students, this meant returning to a computer language that engineers had used for thirty years, called 'FORmula TRANSlator,' or FORTRAN. Roughly halfway through the course, the instructor distributed a homework assignment to write a program in CADCD. CADCD was a special program for producing geometric information about drawings that both CADAM and analysis programs could understand. In other words, one could travel down through CADCD's geometry engine into FORTRAN, across to an analysis program also written in FORTRAN, up into the analysis engine, and then back all the way through CADCD to CADAM's presentation of a drawing on a display screen. Every step involved a transcription from one mathematical form to another, with FORTRAN key to the process of linking drawing to analysis.

Our homework assignment made CADCD part of a mock design problem:

> *The Bearing Company specializes in the manufacture of the sleeve bearing shown [in Figure 7.8]. To satisfy their customers, the company must be able to manufacture this bearing with specific bore size and bolt pattern. As an engineering software consultant, you have been hired to write an application program which is to interface with the CADAM system. This will free the company from the tedium of having to recreate the necessary drawings of the bearing from scratch each time a new design is required.*

The sleeve bearing was a device that helped some part rotate around a rod or shaft without generating a lot of friction. It could achieve the same goal as, say, ball bearings on a bicycle. The large circle in the drawing represented the bore hole for fitting the bearing around the axle, while the two small

FIGURE 1

Figure 7.8 Put This in the Computer as Equations

circles represented holes for bolts to connect the bearing to the rotating part, the wheel.

What made the problem compelling mathematically was that the fictional company made sleeve bearings in different sizes, because customers evidently had parts with different patterns of bolts and different size shafts. Since the manufacturing process presumably demanded a separate drawing for each size bearing, writing an 'application program' in CADCD would make it possible to produce a drawing quickly regardless of size. An application program is a specialized computer program that both performs some local form of analysis while translating its results into the agencies of a more cosmopolitan program. In this case, the students were to write a computer program that would drive CADAM to produce drawings of different size sleeve bearings, as needed.

The ideal image implicit in the problem was the dream of automation, the idea that the computer would spit out whatever drawing the design engineers needed for a specific bearing. By completing the problem, students could gain the sense they were accumulating greater power inside CAD/CAM technology, with control still a distinct possibility. However, recall from chapter 4 the struggles of engineers at the small manufacturing company to achieve automation in exactly this sense. The problem of designing [their main product] in different sizes and shapes closely resembled the sleeve bearing assignment. Yet after nearly a decade of trying, automation had not yet been achieved. Linking configurations of agencies inside CAD/CAM systems could get very tricky.

When I had first walked into Anne Zeilfelder's office to ask permission

to attend her Introduction to CAD/CAM course, I had also asked what I should do to prepare for the class. Without hesitation, she replied, "You should learn FORTRAN." Although I had completed a semester-long course in FORTRAN during the early 1970s, I took her advice and attended a FORTRAN course during the summer prior to the CAD/CAM class. The importance of FORTRAN lay not only in providing a sort of subway transportation system connecting together all sorts of analysis capabilities, but also in providing a necessary layer connecting the agencies of engineering with the agencies of computer science further down in the software and hardware of the computer system. A cartography of travel inside CAD/CAM also had to be a geology.

CAD/CAM students were already supposed to know that the activities of a digital computer were distributed across a vertical continuum, with the high end privileged by its association with humans in contrast with the machine hardware on the low end. In other words, computer stratigraphy attempted to reproduce the dominant image that sharply distinguished the human from the machine. This sharpness could not be maintained, however, as layers of software fell between these two poles. Software, a name that beautifully evokes the ambiguity of combining human agency with machine object, is a whole class of mathematical activities living simultaneously as human and machine. Software can be bought and sold as a commodity, presuming its objectness, yet its value is pure mathematical agency. Good software is good to the extent that programmers have jammed together all sorts of human agencies in machine terms. Software makes the dominant cultural image of human apart from machine appear most historically rooted and sufficiently limited to warrant substantial adjustment and change.[8]

Human agencies lay at the top of this hierarchy of value in computers, being the most complex and thus the most difficult to model mathematically. So-called 'high-level' computer activities, such as high-level languages and application programs, were therefore most human-like in content. CADAM was a high-level program, for example, because it transcribed into mathematical terms the complex human activities of drawing. At the other pole, the purest activities of machine agency, the on-off switching of hardware such as vacuum tubes, transistors, or solid state processors, lay at the bottom of the continuum because these were the easiest to model mathematically. The binary manipulations of 1's and 0's that drove the hardware were also low-level activities, written into what is appropriately called 'machine code.' Generally, only those humans whose identities merged with the hardware lived in machine code, namely some varieties of computer scientists. Although the least complex mathematically, the lowest forms of agency were also the fastest, and moving up through higher strata achieved complexity at the expense of speed. Computer processing across levels thus became a hybrid activity designed to produce human-like practices at machine-like speeds.

For CAD/CAM students, two additional significant levels lay between the high-level CADAM program and the low-level machine code: assembly language and the FORTRAN compiler. In the context of computer processing, each language is a configuration of mathematical agencies functioning in a highly constrained world. Sitting above the machine code that transcribed the switching activities of electronic circuits into the binary manipulations of 1's and 0's, assembly language transcribed manipulations of 1's and 0's into words and grammatical forms borrowed from spoken human language. For example, our FORTRAN textbook told us that the machine code instructions 0010010000000101 and 00100001100000110 could be transcribed into MULTB, the command to multiply B, and ADDC, the command to add C.[9] To CAD/CAM students, assembly language was basically invisible, merging seamlessly with machine code and the electronic switching of hardware unless a problem developed, warranting help from systems people.

The FORTRAN compiler, however, was a matter of intense interest and concern. A compiler is a body of programming written in a lower-level language but according to the logic and syntax of a higher-level language. CADAM had been written in FORTRAN, which meant that all CADAM drawings used the FORTRAN compiler to transform higher-level mathematical activities into assembly language for processing. FORTRAN had been configured to fit worlds of engineering. While I was first learning FORTRAN two decades ago, business students were required to learn COBOL, which was organized in terms of elementary business concepts, while some high schools were teaching BASIC, which used grammatical patterns akin to English sentences. Engineering students were rarely surprised, although often disappointed, that FORTRAN sacrificed simplicity in grammar for power to manipulate equations. It was difficult to learn. I have met engineering professors who think students should learn FORTRAN even if they do not need it, because it trains one to pay attention to details. Once again, access to new agencies came only with new sets of constraints.

Anne Zeilfelder recommended FORTRAN because CADAM, CADCD, and other software employed in the undergraduate CAD/CAM class all used the FORTRAN that came with the mainframe computer. Every time a student drew a line, for example, CADAM reacted to the key action with a large-scale manipulation of data about points coded in FORTRAN. The FORTRAN compiler, assembly language, and machine code all transformed these mathematical activities downward into extremely rapid electronic agencies and then back again to new manipulations of points that CADAM sent to the display terminal as graphical images of lines of projection. FORTRAN was an obligatory stop along every trip down from CADAM to the processor and up through CADAM to the display screen.

To avoid the mathematical idiosyncrasies that appeared by drawing through points, lines, and circles, a user could slip down below CADAM

and code directly in FORTRAN instead of passing through CADAM. Rather than having to choose among fourteen different pathways to construct a line or forty-seven pathways to construct a circle, one could establish a single set of mathematical procedures, or small computer programs called subroutines, for producing every line or every circle. This is what CADCD offered people who wanted to relieve the tedium of drawing bearings over and over again. CADCD actually collected approximately one hundred small subroutines for producing geometric shapes. "Using CADCD for entering geometry into . . . CADAM," advised our manual enthusiastically, ". . . can be far more efficient than entering geometry at the scope [i.e., drawing on CADAM]." Using CADCD transformed CADAM users into FORTRAN programmers.

For example, students could select LINE3D to draw a line in three-dimensional space or CIRC3D to draw a circle in three-dimensional space. The LINE3D routine simply asked the user to enter the coordinates of two points, since a line is defined as connecting two points. The sequence in which one entered the two points established the direction of the line for CADAM's purposes. Entering the same two points in reverse order built a different line. The overall program called LINE3D into action with a CALL statement that included the points in parentheses: CALL LINE3D (Point #1, Point #2). The actual coordinates for particular points in particular lines could be included together in a separate part of the program called an input file. One could thus draw several different lines using a single CALL statement and additions to the input file.

Although appearing straightforward mathematically, things became much more complicated, uncertain, and, indeed, frustrating as CAD/CAM students actually tried drawing through CADCD instead by hand-entered points, lines, and circles. In many respects, students were entering a new world without a map. The FORTRAN compiler used in the lab provided little guidance when one made a mistake in syntax or committed some other error. While tutoring me in CADAM, Eric once said that the FORTRAN on his computer at home "will spit out a number and you can look at the back of the book and find out what the problem was—a parenthesis or something. Most of the time, if it's a compiler error, it'll spit out error code and you can look it up and find out what it is." On the other hand, when he experienced problems on the mainframe compiler, "it was spitting out variables and some things 'not found,' but it really wasn't telling me what was wrong. I had to go back and figure out what was wrong." Students in group interviews complained loudly that finding their way through FORTRAN on the mainframe computer was complicated, to say the least.

Students used widely differing practices for finding their way:

Gary: How do you write FORTRAN programs, using a FORTRAN book?

Jim: I use the FORTRAN 77 book from freshman year.

Kim: But different versions have different things you can't get out of the book, so I've given up on the book. The version I usually use is the Microsoft FORTRAN we got with our computers, and those manuals are awful. So I just mess around with it, try and figure out what works and save the programs and look at those.

Gary: So you use your old programs?

Eric: That's the only thing I use. I don't even try to use the books.

George: I use the textbook.

Jim: The FORTRAN 77 one?

George: Yes.

Jim: They do have sample programs in there. But to figure out how to use the FORTRAN on the mainframe, I ended up using the big books at the front of the lab.

Even worse than the FORTRAN compiler, using CADCD felt like flying blind. West admitted as much after students began to confront him with questions. He directed them away from the manual, the only source of written assistance with the program:

> *I understand some of you are having trouble with the CADCD project. Don't rely on these definitions in this manual. It wasn't meant to be the last word in CADCD.*

The problem, he explained, was that, "CADCD was written before FORTRAN 77."

He explained how to build a little compass, called a log file, to help them locate their positions in CADCD:

> *When CADCD blows up it just tells you, "I had an error in this routine." It doesn't tell you what went wrong. The CADCD routines will not be able to catch errors. The reason for the log file is to get your program to report "I just did this and this." If it blows up, your log file has recorded the last thing executed.*

In desperation, he sent them a sample program to use as a model:

> *I'm going to send a program to your reader to use as a model. Build your programs incrementally. Then you can debug it incrementally. Do not write the whole program all at once. Set up the log file and input file, and get those to run. Then open CADCD and do one part at a time. Here's the importance of decomposition—one little bit at a time. If you still have problems, I'll be happy to help you, so you won't be up until three in the morning.*

When, on the second questionnaire, I asked students if they had any problems with CADCD, I was inundated by the waves of frustration: "Something just would not work, the program would stop and get stuck;

Did not understand the variables and what they were for in the CADCD routines; The ordering of points in the ARC3D command seemed random; Sometimes I'd have to define an arc clockwise and other times counterclockwise to get it to work; It is really picky about how it wants things done; Misspelled CADST as CADSTART, which wasted 1½ hours of debugging; A parenthesis was missing at parameter (P1 = 3.14), the splines gave an error, a student from our department spent four hours with me until we found it; It took me two nights to realize that the program was correct but the drawing would not come up because of a technical error."

No longer hearing expressions of pleasure about the prospect of control, I began to encounter with increasing frequency expressions of distress about not knowing where or how to go to get things done. In fact, as Sandy wrote in her journal, the main pleasure students were experiencing was simply finishing an assignment.

As students moved through the CAD/CAM course, they were becoming powerful users who moved around inside CAD/CAM systems through a variety of coding strategies. Yet each new coding practice placed new demands, for the opportunities built into each new engine also came with new constraints, many of which were specific to a given program itself. As they engaged more and more agencies within the computer, none of which overlapped completely, the scale and implications of the problems they encountered increased accordingly. Gaining control over CAD/CAM by bringing together the agencies of drawing and engineering analysis could take place only by taking up residence deeply amidst the rapidly changing agencies of hardware and software. Furthermore, as we shall now see, the human sensation of control as restricted travel inside the machine also brought with it a sensation of vulnerability, as an invasion of self by the machine.

CHAPTER 8 | Locating It Inside Me: Confusion

CAD/CAM INSTRUCTORS WANTED STUDENTS who understood and appreciated in some deep sense the complex mix of opportunities and limitations that came with participating in and using CAD/CAM technologies. As Dr. West explained in an interview, it was important to cheer students on, or nurture them:

> *These guys are real sharp people. I've told this to the TAs. These guys are sharp kids. They've got all this energy and are looking for help to direct it. We should not treat them like they don't know what they're doing. After they did the CADCD homework, I told them they really accomplished something.*

At the same time, it was important to keep students from becoming over-confident about the capabilities of CAD/CAM systems:

> *CAD/CAM systems don't solve all your problems. They complicate some tasks and make others easier. Don't put all your faith into your CAD system. Gain experience with it before doing the design.*

But beyond iterations of cheerleading and warnings, it was difficult for instructors to explain to students what was happening to them in the course.

The CAD/CAM course may have been giving students what they needed, but it was not what they wanted. They wanted control, or at least access to varying degrees of control. They had become accustomed to

explaining differences among engineering students in terms of contrasting degrees of control, which were themselves the product of unequal human capabilities and motivations. That is, some people were simply better than others. Engineering students knew who they were according to where they stood in homeworks, tests, grades, and grade-point averages. This course was frustrating and confusing because it was difficult to know when one had achieved something. How were students supposed to measure how well they were doing? How could one know where one stood in relation to other students? Just as students had no easy language for how they were gaining power within CAD/CAM technology, they also struggled for ways to explain what was happening to them as people. What are my personal goals with this technology? How do I want to show it on my resume? How do I want to fit it into my career? How much of a CAD/CAM person do I want to be? Such questions were difficult to answer.

This chapter explores what happened to people who participated in CAD/CAM technology. In an important sense, travel was connected to identity. Where one went was connected to whom one became. Rather than simply occupying slots on a ranked list located between submission and control, CAD/CAM students were locating themselves on a more complicated map. Even for students who shared similar desires, actual experiences varied widely. How to locate CAD/CAM in relationship to oneself, indeed as a contributor to self, became the private struggle of CAD/CAM students. Stress over this issue reached its peak during the high-profile conclusion to the course, the design project. Instructors characterized the project as supremely important. "Without the design project," asserted West, "you will miss the point of this course."

"I Want Control"

Sandy Poliachik was one of the few students I encountered in the CAD/CAM class who appeared to desire a thoroughgoing sense of control over the technology. Accordingly, she also appeared to be the most willing to give herself over to its demands. Sandy had experienced a long-standing association with computer technology prior to joining the course, but computers had never been a dominant passion in her life. Unlike Steve Payne, the student described earlier who had enjoyed kingship through computer programming, she would likely never have described herself as "one with the computer." Rather, she wanted control over CAD/CAM to help her get where she wanted to go in and after graduate school.

Sandy had been raised as an 'IBM brat,' an acronym that, for the children of IBM employees, stood for "I Been Moved." Although both parents had worked in the computer industry, Sandy turned to mechanical engineering for her education and career, with no plans to work intimately with

computers. Mechanical engineering was close enough. After finishing her undergraduate degree, she worked as an engineer for three years at a Virginia shipyard, a huge construction operation that built Navy ships. Although she encountered some CAD technologies on the job, her unhappiness with life in a huge company working for the military drove her back to graduate school with a plan to get a Ph.D. and teach. Hoping to make her way to the field of biomedicine, which had long interested her, she pictured a life of teaching and research.

Her strong commitment to learning CAD/CAM technology was part of a plan to use it in a master's thesis project. The project's objective was to design and build a prototype of a portable cooler that could store human organs removed for transplantation for a period of up to twenty-four hours. The standard method of storing organs on ice preserved them only for about four to six hours, which often made long-distance transportation impossible. Her approach would use liquid oxygen. The project appeared to fit her long-term agenda. However, by the time she had finished the research, modeling, construction, and writing on her thesis, Sandy had lost interest in academic life and had accepted a lucrative position working in design engineering at Boeing Aircraft Company in Seattle. She later reported that her experience with CAD/CAM technology probably helped her get the job and, indeed, she was spending her days working on and living through a popular CAD/CAM program called CATIA. At the same time, she was still considering a move to biomedicine.

In an important sense, Sandy was well aware that traveling through CADAM could refashion her identity as a person. She knew the Boeing job would have been less likely had she not gained that experience and that by taking the job she would be identified as a Boeing engineer. She was well aware that a job in biomedical research might be impossible if she did not do the design work on the cooler, and that the planned move to biomedicine was to help fulfill a desire to contribute to society in some important way. In this sense, in following humans into machines and machines into humans, I am simply describing what people such as Sandy know. There is nothing new here.

But how did Sandy know and understand these things about herself? How did she understand knowledge about self in relation to knowledge about technology? The habits of imagination built into her everyday language never displayed conceptual resources for overtly, explicitly, and routinely naming, describing, and mapping ways in which learning CAD/CAM technology connected to whom she was as a person, beyond the language of control. Such connections were appropriate only in side stories, private conversations, and perhaps introspective deliberations. These were not something she could easily dredge up, pull out, examine, and debate with her colleagues. They would not have known what to say or do.

The gap between the desire for and language of control and Sandy's

actual experiences in the CAD/CAM course structured a confusion that progressively eroded her interest and enthusiasm for the course. Consider a selection of passages from her journal. Early on, she thoroughly enjoyed the challenge of learning to manipulate CADAM. Initially unconcerned about the performance of other students, Sandy's journal mapped iterations between moments of powerlessness as she struggled against a series of technical barriers and moments of control as she overcame them. In typical fashion for an engineering course, the opportunity to gain control structured a willingness to accommodate oneself in the process. She stayed in the lab until hunger made work impossible, and problems were merely inconveniences:

Jan 16: First lab. Got passwords, ID's. Learned to draw points, lines, and circles. Pretty exciting. Also learned functions for line manipulation and the window function. So many instructions to remember! Stayed till 7:00.

Jan 18: Went to the Lab again. Got pissed off 'cause the stupid spline point deletion wouldn't work. I left.

Jan 23: Need to do chapters 4–7 for this lab. It's cold in the lab! My right hand gets really cold. I did a lot of the work, but kept screwin' up. I guess that's how you learn.

Jan 28: Wrote computer program and ran off plots of points during the Super Bowl. Made the game more exciting. Ran okay on PC, now need to put it on the mainframe.

Jan 30: Went to lab and drew pictures. Tried to master the AUXVIEW procedure. All those different views are confusing—changing origins and all. Got hungry and couldn't concentrate.

Throughout the semester, Sandy regularly used the word "frustration" to code her struggles with barriers, while the experience of relief poured out through exclamation points. She dedicated herself to getting to the lab and attacking the problems that awaited her. All too often, however, the manual did not work, friends and TAs could not help, and she had to go it alone. As the semester wore on, her attitude began to shift as she encountered a never-ending stream of new problems.

Feb 13: Still doing 3D. If you work in the wrong plane, you get all screwed up! It's fairly frustrating. At least I know what the problem is now.

Feb 21: In class, solid modeling. Today's goal: stay awake. Strategy: take notes. He said a lot of the material was in the Kinko's notes. He was mistaken.

Feb 23: Did about ½ hour of lab work. CADAM has been changed since the manual was written, so sometimes it's a challenge to follow directions. Gets frustrating at times. Sometimes I don't wish to know it so well!

Feb 27: I tried to go through the solid modeling lesson using ISD [the solid modeling program] without messing up too badly. I learned more about ISD than someone who can follow directions. Actually, when you rotate or move images on the screen, 2 images appear. I took a while to figure out how to remove the incorrect figure. . . . It gets frustrating by about the 5th time you have to enter a set of 10 coordinates.

Mar 6: Got up early to use CAD/CAM Lab. Worked on the lab exercise, solid model of a pulley. Wouldn't work. I tried everything. So I left.

Mar 20: I spent half the Lab trying to submit a batch job [run a program on the mainframe computer] to shade my pulley. Someone else tried also. Neither of us managed to get the job to run. Following instructions in manual did not work. Tried a few combinations to no avail. The Lab TA said to forget it and gave us credit for it.

As the end of the semester appeared on the horizon, Sandy's objectives appeared to shift. Her interest was fading and the desire for control receded as she struggled with other students to complete a group design project. She began to focus simply on getting her work done and adding this course to others on her transcript. As her goals shifted from gaining control to doing well, her interest in the performance of others grew. What was necessary to get an 'A', to be ranked high relative to other students, and then get out of there?

Apr 2: Tests returned. I got 53 of 70. Seemed not so good at first. Then Hu said he got a 47 and Dr. West said the average was 46.6 and the high was 58. I felt better.

Apr 4: Yesterday we were supposed to do the finite element lab. I really was looking forward to it, but it didn't run right. Out of 14 userids, only 2 worked. I ended up looking over shoulders to watch someone else do the work. Today in class, Dr. West asked how Lab went yesterday— looking directly at me. When no one answered, he said, "Sandy?" I held up two fingers and he got the message, looked discouraged, pissed.

Apr 10: Got up early (yuck) and worked on the project, 2 hours. Getting tired.

Apr 11: Long day!! Arrived at CAD Lab at 8 A.M. Empty. That's the time to work, if no one decides to give a tour. Class was very dull. I think it was about NC, numerical control. Came back after dinner and worked an additional 3 hours.

Apr 12: Spent 3 or 4 hours in the Lab trying to make a section view of the casting. I followed the ISD manual, but the danged thing won't work! Confused. Asked the TA for help, but he was not sure what to do. Guess I've gotta play on my own.

Apr 13: Talked to another TA about doing a section view, to no avail. Kim said she'd try to go in later and work [on our project]. I don't want to do any more CAD work. I've been in there enough to avoid working there this weekend.

Apr 15: At least 5 other groups were present in the lab when we met at 9:30 P.M. It was very quiet. I suppose they were still assembling their work and were intent on that. As we were walking out, one person asked if we were done "already." Hu said, "Sure, we were done last week!" The tube we'd been using was running extremely slowly [since the groups were competing to use the same mainframe computer], and just checking our drawings was frustrating. I can imagine the frustrations those other groups were feeling.

Apr 19: Watched the 9:30 A.M. group presentation, Mike's beer-can crusher. Very casual. Everyone was seated. They explained their design in detail but didn't discuss CAD/CAM very much. Our presentation went well. We stepped our way through the outline. It seemed as if the idea of the project was to expose us to the limitations of CAD.

By the time Sandy made it to the end of the semester, the learning process had lost all passion. Rather than celebrating, wondering, questioning, or otherwise engaging issues of control, Sandy sold one of her books and her journal simply ended with a bare description of the final exam.

Sandy concluded the course satisfied she would get the good grade she wanted but without a strong of sense of achievement or pleasure, or even a desire to continue and learn more. During the semester, she had adjusted her body to the lab environment so she could cope with the cold and bouts of hunger. She had sat repeatedly for hours at a time trying out all sorts of pathways until she could find something the computer would accept. She had read manuals, played with the system, asked TAs for help, and worked with other students. However, she did not emerge triumphant, in control. Instead, everything was messy, confusing. Contrary to her plan, she used CAD/CAM technology very little, if at all, in her master's research.

In Sandy's viewpoint, the instructor was largely to blame for this anticlimax and confusion. Not only were his lectures boring presentations of lists that had no bearing on lab activities, but ultimately he was responsible for the innumerable exercises that both took too long and often did not work. Sandy became exhausted by her persistence in overcoming the problems, her desire to master the procedures and make the system do what she wanted. Left only with small victories in getting some individual procedure to work, she completed the course perplexed about its main goal. "It seemed as if the idea of the project," she concluded skeptically, "was to expose us to the limitations of CAD." In her journal, group interviews, and occasional conversations, Sandy appeared happiest simply to be finished and moving on to other things.

While perhaps West could have been more stimulating, he clearly did care about student learning. Could something different have been happening here than an engineering instructor simply failing his students? Might Sandy have been, in a way, a victim of her commitment and sophistication? She had embedded herself deeply in CAD/CAM technology and, through persistence and dedication, she had found herself in a new place at the intersection of multiple mathematical agencies. Yet this place was not one her background would have led her to expect or, perhaps, even desire.

Just as her instructor had wanted, albeit without explaining as such, Sandy had achieved a sophisticated understanding and appreciation for the complex opportunities and commitments in CAD/CAM technology. Through enormous commitment and relentless struggle to complete her work, Sandy had successfully adjusted her body and life to fit CAD/CAM technology to them, to make the technology a part of whom she was becoming as an engineer. The problem, however, was that she could no longer expect it to accept its role straightforwardly as an object of control. Disciplined submission had not generated the control that had been promised.

Although I found it difficult to tell the extent to which Sandy's experience in the CAD/CAM course contributed to the declining appeal of a faculty career for solving society's problems, the experience certainly did transform her into a valuable candidate for a job at Boeing working in computer-aided design. Sandy had acquired or achieved something they clearly wanted. It was both unfortunate for her and important in general that this transformation of self had not produced a deeper sense of satisfaction and accomplishment. Perhaps the goal of control hid too much from view.

"I Just Want a Tool"

Eric Schardt was a different case, for he was far from willing to give himself over to the demands of CAD/CAM technology. All he wanted was access to a tool he could keep on hand, like an electric screwdriver waiting in the garage plugged into the wall, and he resisted strongly anything that distracted from this objective. Yet he too would not get what he wanted. Like Sandy, he would find himself exchanging agencies with CAD/CAM technology in ways that would make simple tool use unavailable as an easy interpretation or routine account.

Eric was particularly strenuous in objecting to the mathematics of 'Bsplines' (bee-splines). Although the topic appeared on the syllabus, few students had ever heard of Bsplines prior to listening to West lecture about them, and no one I encountered was the least bit interested. Bspline mathematics was a more complex and involved approach to generating curves than the algebraic approach students already understood. Just as algebra had both offered opportunities and introduced limitations, Bspline mathematics

both empowered and constrained the human agencies that entered to participate. Eric's resistance was instructive.

Including algebra, all the configurations of mathematical agency discussed in chapter 7 prevented one from producing curvy lines, particularly wild-looking ones. Let us say you, as CAD/CAM developer, wanted to help engineers design automobiles. These engineers would love to be able to draw all sorts of smooth curves and surfaces as well as to explain in mathematical terms what they had done. How might the surfaces be designed to minimize resistance to air flow and, hence, maximize gas mileage? What shapes might be most resistant to dents and wear? In other words, how could the agencies of drawing curves and surfaces be linked with agencies of engineering analysis? With a CAD/CAM system offering arithmetic, algebra, analytic geometry, trigonometry, and descriptive geometry, the engineers could draw circles, parabolas, ellipses, and several other types of curves, but after that they would be stuck. So you the CAD/CAM developer begin looking for other forms of mathematics, agencies that could produce wider ranges of curves and surfaces and yet also be translated back with as few steps as possible into lists of points that a computer could process without running too slowly.

The mathematical concept of Bspline rides in here on a white horse. Bsplines live amidst the huge and growing population of agencies in 'computational geometry,' a general term that refers to the representation and analysis of shapes on a computer. The CAD/CAM developer turning to computational geometry could actually wander into all sorts of rooms to locate novel configurations of mathematical agency, but none was fully furnished nor completely decorated. As I will elaborate somewhat in the next chapter, one might encounter 'Coons' curves, 'Bezier' curves, and other types of so-called 'parametric' curves, all of which would take you well past the more commonly traveled regions of mathematical space.

To follow Eric's concerns, we need only understand that, with the mathematics of Bsplines, CAD/CAM students could produce a unique bit of curve simply by specifying four points, known as the 'control hull.' In other words, a curve could be represented in the computer with data about points, which it already was doing. By then multiplying this process over and over again, as computers are wont to do, students could draw curves with just about any shapes they wanted. They were supposed to be thrilled at the opportunity to gain excellent 'local control' over the production of curves through points. They should have been especially pleased that the points only 'approximated' the curve rather than 'interpellating' it, for interpellation meant that each curve would have had to pass through at least two of the points specified, while approximation meant that the points and the curve never intersected. To automobile engineers, for example, interpellation would be far more invasive because it would force the designer to specify exactly where curves and surfaces went before drawing them. They

would have had to know what their designs looked like before producing them. Approximation felt much better.

Both Zeilfelder and West explained Bsplines to CAD/CAM students as a linked series of concepts that students needed to learn and understand. Many students described this work to me as useless memorization, perhaps the best example of classwork that was unconnected with the important learning in lab. In one group interview, Eric was explicit in articulating his objections:

Eric: I'm wondering about the relevancy of some of this stuff.

Kim: Exactly!!!

Jim: I wrote in my notebook how this lecture stuff doesn't really mean anything. None of it seemed to be practical. The history of computers sounds neat, and software development might mean something to a computer engineer or somebody who cares about creating CAD software, but when you sit down all you care about is the menu and what this function key does. That's all that matters to me.

Eric: I've talked with people who have worked with the mainframe CAD at Philip Morris 'cause I wanted to know what kind of work I might get into. They said, "We don't write programs. We use whatever we've got." They've got computer people who write the programs. I think that should apply here too. Basically, you're going to want to draw a circle. You really don't care how the computer draws it. It might be neat to find out how it does it, but these Bspline curve equations, I could care less how these equations calculate a surface.

In another group interview after a midterm test, students were complaining about the question, "What is the difference between interpolation and approximation?" Eric saw the question not as an engineering issue at all but something that involved computer science. For him, CAD/CAM should be more like a screwdriver or hammer.

George: I wrote that interpolation puts the lines [curves] through the points and in approximation the lines are kind of like close to the points. But who cares, I don't know. I just put this in my notes, but I don't know what that has to do with anything.

Eric: Obviously he wants us to see that there are different ways that you can make the computer do it. But you know the computer is going to approximate curves no matter what [because it is digital and converts equations to points]. As long as you're an engineer, the reason that you're using this thing is because you're maybe going to show something visually or you're drawing up a part so that the machine shop can make it. So if it's dimensioned right, you really don't care how it gets there, cause you're learning how to use the system, not program the system.

Gary: That's a good point.

Eric: I think West's into programming the system as well as learning the system. If you're going to program, you need to know how people are going to use it, but if you're going to use it you don't need to dive down into how they program it.

Kim: Right!!

Eric: I'll put it this way. I think I would rather learn how to use the system, how I can use it to draw parts and how I can get it to make parts using NC, but I don't care how it does it. The thing does it, it's been programmed to do it, and it's going to do it to the best of its ability. If it's the only system I got and it's going to do it to the best of its ability, whether it's an approximation or an interpolation doesn't mean a whole lot of difference, 'cause it's all I got. That's what I'm going to use.

I'm an engineer and I'm just using it as a tool. Just like I would use a hammer or a screwdriver, and I don't ask how they build hammers or why they shape them the way they do or any of that stuff.

Gary: What if you plan on becoming a software engineer?

Eric: I think it would be great for someone who's planning on becoming a software engineer. Or a computer engineer.

Gary: Most people in this class are not.

George: Most ME's [mechanical engineers] are not. EE's [electrical engineers] are.

Gary: Double E's are?

Eric: I think even the double E's wouldn't want this stuff. The double E's would want more of the hardware type stuff. I think most of the double E's are into computer hardware. I don't know where you pull a software engineer out of.

Unlike Sandy, Eric was not interested in accommodating himself to CAD/CAM technology. He wanted a tool, a good, solid, nonhuman object, such as the hammer or screwdriver, that he could turn to and use when he was in need. Let us bracket for now any discussion of how even simple tool use fashions the bodily agencies of the tool user. I would wager, however, virtually all of us always wield a hammer or use a screwdriver with the same hand; try the other one and then account for the difference in how one configures the body. The key point now is that Eric resisted anything that appeared to ask him to see himself or have others see him as in complete control of CAD/CAM technologies, to become the human agent behind the technological force. Such would have changed him into a CAD/CAM developer, a programmer, a computer scientist, or something else that differed from what he desired to be. For Eric, technologies existed for humans to use or abuse.

One opening into Eric's passions, desires, and sense of position or identity came from the way he consistently presented himself not only as a student but as an employee as well. Eric had extensive experience working in industry as a 'co-op' student, a term that refers to participants in the Cooperative Education Program. Co-op students alternated semesters between school and work, spending at least three semesters on the job before graduation. Eric frequently called attention to this experience by characterizing himself as a 'fifth-year senior,' a term that cut two different ways. On the one hand, a fifth-year senior was a mature person, which accounted for

why Eric had become student leader of the solar car design project. On the other hand, a fifth-year senior was older than most undergraduate students, which accounted his strong desire to "get out" and "get a real job." Living not only in the world of education, where one gained status through learning, but also in the world of industry, where one gained status by doing a job and satisfying a boss, Eric routinely portrayed his learning in relation to his job.

Eric was outspoken in group interviews, sometimes dominating the discussion with a range of complaints about inattentive professors and insufficient career opportunities. He was offended by professors who seemed more interested in research and graduate students than in working with undergraduate students. He delighted in the annual Golden Shaft award, a crankshaft on a plaque, which was given each year by senior mechanical engineering students to the professor who had screwed students the most during their undergraduate years. He wanted the senior class to endow a fund to help teachers, but was disappointed to learn that students could not raise enough money to make a difference. He wanted courses to focus more on providing students with what they would need in future jobs rather than emphasizing theory so much. He was indignant, yet uncertain, about the fact that women engineering students were finding jobs much more easily than men, despite having similar grades. He kept track of occasions when students knew more about something than professors, such as in the following passage:

> I went into the lab the other night to finish some exercises. The computer kept saying that I did not have enough space, so it would not run the solid modeling program, which is funny because it worked Tuesday in lab. What's the deal with these computers, can they be that screwed up ? (I think we all know the answer to that question.) After West could not figure it out, one of the members of the solar car team who knows a lot about CADAM and CATIA fixed my memory problem, and ISD worked. Pretty strange that my professor couldn't fix my computer but an undergrad student could.

In sum, Eric portrayed learning as the acquisition of tools for the workplace: if you got them, you could do it; if you didn't, you couldn't. In his language, just about everything else that took place was somehow extraneous to the core process of getting the tools one would need on the job.

At the same time, Eric's strongest passions and most acute pleasures and worries appeared to deal with areas of connection between his practices and his person, which the image of tool use hid. Who he was also seemed to be at stake in what he was doing. A lifelong automobile lover, he had dreamed of getting a job in design engineering at General Motors, and had involved himself with the solar car project to demonstrate this

commitment. Eric was hurt and confused that GM seemed not to recognize this, denying him because it was not hiring. He rejected the idea of returning to his co-op employer, a nuclear power plant owned by Virginia Power Company, because he could not picture himself as a nuclear engineer: "Once you're stuck in the nuclear industry it's hard to get out." Accepting a position at Philip Morris offered greater appeal because it was closer to home in Richmond, Virginia, yet tobacco was less inspiring than automobiles. Instead, he pursued a position with Cummins Engine Company, which made diesel engine blocks for trucks, because he thought the job might provide the right springboard into a major car manufacturer. Cummins was frightening, however, because it was far away. Its location in Columbus, Indiana, was "out in the middle of nowhere."

Eric resisted the extent to which grades seemed to determine where he could go and how he would fit, to the exclusion of other things that also demonstrated his value, such as his co-op experience and his dedication to the solar car project. He protested, for example, the fact that company representatives visiting campus seemingly relied exclusively on grade-point averages to select students for interviews. Although his grades were not sufficiently high to qualify him for funding in graduate school, that was acceptable, because he felt research did not fit him anyway:

Eric: The department head is going to try and get me an interview with GM or somebody. Looks like it is Columbus, Indiana, for me.

Kim: What about graduate school?

Eric: I don't think I could get enough money [win a graduate assistantship]. You've got to get in the high three's to get any decent money. I don't have good enough grades. I talked to Dr. Lynn Harris. He considered bringing me on, but his project is on thermo [thermodynamics] and I'm not too big on thermo. This school puts so much emphasis on research, and bringing in money.

As students began to receive offers of employment, starting salary emerged in group discussions as one marker alongside technical field and geographical location of how getting jobs, or not getting jobs, defined individuals. Touching on each of these considerations, the following exchange illustrated Eric's desire to feel at home, trading off location against the dream of designing automobiles:

Eric: I would love to have a job offer from Philip Morris. I'd get a free trip home to Richmond, get some free meals. It might be interesting if they could offer me 35 or 36 [laughing, because unlikely].

Jim: It's not the money.

Eric: Last year they were hiring at 33-eight.

Sandy: Would you take that over Cummins?

Eric: It would be a tough choice. It would be the money, definitely not the job. Yet, moving to Columbus, Indiana [sighs]. You have to get an apartment by yourself. Chances are you cannot meet people [i.e., women; sighs again]. I look at it as a steppingstone to GM or Chrysler. Cummins is offering 33. That's average. One person was offered 35-nine.

Although Eric took the job with Cummins to pursue the dream, he was indeed very lonely so far away from home. Within a year he had returned to Richmond and accepted a job with Philip Morris. He told me this on the telephone with uncharacteristic sheepishness, which I read as owing partly from admitting the loneliness and partly from giving up on the dream.

Like other engineering students, Eric Schardt was stuck living simultaneously in two worlds indexed by grades, but his language for explaining grades relied on only one of these worlds. "I don't do so well on tests" was a difficult admission of weakness, a lack of capabilities, a failure of self. It needed no further explanation, and for anyone to question it further would have been rude and embarrassing. Yet by immediately following that admission with "They just look at grades" and "They don't look at other stuff," he was also marking his second world, the one in which the acquisition of grades functioned alongside several other considerations to establish and transform personhood, to reposition continually a changing self. Eric did not have at his disposal a routine language for resisting the dominant linkage between his grades and his personhood and enabling his claim that co-op experience and solar car work should have counted more to be heard as a legitimate challenge rather than a sorry complaint. He could not appeal to a regular way of talking that mapped how grades, co-op experience, and project work all constituted a unique sort of person who had positioned himself in relation to both machines and humans in valuable ways. He had no easy way to describe and understand better the connections between his desire for tools, his desire to belong, and his resistance to what was happening in the CAD/CAM course.

Eric's desire to belong thus figured in his resistance but not his explanations. Relying on the dominant cultural image of technology outside society, Eric saw only two options opening before him: He could either be a CAD/CAM developer in total control of the technology or an engineer using CAD/CAM as a tool. Since developing CAD/CAM technologies did not fit his dream, he was left to use CAD/CAM as a tool. He had no other resources for explaining why moving around inside CAD/CAM technologies did not feel right or, alternatively, how moving around inside CAD/CAM technologies and letting CAD/CAM technologies inside his body and life might have opened up new pathways for getting to the automotive industry or otherwise achieving a greater sense of belonging. Perhaps the goal of simple tool use hid too much from view.

Systematic Confusion

The design project brought to a head the tension in the CAD/CAM course between the instructors' desire to have students appreciate simultaneously the opportunities and limitations of CAD/CAM technology and the students' desires to control or use it. The project extended beyond making 2D drawings and building 3D wireframe models into design 3D objects with solid models. Working only with 2D drawings and 3D wireframes was inadequate as training for students who had already experienced the engineering sciences and were ready to take the next big step into real-world design. Furthermore, a drawing course in the senior year, even a fancy drawing course on the computer, could never have gained legitimacy in the engineering curriculum. Only through a design project using solid modeling could instructors show students how to integrate CAD/CAM technology into the practices of engineering problem solving they had already acquired. The major lesson for students, however, was simpler and more jarring: They would not be able to achieve control of the technology in this course, and someone was to blame.

As we saw in chapter 7, Dr. West had often struggled for language to explain that CAD/CAM would never fully automate the human process of engineering design. Toward the end of the course, he used students' experiences on the project as the main vehicle for explanation:

> *The project objective is to achieve a design, not just to figure out what the CAD system is good for making. Only then will you find out what the CAD system is good for or not. That's what this course is about.*

George elaborated the point in a group interview, relating a conversation with West:

George: He told us that all those pictures that were up last semester were not what he was looking for. [The previous semester students had used solid modeling to practice complex drawing rather than to complete a design. This was unsatisfying for faculty.] He wants us to come up with a design project, not anything big, but something that we can choose and then get in there and wrestle with the CAD system to make the CAD system produce this part or little design area that we have chosen. The big thing is for us to get away from the basic stuff in these manuals and force the CAD system to do something that's not written out. He wants us to get black and blue on it.

Gary: Like what?

George: I think he wants us to think about spatial relations. . . .

Gary: How would CADAM help you to design?

George: As far as bending the CADAM system to produce a design, he said some guys came up with the idea of how to produce a spring on the CAD system.

No one had ever figured that out before. Another one that got the highest grade last semester was a souped-up Solarflex machine. He said that when he first saw it, he didn't know how they would produce a springlike device that you could push on but didn't collapse. They got in there and wrestled with the capabilities of the CADAM system and made it work. And that's what he wants us to do.

Jim: It seems like the people who were lucky enough to do that got the best grade.

In the faculty viewpoint, producing solid images of objects was a particularly good activity for conveying the opportunities and the limitations of CAD/CAM technology because it presented students with both of these in particularly concentrated forms. The strengths of solid modeling were considerable, the limitations glaring. But since students could not know this in advance, choosing a project that pushed solid modeling to its limits would be difficult. They would have to "get lucky" if a given project was going to demonstrate their promise as budding design engineers.

What students encountered initially was simply another labyrinth of pathways that began with pressing SOLIDS on the function keypad. This was different, however, because instead of plotting a trajectory through the agencies of CADAM, this key put one on an escalator into a wholly different kind of world than students had yet experienced. Leaving CADAM was necessary, for the agencies in this virtual world were not built of points, lines, and circles but of mathematical objects that lived in three dimensions. Students understood this as learning Interactive Solids Design, ISD, which was a program IBM had purchased from a software developer and then included with CADAM in its equipment grants. Pressing SOLIDS activated ISD.

Once in ISD, students could build objects out of a small set of rudimentary object forms, called 'primitives.' The use of this word was instructive. When the dominant cultural image of technology was used generally to mark the progress of society, civilizations with lots of technology became 'advanced' while those with little technology became simple or primitive. In the same way, then, that primitive human societies supposedly lacked complexity or sophistication, so it was with the primitive objects: box, wedge, sphere, cylinder, cone, ellipsoid, slab, and body of revolution. These were mathematically simple objects, lacking many subtle features associated with physical objects with the same labels, such as uneven surfaces or slightly rounded corners.

Students could build more complex objects by adding and subtracting primitives through mathematical agencies called 'Boolean' operations. Figuring out the 'union,' 'intersection,' and 'difference' of overlapping Venn diagrams was the analog in two dimensions of performing Boolean operations on ISD primitives in three dimensions. The ISD manual explained, for example, different ways that a box and a cylinder could interact with one another (Figure 8.1). Adding a cylinder to a box produced a block with a peg

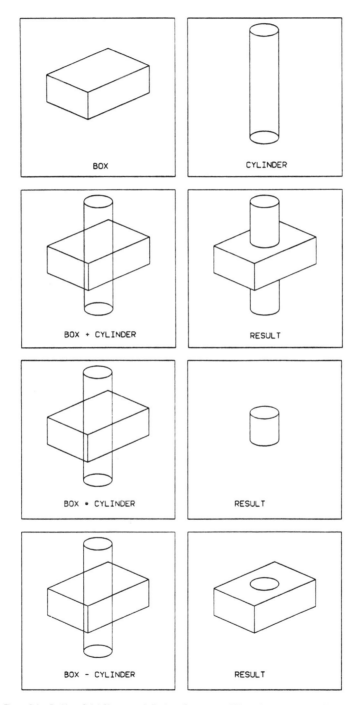

Figure 8.1 Building Solid Objects with Boolean Operations of Union, Intersection, and Difference

through it; finding the intersection produced a smaller cylinder; and subtracting the cylinder from the box produced a box with a hole in it. In the mathematical agencies of ISD, empty spaces were actually solid spaces full of emptiness, for every empty space implied the existence of a solid geometrical object that could fill it.

Students could create an ISD model by starting with a CADAM drawing in two dimensions. The exercise book in lab, for example, described how to take the 2D drawing in Figure 8.1 and then transform it systematically into a solid model by converting shapes into 'slabs.' Whereas a box was rectangular on all sides, one could make a slab by taking any closed shape in two dimensions and then extending it down into a third dimension. The slab was the most flexible primitive by far in the ISD collection of mathematical agencies. (See Figure 8.2.)

For CAD/CAM students, the images produced by these strategies were both satisfying and powerful. For example, Figure 8.3 presents a 'solid model' of a hydraulic jack, the sort of jack you might use to hold up your car while you change a tire. Steve Payne designed it in a CAD/CAM course he took a year after I completed my course.[1] I often heard the solid model presented as the most desirable and satisfying CAD/CAM construction because it was what engineers described as a "complete, unambiguous representation" of the object depicted. The mathematical agencies of solid modeling distinguished the inside of an object from its outside. One could see, for example, the various components of the jack quite easily. Neither 3D wireframe modeling or surface modeling, which we will encounter in greater detail in the next chapter, achieved this crucial translation of a routine agency in engineering design. Distinguishing outside from inside was not a problem for engineers building prototypes by hands, but was a significant problem for people who made their three-dimensional objects on the computer.

The database of points that Steve Payne had produced to describe this solid model contained information not only about points and lines but also about the space inside the object. He thus could use the model to ask questions about the inside of the object, such as its volume, and about the object's location, such as how far it was from other objects or whether or not it intersected other objects. Presence of these additional geometrical agencies made it possible to link the drawing to forms of engineering analysis, such as calculating its weight or center of gravity, making it appear that solid modeling fit nicely into the routine design practices of engineers.

Experienced CAD/CAM travelers, however, knew otherwise. They could easily point out many limitations, for making solid models of most objects was both tedious for the engineering user and enormously constraining for the engineering analyst. Visualize, for example, the shape of the last carjack you have seen or handled. Most likely, the surfaces were rounded, the corners rounded, the base slightly concave to improve strength, and the ratchet head probably a complex of shapes that could not easily be

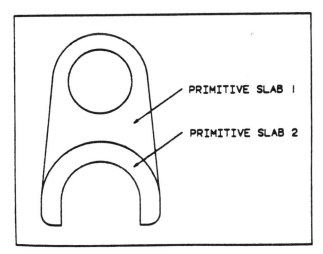

PRIMITIVE SLAB 1

PRIMITIVE SLAB 2

Figure 8.2 Seeing Objects as Combinations of Slabs

broken down into spheres, cylinders, boxes, and slabs. Traveling into the world of solid modeling forced students to simplify dramatically the shapes of objects they were there to create and manipulate. Just as they gained the ability to engage a wider range of engineering agencies, they also had to give up the expectation of treating computer objects as entirely analogous to the concrete objects they were supposed to represent. Riding up the escalator into solid modeling, one entered a vexing world of mathematically perfect shapes that was starkly isolated from the messier world it emulated.

Figure 8.3 A Design Project: Hydraulic Jack Made from Slabs

Although design projects in engineering generally meant applying scientific principles to solve some sort of technical problem, the CAD/CAM project took one somewhere else. A first site of confusion and resistance came when Dr. West told them not to put a lot of time into scientific analysis, but just to do some quick "back of the envelope" calculations.[2]

Eric: That's something I wanted to bring up. You know, he's talking about these back of the envelope calculations for making designs. You cannot make a design with a back of the envelope calculation. He wants us to design something and put it on the system. He doesn't want us to copy something. That's what I thought we were going to be doing, which is why we were going to do that transmission [draw a solid model of an automobile transmission]. But he wants us to design something.

Sandy: Did you go talk to him?

Eric: He pretty much shot down two of the ideas we had because they were more of a solid modeling project rather than a design project.

Kim: What exactly does he want?

Sandy: He's not very specific.

Eric: He's expecting us to design something. Obviously you cannot design something simple, because it won't take the man-hours that he wants us to put in. If it's simple, you put it on the system and it's done. But if he wants some type of design that's going to take the man-hours to put onto the CAD system, the design has to take a lot of man-hours too. So now it is not only a CADAM class but also a design class.

Jim: And he hasn't given us a problem. We have to pull something out of our butts. Somehow we have to use CADAM to help in the design.

Sandy: But we haven't learned solid modeling yet. The only thing we know how to do right now is 2D and 3D geometry.

Jim: And he wants us to have a proposal by Wednesday.

Eric: And it's not like we can change this thing after we've come up with a proposal. We're stuck with whatever we pick by Wednesday. And if we decide it's an impossible thing to do . . . too bad.

Gary: What's your group going to do?

Eric: We have to go re-conference with him. Right now we're looking at designing a supercharger for the formula car [another senior design project, building a small race car].

Reacting to the project assignment actually brought to the surface a third alternative to Sandy's desire for control and Eric's desire for a useful tool: just getting through the course, whatever that took. Jim, George, and, to a certain extent, Kim all were pursuing this option. Jim and George in particular were quite explicit that their primary goal in the course had become just getting through and getting out. They knew that completing the course for a grade entitled them to claim knowledge of CAD/CAM technology on their resumes, but neither wanted to locate it in positions of greater significance in their careers and lives. Kim seemed to shift back and forth between wanting access to a tool and giving up on trying to gain control.

Attitudes stemming from all three of these perspectives converged in strategies of resistance. For example, students delayed completing routine assignments, such as turning in progress reports.

Jim: When are the progress reports due?

Eric: This week, I think. I got to remember one this time.

Jim: Yeah, so do I.

Eric: [jokingly quoting his report] "No progress, not much different than last week."

Sandy: [chiming in] "We decided to wait till the last week."

Gary: What will you really do?

Eric: What, for the progress reports? Some kind of BS, I guess. Sit down at the terminal and get creative with a beer.

Jim: Well, do an hour's worth of work and then make it look like a week's work. It would be really hard to go in there and not do anything.

Eric: No, 'cause you could say things like, "Oh, we've been discussing the modeling [laughs], the screw-type compressor and some solutions have been discovered," or something like that. Throw some big words in there.

George: Be vague. Be vague.

Although required to formulate design objectives, students turned the projects into drawing exercises anyway. For example, when they encountered difficult geometric complexities, they simply left things out. In her journal, Sandy described the problems her group had modeling the casting for their stadium light and how, in the end, they eliminated the lamp itself. A serious problem in Eric's group was trying to use the slab to make a helix:

> The thing is, you can't helix in ISD. We've got a screw type compressor on our supercharger, so it's like a helix wrapped around the inside of a cylinder. It's almost like a screw but it's got a bigger pattern to it. There's no way to get that helix in the ISD and model it. What we can do is make a slab that looks like one of the pieces and then rotate it. It's six inches long and we can take a chunk one-tenth of an inch thick and then rotate it a little bit each time. But do you realize how much space in the computer that's going to take up? About sixty chunks.

His group finally gave up and drew a bunch of circles to represent a helix. Meanwhile, Kim described how leaving things out was a way to cope with her confusion:

> How should we design on ISD? I think if someone explained it to me I would feel a whole lot better about the design. I mean we left out some parts that should be fairly simple to design so it's basically down to [drawing] a solid model. Shouldn't we be learning CADAM instead of being thrown another design project? I mean if he can explain that or justify and say that is what he wants us to do, then that's fine, but coming into the class I thought it was kind of learn CADAM for yourself. He exposed us to that, which is why the design part was so confusing. Yeah, now it is obvious he wants design.

From the instructor's point of view, by recognizing the limitations of ISD, students were successfully simulating a design process, for design was always messy. In the last class after project presentations, West offered congratulations and a final explanation:

You all did a real good job on the projects. The whole idea of the project is to give you a chance to explore design and try to use a CAD system to realize that idea. In almost all cases, it was painful in a lot of areas. I don't think that is atypical of this system. Granted, there are much better solid modelers than ISD, but there are 'Gotcha's' all along the path. Some of you hit more problems than others, but it always is going to be that way. Things just do not work that smoothly. I think you know that now. The comment everyone made that ISD helps you to visualize better is certainly true, but the other thing is we really didn't get you the tools, finite elements, heat transfer, or simulation software to allow you to do more than just see what you're designing. You guys did a good job.

Furthermore, I think you'll start the next design a little bit wiser, and that will serve you well. It's not the commands that count. I don't care what commands you use. The thing you learn is how to attack the problem through CAD/CAM. It makes you plan ahead. Regardless of what system you use, you will now be much better off. You'll also know to carry a bottle of Tylenol for the headaches along the way. CAD/CAM systems don't solve all your problems. They complicate some tasks and make others easier. Just drawing a point, for example. Don't put all your faith into your CAD system. Gain experience with it before doing the design.

But students saw this differently. The problems they encountered with CAD/CAM technology did not feel like routine problems of design process. They had come here with different expectations drawn from their other courses. When one dealt with technology, the issue was control. Having been denied control, they experienced the limitations of CAD/CAM largely as limitations in the course:

Sandy: Was the intention to get us to realize the limitations of the system?

Kim: He could have done that with a modeling project. I still don't understand why he made such a big deal out of designing, other than because he had to. I think they really need to sit down and define the purpose of this class.

Sandy: We were going to hand in our "back of the envelope" calculations on the back of an envelope.

Eric: That would have been great. You know, think about it, I don't think just modeling something would have been any different from what we did. 'Cause we would have seen all the different drawbacks from just modeling something.

Kim: I don't know that anybody used it in any way to design.

Jim: I didn't hear anybody.

Kim: Including all the analysis stuff would be great but we don't know how to use it.

Gary: Some people tried to say in their presentations that they did some analysis, but they were bullshitting. They were trying to suggest that they were

using this to design. Obviously, nobody was. If you have to eyeball things in, then what you've got is a picture.

Eric: The good thing, of course, is that it helps you to fit things in. We needed to show both the engine and the supercharger behind it. We told him that we wanted to be sure that the supercharger would fit where we wanted it to fit. That was the main reason I used ISD. I can see that being a good use for it, to see if everything fits, almost like a plant layout. You want to be sure that everything is going to go into the space that you want it to go in, to find that certain area. Obviously, that's something you can't do easily in CADAM alone.

Gary: So you learned how to draw pictures and mess with the mainframe?

Kim: How to call that phone number in the computer center to tell them [the system's] down again.

Eric: We already knew how to do things at the last minute. That's a well-honed talent. We have perfected it by the senior year.

The only outstanding question was who should bear the blame, the instructor or some invisible university authority:

George: I was walking back to my dorm and Dr. West was headed for the library. So we walked along and talked. So I asked him—I was pretty sure of the answer to this question when I asked him but I asked it anyway—if he decided what was taught in the class or did the university decree what he taught. I've been to his office and talked to him a few times. I think he's a pretty great guy so anybody that neat can't be [that] bad a teacher. [laughs]

He's very aware this class has too much information. He's very aware by the looks on our faces during the class that we aren't learning and don't care about a lot of his lecture stuff. He wishes a large part of the things that he's called on to teach in the class could be lopped off. He's working within the constraints that have been placed on him.

He says that his main goal in what he does is to get us to grab hold of the big picture of CAD/CAM as just a support tool. It's not this big thing that the world will one day rotate around. It's just a support tool to be used by us in industry, and possibly a very good one.

Jim: That's kind of interesting. He realizes that we don't care about this stuff.

Sandy: Basically all this should be is one lecture period and the rest labs. He can tell us all the important things in that one lecture period.

Learning CAD/CAM technology was thus an experience in the fashioning of selves as students found themselves changed by the process of getting inside the technology and adapting themselves to it. Although faculty appreciated the complexities involved in entering the technology and allowing it to become part of oneself, they could not describe the process in such terms without looking silly and appearing to confuse machines with humans.

Students resisted a process that deviated from the practice of gaining control, which they had experienced many times over. They acquired practices that blurred the boundaries between themselves and the CAD/CAM machines but did not overtly link this process to other experiences of self-fashioning, such as plotting career strategies. Getting inside CAD/CAM or letting CAD/CAM inside themselves did not have any clear or sensible meanings in the dominant language of gaining control. Students did not routinely connect the pathways they plotted into and within CAD/CAM technologies with the pathways they plotted for their lives.

Relying on the dominant image of technology outside human society thus appeared to structure a systematic confusion in the CAD/CAM course by leading both instructors and students to formulate and describe objectives in control terms. Everybody knew that industry was charging headlong in CAD/CAM technology and that any demonstration of understanding could be a ticket to a job. The legitimacy for teaching CAD/CAM was there, but the theoretical strategies for integrating it into established practices of engineering education were not. CAD/CAM learning rested uncomfortably in both the engineering curriculum and the bodies of its students.

Would retheorizing the learning practices in this course make a difference? Would it be helpful to think about teaching CAD/CAM as the locating of students inside the machine and the machine inside students? I address this question in chapter 10.

CHAPTER 9 | The Making of Experts

I NEVER MET THE MAN, but it was not really necessary. He had been gone from the CAD Lab over a year by the time I arrived, yet his reputation was established and secure, and I could figure out a lot about him by watching the others. Although only a master's student, Steve Wampler had coded the bulk of the fifteen-thousand-line CAD program called ACSYNT/VPI (ACSYNT-V-P-I) in less than six months, producing more than eight hundred flow charts to map the logic in the code. Dr. Myklebust once told me, "We want students here with creativity and drive. Steve was one."

The story behind Steve's work had already gained mythical status in the lab, in the sense that it helped explain to everyone their collective origin. One day in 1987, in the weekly colloquium held in the mechanical engineering department, Sam Wilson was outlining with typically intense passion the sorts of projects that two government agencies were interested in funding or co-funding. These were the Defense Advanced Research Projects Agency (DARPA) in the Department of Defense and the Ames Research Center (Ames) in the National Aeronautical and Space Administration. A long-time researcher and administrator at Ames in the heart of Silicon Valley, Wilson had gone to the Department of Defense for a year to work at DARPA, which had long provided a main source of military funding for university-based research. One of Wilson's long-standing interests was in enhancing the ACSYNT computer program that Ames engineers had been using to evaluate design concepts for military aircraft. Wilson wanted to continue improving work in synthesizing different types of analysis and already had several grants outstanding to faculty at Virginia Tech, his undergraduate alma mater.

Aware that the computer output from an ACSYNT calculation was a long list of numbers, Dr. Myklebust rose at the end of Wilson's talk to ask if he had any interest in visualizing the output from ACSYNT through geometric modeling. In other words, might it be worthwhile to convert those numbers to pictures? "He offered me $100,000 on the spot," said Myklebust in an interview. "We worked out the arrangements that night." In a separate interview, Wilson said,

> *I saw what he had done previously with [a helicopter program] and I asked, "Can you do this with fixed-wing programs?" He said, "Sure we could. We can do anything." So I went back and got the $50K from my boss and $50K from NASA and put it together.*

Myklebust's version of the story then relates a long struggle in his lab to build models of aircraft surfaces using a format that would intersect nicely with equations commonly used in aircraft design, as well as an eventual decision to fall back on a simpler approach that would get some pictures on the screen and 'show results.' The desire was to locate a method for converting the numbers that ACSYNT analysis produced into models of curves and surfaces using Bsplines, but they were forced to adopt a different format. As Myklebust told it, he "put several students to work on the problem." One of these, a master's student named Steve Wampler, "worked like crazy." "After I showed him how to do the charts [i.e., written flow charts for a structured computer program]," Myklebust explained, "he took off like a shot. He worked like a madman." Six months later, he continued, "We took it out there to Ames, and they went nuts." As Wilson put it, "In December, I was back at Ames. Myklebust came out and they had already done it. It was beautiful. I was in love. Great!! I had been trying to get this for ten years—someone to get me a built-in look at the airplane."

When I arrived in the lab, everyone was still working with Steve Wampler's graphics code, the main part of which was called ACSYNT/VPI. What the graphics code was and who Wampler was had become merged together. Wampler somehow was still there, still present in the lab. People had to deal with him everyday, for they had to work with his code. Like others who had contributed to ACSYNT/VPI, Wampler the programmer was living in the code even though the body of Wampler was, as I was often told, "off to IBM."

Steve Wampler had become a skilled expert. In a world dominated by a sharp cultural boundary between humans and machines, the terms 'skill' and 'expertise' can be perplexing. Both referring to something located inside of people, these characteristics are largely unanalyzable, consisting of internal capabilities or tacit knowledge that outside observers can only surmise or infer. During my fieldwork, I regularly heard the term 'CAD person' applied with reverence to those who worked 'inside CAD' by those who

considered themselves somewhere on the 'outside.' For example, an audience member at the National Design Engineering Show and Conference asked a question after one presentation by saying, "I'm not a CAD person but . . ." I sometimes wondered what a CAD person was, how one became one, what it was like to be one, and, indeed, whether I was becoming one myself. The dominant image of technology outside society set off CAD persons as special people while limiting one's ability to examine the specialness.

This chapter explores the making of CAD persons. Making visible experiences hidden by the dominant image of technology outside society shifts in important ways what it meant for students to acquire skill and become experts. That is, since CAD/CAM students were learning how to adjust their bodies to be able to travel through CAD/CAM systems, skills could be described in external terms, i.e., in terms of the specific agencies of drawing, design, and analysis made possible by the joining together of human and machine. In other words, skills appear as the configurations of adjustments people actually made to use CAD/CAM systems, to become their users, freeing the concept from its metaphysical mystery while also making it easier to understand and interpret differences among the skills or expertise of different people. The expert becomes the person whose identity is wholly connected to the machine.

Birth History

One can tell a lot about how people experience the present by exploring how they structure the past. Every form of historical account gives visibility to or privileges certain things while leaving out or ignoring other things. The dominant image of technology outside society includes an historiography, or approach to interpreting history, that structures time as a sequence of technological innovations, each of which possesses a distinctive origin story or account of its creation. The image makes engineers special as the creators of new technologies.

As the Wampler story illustrated, the engineering historiography of CAD/CAM technology generally relied on accounts of the genesis of new technology, namely who originated it and how it got here. The focus was sometimes on the technological objects themselves, e.g., ACSYNT or ACSYNT/VPI, and sometimes on the mathematical agencies that constituted the essential contents of such objects, e.g., flowcharts, lines of code, and Bsplines. In either case, what got accomplished were family genealogies. As if they were walking guests backwards through the family photo album, explaining who begat whom, engineer-historians of CAD/CAM technology tended to point backwards from each contemporary technology to its point or points of origin. These maps of descent lines, e.g., the marriage of Myklebust and Wilson to produce Wampler, were thus not accounts of dead things, but of things very much alive and kicking in the present.

Every written history of CAD/CAM technologies I have seen in engineering contexts calls attention to 'interactive computer graphics' as the core technology distinguishing the field and points back to 'Sketchpad' as the crucial point of origin. Attributed to the engineering genius of Ivan Sutherland while he worked at MIT during the 1960s, Sketchpad was a simple device that nonetheless demonstrated the possibility of active drawing and manipulation of objects on a cathode ray tube. The Introduction to CAD/CAM class, for example, began with a brief history listing Sketchpad as the initial creative product founding the field. As our textbook put it, "To many observers, [Sketchpad] marks the beginning of interactive computer graphics."[1] Perhaps the most prominent early native historian of interactive computer graphics, S. H. Chasen located Sketchpad alongside APT, the computer program used in numerically controlled machinery, passive graphics, the light pen, 'tablet' input, and proprietary developments at General Motors as key technologies in the 1950s and early 1960s constituting the "birth of interactive computer graphics." His account of each technology included a story depicting the events of birth.[2]

Writing in 1981, Chasen then traced the 'childhood' and 'adolescence' of a technology that had not yet matured. During the 1960s, the childhood period included software development at Lockheed that led to CADAM (our classroom software), development of time-shared systems with multiple graphic terminals, McDonnell's work leading to UNIGRAPHICS, the rise of academic work on computer graphics and geometric modeling, development of computer-independent graphics, and the advent of the storage tube display technology and turnkey system. The appearance of new technologies during the adolescent 1970s increased so quickly that Chasen replaced his narrative account with a year-by-year listing of accomplishments and expanding professional interests and organizations.

In such genealogies of technology, getting one's name attached to something was one's ticket to immortality—one became an ancestor, a producer of lasting progeny. It is in this sense that Steve Wampler still existed in ACSYNT/VPI even though he had accepted a job and left. In Euroamerican kinship systems, one exists in the future through children who carry on an essential biogenetic/spiritual substance or essence. In other words, we live for our children because we live through them. So it is with the producers of technologies that impact on society and guarantee progress. We are to celebrate the progeny of those who really 'produce,' and mourn, or, worse, forget those who remain childless.

I first came to appreciate the potential intensity of this desire for continued life through technology during an interview with Bob Mann, a prominent MIT professor of mechanical engineering who had specialized in engineering design throughout his career. At the end of a fascinating ninety-minute interview tracing the struggles of design education and research during decades that placed ever-increasing value on engineering science,

Professor Mann suddenly shifted the topic. He began to recount the early history of computer-aided design and the role his division within the department played in originating and developing this concept. I slowly became aware that another researcher had recently claimed in a published account to have given birth to the concept, and Mann wanted to set the record straight. He gave me reprints of two earlier publications, Mann and Coons (1965) and Mann (1981), which established that he and Steven Coons were there at the moment of creation, and a just-completed twenty-page history of computer-aided design called "Computer-Aided Design—1959 through 1965—in the Design and Graphics Division of MIT's Mechanical Engineering Department" (Mann 1991). This history details in third-person who was serving on whose Ph.D. committees and who was doing what when the crucial birth events took place. The name Coons was already immortal, despite his death, for he had given birth to 'Coons patches,' a mathematical technique for describing a big complex surface as the sum of small, simpler surfaces, called patches. The birth history of the label CAD was evidently an acute issue for Mann because he was approaching retirement. For him, the question of accuracy was also a question of persistence, of survival.

Birth history also seemed to play a significant role organizing daily life back in the CAD/CAM Lab. But in that case, the issue was always one of becoming, of the sort, "Will I, can I, give birth?" The impact theory's version of history not only canonized those who had made it and gained the status of genius. It also put a great deal of pressure on those who were not there yet.

Becoming Hardware and Software

Doing master's- or Ph.D.-level work in the CAD Lab meant that the technology was making more than a partial claim on selfhood, involving a struggle of one's being as a whole. Whereas undergraduate students struggled to fit themselves to CAD/CAM and CAD/CAM to themselves, for graduate students the stakes were much higher. Minimally, the acquisition of expertise involved extensive travel inside the system, so describing the process requires mapping some of the technical dimensions in greater detail.

I began attending the weekly meetings of ACSYNT researchers, attending graduate courses, and otherwise hanging around the lab. I was already well aware of the sharp boundary between undergraduate and graduate activities, for the lab was divided into two sides, and I had become accustomed to watching graduate students through the glass wall that separated their research activities from the undergraduate lab. Also, for some graduate students, working as teaching assistants in the undergraduate course with salaries paid by the department served as apprenticeship for research work with outside funding. The primary charge for student researchers working

on ACSYNT/VPI was to enhance features of the graphics code in ways that would count as legitimate academic research in geometric modeling and that Institute members would find valuable.

Membership in the group appeared to depend upon one's willingness to undergo significant personal transformation. For example, James Williams [pseudonym] had returned to graduate school after three years at AT&T, where he had spent most of his time testing circuits on wiring boards, a job he found intensely boring. J.W. was an attractive candidate for the CAD Lab both because of this experience and because, prior to finishing his undergraduate degree, he had enrolled in the Introduction to CAD/CAM class. "Good ole senior design projects," J.W. remembered. "We sat around and got drunk for the first three months, and then did something the last month." In an interview, he described how "Dr. M," as Professor Myklebust was known to students in the lab, had telephoned him during the summer to offer a graduate assistantship. A graduate assistantship paid $1,100 per month for nine to twelve months, at twenty hours of work per week, less approximately $3,000 per year for tuition. Each year the mechanical engineering department ranked incoming students and awarded assistantships on the basis of the rankings. Professors competed with one another to have the best and most appropriate students assigned to them.

Dr. M gave Williams the option of starting right in on the ACSYNT/VPI project or working as a teaching assistant in the lab. Williams chose the latter. "I felt scared coming back in," he said. "I didn't figure I could contribute much to ACSYNT. Plus he was pushing me that way, He needed a TA. It's a good way of getting people up to speed before they start on a project. I would've wasted their money otherwise."

Working as a TA, however, was not particularly enjoyable. "[It was] a pain in the butt," he said. One difficulty was that the course had changed in significant ways since he had taken it: "[W]e hadn't had CADCD or ISD, so I was constantly trying to stay ahead of the class." His main problem became balancing the work of teaching with the work of learning. "[Anne Zeilfelder] had this idea that you spend fifteen hours in the lab for office hours and teaching, plus the assignments to grade. She assumed that took the other five hours. That didn't allow a lot of hours to play catch-up. I was constantly here that semester." This experience became the beginning of a long-term commitment.

In contrast with undergraduates fitting their bodies to CAD/CAM technology sufficiently to claim in job interviews some measure of control, graduate students were refashioning themselves sufficiently to establish a deep, abiding, long-term personal connection with CAD/CAM hardware and software. For budding experts, CAD/CAM was becoming a significant marker of a total personal identity, a career track or way of life. Much of the transformation took place in two semester courses called CAD I and CAD II, which functioned together as a single rite of passage. Although other schools

I researched had different names and formal structures for the material in these courses, the transformations they achieved appeared very similar. Based on the ways participation in these courses came to define people as CAD persons, I came to think that better names for them might have been Becoming Hardware and Becoming Software.

Becoming Hardware fitted students to current technologies in the computer graphics industry, moving well beyond introductions into all the major classes of graphics hardware and software, often mapping company by company. For example, where undergraduates had been positioned amidst three different classes of display hardware, such as, the vector refresh, direct view storage tube, and raster scan, graduate students were positioned in the midst of specific models manufactured by Tektronix, Sun, Evans and Sutherland, Silicon Graphics, IBM, Stellar, and so on. Students were brought deeply into the digital world of graphics processing so they could understand and participate in the widely varying choices each manufacturer had made or could have made. During this study, students learned to work with IBM 5080 (pronounced fifty-eighty) and 6090 (sixty-ninety) terminals and a couple of Tektronix terminals, all connected to an IBM mainframe computer, as well as the display hardware on IBM RT and Silicon Graphics IRIS workstations. Aiming ultimately to write their own software, students would thus be better able to engage the diverse mathematical agencies they encountered in hardware.

"How many bit planes are available in a display system?" This was regularly the big question, the bottom line, when it came to sizing up some graphics hardware. A raster-scan display device divided up the screen into a maze of points, or 'pixels,' that lit up individually. Each pixel was controlled through a map of information that was stored and managed in digital memory processors. The simplest map was when the on-off action of the pixel was controlled by a single on-off bit of information. Because a display screen was visually of a two-dimensional plane, this simple map of information was characterized as a single bit plane. Bit planes controlled pixels.

Students Becoming Hardware acquired all sorts of reasons for turning pixels on and off. For example, 'hidden-line removal' was a common strategy for making solid models look like objects. This involved turning pixels off for lines that would be hidden from view if one were actually holding the object represented. Having additional bit planes for hidden-line removal would enable you to display such images more quickly, although such systems cost more. In general, the more bit planes one had available, the more options one had for messing rapidly with the lighting of pixels. Achieving animation on the screen, such as active rotation of objects, involved extremely rapid mathematical decisions to turn pixels on and off.

Probably the main use students gained for multiple bit planes was to produce colors on the screen. A color display device included three different color 'guns' in the cathode ray tube: red, blue, and yellow. Mixing the

electron beams from these guns, in different intensities, produced the different colors. The number of colors one could make depended upon the number of available bit planes, with options increasing according to the binary logic of digital computation. For example, the simplest case above of one bit plane was represented as $2^1 = 2$ options, on and off. Two bit planes gave one the option of four possible colors, or $2^2 = 4$. More common capabilities in display hardware included eight bit planes to produce 256 colors, since $2^8 = 256$, or twenty-four bit planes to produce 16.7 million colors, since $2^{24} = 16.7$ million.

The graduate students Becoming Hardware also learned to sort out display hardware according to a range of fancier capabilities. Having a 'frame buffer' sped up display processing considerably because it was a complete extra set of bit planes that loaded up with information while other bit planes were lighting up pixels. 'Anti-aliasing' allocated some memory to smoothing out diagonal lines across the screen. Because drawing diagonal lines with a rectangular array of points could make the lines look crooked, anti-aliasing messed with the intensities of pixels so the lines appeared straighter. 'Depth cueing' enhanced the 3D effect by increasing pixel intensity on features that were closer to the viewer. 'Z-buffering' was the set of bit planes dedicated to hidden line removal. 'Hardware shading' was an especially important, yet complex, display function for making images look like photographs.[3] Initially achieved through relatively slow software strategies with names like Constant, Gouroud, and Phong, shading through hardware was becoming standard. A final common question was, "How many polygons could it draw per second?" A polygon was simply a multisided geometric object, such as a triangle, with three sides, or a rectangle, with four. The word was important because measuring polygons per second was about the only strategy, albeit a crude one, for comparing the speeds of different graphics workstations.

Becoming Hardware also embedded students in some standardized software. Because display systems were both so different from one another and changing rapidly (chapter 4), it was impossible to write applications software that would fit them all. A danger was that CAD/CAM research could find itself thoroughly dependent on rapidly changing technologies from the unpredictable world of venture capital. For CAD/CAM researchers to substantiate the claim that they were contributing to knowledge, their work could not advance the interests only of specific vendors; otherwise, research would have become consulting. CAD/CAM researchers thus became perpetual advocates for a dream they called 'device independence,' making the value of their knowledge work independent of the specific devices in which it was realized.

The main strategy for pursuing device independence was to establish and maintain an additional layer of mathematical agencies between display hardware and applications software, namely graphics standards.[4] Students

learned two different standards, the older Graphical Kernel System (GKS) and the newly emerging Programmer's Hierarchical Interface Graphics System (PHIGS [figs]), both of which had been developed and adopted through the International Standards Organization. GKS and PHIGS specified standard ways for coding basic sets of graphics functions and structures, including everything from the widths of lines and colors of text to how to distinguish inputs from keyboards, mouses, dials, tablets, and so forth, and how to present 3D models from different perspectives. If vendors built display hardware that recognized these standard graphics routines, then presumably an applications program written for one vendor's workstation would be able to run on others as well.

As Figure 9.1 illustrates, CAD/CAM students were actually encountering more levels of mathematical agencies, but they could take some of these for granted. Appearing in a student text, the model separated the display terminal at the bottom from the host computer above it. Following the technology rush of the 1980s, it assumed that the bit planes we encountered above were located in memory processors in the display terminal rather than some central processor. Users traveled upward through a data communications line into the computer box, where they encountered the system software for the main host computer, which itself included a few layers of translation from the operating system to assembly language to hardware. Other types of people lived in these places—computer scientists. Computer scientists also lived in communications interface routines, the protocols of connection, and device driver routines, which translated all the commands received from the computer and communications interface into forms the display hardware could understand. As long as CAD/CAM students had the proper software somewhere, they could take these activities for granted. GKS and PHIGS fell into the next category of 'high-level graphics routines,' while ACSYNT/VPI and virtually all the other software used and written in the CAD/CAM Lab were various kinds of 'user applications programs' located at the top. Where undergraduate CAD/CAM students had lived entirely at the top, skimming along its surface, graduate students Becoming Hardware had to climb in there, onto the backs of the computer scientists.

Students quickly learned that standards were never standard. Formal agreements about standards were typically the product of slow, tedious decision-making processes, yet vendors were always seeking an edge in their markets. Those companies preparing to produce and sell software standards thus always added some attractive options or enhancements to an agreed-upon or forthcoming standard. Students Becoming Hardware thus found themselves having to live simultaneously in the remarkably distinct worlds of GraPHIGS and FIGARO, sold by IBM, and Template Graphics, respectively.

Much of the classwork in Becoming Hardware thus required one to acquire, through patient memorization and bodily discipline, the mathematical agencies to produce a maze of detailed, standardized graphics functions.

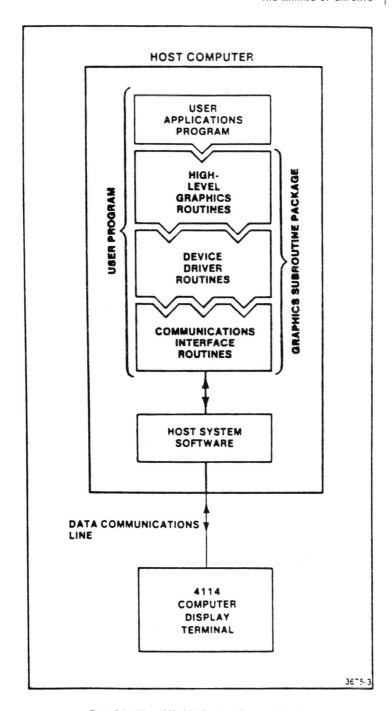

Figure 9.1 Where CAD/CAM Graduate Students Had to Live

At center stage were graphical transformations, which transformed 3D models through translation, moving an object along a line; scaling, making an object bigger or smaller; and rotation, turning an object in two-dimensional or three-dimensional space. Not only did students learn the equations for producing such transformations, but they also learned the specific programming practices for producing the equations. In sum, Becoming Hardware positioned students in virtual locations above computer science and below applications programming. As Sankar Jayaram, my instructor in the course, explained to students, "These are things you need to know to be in this business."

The second course, CAD II or Becoming Software, propelled students into the middle of the fray, the place where the action was, the core of CAD/CAM research. It located students deep in the complex mathematics of geometric modeling, or the mathematical representation of curves, surfaces, and solids. Surface modeling, defining objects in terms of their external surfaces, was the focus because many forms of engineering analysis, such as heat transfer and fluid dynamics, rely upon theories of forces or movements over or through surfaces. Such theories usually took the geometry for granted, as did theories of heat transfer that assumed flow through a two-dimensional plane. Analyzing forces or movements on a more complicated surface, such as an airplane wing or automobile body, could require extremely complex equations. Computational approaches to these forms of analysis, that is, approaches that used the computer, kept equations simpler by breaking up complex surfaces into thousands of small unit surfaces that were easier to describe mathematically, such as triangles or rectangles. The computer made calculations for each unit surface and then added up all the surfaces to approximate the behavior of the whole. Such approaches worked only because computers could do all the calculations very quickly.[5]

Geometric modeling was tricky to do because it involved developing novel methods for describing curves, surfaces, and solids that achieved three different objectives as the same time. Good methods were internally coherent mathematically, could be translated easily into the equations used in engineering analysis, and minimized processing time on the computer. Any student who dared enter the world of geometric modeling was thus accepting a challenge to become part mathematician, part engineer, and part computer scientist. Taking this step posed a threat to both body and career. The core of the danger, as well as the opportunity, lay in accepting that geometry could be an important place to do engineering research.

The big opportunity was to move to a world that was beyond three-dimensional space, a world that depended on three dimensions for its existence and yet offered control over them. This was the world of parametric space. Consider, for example, an example of translation. Perhaps students desired to move a circle across the screen. Visually, the location of the circle would move, but the circle itself would remain intact. However, from a

traditional algebraic perspective in a coordinate system, each incremental movement of the circle in the coordinate system would require a new equation and, hence, was a different circle. For example, the initial equation $x^2 + y^2 = 1$ would have to become $(x + a)^2 + y^2 = 1$, with a different calculation every time 'a' changed. Constantly recalculating and redrawing the circle could take a lot of computer time. Parametric space came to the rescue by separating the mathematical description of the circle from the mathematical description of the movement. In this case, the x and y values of points on the circle could be made dependent on a single parameter, the angle one made as one moved around the circle: $x = \sin\Theta$, $y = \cos\Theta$.[6] These parametric equations would hold no matter where the center was located on the screen, so the shape of the circle would remain constant. One had left behind the three-dimensional coordinate system while gaining control in it at the same time.

Another big bonus of parametric space was that one could draw and control complicated shapes by increasing the number of parameters. Parametric space was actually a whole population of new geometric spaces living beyond 3D. For example the equation $y = ax^3 + bx^2 + cx + d$ could be used to draw different curves depending on what numbers one substituted in for the four coefficients a, b, c, and d. The parametric form of this equation split it into two equations with one parameter and eight coefficients: $x = au^3 + bu^2 + cu + d$ and $y = eu^3 + fu^2 + gu + h$. The parameter was u and the coefficients were a, b, c, d, e, f, g, h. This form could generate a far greater variety of shapes. The general point was that mathematical theorists of geometric modeling were looking for ways to represent curves and surfaces that provided ever-increasing numbers of parameters with which to play, draw, model, and live.

A common strategy for increasing parameters and calculations without slowing down the computer too much was to layer parametric equations on top of one another. That is, just as x, y, and z values might depend upon the values of nine other parameters, so might the values of these parameters depend upon other parameters in a higher layer. Although students surveyed all sorts of approaches to the first layer,[7] the course gradually concentrated on one form in the first layer, the control hulls of Bsplines so resisted by undergraduate students in chapter 8, and one approach to a second layer, the world of 'knots.'

The mathematical, engineering, and computer science beauty of the Bspline curve was that one could draw precisely controlled, smooth curves using only data about points. Let us say a group of students wanted to draw a car fender they had just modeled in clay. They could get this shape into the computer by measuring points on the clay, connecting these points with little curves and surfaces, and then adding them all together. They would need equations for curves and surfaces that passed through the points they measured and produced smooth surfaces. Even one significant change in

shape mathematically, such as a big bump in the curve, could drastically alter subsequent analyses of aerodynamics and stress. The Bspline curve consisted of a large set of smaller curves. The great trick was that each of the smaller curves could be generated by specifying four points, called the control hull. The control hull lived in parametric space one layer above three-dimensional space, and the smoothness of the curves was determined by parameters called knots in a second layer. All the curves and surfaces could now be produced entirely through combinations of data about points, for which digital computers were very good. In fact, with CAD/CAM systems built with Bsplines, the whole step of clay modeling could be done on the computer.

Students who accepted the discipline of geometric modeling established new relationships with the geometric images on display screens. Having entered parametric space, they had merged themselves with the complicated layers and webs of mathematical agencies involved in generating images. For the students I followed, the sacrifices involved appeared to be worth it. Although giving up or suspending other sorts of bodily agencies, such as the artistry of clay modeling, and valuing all of one's actions wholly in mathematical terms, the payoff was the opportunity to do new things, to add new agencies to the mathematical processing of geometric models. Geometric modeling was the key activity of CAD persons.

Ownership

Visiting CAD/CAM systems was not enough for budding CAD persons. Graduate students could not simply become temporary guests or tenants of the machine, or even only guides for others. They had to make contributions, produce their own creations, build places for others to travel. As a way of leaving behind a trace of self, they had to own something.

Bob Jones and Fred Marcaly arrived in the lab as master's students at roughly the same time. Bob had been an undergraduate at Western Michigan University before working for a couple of years in industry. An outwardly confident, assertive, ambitious, and, yet, playful person, he had come back to school to gain a credential in software engineering, which he considered important to moving up in the world of engineering design. The University of Michigan had offered him admission but no financial support initially. "You have to come from a prestigious school," he told me in the lab one day, "to get support at first." So he took the difficult step of leaving his girlfriend in Kalamazoo for eighteen months and accepting a graduate assistantship at Virginia Tech, where he joined the ACSYNT project. "In some ways," he said, it was "probably better that she is not here" because he found himself "basically living in the lab."

Fred was looking for a way to get into the automobile industry. A quiet,

mild-mannered guy, he described his educational career in engineering as a series of struggles, and "persistence" as his most important quality. Fred had begun his engineering career at Purdue University, but he felt lost and out of place and his grades suffered the first year. Before the year ended, he transferred to a smaller school, Widener College, where he completed his undergraduate degree in mechanical engineering. Because a job in the automobile industry was not forthcoming after graduation, Fred applied to graduate school in search of the right key. He was clearly in awe of anyone with a Ph.D., which he considered a marker of persistence in the highest degree. Struggling to make his way through the daily demands of CAD education and research, Fred sought refuge in the quiet of late-night work, sometimes staying in the lab until dawn.

Within the ACSYNT project, Bob and Fred stood for Bsplines. They found their bodies, lives, and careers caught up in a plan to rewrite the ACSYNT/VPI code using Bspline surface models. The justification was that this step would help engineers in conceptual design link their models to the more complex computer codes used downstream in preliminary design.[8] In particular, one rapidly growing area was 'computational fluid dynamics' (CFD), which used supercomputers to analyze the precise flows of air across every surface of an airplane in a never-ending search for strategies to increase 'lift' and reduce 'drag' at speeds both below and above the speed of sound. At NASA-Ames, CFD work was headquartered in a special building off by itself that looked like a shrine for the supercomputer.

Bob's task in his master's thesis was to figure out how to describe mathematically the intersections between the surfaces of different components of an aircraft, such as wing, fuselage, and tail. Because CFD codes did not distinguish the different parts of an aircraft but analyzed airflow over the whole thing, assuming surfaces without sharp corners or edges, it was important for surface models to achieve that same effect. Bob had to find a way to join Bspline models of individual components in a way that would produce an exceptionally smooth transition between them. Another way of saying this is that Bob had to figure out a way of automatically transforming a sharp corner into a rounded corner or fillet, all using the mathematics of Bsplines.

Fred's task was also to model an aircraft with Bsplines, but with a different approach. Rather than taking for granted that an aircraft consisted of distinct intersecting components, he was to pretend that it was one large, continuous surface and then produce a mathematical model of the whole thing. For reasons I never understood, this turned out to be impossible mathematically, and he shifted to a different project. This shift was significant for his identity as a CAD person. Although Fred could have argued that he had contributed to CAD/CAM knowledge and, hence, deserved a master's degree by demonstrating the impossibility of one approach to surface modeling, such an award would have left him out of CAD history. Fred

would have stood for an impossibility, a void, a gap. Nothing could be named for him. Rather than being able to claim a spot in the CAD/CAM descent line, he would have stood for a pathway not taken, a decision abandoned, an approach that could not lead to innovation and progress. He could have become known as a researcher with a bad sense of direction. Clearly, becoming an icon of nothingness was a less than desirable strategy for a CAD person wanting a job and a place in the field. He had to move on to something else, eventually landing on the tasking of reducing the amount of data required for a Bspline model of an aircraft.

Bob achieved some success in his research on intersections, "getting a thesis out of" formulating a method for automatically filleting the intersections between two surfaces. His work fell short of automatically filleting corners where three different surfaces come together, such as the four corners on the floor of a rectangular room. Fred produced a method for reducing the amount of data necessary to model Bsplines surfaces by means of 'knot removal,' or reducing the number of parameters needed in the second layer of Bspline mathematics. As master's-level research, these projects certified their authors as legitimate CAD persons who had made permanent places for themselves inside the machine. They were now worthy either of more advanced research or paid positions in software engineering. Bob took a job designing automotive seat mechanisms while Fred found a job in the auto industry.

Ph.D. students had to leave behind more than a trace. After I left the Lab, Uma Jayaram, a Ph.D. student in CAD/CAM, accomplished the larger goal of converting the entire ACSYNT/VPI code to Bspline format from a more primitive form. Uma had been trained initially as a mechanical engineer in India at the prestigious Indian Institute of Technology. After being ranked #482 on an entrance exam taken by one hundred thousand people, she had won one of two hundred available scholarships and entered IIT at Kharagput as the only woman in a class of fifty-five mechanical engineering students. She was actually the first woman at her institute to select mechanical engineering as a first choice, which had always been almost exclusively the province of men. Highly placed women had tended to go into electrical engineering, which was ranked slightly lower in status than mechanical. Because advanced degrees from the United States carried great prestige, both she and her husband, Sankar Jayaram, came to the United States to pursue doctoral degrees. Both also found their way to the CAD/CAM Lab.

In a way, Uma's work did shift Steve Wampler into the past. "It was complicated," Uma said in to me in an interview. "I was supposed to put everything together so it looked seamless. Fortunately, there's been no major problems." "She did wonderful work," said Myklebust, her advisor. Wampler still lived in the code, for the traces of his presence were everywhere, but it was no longer his as a whole. The ownership had shifted. The baton had been passed. The furniture in the graphics code now

belonged to Uma, and stories changed accordingly. I talked with a couple of newer students who traced genealogies that followed Uma Jayaram's contributions back through Bob Jones, Fred Marcaly, James Williams, Steve Wampler, and numerous others whose owned something in the code and, accordingly, were worthy of position in its history.

I had an experience in the lab myself that reinforced my sense that owning code was crucial to achieving membership and place. Since I had been busy trying to understand the structure of the CAD/CAM industry, Myklebust asked me if I would be interested in designing an expert system to help potential buyers select and configure specific systems, for which he would pay me extra summer support. I accepted, wanting both the money and to make a contribution. I also thought designing an expert system was likely to be the best way to understand how they worked. Initially, the task involved figuring out how to adapt an IBM software product for writing expert systems, which was called Expert System Environment (ESE [E-S-E]). Having my own research project in the lab changed my relations with students, who stopped inquiring why a professor would be interested in, as Williams put it, "a bunch of students working with a cheesy code," and began teasing me about my efforts. "I hear you're the expert on the expert system," said a student one day. "I trust you will now be here all night every night," added another. When my oldest daughter came into the lab one day to see what I was up to, several male students stopped by to introduce themselves and tell her I was now "owned by the lab" and that she "shouldn't expect to see much of [me] anymore."

I had expected the job to involve simply learning another applications program without a thoroughgoing personal involvement and commitment. However, I quickly found the pressure to make a difference, to extend my own agencies into the machine, too great to resist. In addition to building a system of expert answers to likely questions from prospective users, I needed also to build a large database of information about rapidly changing hardware and software. If my answers were going to take the form, "Go try such-and-such," I had to put together a large list of such-and-suches. Taking this one small additional step involved six weeks of negotiations and false starts with technical support personnel from the University Computing Center. ESE was not a database program and I had to figure out how to connect it to SQL (see-quil) a popular database program not then available on my system. I began to feel I had to travel everywhere in order to take my first step. As the weeks wore on, I felt increasingly inadequate, for not only was I not the expert on the expert system, I could not even get the damn thing to run. I asked for help in some instances but was mostly too embarrassed to reveal my ignorance. I was an outsider.

Then, finally, I had a great week. One Saturday night, I got a small program to run properly, and I had a sense of what needed to be done to make it bigger. I encountered a series of small problems, and began to go to others

with intelligent questions for help. I went through a series of interactions: trying something, encountering 'errors,' and resolving them. By the end of the week, I realized that my whole attitude had changed. I had become part of the lab. I was a member. I was becoming a CAD person. But what was it that had changed? Why were things different? It suddenly hit me: I had bugs. I was contributing to the lab because I was now coding. I was producing something that might establish a small place for myself in CAD history.

At the same time, the experience of belonging was interesting for me because it was, in a way, also alienating. Until that point, I had considered working toward becoming an adjunct faculty member in mechanical engineering, perhaps contributing to engineering research. But my struggles with bugs had not been enough fun, not sufficiently satisfying. Creating a rudimentary expert system had given me less pleasure than figuring out how people designed and used expert systems. Although engineering had long ago made an indelible impression on my body and life, my career goal had shifted away from designing new technologies. After a drink to celebrate the moment, I began a long process of withdrawing myself from full participation in the project and the lab. Becoming a CAD person was not for me.

Experts in Science?

Whereas graduate students lived with a challenge to prove they could become CAD persons, faculty researchers lived with a challenge to prove that being a CAD person was a worthwhile way to do academic research. Competitiveness, automation, and the dominant image of technology outside society offered a significant source of legitimacy, but CAD/CAM researchers still had to cope with condescension. Every researcher I talked to at any length mentioned the problem of 'pretty pictures.' Referring to other professors in mechanical engineering, Uma Jayaram once remarked to me that "in the department, people say that in CAD/CAM they just make pretty pictures." Don Riley, then associate professor of mechanical engineering at the University of Minnesota, told me, "I got promoted on what they call 'pictures,' but the junior guys are now saying, 'I can't afford to do that.'" Consider also this exchange with David Gossard, professor of mechanical engineering at MIT, about his career in CAD/CAM research:

Gossard: [When I started], graphics was considered a brash newcomer on the academic scene in general, and the engineering academic scene is even more conservative. I found out very quickly that I had to make my way, earn my spurs as I went. I had to prove, often at great length, that this is not an area to invest in just because of the flashing lights. . . .

Downey: Is that still a problem today?

Gossard: Oh, very much so. You bet. You bet. Many among us would disdain-

fully refer to the 'pretty pictures' and 'just another pretty face' and so forth. So yeah, very much so. It's still a fact of life.

Explanations for this state of affairs generally pointed to World War II, or Sputnik, or some other point in the just-distant-enough-to-be-significant past, when all power in engineering research had shifted away from the 'design' and 'manufacturing' side of engineering to the 'science side.' The science side in mechanical engineering was the side of 'thermal-fluid sciences,' 'analysis,' or 'theory work,' which had indeed prospered during the previous few decades. Meanwhile, the design and manufacturing side had languished as a required component of undergraduate curricula but not something that could serve as a legitimate subject of research. As Gossard noted:

> *If we take kind of a twenty-year vision here, since World War II, in the classical pecking order of the engineering disciplines, such as vibrations, heat transfer, fluid mechanics, thermodynamics, and so on, design and manufacturing have been distinctly seen as second-class citizens. I mean, surely you were aware of that.*

Or as Riley put it in 1990:

> *Up until maybe the last five years, it was very difficult for people in the design area to get funding from agencies like NSF, and to get peer recognition in terms of promotion decisions. In my mind, that is a real fundamental conflict within mechanical engineering—between what I will call the 'science side' versus the 'methodology in application,' which is related to design and even to manufacturing.*

The science side set the agenda and criteria for rewarding faculty. "You get rewarded for research, teaching, and service," said Gossard, "in that order, basically." In addition, "research, it turns out, which I didn't discover until very late, is fortunately measured in several different currencies." The main currency was "refereed journal publications," but "you can also have what I would call 'raw activity' as measured by either money, you know— sponsored projects, or students, or equipment, or any other signs of life." "I also found out later," he added, "that ideas count to a surprising degree." Demonstrating that one had ideas involved "people from other schools writing long, soul-searching letters that say, 'Yeah, that guy Gossard's got some good ideas. He did the blah-blah work, you know, which has since been picked up by other people and has influenced researchers at the blah, blah, blah.'"

Riley described the measures of value in similar terms. "What you look at," he said, "is evidence of productivity and value. Journal publications are always right at the top of the list." It was significant that, in engineering,

"right after that is funding, but funding without results is no good. You could bring in a half million dollars of funding, but if you are not publishing, you are not going to make it." Also, not all journal publications were the same, for "there's a hierarchy in publication." At the top were the "archival journals," which meant that "in five or ten years from now, somebody might want to read it," followed by "other kinds of journals that aren't as good." After that were "refereed conference proceedings" but "some promotion and tenure committees do not count those." Finally there are "things of little relevance" such as "an article in a mechanical engineering magazine." Books "are of some value, but mainly at the senior level."

In the context of an emphasis on basic research in engineering science, research on computer-aided design and computer-aided manufacturing tended to find itself on the margins. The main point of contention was whether the computer offered a legitimate site for doing research or was simply a support tool for other sorts of research. In other words, the dominant image of technology outside society tended to make CAD/CAM research feel more like technological development than contributions to the general stock of human knowledge. "The issue," Riley said, "is whether you can get it published anywhere, and there are not many outlets for such work," especially in the main journals of the professional society, the American Society of Mechanical Engineers (ASME). "My Ph.D. thesis," he continued, "had to do with analyzing human motions using computer graphics and interactive techniques, and I couldn't get that published in any ASME journal." Nevertheless, he was able to gain tenure by involving himself in so many projects that he became indispensable:

> I think I am sort of a counter argument to everything I have been telling you, [laughs] because I haven't worried much. I know I have to do publishing, and I do try to get things in journals from time to time, but I haven't let that be my driving force. I have a lot of joint publications [he got second authorship by helping people do visual analyses of their models], a lot of refereed conference publications. I do a lot of collaborative stuff and administrative kinds of things. I think the fact that I just worked very hard and have done so many things that it was hard for them not to promote me.

In other words, knowledge development inside of technology could possibly provide grounds for promotion and tenure, but it was difficult to explain exactly how. Only two available options helped explain CAD/CAM research in terms familiar to engineers: doing science or making pretty pictures.

Initially in seeking tenure, Gossard had aggressively pursued a wide range of projects spanning the gap between design and manufacturing, from designing a new computer-controlled machine for bending sheet metal to ensure that it sprung back to the right shape ("I got a royalty check three

weeks ago") to coding CAD software that began not by drawing points, lines, and circles but by defining parameters such as length, width, and height in relation to one another. He was a living example of the national goal to smash the boundary between design and manufacturing through automation. Although building a lab with fifteen students, Gossard worried that science-side colleagues would find his work too diffuse to warrant tenure: "I finally made the personal decision that, if I was going to make my mark in the international research community, I was going to have to specialize." He chose the CAD work: "I dropped the CAM side." Unlike his work in machine design and manufacturing, in CAD "at least you're manipulating equations."

The significant change during the previous five years that Riley mentioned had been a massive shift in funding priorities. Since its establishment in 1949, the National Science Foundation (NSF) had actively legitimized new fields of scientific research by establishing funding programs to support research within them. During the 1980s, NSF had begun to emphasize research oriented to enhancing American competitiveness. In 1985, for example, the Engineering Directorate within NSF had reorganized itself into five divisions, only three of which were reserved for traditional areas of 'basic' research in the engineering sciences. One new division was devoted to expanding scientific research in design and manufacturing. Its program description asserted that it was "concerned with developing engineering science bases in fields such as design, manufacturing, and computers which do not currently benefit from such a knowledge base." A second new division was devoted explicitly to the problem of competitiveness, "support[ing] research and related activities in areas where new knowledge can contribute to the industrial competitiveness, manpower, and infrastructure needs of the U.S." The doctrine of competitiveness, with its goal of automation and implicit reliance on the impact theory of technology, had begun to channel research support to the general areas of design and manufacturing. Research on the margins of engineering science had begun to get support from the center.

One new area gaining support was 'design education,' which began to attract greater interest among engineering instructors and really caught NSF's attention beginning in about 1987 or 1988. In the past, said Gossard, "You ha[d] to teach design because the students ha[d] to go do it, but nobody liked to do it, and it was not rewarded. No one who did it got rewarded. It all kind of circled down on itself. Yeah, it was ugly. It was bad." But things had been changing. Gossard described a colleague who was firing students' passions with design contests built around the control of machines:

> *Any kind of sour grapes by the faculty was drowned out by the students cheering for Machine A to beat Machine B. They scream like crazy for Machine A to rip B's arm off or kick it off the platform. So much life and enthusiasm and control.*

In other words, faculty in design education, "the popsicle stick and bailing wire bunch," appeared to be gaining visibility but were facing a huge uphill struggle for respect.

A second new area was 'design theory and methodology,' which sought to build a theoretical or scientific foundation for the practice of design. Gossard described,

> *This crew is pursuing the dream or, I should say, the idea that design, and manufacturing too for that matter, should have, can have, and will have someday a set of underlying fundamental principles, which can be expressed in textbooks and formulas and procedures. It'll be some kind of codified design wisdom.*

Gossard had begun choosing his words carefully. Perhaps it had something to do with the fact that one founder of this movement had recently become his department head. I had initially encountered research in design theory and methodology while attending a large conference of professors in mechanical engineering. I had been surprised at the extent to which these researchers reached outside of engineering to draw theoretical insight from psychology, cognitive science, and social science to develop models of design thinking and action. I had wondered how they would fare while operating on the margins of conventional engineering research.

Gossard: Those people are in a real crunch, a real jam.

Downey: Yes, I've seen. They appear to be people who live on the margins of their departments. They even dress differently than the traditional researchers. I attended sessions on both sides.

Gossard: Oh, you did? Oh good.

Downey: Has design theory and methodology gained permanent status in your department [MIT's Department of Mechanical Engineering]?

Gossard: No. No, absolutely not. That's what I'm saying. Those people have a real problem . . . at least around here. This is a sufficiently conservative and hard-nosed place. They won't give that the time of day. On something like that, they say, this theory of design . . . rubbish!

CAD/CAM research was part of a third new area called 'design automation,' which was achieving greater credibility than the others. As illustrated by the courses in Becoming Hardware and Becoming Software, work in this area looked more like established activities in the engineering sciences because it was intensely mathematical. Design automation had received scientific sanction from NSF, new refereed journals had begun to appear (although amidst never-ending concerns about their 'scientific' quality), and a new division within ASME called Design Automation had provided a place for researchers to congregate and build solidarity. Finally, throughout the 1980s, large grants of equipment and support for research

had been rolling in from industry. In other words, in terms of the conventional measures that Riley and Gossard outlined above, CAD/CAM research had become almost indistinguishable from traditional research in the thermal-fluid sciences.

Nevertheless, ambiguity remained about whether CAD/CAM research contributed to knowledge or to pictures, and resistance continued:

Downey: I would expect that there's still those faculty who don't understand this, who still see it as bells and whistles because it's just the mathematical manipulation of pictures, who say things like, "So what, you can calculate the intersection between two surfaces. Big deal."

Gossard: Oh yeah. Oh yeah. That's true. But at least you're manipulating equations. The poor guys in design education are manipulating popsicle sticks. I'm telling you, they [the science faculty] just go ballistic.

Don Riley summarized how concerns about competitiveness had helped researchers in design and manufacturing gain visibility, even prominence, but not a sense of acceptance and security:

Riley: If you look at design programs around the country, they are generally very small and unrecognized. Sometimes they can even be a little paranoid of what was regarded as persecution from the science side. It's only been in the last ten years, as international competition and things like computer-aided design, robotics, computer-aided manufacturing, and artificial intelligence have started to become more and more fundable by a variety of agencies. There has been more and more interest in industry, and more and more attention to these issues, so design programs have started to grow again.

Also, ten years earlier there were maybe one or two manufacturing engineering programs in the country. The feeling then was, "Where is the research in manufacturing? All you do is build things." We were leading the world and nobody cared about competitiveness. Then as the Japanese started to catch on and emphasized quality and good solid engineering process, that's when people started paying attention.

Downey: I see. It seems that new legitimacy has come from the wider societal concerns about being beaten by the Japanese. The new legitimacy kind of flows in. We need new technologies, we need to train new students in these new fields, and increasing monies are available to people who want to do research on design and manufacturing. That seems to help faculty members strengthen their stands with their colleagues.

Riley: It has, but often some of it is done in a cosmetic way. They say, "Let's support design and manufacturing" but then when the crucial decisions come. . . .

Downey: Like what?

Riley: Like promotion and tenure. Those people still have a tough time getting through that process.

More Than One Dimension

Expertise was only one dimension of selfhood alongside others. In becoming CAD persons, students and faculty were building the agencies of CAD/CAM technologies into their bodies, justifying the sense that they were becoming experts. Although becoming a CAD/CAM expert had its downside in academic worlds that placed highest value on forms of scientific knowledge, there were also many benefits, including opportunities for jobs and funding. The dominant image of technology had long hid or made less valuable ways in which knowledge development could take place in the form of new agencies built into machines, such as improvements in geometric modeling. Also hidden were the ways in which the human expert might be more than an expert, or other than an expert. In other words, making visible ways in which skills or expertise might be experienced as configurations of technological agencies built into people not only makes the cultural boundary between human and machine something that could be experienced within humans, machines, or humans and machines. It also raises questions about how people called experts negotiate relationships between the expert and nonexpert parts of their lives and selves. One is never only an expert. For example, Arvid Mykelbust was not only a CAD/CAM expert, he was the CAD/CAM Lab. The CAD/CAM Lab was him, in the sense that everything that took place in the lab reflected on him, and vice versa.

One afternoon Dr. M showed up at the lab for a short time. The word I got was that he would be in for two hours. He had just returned the previous day from a trip overseas, and would be leaving the next day for a trip to the West Coast. Sankar Jayaram, who by that time was a temporary faculty member, knew he was coming and met him with a pile of paperwork. There was a rush to his door as students jumped up to request a bit of his time. I too needed to talk to him about my project. I realized then the extent to which, although we had all established relations with one another, who we were somehow all depended on him. Like spokes surrounding the hub of a wheel, we all had one-to-one relationships with Arvid, Dr. Myklebust, or Dr. M.

A few weeks later, I received a call from then Lab Director David Meehan, admonishing me for pulling an end run on the lab. In attempting to get the database program, SQL, installed on the lab computer, I had called the University Computing Center to request that it take a key initial step for me. David said, "You should have gone through the lab since this is software from the IBM grant. Arvid will be upset if he knows that someone else requested installation." When he realized that I had no idea I had done anything wrong because I did not understand the relationships involved, he backed off a bit and suggested gently that perhaps Arvid did not need to know what had happened after all. The University Computing Center had sent messages to both of them acknowledging the installation. Perhaps Arvid would not notice the message or would think he had made the request. It

THE MAKING OF EXPERTS | 233

was just that the Computing Center had been taking weeks to get some other software up and running, and I had managed to get something else done in twenty-four hours. I concluded the conversation by pledging my allegiance to the lab and expressing appreciation for his protection.

The CAD/CAM Lab was Dr. Myklebust and Dr. Myklebust was the CAD/CAM Lab. He had been its first and only director and had won a million-dollar grant from IBM to stock it with updated hardware and software. Despite the fact that students were working hard to establish places for themselves in CAD history, they were all working for Dr. M. Any degree of ownership they attained also belonged to him, because everyone's project belonged, in part, to him. He got a little piece of every action. He was a co-author of every paper. All useful output from the lab had the effect of accruing power and authority to him, and he was out scouring the countryside for more sources of support for his growing lab that would yield more good work and cycle more and more credit his way. This was an important story repeated over and over for many researchers and their laboratories. The head of a lab was a Big Owner.[9]

But more was involved than cycles of credit and control, for his life and identity changed in the process. Living at the confluence of different kinds of professional relationships meant that Dr. Myklebust and the CAD/CAM Lab had to cope with enormous pressures to occupy different sorts of positions simultaneously. Working to achieve legitimacy in engineering science was only one part of an activity that included delivering usable technologies to government and industry sponsors, providing a home for learning, and ensuring a steady flow of talented and capable potential employees. Each new relationship that the man and the lab acquired became a new source of identity that challenged them to be or become whatever it was that relationship demanded. In other words, both Dr. Myklebust and the CAD Lab had to accept the burden, and sometimes the format, of multiple relationships, multiple identities, multiple selves, interacting with one another. In order to keep the whole ship afloat, they had to accept the complexities of life as multiple selves.

One day everyone who was working on the ACSYNT project wandered into the lab's conference room for the weekly meeting. I had been attending as an observer. The university was in the midst of negotiating the lab's participation with NASA and several aircraft companies in the ACSYNT Institute. Written on the whiteboard in front of us was the ever-changing list of deadlines for all concerned, such as "Install ACSYNT on VAX—Fred; Install ACSYNT on IRIS/Personal IRIS—Bob and Uma; Install ACSYNT on IBM/RT—Dan; and Test Version Control—Kolady." These deadlines seemed to have less to do with fundamental research in geometric modeling than work in a software company. Indeed, faculty and graduate students were preparing a second release of ACSYNT/VPI to send to prospective Institute members.

Suddenly an important phone call was forwarded to the room. On the other end was an engineer at an aircraft company that was considering joining the new venture. Dr. M took the call and motioned for everyone to be quiet. Nine of us sat for fifteen minutes as Dr. M sold the new joint venture to this engineer, who was a manager in conceptual design.

Myklebust: Yes, [Aircraft Company A] and [Aircraft Company B] have already sent in their checks. We've had several requests for multiple machine licenses at a given site. But we've already been talking to your helicopter people. If different groups inside one company want different types of modifications, we'll have to issue separate licenses. The fee is $30,000 per year, on a five-year contract. I'll have the director of AmTech call you. . . .

Yes, we provide the technical support here. We have a number of staffers, full time programming help, and a secretary. We also ask all companies to provide personnel to work on this. NASA wants to provide a baseline code for aircraft companies so they can all communicate on both fighter and commercial aircraft. We're hoping everyone will use the baseline code and then add their own modules. We want to protect very carefully everyone's proprietary interests, but still have a baseline code. Everything is based on international standards [PHIGS] so you can work on multiple workstations. We also received in this lab a $1.5 million grant from IBM for work that includes a real-time flight simulator and work on dynamics to allow the test flying of different aircraft. . . .

February is our Beta release date [a release of software before all bugs are removed]. . . . We haven't even discussed things like security, but we have rejected Rolls Royce as a member because they are not an American company. You can call me or Professor Jayaram at [this number].

After hanging up, Dr. M turned to explain the call to us:

He had a group there listening on the speaker at his end. Call the lawyer at AmTech and get a contract to him right away. He asked if he could get ACSYNT on a free trial basis. I shuffled on that. I had to throw in that stuff on the simulator and flight dynamics—J.W., you've got a year. The guy was also miffed he didn't reach us directly. It's very important that someone's in the lab to answer the phone every hour of the day.

Gaining support to do fundamental research on geometric modeling had also transported the group into a quasi-commercial world of software development. Driven in the first instance by the desire for creation and ownership, researchers in the lab found themselves having to accept additional demands on their everyday lives and ambiguity in their selves.

Being a *funded* CAD person, or expert, thus meant not only inventing for the good of all but also delivering for the good of some. Accordingly, CAD/CAM researchers always had to decide, either explicitly or implicitly, how they positioned themselves in relation to the technologies they were

helping to develop. To what extent did they agree or disagree with the directions they were helping to support? Were they participating enthusiastically or just going along for the ride? Did they accept the trajectory they were following, or did they want to make it swerve? How did this relate to other aspects of self, such as Bob's relief that his fiancee had not moved to Virginia to join him?

Arvid Myklebust had joined the university in 1983, hired by a retiring department head who was strongly committed to research and teaching in computer-aided design. The incoming department head was supportive of such efforts but not passionately committed to them. From the moment of his arrival, Dr. Myklebust lived amidst sets of demands and opportunities in CAD/CAM research and education that produced a continuing state of ambiguity about himself and his lab. On the one hand, he brought in more money than anyone else in the department and gained access to some of the best space in the building for his lab. Also, many of the people working for him were clearly grateful for the opportunities he provided to participate in the 'real world.' On the other hand, the intellectual status of CAD/CAM research remained a matter of continuing debate and Dr. Myklebust generally published his work outside the mainstream journals of the discipline. In addition, I sometimes encountered concerns that he did not appreciate the extent to which everyone in the lab was living with multiple demands, only some of which they were paid to confront.

I did know from our initial meeting that Dr. Myklebust had concerns about the impacts of CAD/CAM technology, and I had learned by attending a picnic that he owned a farm on which he relied exclusively on horses for power. Not until I interviewed him did I understand that he connected these through a larger concern about the implications of large-scale consumption for the environment:

Myklebust: We shouldn't be manufacturing things just for the sake of making a profit. If computing does anything, it gives us time to do things better, at a very small environmental cost. Or at least it used to be a small environmental cost. Now it's getting to be an enormous one because there are ten pc's in every home, just like there are ten televisions. I guess in terms of electricity and impact on the environment, it probably has a much smaller impact than most other machines we use. So it can amplify our abilities, not to think but to evaluate possibilities for things, by computing them much more rapidly. It ought to be used to help us instead of to make things worse for us.

Downey: How would it help us?

Myklebust: Out of a group of twenty-seven things we probably need zero of them. I haven't had a television for thirteen years, and many times I've considered getting rid of my telephone. It's not because I'm an oddball. It's because I don't find any good reason to have it except to call people on emergencies. If you take yourself away from pop culture for a period of time, for a year or two, all of a sudden you

begin to realize that the things people think are important, the goods they buy, aren't so important. But it's hard to see that when you are plugged into it. I get in the mail probably five catalogs a day. Sometimes I look through them. None of it do we need. They are pummeling us with that stuff.

Downey: How do you connect this to your teaching?

Myklebust: What's the purpose of all this? Someone who's trained in the engineering sciences, which is what they are educated in these days, when they get to us they're faced with something industry is doing in a big way and a practical way. The real question becomes: What is it that the students need to get from this? It's been my feeling all along that the course should focus heavily on utilizing the tools that are available to be able to do a much better job of design. The benefits you gain in time [from CAD/CAM] you can either spend on turning out more products, or improving the existing designs instead of doing them in a more sloppy way. My strongest feeling is better quality design. I want to see stuff designed with the same quality as if a craftsman did it. The craftsmen don't exist anymore, very few of them anyway. There's no reason why the designer can't take the role that the craftsman had at one time. I want to integrate the concept of doing good design together with having the best tools available to do it and make them learn the process rather than learn about the tools.

I feel very guilty, quite honestly, when I think of turning students out of here that are going to go out and do manufacturing. I try and let them know that we don't need to manufacture stuff just for the sake of manufacturing. There is this month, in the *Utne Reader*—the *Utne Reader* is a collection of different viewpoints from disparate segments of our society, not necessarily in the mainstream. It has a tendency to note trends, things that are really happening. There is an article this time that talked about 'sustainable manufacturing.' They talked about Ben and Jerry's ice cream, which is rated as the number one socially conscious company. They pointed out that, even if you take every company in the U.S. or in the world, and you make them socially responsible, that still isn't going to stop the impact on the environment from constantly taking resources and producing stuff that always generates waste. Somehow you have to change the philosophy of what we mean by corporations and the production of goods to be able to stop this destruction of our environment. We are doing it at an ever-increasing rate. It is horrifying. I guess people are not going to notice it until it starts showing up on the television.

Downey: Well, that's been one of my concerns about the ACSYNT Institute. While I love the boundary blurring to produce greater cooperation, there's also a national boundary drawn around it because the goal is to enhance American competitiveness in building airplanes. While I like the direction, I want to go beyond national interests to . . .

Myklebust: [pointing at tape recorder] Could you turn that thing off for a minute?

The whole idea of the expert, appearing in this study as the CAD Person, hides the struggles people experience to locate expertise as a part of their everyday lives and selves.

CHAPTER 10 On the Replacement of Humans with Machines: A Different Humanism

IMAGES COUNT. Every image, whether in CAD/CAM models or cultural stereotypes, makes some things visible while hiding others. The analytic exercise of making more visible things that get hidden and then locating these alongside the dominant image can constitute a significant intervention by reorganizing the relationships among them. The dominant cultural image of technology outside society establishes a sharp boundary between humans and machines that hides human experiences of connectedness, including both an anthropomorphic sense that machines live with human agencies and a robotic sense that humans lives with the agencies of machines. Perhaps the most important contribution one can make in revealing what images hide is to begin to imagine how things might have been otherwise, both an assessment of history and a policy statement about future possibilities. If such a practice of image reevaluation became routine, might both popular and academic audiences become more open and receptive to alternatives such as those posed by academic theorizing in technology studies?

This book is about the life of a boundary. In other words, it has sought to follow the cultural boundary between humans and machines as this boundary has been lived in one historical and cultural context, the development of CAD/CAM technologies in the United States during the 1980s. The long-dominant image of technology outside society gained renewed vigor during the 1980s as the doctrine of competitiveness shifted international struggle for global dominance from a military to an economic idiom and made productivity in manufacturing the key to national survival. According to this doctrine, the nation would be able to survive only by rebuilding

industry, education, and research around a metric of productivity. Demands and strategies for increasing the productivity of humans saturated these arenas. Yet I now again want to raise the possibility that the greatest force of competitiveness may lie in how it constrains the imagination rather than fires it.

This book has explored how the dominant image lived in the everyday experiences of humans involved with CAD/CAM development and use. Its main finding is that these experiences extended far beyond activities marked by the words 'development' and 'use.' Touring through the activities of industry, education, and research, we repeatedly encountered human experiences that seemed to cross the boundary between human and machine, experiences even of humans who regularly relied on this boundary when explicitly accounting for their own activities. Humans sometimes seemed to locate the boundary inside the technology itself and sometimes inside themselves as people. This cultural study of CAD/CAM technology thus emerges with an interaction between distinct modes of theorizing, one dominant and possibly one subordinate.

I have used the word 'agency' to describe human experiences of features that pertain to the boundary between humans and machines and yet could be found in both humans and machines. Of course, the etymology of the word has located it wholly in a human context, as one candidate for a label describing the essentially human. Like 'labor,' 'consciousness,' or 'natural language,' agency is often held up as an essential index of humanness, in this case referring to the exercise of will by a human subject. In this usage, having agency has generally meant being able to exercise will in a conscious, deliberate, choosing manner. Without subjective consciousness, machines could make no choices, exercise no will, and, therefore, have no agency, by definition. Yet the human experiences involved in locating me inside CAD/CAM and CAD/CAM inside me made any a priori boundary drawn around human choice, will, and consciousness distinctly fuzzy. Wherein lay choice when learning CAD/CAM required a thorough disciplining of the body? Wherein lay will when fitting CAD/CAM into the workplace required reorganizing the humans and machines already at work there? Futhermore, wherein lay consciousness when humans automatically focused their hands and eyes to gain access to a CAD/CAM machine and then spontaneously experienced sensations of travel inside it? Assigning an event of will to every human action ignores the extent to which we act habitually, without conscious choice or judgment. Treating machines as dumb objects ignores the extent to which we rely on them as key constituents of social life. Does it make sense to devalue the activities of machines in society, in principle and in advance, when we humans attribute so much power to those activities? Human experiences of CAD/CAM technology regularly located humans inside machines and machines inside humans. Might it be worthwhile to modify our theoretical concepts accordingly?

By taking for granted the distinctiveness of humans as a presupposition of social, cultural, or behavioral analysis, I believe we too often privilege the human condition at the expense of the conditions of humans. For example, treating labor as the essential human contribution to economic production makes it possible to devalue humans in the process and to think we can easily replace humans with machines. This book casts serious doubt on whether or not such ever happens beyond those cases in which the humans were already defined in extremely narrow terms. Some people may develop or purchase new technologies with that as the goal and even define humans in those terms, but I would wager that such actions always hide important ways in which the humans contributed more than labor and ways in which technologies introduced more considerations than simple automation of formerly human activities.

In order to present and interpret my data, I expanded the concept of agency to refer to acts of positioning in society regardless of whether these acts were undertaken by humans or by machines. This perspective draws no distinction in principle, for example, between the agencies of the human user sitting at the terminal back in Figure 1.1 and the mathematical agencies of the friendly engineer located inside the CAD/CAM system. Rather it brackets both the human and the machine, meaning that it takes their features to be problematic, something to made plausible by analysis rather than to be assumed at the outset.

I would now like to speculate on the question: What if these other experiences, other concepts, other modes of theorizing were more visible, even dominant? In other words, what if the dominant image of technology did not dominate CAD/CAM development and use? What if neither participants nor observers of CAD/CAM machines and humans had taken it for granted that technology stood outside of a society that consisted only of humans? What if no one had assumed at the outset that the agencies of humans were inherently distinct from the agencies of machines?

If the experiences of humans involved with CAD/CAM technology can be taken as a guide, such questions are not as crazy as they might sound otherwise. Relocating the agencies of machines inside society alongside the agencies of humans need not amount to some sort of high-tech foolishness. It need not require an anthropomorphic leap of faith that could be taken only by some hopeless technophiliac blinded by the seductions of science fiction fantasy. Rather, relocating the agencies of machines could amount to giving visibility to human experiences of machines that the dominant image has long hidden and devalued, simply shifting emphasis among current arrays of cultural meanings rather than departing clear realities for the luxury of wishful thinking.

What, then, if a shift did take place in everyday habits of imagination such that what was taken for granted was a question about the contents of human agency rather than an assumption? Would bringing technology into

society have made a difference in human experiences of CAD/CAM technology? Might it, for example, have focused greater attention on those experiences? If separating the human from the machine actually shifted attention away from humans rather than on them, might reimagining the agencies of humans and machines in education, industry, and research help make this attention shift back? I have no illusions about what it would take actually to achieve such a shift in everyday habits of imagination. But I am also convinced that shifts in habits of imagination, including a commitment to revealing routinely what dominant images hide, can occur if people are willing to imagine them.

What Might Have Emerged in Industry?

In this revised world, it was no longer possible to reduce human agency to labor. The idea that what humans contributed to industrial production was the pure process of work had become a somewhat perplexing thought, a peculiarity that obviously had depended upon an especially confining notion of what it meant to be human. Humans participating in a corporate organization no longer saw themselves as selling their labor to the company, and companies no longer saw the road to success as lying in the reduction of labor costs.

Instead, humans had become complex and diverse configurations of agencies whose value and importance depended upon how these agencies fit together with other agencies found both inside and outside of a given company. The main question had become one of fit. People with experience were no longer just expensive employees but people who had traveled amidst the humans and machines of the company in thoroughgoing ways. The best ones were particularly good at mapping how current problems engaged both people and machines and how moving or acquiring new people or new machines might or might not fit into existing configurations of agencies. Everyone tended to initiate problem solving by mapping the present: What was currently involved? What constituted any distinct perspectives? What did people know or not know, i.e., what sorts of agencies were currently present? Much like the CAD/CAM consultants described in chapter 4, these humans portrayed problems as relationships between the present and the future, where movement from one toward the other depended upon a reconfiguration of agencies that involved both humans and machines. Everyone paid attention to the changing power relations among humans with each new development, for such was crucial to helping everyone gain a stake in successful outcomes.

Because new machines, such as CAD/CAM technologies, offered the possibility of introducing new configurations of agencies, it made sense neither to reject their arrival in advance as necessarily detrimental to human

experiences on the job or to celebrate them as the providers of all things good. The idea of acquiring new technologies for the purpose of replacing humans appeared foolish because it meant that these humans had been exercising on the job only a small subset of the agencies they had acquired through education and training. Rather, the problem of production was always a problem of how to piece together configurations of human and machine agencies in desirable ways. Would a new machine help or would it demand too many other changes? Since all employees had value as humans, even the desires of the lowest paid employees counted.

Believing that investments in humans generally provided benefits for longer periods than investments in machines, the dominant perspective had shifted from looking first to new technology to provide solutions to looking first at reconfiguring the activities of existing humans with existing machines. New technologies still often brought wonderful new capabilities, but these benefits had to be demonstrated rather than assumed. One result was that companies no longer felt they had to keep up with or integrate every latest technological innovation.

New developments in CAD/CAM technologies no longer pursued the ideal of automation. The question of whether or not the slash between CAD and CAM should stay or dissolve away had paled in comparison to a host of new questions about how various forms of two- and three-dimensional modeling might fit into the actual work practices of drafters, engineers, and other employees. For example, shifting from drawing boards to computer scope was no longer assumed to be a desirable transition in all cases. Also, lots of new technologies became available to help drafters build credibility for their drawings and connect their work practices more closely to those of engineers. The distinction between hardware and software began to lose significance as the emphasis in CAD/CAM development shifted to helping humans and machines in production rather than replacing them.

The whole idea of turnkey systems, which were expected to run mostly on their own, had given way to the idea of strategically positioning new agencies in old contexts. For example, small manufacturing companies with relatively minor design problems and small design staffs were pleased to acquire computer modeling systems that focused first on topological completeness to help machinists, even though these models lacked visual integrity and were difficult to explain to others. Engineers in large companies who worked on complex designs such as automobiles and aircraft were pleased to acquire modeling programs that regularly pointed out what they did not know and could not do by explaining clearly what sorts of mathematical agencies made up their calculations. Equally delightful was a new emphasis not simply on isolated and clearly bounded objects, such as the individual aircraft, but on how such objects might function and live in their intended environments, such as airports, airspace, maintenance shops, and the process of decommissioning.

The idea of productivity had lost meaning in this world because it focused attention far too narrowly on the agency of work in humans, forgetting entirely that other valuable agencies had been vested in and attributed to both humans and machines. For example, CAD/CAM technologies remained important to the engineers at [the local manufacturing company] primarily because these helped foster communication among humans inside the company as well as with the people and organizations that purchased the company's [main product]. An enhanced sense of cooperation had developed because each engineer could call up any other drawing and connect his or her work to the activities of others. Design and manufacturing engineers regularly traveled to one another's locations in the plant to articulate and resolve differences between their distinct perspectives. Buyers now displayed greater confidence in changes that engineers proposed because they could assess better how the reconfigured agencies would fit in their workplaces. Drafters were no longer evaluated according to the rate at which they could produce drawings by themselves but by their abilities to help shepherd developing designs through various stages of production, thus connecting their work with that of others. Events of deskilling still occurred on occasion but these were always great cause for concern, for such meant that severe wastes of human agencies were taking place.

Because engineers could easily understand and articulate the mixes of human and machine agencies that constituted the production processes, they tended to replace accountants and finance people as the humans most prepared to formulate strategic plans and company policies for they made strong efforts to map and take account of the diverse agencies of working humans. Engineers no longer had to justify the purchase of CAD/CAM equipment according to the extent to which they could lay off drafters, for such no longer made sense. Finally, decision-making bodies in the company included representation from all groups.

In this revised world, a corporation no longer pictured itself as an autonomous actor constantly facing death in a hostile, combative world but as a collaborative organization whose longevity depended upon establishing trusting relationships with both people and organizations. Because short-term profitability was much less important than long-term trust, the corporate person became much more than a narrowly defined economic agent. The heretofore limited concept of technical support expanded to become the overarching metaphor defining relationships among the producers and consumers of new technologies.

A significant lesson from widespread experiences with CAD/CAM technologies had been that the sales transaction established a relation of mutual dependence between buyer and seller that lasted as long as the technology and its various upgrades. A seller was no longer simply a maximizer of short-term economic interests whose responsibility in a transaction

ended with its completion, but became more of an organizational consultant that fulfilled its own interests best by working altruistically for the good of its clients. New products were driven not toward commodification by an exclusive reliance on price/performance considerations, with its corresponding multiplication of brands and models, but toward extensive links and connections with other products by the desire to build as many lasting alliances as possible with other organizations. Salespeople did not win commissions at the point of sale but earned more regular income by helping to establish and maintain committed relationships.

Meanwhile, a buyer was no longer an anxious, isolated customer who waded through massive waves of organized disinformation in search of perfect technological solutions but had become a client who sought advice and assistance from consultants on how to fit new machine and human agencies to existing configurations of machines and humans. Purchase of equipment and software marked a commitment to longer-term connections. In short, the market relationship had been transformed into something more akin to a marriage than a war.

In the CAD/CAM industry, new companies no longer rocketed to success or failure on the strength of venture capital. In fact, the venture capital industry itself had become far less important as investment patterns shifted from an exclusive focus on new technologies to a shared interest in both technologies and humans. Corporate experiences with CAD/CAM technologies had made it clear that replacing humans with machines made far less sense as a strategy for improving industrial production than continually developing the agencies of both humans and machines. The education of humans no longer ceased at the moment of hiring but became a routine component of the agencies of work. As elsewhere in industry, Wall Street receded in importance as financial support for corporate activities shifted increasingly into the hands of employees.

CAD/CAM developers had become acutely aware that excesses in marketing were a sure way to reduce credibility with clients. Advertisements for CAD/CAM technologies no longer dared claim to provide humans only with solutions to their problems without also attempting to identify the new problems that would also be likely to arise. Everyone knew that such was both foolish and dangerous.

Rather, the main issue in advertising became a question of fit: How might the agencies that have been transferred to these machines fit the likely configurations of agencies among prospective clients out there? Trade shows were still great fun but not because frightened, largely male, prospective buyers could act out fantasies of control. Instead, attending a trade show felt more like going in for counseling: Participants paid for the opportunity to talk freely about their problems and acquire strategies to deal with them. Among vendors paying for space at the show, the fast talkers had

been replaced by patient listeners. Both the trade shows and the industry as a whole were now heavily populated with women.

From watching the earlier activities of corporations that had laid off humans in the name of increased productivity, national governments, including the federal, state, and local governments of the United States, had come to believe that maximizing the short-term profitability of multinational corporations served the interests only of senior managers and those people who owned large amounts of stock. The idea that maximizing self-interest in a free market would serve the interests of the whole obviously could have merit only where the size of the company was small relative to the size of the nation, and governmental regulation consisted of ensuring balance. Because these governments still depended primarily on personal income taxes for their support, national policies had shifted to emphasize investment in the agencies of humans and to maximize the possibility that humans would have access to quality work and reasonable income. The core value of freedom could no longer be interpreted primarily as the freedom to consume, for its meaning had shifted to emphasize freedom to build and maintain long-term committed relationships both inside and outside the home, for which reasonable income was essential.

As a result of these changes, the nationalist doctrine of competitiveness became transformed into a doctrine that had to assume connectedness before even beginning to theorize competition. Competition among nations now took it for granted that all were linked together inextricably by a growing set of emerging global infrastructures, such as communication, trade, travel, entertainment, financial, and engineering infrastructures, all of which included both machines and humans. No nation could successfully convince itself that it was an isolated, autonomous individual, and attempts to apply military images of dominance and control to economic activities were widely judged to be extremely short-sighted proposals. Transnational competition still existed but was experienced as something more akin to a sports contest, i.e., an Olympics of political economy. In this new context, victory did not mean total dominance for one nor complete destruction for another because the competition was all about how to provide a high quality of life for human citizens.

Lost in this world without the old dominant image was the shiny luster of new technologies, along with the ability of humans to vest technologies exclusively with the power and authority to solve human problems. Technological innovations were still crucially important, but perfect fit was extremely rare. Overall, humans experienced a great deal more pressure to develop, adapt, and transform their own agencies to solve their problems, but this felt quite different from becoming flexible bodies who maximized the productivity of human labor. People appeared to find this more demanding, but also more affirming.

What Might Have Emerged in Education?

In this revised world, engineering students no longer entered the CAD/CAM Lab expecting to achieve control over the technology. Sandy Poliachik no longer sought to manipulate the system, and Eric Schardt no longer hoped for a simple tool he could turn to when he needed it. Such thoughts, in fact, never occurred to them. Rather, along with other students, both accepted an initial submission to the technology as a first step in building the agencies of CAD/CAM technology into their lives and selves and thereby establishing, at the same time, an initial presence in the industrial world of CAD/CAM technology. The issues that concerned them were questions of fit.

A key early delight was that students were no longer embarrassed by the experiences they had inside the software and hardware they were using. In fact, such experiences became the main focus of attention and discussion. Students found themselves talking more easily and openly about what was happening to their bodies and minds, both cognitively and emotionally, as they learned CAD/CAM. Was disciplining their bodies by accepting the agencies of the machine something they enjoyed and would be willing to continue on the job? Did they find it stimulating intellectually to connect mathematical agencies in geometry or algebra with mathematical agencies in thermodynamics or fluid mechanics? Was attention to any crucial agencies in design, manufacturing, or other activities lost in making these exclusively mathematical connections? Did they enjoy the constant demand to travel to new places, memorize new pathways, and engage new agencies? Did fitting the agencies of CAD/CAM into their bodies also fit grander career plans? Which areas of CAD/CAM were most important to emphasize as they formulated these plans?

Sometimes students found themselves competing with one another to travel to different places in the CADAM program, to follow the pathways that became available at each fork in the virtual road. Their main challenge was to articulate as best they could what mathematical agencies they had enlisted along the way and how such encounters might position them in industry. For example, students devoted considerable time and effort to figuring out how many ways drawing on CADAM differed from drawing on a board with pencil and paper. Rather than simply learning how to use specific programs, students systematically compared these to others, sorting out the various layers of translations that took place between software applications and binary processing in hardware. They assessed the gains and losses involved in giving direction to every line drawn on the computer, and they struggled to describe the distinct mathematical agencies that went into 2D drafting and 3D wireframe, surface, and solid modeling. Articulating what humans with a given CAD/CAM system could not do, in addition

to that what they could do, also became a key strategy for explaining how specific technologies fit in the workplace.

In this revised world, CAD/CAM students voraciously consumed the lecture material in the course, seeing clearly that learning how to make mathematical models made little sense without also mapping the industrial practices within which these might fit. Students no longer equated CAD/CAM technology with automation because they viewed CAD/CAM as a massive array of technologies, each with a distinct configuration of agencies. The whole idea of simply replacing humans with machines had become problematic and, in many cases, ludicrous. Humans could be replaced by machines only in places where humans had already been so devalued that only a limited set of agencies were at stake. Rather than automating factories, students were learning how to map the introduction and participation of CAD/CAM technologies in the workplace. What were different ways that technical workers distinguished design and manufacturing? Was it common, for example, to distinguish conceptual, preliminary, and detailed design? How was work distributed among engineers, designers, drafters, and other humans? Were the functions of drawing and analysis assigned to different sorts of people? Assured that the main problem was to figure out how configurations of CAD/CAM agencies might merge with configurations of human and machine agencies already in place at particular sites, students no longer minded memorization if such meant remembering not lists of bodiless features but ways of transporting their bodies from place to place as users inside the machine.

Students spent considerable time debating the merits of trying to merge design and manufacturing through the computer. All asserted that achieving total centralized control of production processes by translating these entirely into mathematical terms was a somewhat perverted and narrow fantasy that appeared to show little understanding of the diverse human and machine agencies in most every production process. All were also capable of showing how developments in CAD/CAM technology to date were primarily developments on the design side. To them, CAD/CAM had really grown up as CAD/cam. The substance of the debate was thus about whether or not it was possible to write more of the agencies of manufacturing into CAD work and what might have been gained or lost in the process. For example, would it have been worthwhile to rewrite CAD programs entirely in terms of an image of manufacturing, building objects around the desire for topological integrity, in preparation for machining or other operations, rather than an overriding concern for visual completeness? Should new attention have been focused on the positions and roles of drafters, such that these people might become relocated as talented, strategic mediators between design and manufacturing rather than as human drawing machines? Although this debate was not resolved, many new ideas emerged about how to fit the agencies of CAD/CAM technology to the

diverse agencies of production without ever coming close to the silly and horrifying thought of replacing humans with machines through automation.

The engineering instructors in this revised classroom took new pleasure in their jobs because the tasks involved now demanded a great deal more of them. No longer could they view themselves as simply transmitting knowledge, dipping into the stock of established, authoritative engineering knowledge, and delivering it into the heads of engineering students. Bob West, Anne Zeilfelder, and Arvid Myklebust no longer had to find space for a desire to help students within a system that wanted to reduce them to teaching machines, disciplined messengers who transmitted knowledge without opening it for fear of perverting it with personal considerations. Rather they all now viewed the task of teaching as trying to lead groups of students from diverse starting points to diverse endpoints through sets of pathways that were sometimes shared by all and sometimes tailored to individual agencies and desires. That is, in this world instructors found themselves asked to focus on how their human students differed from one another along various dimensions rather than reducing all to a single common dimension and denominator, i.e., the learning machine, an empty vessel to be filled with bodiless knowledge. Some students arrived with co-op experiences; some were aiming for particular sorts of jobs; some were putting together sets of electives that interested them but were not sure why; some had no idea where they were headed. Instructors now received credit for treating individual students as people with distinct trajectories, and the guiding question in CAD/CAM pedagogy became, "How can I help you get to where you want to go?" The first step in good teaching became finding out and understanding each student's sense of direction. Teaching was no longer the production of uniformity but the guidance of diversity.

CAD/CAM students still took tests in this world and received grades, but grades were no longer the main marker of individual capability and accomplishment. A graduating student was no longer simply a human with a grade-point average. Rather, students found it important to build portfolios that presented in convincing fashion how various learning processes had combined to produce unique configurations of agencies and made each especially appropriate for a particular range of career tracks. Eric was able to convince prospective employers that his courses, co-op experience, and work on the solar car had prepared him well for design work in the auto industry. He had spent considerable time in the CAD/CAM course traveling through the mathematical details of surface modeling. He had researched the CAD/CAM systems used by auto manufacturers, could describe the major agencies that each included or omitted, and was able to map how different groups in these companies might react to newly emerging CAD/CAM technologies.

Meanwhile, Sandy had found her way successfully into biomedicine after completing a research project in the CAD/CAM class that mapped the

history and likely future of CAD/CAM technologies in that field. Her master's thesis project still focused on designing a portable cooler for organ transplantation, but the thesis now located this problem as one of several types of technological problems in biomedicine into which CAD/CAM technologies might fit. Since the idea of gaining control over CAD/CAM technology now never occurred to Sandy, her portfolio built a picture instead of a person who was willing to explore the mathematical agencies of machines thoroughly and who, from her previous travels at the shipyard, was also experienced at fitting together the agencies of both machines and humans.

Something was indeed lost to CAD/CAM education in this new world—Steve Payne no longer felt like a king, not even in those moments of excitement when he got a difficult program to run. He no longer found himself slapping his knees, standing up, and throwing out his arms in an expression of victory over the computer. Rather, he regularly found himself discussing with students and professors the wonderful pleasures and difficult pains of locating himself in CAD/CAM technology and CAD/CAM technology in himself. It was now O.K. to feel one with the machine.

What Might Have Emerged in Research?

In this revised world, scientists and technologists no longer produced godlike acts of creation. The human developer of a new technology could no longer claim the status of superhuman inventor, a heroic genius with a name that went down in history according to the extent to which the technology promoted progress. Because the ideal of automation no longer attracted the support of engineers, they had come to celebrate the fact that their work could now be described comfortably as social engineering. The stigma associated with this term had disappeared, for it no longer involved the controlled molding of society by technocrats who placed the highest value on technical rationality and efficiency, even if such came at the expense of humans. Social engineering now consisted of efforts to design and implement configurations of human and machine agencies to fit and improve existing configurations of humans and machines, without presuming in advance what improvement might mean. Through revised strategies of education, engineers had become adept at mapping all technical problems through humans and were particularly good at assessing how various proposed configurations of humans and machines fit the perspectives and interests of the full range of human stakeholders. Engineers agreed that failing to examine the power implications of technological developments was a sure indicator of poor design work.

Research and development on CAD/CAM technologies had gained a new sense of purpose, although with a different direction. Abandoning the

ideal of the fully automated factory as a naive fantasy appropriate for an earlier era, research on how to integrate computers into industrial production always began by mapping distributions of human and machine agencies across various workplaces. With a greater level of concern about connectedness and commitment to cooperation, it no longer made sense to proliferate models and brands. Because the presumption that one solution was good for all did not hold, there was always the danger that a university researcher could become too involved with one company or activity. But researchers who built multiple relationships received the greatest approbation and rewards.

Human researchers found themselves no longer living in the lab, formulating solutions to be applied uniformly outside the lab. Rather they spent considerable time and effort mapping human and machine agencies in the workplace. For example, students such as James Williams, Bob Jones, and Fred Marcaly no longer shouldered the burden of making unique, permanent, and nameable contributions to the general stock of knowledge about geometric modeling. They still loved the process of developing new technologies but had come to view this more as a diffuse and double process of transferring human agencies into the machine and machine agencies into humans. Their attention was now focused on making specific contributions to current problems, such as by debating at length exactly what specific configurations of agencies should be coded into ACSYNT/VPI to help it fit a maximum number of production environments. They were also pleased to receive credit toward their degrees as much for fitting this code to different forms of hardware as they did for advancing the mathematics of Bsplines.

As head of the CAD/CAM Lab, Arvid Myklebust found himself having to cope with a loss of prominence in one sense and an acknowledgment of his importance in another. No longer was every project in the lab his project, nor every new idea something for which he would receive the most credit. Nor also were all failures his failures. Instead, he found himself and others attributing a great deal more importance to the work of negotiating strong alliances among funding agencies, clients, students, and colleagues. He was rewarded less for inventive mathematical genius and more for building lasting relationships that furthered simultaneously the goals of education, production, and citizenship, the latter recast increasingly in global terms. Professor Myklebust had come to view the demand for multiple identities less as a burden and source of stress and more as a source of strength and longevity for his students, his lab, his department, and himself. Finally, he was just as committed to developing and using graphics standards as he had been previously, but the goal was not to avoid becoming identified too much with one corporation but to maximize the extent to which the agencies in new technologies could be linked and made compatible with those already in the workplace. The idea of purposely developing technologies that were incompatible with existing or other new

technologies had become inconceivable. Doing basic research and development meant configuring machine and human agencies that were compatible with a maximum of humans and machines. Myklebust was delighted at the extent to which collaborations developed among colleagues within his department, between departments, and between universities.

Syed Shariq was pleased to report that new forms of collaboration across industry, universities, and government were proliferating more quickly than he would have ever dreamed. He was spending the bulk of his own time figuring out ways of implementing joint nonprofit ventures across national boundaries, sometimes involving national governments and sometimes not. He was particularly delighted that getting a joint venture to work no longer depended upon locating an unusually flexible technology, into which human agencies could be written without the humans involved having to make significant adjustments in their identities. In this revised world, the need to make significant adjustments in human agencies and, hence, human identities with every innovation was what everyone now took for granted.

We can now see that inverting the modes of theorizing whose interaction constituted CAD/CAM culture did indeed produce whole new experiences for the humans involved. By having drawn a sharp and indelible distinction between the human and the machine, the previously dominant image of technology may have focused attention on the human condition but at the cost of making it more possible to ignore and devalue the conditions of humans. Through this distinction, it had become possible in education to reduce humans to empty vessels that might or might not become filled with knowledge and who could be evaluated according to this linear measure. It had become possible in the workplace to reduce humans to the single agency of undifferentiated work, thus lumping together diverse human contributions as labor. It had become possible in research to reduce most humans to secondary and subordinate status below the elite few who got to be called 'genius.' And it had become possible to formulate a doctrine of competitiveness built on the incredibly narrow image of replacing humans with machines through the concepts of productivity and automation. Yet as the CAD/CAM developments described in this book suggest, human experiences with machines have blurred and belied this distinction all the time.

Must we confine ourselves to such a narrow concept of our lives and sensations? Perhaps we could reimagine the machine into society in everyday habits of imagination. Perhaps we could convince ourselves to look at humans in wonder and ask what makes them so different from one another. Perhaps it could become routine to understand learning as the fashioning of human selves through complex and variable configurations of agency. Maybe we can cast aside the amazingly restricted and inflexible goal of increasing human productivity and focus instead on mixing the

agencies of humans and machines to build committed and lasting relationships in the world. If technology were no longer available as a convenient external force guaranteeing progress and demanding adaptations, might we begin to design and build technologies such as CAD/CAM not to replace humans but to help them?

Taking the human for granted has legitimized reducing people to vessels, to labor, to failures. Shifting the machine inside society as an everyday habit of imagination means that we could look at people in wonder, always asking, What's inside there? What is built within the boundaries of that skin? What are the complex configurations of agencies that have been built into that self? In a revised image that grants legitimacy to those experiences the dominant image has hidden, technology can no longer be a device for hiding human agency. Far from producing the anthromorphic, it calls attention to what is distinctive about humans as people.

Notes

Chapter 1

[1]Seireg (1981) and Krouse (1981f). See also Chasen (1981) and Fulton (1981) in *Mechanical Engineering* and Beercheck (1982), Blauth and Preston (1981), Foundyller (1981), Gondert (1982), and Krouse (1980, 1981a, 1981b, 1981c, 1981d, 1981e, 1982) in *Machine Design*. For additional examples, see Groover and Zimmers (1980) in *Industrial Engineering*, Christman (1983) in *Computers In Mechanical Engineering;* Inglesby (1982) in *Assembly Engineering;* Kinnucan (1982) in *High Technology;* Lerro (1980, 1981, 1982) and Simon (1982) in *Design News;* Sager (1983) in *Electronic News;* and Clayton (1982) and Freedman (1983) in *CAD/CAM Technology.*

[2]Turning to technology has not always meant the same thing in the United States. For example, Hughes (1975) follows evolving American attitudes toward technology from the "shock of realization: the man-made world" through the "thrill of the technological transformation," "realization of technological power," and "ambivalence, technocracy, and scientism." See also Hughes (1989), Marcus and Segal (1989) Segal (1985, 1994), and books reviewed and articles in *Technology and Culture,* the journal of the Society for History of Technology.

[3]For a list of other technologies that appeared promising during the early 1980s, see National Research Council (1982).

[4]Throughout this book, single quotes identify words or phrases that stand for significant concepts while double quotes mark direct quotations.

[5]Port (1986). See also a sampling of other articles from *Scientific American* (1982), *Business Week* (America Rushes, 1983), *New York Times* (New Allure, 1983), *U.S. News and World Report* (Jobs, 1985), *Technology Review* (Blumenthal and Dray, 1985), *Design News* (Artificial, 1986), and *Industry Week* (CAD/CAM, 1989).

[6]National Commission on Excellence in Education (1983), Business-Higher Education Forum (1983), U.S. Congress (1984), U.S. Congress (1986), President's Commission on Industrial Competitiveness (1985, 1987), National Research Council (1985), Council on Competitiveness (1988), and several professional engineering societies, such as the American Society of Mechanical Engineers (1986) and Institute of Electrical and Electronics Engineers (Christiansen, 1987).

[7]Ramo (1980) and Dertouzos et al. (1989; see Appendix 1 for additional list of reports). See also Beeby (1982), Krouse (1982), and Aerospace Industries Association (1987).

[8]See also the collection of reading on competitiveness and American values in Goldman (1993).

[9]National Commission on Excellence in Education (1983).

[10]Ramo (1980, 8).

[11]Dimancescu and Botkin (1986, xvii) and Ramo (1980, 9).

[12]Council on Competitiveness (1988, 10).

[13]Council on Competitiveness (1988, 1).

[14]Aerospace Industries Association of America (1987, 5).

[15]For further work on Total Quality Management, business process reengineering, and the corporate culture movement, see Bank (1992), Fellers (1992), National Aeronautics and Space Administration (1992), Hammer and Champy (1993), Johansson et al. (1993), Deal and Kennedy (1982), and Kunda (1992).

[16]For an analysis of pipeline images and policies, see Lucena (1996). For an introduction to pipeline policies, see also Bowen (1988) and other articles in the special issue of *Engineering Education*. On the importance of flexible bodies, see Martin (1994).

[17]See Pfaffenberger (1992) and Downey and Dumit (1998b) for more on the Basic Story of science and technology and its effects.

[18]For more on popular theorizing and academic theorizing, see Downey and Rogers (1995).

[19]See Chasen (1981) as well as selections from the bibliography in Acland and Lane (1982).

[20]Machover and Blauth (1980, Foreword).

[21]See Leslie (1983) for an account of the development of tension between science-based design and manufacturing at General Motors during the 1920s.

[22]Lerro (1981, 46).

[23]Smith (1985).

[24]See Majchrzak and Salzman (1989), Liker and Fleischer (1989), Forslin, Thulestedt, and Andersson (1989), Adler (1989), Badham (1989), Lee (1989), Sinclair, Siemieniuch, and John (1989), Manske and Wolf (1989), Brooks and Wells (1989), Salzman (1989), and Plonski (1989).

[25]Liker, Fleischer, and Arnsdorf (1992, 75).

[26]For vision statements about computer-integrated manufacturing, see *New York Times* (New Allure, 1988), Bertain and Hale (1987), Teicholz (1984), G. J. Hess (1983, 1984), and Manufacturing Studies Board (1988).

[27]Ogburn (1945). See also Gilfillan (1935a, 1935b), Ogburn (1933, 1945), and Ogburn and Nimkoff (1955).

[28]The literature on impacts during the 1970s is huge. For a sampling of published work on impacts during the 1980s, see Office of Technology Assessment (1982), Leontief and Duchin (1986), Sorensen et al. (1987), Miller (1989), and Sharda et al. (1989).

[29]In practice, I think this challenge has been less clear, particularly when projects have been developed in anticipation of detailed impact analysis.

[30]See also Bijker and Law (1992a). I am aware that this characterization blurs many important differences among forms of research in the social construction and social shaping of technology. I direct your attention to excellent reviews in Bijker (1995b) and Cronberg and Sørensen (1995), as well as MacKenzie (1990) and Woolgar (1991), as starting points for more thorough investigation. Consider also related work drawing from ethnomethodology, such as Suchman (1987).

[31]For an elaboration of this argument, see Downey (1992).

[32]Woolgar (1981).

[33]A founding work in this field, Bruno Latour and Steve Woolgar's *Laboratory Life* (1985 [1979]), cleared the way for constructivist analysis with its first chapter, "From Order to Disorder," then summarized the approach with the last, "From Disorder to Order."

[34]See, for example, Bijker, Hughes, and Pinch (1987b) and Bijker and Law (1992b). Constructivist science studies has found itself threatened similarly, but far more severely, in the so-called 'science wars,' which basically amounts to scapegoating by scientists who feel themselves threatened by rapidly changing priorities in the academy.

[35]Much constructivist work is currently addressing this sort of problem. See, for example, Bijker (1993, 1995a) and numerous works cited in Williams and Edge (1995).

[36]See, for example, Ellul (1964), Marcuse (1991 [1964]), Mumford (1963, 1970). Starting points for related work in the philosophy of technology are Winner (1977) and Pitt and Lugo (1991).

[37]Toffler (1970, 1980).

[38]Majchrzak and Salzman (1989) advocate a "sociotechnical systems paradigm" to analyze the social and organizational dimensions of CAD/CAM development. See also De Greene (1973) and Pasmore and Sherwood (1978).

[39]See, for example Callon (1980a, 1980b, 1986, 1991), Latour (1987, 1991), Law (1987a, 1987b, 1991), and Law and Callon (1992).

[40]The theory parallels constructivism in picturing movements from disorder to order as 'heterogeneous engineering,' an image that treats innovation as the convergence of heterogeneous mixes of factors and considerations rather than as a linear technical logic. At the same time, it differs from constructivism both by involving humans and nonhumans and by including impacts as network constraints. Yet actor-network theory also contrasts with impact studies by treating these constraints not as external forces but as a routine feature of network activity and, hence, of society.

[41]According to Bruno Latour, the Centre de Sociologie d'Innovation at the École des Mines in Paris, which is the home of actor-network theory, has derived as much as half its annual support from consultant activities. Michel Callon coded the theory into a computer algorithm called co-word analysis that produced for clients, usually government agencies, pictures of their networks and their strategies by analyzing

the co-occurrence of key words in their reports and other documents. As Callon tells it, for technically trained people who tended to theorize science and technology outside of society, both the process and the results were often shocking. Since it was the computer that was telling them about themselves, Callon and fellow consultants transformed themselves from human sociologists with soft, subjective opinions into hard-nosed and objective scientific experts.

[42]See Douglas and Wildavsky (1982).

[43]The word 'interest' is actually too narrow to capture the range of work in the social shaping of technology, with its intellectual home at the University of Edinburgh. See, for example, Mackenzie and Wajcman (1985) and references in Williams and Edge (1995). For a citation classic on boundary work in science, see Gieryn (1983).

[44]See, for example, Nelkin (1992) and Downey (1986a, 1986b, 1988a, 1988b).

[45]See Zald and McCarthy (1988 [1979]) and McAdam, McCarthy, and Zald (1996).

[46]Available literature on the class structuring of new technologies is quite large. Starting points relevant to this study include Aronowitz and DiFazio (1994), Noble (1984), Braverman (1974), Shaiken (1984), and Cooley (1980).

[47]Starting points on race and technology can be found in Harding (1993).

[48]Starting points on the gendering of technology include Cowan (1983), Cockburn (1983, 1985), Hacker (1990), Sørensen (1992), Green, Owen, and Pain (1993), Wajcman (1991), and Cockburn and Furst-Dilic (1994).

[49]See Winner (1980, 1986).

[50]See Badham (1991), especially "Appendix 7: Deskilling or Reskilling? The Debate," for an excellent account that provides a more comprehensive survey in an Australian context. Also, in the 1989 collection in *IEEE Transactions on Engineering Management,* virtually all the studies build upon empirical surveys. One of the "general findings" was "lack of evidence for the technological determinism, deskilling, and employment displacement" (Majchrzak and Salzman 1989, 178).

[51]Some additional starting points from cultural anthropology include Davis-Floyd (1992), Downey and Dumit (1998), Dubinskas (1988), Escobar (1995), Fischer (1995), Forsythe (1993a, 1993b, 1994), Gusterson (1996), Hakken (1993), Hess (1991, 1993, 1995), Hess and Layne (1992), Marcus (1995), Martin (1987, 1992, 1994), Nader (1996), Nespor (1994), Pfaffenberger (1988, 1990, 1992), Rabinow (1995), Toumey (1994, 1996), and Traweek (1988, 1992, 1993, 1995a, 1995b, 1996a, 1996b, 1996c, Forthcoming).

[52]Starting points for research on cultural studies of science, technology, and medicine include Bhabha (1994), Foucault (1970), Foucault, Martin, Gutman, and Hutton (1988), Gray (1995), Harding (1991), Haraway (1991, 1997), Penley and Ross (1991), and Stone (1995).

[53]Examples include work in cultural history, sociology, and social psychology, including Starr (1982), Lave (1990), Lave and Wenger (1991), and Turkle (1984, 1995).

[54]In this perspective, the boundary between technology and society appears as a historically specific configuration of meanings that challenges the people who encounter, engage, or use it For example, in *Discipline and Punish,* Michel Foucault (1979 [1975]) argued that the whole idea of technology as a force of control on and within society depends upon an image of society as a collectivity of individuals, whose main problem is social order and control. The so-called universal Hobbesian

problem of social order, i.e., that every society has to figure out how to guarantee order, was therefore motivated historically. In the previous cultural epoch, the body politic of the people had lived in the physical body of the monarch and key power issues involved fine-tuning this relationship rather than establishing and maintaining control by one individual over others. Thus evolution of the image of technology as a vehicle for, or agent of, social control has been part of the more pervasive development of Western individualism and its problematic of control.

[55] A good example is Rapp (1998).

[56] See, for example, Martin et al. (1998) and Toumey (1994, 1996).

[57] Examples include Hess (1995), Heath (1998), and Rabinow (1995).

[58] Joseph Dumit, Sarah Williams, and I have offered 'cyborg anthropology' as a label for this pathway to intervention. See Downey, Dumit, and Williams (1995) and Downey and Dumit (1998b) for elaboration.

Chapter 2

[1] Cahners Exposition Group (1990a).

[2] Cahners Exposition Group (1990b, 3).

[3] For more work on the erotics of technology, see Hacker (1989), Stone (1995), and Traweek (1995a).

[4] At the show, I began collecting and reviewing the advertising materials for CAD/CAM hardware and software. I distributed business cards requesting follow-up contacts from sales representatives. Afterward, I began calling or writing to every CAD/CAM company I could identify, requesting advertising materials, demos, videotapes, and so forth. I eventually amassed enough material to fill a four-drawer file cabinet. CADKEY and Autodesk sent me complete copies of their software, which sold on the open market for roughly $3,000 each.

[5] During the course of my research, the CAD/CAM Lab was renamed the CAD Lab. I use whichever name is appropriate at the time.

[6] Other places to follow the convergence of education and sales are the magazines dedicated to engineering, which include not only advertising from manufacturers but also publish articles documenting the promises of new technologies and the risks involved in not accepting them. Consider, for example, *Mechanical Engineer, Computer Graphics and Applications,* and *IEEE Spectrum.*

[7] Note that the graphics 'standard' came in different versions. See chapter 9.

Chapter 4

[1] Helsing (1988, 6).

[2] Helsing (1988, 6).

[3] Kozmetsky, Gill, and Smilor (1985, 1).

[4] Beltz (1994).

[5] Helsing (1988, 6).

[6] Bygrave and Timmons (1992, 109).

[7] Bygrave and Timmons (1992).

[8] Gauhan (1983, 1).

[9]The military still served as a source of demand. In 1982, for example, the U.S. Navy issued a $63 million contract for CAD/CAM equipment.

[10]U.S. International Trade Commission (1984).

[11]Bishop and Miller (1981, 126) and Knox (1980, 66).

[12]*Anderson Report* [hereafter *AR*], March 1981.

[13]See Introduction in Machover and Blauth (1980).

[14]*AR*, February 1981.

[15]*AR*, September 1982.

[16]*AR*, March 1983.

[17]*AR*, June 1981.

[18]Machover and Blauth (1980, 8).

[19]Foundyller (1980, 80, 88, 89, 90).

[20]*AR*, September 1983.

[21]*AR*, December 1982.

[22]Creative Strategies International (1983).

[23]Sterling (1983, 1).

[24]Clayton (1982, 26).

[25]*AR*, August 1985.

[26]*AR*, August 1984.

[27]*AR*, August 1986.

[28]*AR*, October 1985.

[29]Walker (1989).

[30]*AR*, January 1986.

[31]Daratech quote—workstation, pc.

[32]*AR*, June 1985.

[33]*AR*, May 1986; *AR*, December 1986.

[34]*AR*, December 1985.

[35]*AR*, September 1985.

[36]*AR*, October 1985.

[37]*AR*, August 1984.

[38]*AR*, December 1985.

[39]*AR*, February 1986.

[40]*AR*, June 1985.

[41]Dataquest, *General Newsletter* 1990, 6.

[42]Dataquest, *General Newsletter* 1990, 2.

[43]Dataquest, *General Newsletter* 1990, 6.

[44]Dataquest, *General Newsletter* 1989, 1.

[45]Dataquest, September 1989.

[46]*AR*, July 1986.

[47]*AR*, September 1989.

[48]Dataquest, *General Newsletter* 1989, 1.

[49]Dataquest, *General Newsletter* 1989, 6.

[50]Dataquest, *General Newsletter* 1989, 1.

[51]Dataquest, *General Newsletter* 1989, 1.

[52]Dataquest, *General Newsletter* 1989, 1.

[53]Continued developments in microprocessors actually would keep the boundary between hardware and software fairly unstable, particularly after Intel established alliances with Microsoft and other software manufacturers.

[54]"Operating systems and graphics software will become the platforms, while the actual hardware will determine the performance point" (*AR,* January 1988).

[55]*AR,* January 1988.

[56]Dataquest, *General Newsletter* 1990, 6.

[57]*AR,* November 1987.

[58]Dataquest, *General Newsletter* 1990, 6.

[59]*Computer-Aided Design Report* 11(3):5–6, March 1991.

Chapter 5

[1]See, for example, U.S. Congress (1983), Webre (1987), and U.S. General Accounting Office (1991).

[2]Statement made at closed members' meeting, ACSYNT Institute, Blacksburg, Virginia, May 3, 1991.

[3]Wampler, Myklebust, Jayaram, and Gelhausen (1988).

[4]For detailed discussion, see Downey (1995).

Chapter 6

[1]The first time around I was awestruck and uncomfortable at being back in an environment I had left long ago. I quietly attended lectures and laboratory sessions, taking lots of notes. The second time I was a more assertive researcher, tape-recording and transcribing lectures, labs, small group interviews, and individual interviews, as well as conducting brief surveys, asking students to keep journals, and collecting students' notes and other documents. I draw on all of these materials, along with some data from other engineering classes I have attended since.

[2]All computer commands are capitalized.

[3]I did consider enrolling on many occasions, or even formally auditing classes so I could call myself a student and build a transcript of grades. Instructors sometimes gently prodded me to enroll in their classes, clearly feeling more at ease with my presence as a student than the more ambiguous and threatening role of participant-observer. I justified hanging on to my ambiguous status for two reasons: power and fear. By enrolling, whatever status I would have gained with students I would have lost with faculty. The ambiguous role maintained access to both. At the same time, I could not bear the thought of studying for tests again. I found myself in internal debates saying coyly but with more than superficial conviction, "I no longer take tests, I give them." I could not accept the pressure of receiving critical scrutiny from engineering faculty, nor the possibility of earning poor grades and having to cope with the sense that I was no longer proficient at engineering problem solving.

[4]How engineering pedagogy confronts students differently according to the challenges they also experience from cultural stereotypes by race and sex is the subject of a separate research project, co-organized with Juan Lucena. See, for example, Downey and Lucena (1998). Although I did not attempt in this study to sort out the agencies of gender in desires for control over CAD/CAM, full accounts of how learning CAD/CAM contributed to the fashioning of selves would have to explore overlap between the challenge to control CAD/CAM and the stereotypic challenge to men to prove themselves by achieving control over others. This is not to say that all men or all women behaved alike, but that people labeled 'male' had to deal with different stereotypes than people labeled 'female.'

[5]Engineering paper is a cross between unlined paper and graph paper. One writes on the unlined side, guided by faint lines that show through from the other side.

[6]Considerable research on the concept of 'user' is taking place in both technology studies and research in human-computer interaction. Some starting points include Akrich (1992, 1995), Murray and Woolgar (Forthcoming), and many references cited in Williams and Edge (1995).

Chapter 7

[1]One implication of following coding practices in some detail is that it shifts a bit the stereotypic image of computers as information technology. That is, the technology is an aggregate of bits of information. This account illustrates the extent to which people experience computers as communication, as the rapid translation of one configuration of agencies into another. This in turn might help us understand why problems of compatibility have become so routine as an effect of computer development, especially as CAD/CAM and other computer technologies have become commodified.

[2]You might compare this idea of transcription with the concept of translation in actor-network theory (e.g., Latour, 1987). While CAD/CAM students very much achieve the sort of spatial movement that Michel Callon, John Law, and Bruno Latour have analyzed so beautifully, they also appear to achieve a sense of continuity as well, a reproduction of previous relations. The word translation could be used to convey this sense as well, for a good translator of, say, French to English somehow preserves the sense of the original by finding roughly equivalent locations for words and phrases in the translation. I use the concept of transcription here because it calls attention to continuity while also recognizing change, even though what gets transcribed are acts of positioning, or agencies.

[3]Starting points in the social study of mathematics include MacKenzie (1981) and Restivo (1992).

[4]*MicroCAD News Staff* (1990, 25). The gender-neutral 'drafter' has slowly replaced the gender-specific 'draftsman' as the proportion of women doing drafting full time has increased significantly, although still much less than fifty percent.

[5]A significant difference between design and manufacturing activities lies in contrasts between how engineering drawings should be read. See chapter 4.

[6]Earle (1991, 122).

[7]Earle (1991, 123).

[8]See Star (1990) for an account of how electronic CAD/CAM software theorizes layers in order to lay out the features of circuit boards.

[9]Nyhoff and Leestma (1992, 21).

Chapter 8

[1]I waited too long to request copies of the design projects in my course. By the time I inquired, they had all been deleted from the system.

[2]In subsequent years, instructors generally gave students design projects that were more structured. In the case of the carjack, for example, students were given a list of specifications to fulfill, such as the size and weight of the car to be lifted and the requirement to use hydraulic power. Although this shift in pedagogical strategy changed the story somewhat, it did not resolve the CAD/CAM issues raised here. They still struggled with the realization that control was not possible.

Chapter 9

[1]Groover and Zimmers (1984, 56).

[2]Chasen (1981, 32–36).

[3]For example, pay attention to the complex shading functions in the movie *Toy Story.* Produced by PIXAR, Inc., which specializes in sophisticated rendering, the movie had a whole team that worked on shading.

[4]The word 'standard' is both interesting and highly problematic, especially in an American context. The International Standards Organization, ISO, is responsible for setting a variety of standards that apply across national boundaries. European countries generally have a single national standards organization, whose job is to coordinate activities with national boundaries and participate in ISO. The United States, however, has hundreds of organizations setting thousands of standards, virtually all existing in ambiguous locations on the boundary between the 'public' and the 'private.' Although the American National Standards Institute serves as the official U.S. representative in ISO activities, it does not coordinate all standard-setting activities inside the country. The process of standard-setting is complicated further by the phenomenon of 'de facto' standards, which frequently involves one company becoming so powerful that it can ignore or preempt shared decision-making processes and dictate the activities of others. MS-DOS and Windows are the most prominent examples. I do not pursue in detail the roles of standards in CAD/CAM development, although these are significant.

[5]I have just danced lightly over a huge, complex, and important field called 'finite element modeling.'

[6]In these equations, x varies as the sine of angle theta, while y varies as the cosine of angle theta.

[7]These were blending functions, Hermite representation of tensor products, Bezier curves with or without Bernstein polynomials, Barycentric representations of projective geometry, approaches to piecewise linear interpolation, degree elevation and reduction, and piecing spline curves in Bezier format.

[8]Corners and edges come in different degrees mathematically. Everyday corners and edges are first degree 'tangent discontinuities.' A first degree, 'C1,' or tangent continuity occurs when connecting two surfaces does not produce an edge between them. For example, picture the top half of a circle with two lines touching it, one somewhere on the left side and one on the right. Each of these lines is tangent to the circle. Now slide the lines up toward the top. When they reach the top, they converge together and become one line. Presto, you have C1 continuity. If the circle has some sort of edge at the top, the two lines will never converge together, but will intersect at an angle. Now you have a tangent discontinuity. Because CFD computer codes describe fluid flow with higher-order equations than straight lines and also demand continuous surfaces, the points of intersection must be continuous to a second degree. For an example of second degree, or C2, continuity, stand beside your car and examine the reflections on the surface of a fender. Any transitions that do not produce a break in the reflection are achieving C2 continuity. In a CFD analysis, if C2 continuity is not achieved, the calculations of flow across a surface will come to an abrupt stop. Using Bsplines in geometric modeling makes it possible to produce surfaces with C2 continuity.

[9]See Latour and Woolgar (1985 [1979]) and Latour (1987) in *Laboratory Life* for detailed accounts of the accumulation of power and status to laboratory directors.

References

Acland, J., and D. Lane. 1982. *Computer-Aided Design: An Introductory Bibliography.* London: The Institution of Electrical Engineers.

Adler, Paul S. 1989. CAD/CAM: Managerial Challenges and Research Issues. *IEEE Transactions on Engineering Management* 36 (3):202–15.

Aerospace Industries Association of America. 1987. Key Technologies for the 1990s: A Report of the Aerospace Technical Council of AIA. Washington, D.C.

Akrich, Madeline. 1992. The De-Scription of Technical Objects. In *Shaping Technology/Building Society: Studies in Sociotechnical Change,* edited by Wiebe E. Bijker and John Law. Cambridge, Mass.: The MIT Press.

———. 1995. User Representations: Practices, Methods, and Sociology. In *Managing Technology in Society: The Approach of Constructive Technology Assessment,* edited by Arie Rip, Thomas Misra, and Johan Schot. London: Pinter Publishers.

America Rushes To High Tech For Growth. 1983. *Business Week,* 28 March, 84–90.

American Society of Mechanical Engineers. 1986. *Goals and Priorities for Research in Engineering Design: A Report to the Design Research Community.* New York.

Anderson Report. Various issues. Simi Valley, Calif.: Anderson Publishing Company.

Aronowitz, Stanley, and William DiFazio. 1994. *The Jobless Future: Sci-Tech and the Dogma of Work.* Minneapolis: University of Minnesota Press.

Artificial Intelligence: Expert System Model of the Design Process. 1986. *Design News,* 3 March, 69–156.

Badham, Richard. 1989. Computer-Aided Design, Work Organization, and the Integrated Factory. *IEEE Transactions on Engineering Management* 36 (3):216–26.

———. 1991. *Computers, Design, and Manufacturing: The Challenge.* Canberra: Australian Government Publishing Service.

Bank, John. 1992. *The Essence of Total Quality Management.* New York: Prentice-Hall.

Beeby, William. 1982. The Future of Integrated CAD/CAM Systems: The Boeing Perspective. *IEEE Computer Graphics & Applications,* January, 51–6.

Beercheck, Richard C. 1982. CAD Techniques Speed Hydraulic Design. *Machine Design,* 22 July, 69–72.

Beltz, Cynthia, ed. 1994. *Financing Entrepreneurs.* Washington, D.C.: AEI Press.

Bertain, L., and L. Hale, eds. 1987. *A Program Guide for CIM Implementation,* 2nd ed. Dearborn, Mich.: SME.

Bhabha, Homi. 1994. *The Location of Culture.* New York: Routledge.

Bijker, Wiebe E. 1993. Do Not Despair: There is Life after Constructivism. *Science, Technology, and Human Values* 18:113–38.

———. 1995a. *Of Bicycles, Bakelites, and Bulbs: Toward a Theory of Sociotechnical Change.* Cambridge, Mass.: The MIT Press.

———. 1995b. Socio-Historical Technology Studies, Illustrated with Examples from Coastal Engineering and Hydrological Technology. In *Handbook of Science and Technology Studies,* edited by G. E. M. Sheila Jasanoff, James C. Petersen, and Trevor J. Pinch. Newbury Park, Calif. and London: Sage.

Bijker, Wiebe E., Thomas P. Hughes, and Trevor J. Pinch, eds. 1987a. *The Social Construction of Technological Systems: New Directions in the Sociology and History of Technology.* Cambridge, Mass.: The MIT Press.

———. 1987b. General Introduction to *The Social Construction of Technological Systems: New Directions in the Sociology and History of Technology,* edited by Wiebe E. Bijker, Thomas P. Hughes, and Trevor J. Pinch. Cambridge, Mass.: The MIT Press.

Bijker, Wiebe E., and John Law, eds. 1992a. *Shaping Technology/Building Society.* Cambridge, Mass.: The MIT Press.

———. 1992b. Introduction to *Shaping Technology/Building Society,* edited by Wiebe E. Bijker and John Law. Cambridge, Mass.: The MIT Press.

Bishop, Albert B., and Richard A. Miller. 1981. IE's Expertise is Well Suited to Role of Integrating CAD and CAM. *Industrial Engineer,* November, 126–29.

Blauth, Robert E. 1980. What is CAD/CAM? In *The CAD/CAM Handbook,* edited by Carol Machover and Robert E. Blauth. Bedford, Mass.: Computervision Corporation.

Blauth, Robert E., and Edward J. Preston. 1981. Computing the Payback for CAD. *Machine Design,* 20 August, 90–5.

Blumenthal, Marjory, and Jim Dray. 1985. The Automated Factory: Vision and Reality. *Technology Review,* January, 29–37.

Bowen, J. Ray. 1988. The Engineering Student Pipeline: Introduction. *Engineering Education* 78 (8):732–34.

Braverman, Harry. 1974. *Labor and Monopoly Capital.* New York: Monthly Review Press.

Brooks, Laurence S., and Christopher S. Wells. 1989. Role Conflict in Design Supervision. *IEEE Transactions on Engineering Management* 36 (3):271–81.

Buchiarelli, Larry. 1994. *Designing Engineers.* Cambridge, Mass.: The MIT Press.

Business-Higher Education Forum. 1983. *America's Competitive Challenge: The Need for a National Response.* Washington, D.C.

Bygrave, William D., and Jeffry A. Timmons. 1992. *Venture Capital at the Crossroads.* Boston: Harvard Business School Press.

CAD/CAM. 1989. *Industry Week,* 17 July, 4–65.

Cahners Exposition Group. 1990a. Floor Plan #1. National Design Engineering Show & Conference West. Stamford, Conn.

———. 1990b. *Preview.* National Design Engineering Show & Conference. Stamford, Conn.

Callon, Michel. 1980a. The State and Technical Innovation. A Case Study of the Electrical Vehicle in France. *Research Policy* 9:358–76.

———. 1980b. Struggles and Negotiations to Decide What Is Problematic and What Is Not: The Socio-logics of Translation. In *The Social Process of Scientific Investigation,* edited by R. K. Karin Knorr and Richard Whitely. Dordrecht, Netherlands: Reidel.

———. 1986. The Sociology of an Actor-Network: The Case of the Electric Vehicle. In *Mapping the Dynamics of Science and Technology,* edited by Michel Callon and Arie Rip. Basingstoke, U.K.: Macmillan.

———. 1991. Variety and Irreversibility in Networks of Technique Conception and Adoption. In *Technology and the Wealth of Nations,* edited by D. F. C. Freeman. London: Frances Printer.

Chasen, S. H. 1981. Historical Highlights of Interactive Computer Graphics. *Mechanical Engineering,* November, 32–41.

Christiansen, Donald, ed. 1987. *Engineering Excellence: Cultural and Organizational Factors.* New York: Institute of Electrical and Electronic Engineers, Inc.

Christman, Alan M. 1983. The Coupling of CAD and CAM. *Computers in Mechanical Engineering,* September, 26–29.

Clayton, R. J. 1982. CAD/CAM Integration: 2 + 2 = 5. *CAD/CAM Technology,* 21–6.

Cockburn, Cynthia. 1983. *Brothers: Male Dominance and Technological Change.* London: Pluto.

———. 1985. *Machinery of Dominance: Men, Women, and Technical Know-How.* London: Pluto.

Cockburn, Cynthia, and Ruza Furst-Dilic. 1994. *Bringing Technology Home: Gender and Technology in a Changing Europe.* Milton Keynes: Open University Press.

Computer Aided Design Report. 1991. 3 March, 5–6.

Computer-Integrated Manufacturing—From Vision to Reality. 1983. *Production Engineering,* November, 46–53.

Cooley, Mike. 1980. *Architect or Bee? The Human-Technology Relationship.* Boston: South End Press.

Council on Competitiveness. 1988. *Picking Up the Pace: The Commercial Challenge to American Innovation.* Washington, D.C.

Cowan, Ruth S. 1983. *More Work for Mother: The Ironies of Household Technologies from the Open Hearth to the Microwave.* New York: Basic Books.

Creative Strategies International. 1983. *Emerging Markets for Business Graphics.* San Jose, Calif.

Cronberg, Tarja, and Knut H. Sørensen, eds. 1995. *Similar Concerns, Different Styles?: Technology Studies in Western Europe, COST A4.* Brussels, Belgium: European Commission.

Dataquest. Various years. *General Newsletter.* San Jose, Calif.: Dataquest Incorporated.

Davis-Floyd, Robbie. 1992. *Birth as an American Rite of Passage.* Comparative Studies of Health Systems and Medical Care, no. 35. Berkeley and Los Angeles: University of California Press.

Deal, T. W., and A. A. Kennedy. 1982. *Corporate Cultures: The Rites and Rituals of Corporate Life.* Reading, Mass.: Addison-Wesley.

De Greene, Kenyon B. 1973. *Sociotechnical Systems: Factors in Analysis, Design, and Management.* Englewood Cliffs, N. J.: Prentice-Hall.

Dertouzos, Michael L., Richard K. Lester, Robert M. Solow, and the MIT Commission on Industrial Productivity. 1989. *Made in America: Regaining the Productive Edge.* Cambridge, Mass.: The MIT Press.

Dimancescu, Dan, and James Botkin. 1986. *The New Alliance: America's R&D Consortia.* Cambridge, Mass.: Ballinger Publishing Company.

Douglas, Mary, and Aaron Wildavsky. 1982. *Risk and Culture: An Essay on the Selection of Environmental Dangers.* Berkeley: University of California Press.

Downey, Gary L. 1986a. Ideology and the Clamshell Identity: Organizational Dilemmas in the Anti-Nuclear Power Movement. *Social Problems* 33 (5):357–73.

———. 1986b. Risk in Culture: The American Conflict over Nuclear Power. *Cultural Anthropology* 1(4): 388–412.

———. 1988a. Reproducing Cultural Identity in Negotiating Nuclear Power: The Union of Concerned Scientists and Emergency Core-Cooling. *Social Studies of Science* 18 (2):231–64.

———. 1988b. Structure and Practice in the Cultural Identities of Scientists: Negotiating Nuclear Wastes in New Mexico. *Anthropological Quarterly* 61 (1):26–38.

———. 1992. Agency and Structure in Negotiating Knowledge. In *How Classification Works: Nelson Goodman among the Social Scientists,* edited by Mary Douglas and David Hull. Edinburgh: Edinburgh University Press.

———. 1995. Steering Technology through Computer-aided Design. In *Constructive Technology Assessment,* edited by Arie Rip, Thomas Misa, and John Schot. Academic Press.

Downey, Gary Lee, and Joseph Dumit, eds. 1998a. *Cyborgs and Citadels: Anthropological Interventions in Emerging Sciences and Technologies.* Santa Fe, N. Mex.: The SAR Press.

———. 1998b. Locating and Intervening. In *Cyborgs and Citadels: Anthropological Interventions in Emerging Sciences and Technologies,* edited by Gary Lee Downey and Joseph Dumit. Santa Fe, N. Mex.: The SAR Press.

Downey, Gary Lee, Joseph Dumit, and Sarah Williams. 1995. Cyborg Anthropology. *Cultural Anthropology* 10 (2):264–69.

Downey, Gary Lee, and Juan C. Lucena. 1998. "Engineering Selves: Hiring Into a Contested Field of Education." In *Cyborgs and Citadels: Anthropological Interventions in Emerging Sciences and Technologies,* edited by Gary Lee Downey and Joseph Dumit. Santa Fe, N. Mex.: The SAR Press.

Downey, Gary Lee, and Juan D. Rogers. 1995. On the Politics of Theorizing in a Postmodern Academy. *American Anthropologist* 97 (2):269–81.

Dubinskas, Frank, ed. 1988. *Making Time: Ethnographic Studies of High-Technology Organizations.* Philadelphia: Temple University Press.

Earle, James H. 1991. *Graphics for Engineers with CADKEY.* Reading, Mass.: Addison-Wesley.

Ellul, Jacques. 1964. *The Technological Society.* Translated by John Wilkinson. New York: Vintage Books.

Escobar, Arturo. 1995. *Encountering Development.* Princeton: Princeton University Press.

Fellers, Gary. 1992. *The Deming Vision: SPC/TQM for Administrators.* Milwaukee, Wis.: ASQC Quality Press.

Fischer, Michael M. J. 1995. Eye(I)ing the Sciences and Their Signifiers (Language, Tropes, Autobiographers): Interviewing for a Cultural Studies of Science and Technology. In *Technoscientific Imaginaries: Conversations, Profiles, and Memoirs,* edited by George Marcus. Chicago and London: University of Chicago Press.

Forslin, Jan, Britt-Marie Thulestedt, and Sven Andersson. 1989. Computer-Aided Design: A Case of Strategy in Implementing a New Technology. *IEEE Transactions on Engineering Management* 36 (3):191–201.

Forsythe, Diana. 1993a. Engineering Knowledge: The Construction of Knowledge in Artificial Intelligence. *Social Studies of Science* 23:445–77.

———. 1993b. The Construction of 'Work' in Artificial Intelligence. *Science, Technology and Human Values* 18(4):460–79.

———. 1994. STS (Re)constructs Anthropology: Reply. *Social Studies of Science* 24:113–23.

Foucault, Michel. 1970. *The Order of Things: An Archaeology of the Human Sciences.* New York: Vintage.

———. [1975] 1979. *Discipline and Punish: The Birth of the Prison.* Harmondsworth, U.K.: Penguin.

Foucault, Michel, Luther H. Martin, Huck Gutman, and Patrick H. Hutton, eds. 1988. *Technologies of the Self: A Seminar with Michel Foucault.* Amherst: University of Massachusetts Press.

Foundyller, Charles M. 1980. The Psychology of CAD/CAM. *Design News,* 21 April, 80–90.

———. 1981. Buying a Turnkey CAD/CAM System. *Machine Design,* 22 October, 77–82.

Freedman, M. David. 1983. The Automated Factory in the '90s. *CAD/CAM Technology,* Summer, 11–12.

Fulton, Robert E. 1981. Using CAD/CAM to Improve Productivity: The IPAD Approach. *Mechanical Engineering,* November, 64–69.

Gauhan, Timothy O. 1983. CAD/CAM Industry Overview. CAD/CAM Industry Conference, September 26–28, 1983, Newport Beach, California. San Jose, Calif.: Dataquest Incorporated.

Gieryn, Thomas F. 1983. Boundary-Work and the Demarcation of Science from Non-Science: Strains and Interests in Professional Ideologies of Scientists. *American Sociological Review* 48:781–95.

Gilfillan, S. C. 1935a. *The Sociology of Invention.* Cambridge, Mass.: The MIT Press.

———. 1935b. *Inventing the Ship.* Cambridge, Mass.: The MIT Press.

Goldman, Steven L., ed. 1993. *Competitiveness and American Society.* Bethlehem, Pa.: Lehigh University Press.

Gondert, Stephen. 1982. Evaluating Turnkey Systems. *Machine Design,* 25 November, 40–43.

Gray, Chris Hables, ed. 1995. *The Cyborg Handbook.* New York: Routledge.

Green, Eileen, Jenny Owen, and Den Pain, ed. 1993. *Gendered by Design? Information Technology and Office Systems.* London and Washington, D.C.: Taylor and Francis.

Groover, Mikell P., and Emory W. Zimmers. 1980. Automated Factories in the Year 2000. *Industrial Engineering,* November, 34–43.

———. 1984. *CAD/CAM: Computer-Aided Design and Manufacturing.* Englewood Cliffs, N. J.: Prentice-Hall.

Gunn, Thomas G. 1982. The Mechanization of Design and Manufacturing. *Scientific American,* September, 115–30.

Gusterson, Hugh. 1996. *Nuclear Rites: A Weapons Laboratory at the End of the Cold War.* Berkeley: University of California Press.

Hacker, Sally. 1989. *Pleasure, Power, and Technology: Some Tales of Gender, Engineering, and the Cooperative Workplace.* Boston: Unwin Hyman.

———. 1990. *Doing It the Hard Way: Investigations of Gender and Technology.* Boston, Mass.: Unwin Hyman.

Hakken, David, with Barbara Andrews. 1993. *Computing Myths, Class Realities: An Ethnography of Technology and Working People in Sheffield, England.* Boulder, Colo.: Westview.

Hammer, Michael, and James Champy. 1993. *Reengineering the Corporation: A Manifesto for Business Revolution.* New York: Harper Business.

Haraway, Donna. 1991. Situated Knowledges: The Science Question in Feminism and the Privilege of Partial Perspective. In *Simians, Cyborgs, and Women: The Reinvention of Nature.* New York: Routledge and Kegan Paul.

———. 1997. Modest_Witness@SecondMillennium.FemaleManc_Meets_Onco-MouseT. New York: Routledge.

Harding, Sandra. 1991. *Whose science? Whose knowledge? Thinking from Women's Lives.* New York: Cornell University Press.

———, ed. 1993. *The "Racial" Economy of Science: Toward a Democratic Future.* Bloomington: Indiana University Press.

Heath, Deborah. 1997. Bodies, Antibodies, and Modest Interventions. In *Cyborgs and Citadels: Anthropological Interventions in Emerging Sciences and Technologies,* edited by Gary Lee Downey and Joseph Dumit. Santa Fe, N. Mex.: The SAR Press.

Helsing, Roy G. 1988. *Venture Capital Inside Out: An Entrepreneur's Guide to How the System Works.* San Francisco: Transwest Ventures

Hess, David. 1991. *Spirits and Scientists.* University Park: Pennsylvania State University Press.

———. 1993. *Science in the New Age.* Madison: University of Wisconsin Press.

———. 1995. *Science and Technology in a Multicultural World.* New York: Columbia University Press.

Hess, David J., and Linda L. Layne, eds. 1992. *Knowledge and Society: The Anthropology of Science and Technology.* Vol. 9. Greenwich, Conn.: JAI Press.

Hess, G. J. 1983. Computer-Integrated Manufacturing—How to Get Started. *Autofact 5.*

———. 1984. Computer-Integrated Flexible Manufacturing. *Autofact 6.*

Hughes, Thomas P., ed. 1975. *Changing Attitudes Toward American Technology.* New York: Harper & Row.

———. 1989. *American Genesis: A Century of Innovation and Technology Enthusiasm, 1870–1970.* New York: Viking.

Inglesby, T. 1982. CAD/CAM: Should We or Shouldn't We? *Assembly Engineering,* March, 48–50.

Jobs of the Future. 1985. *U.S. News and World Report,* 23 December, 40–45.

Johansson, Henry J., Patrick McHugh, and William A. Wheeler. 1993. *Business Process Reengineering: Breakpoint Strategies for Business Dominance.* Chichester, U.K. and New York: Wiley.

Kidder, Tracy. 1982. *Soul of a New Machine.* London: Allen Lane.

Kinnucan, P. 1982. Computer-Aided Manufacturing Aims for Integration. *High Technology,* May/June, 49–56.

Knox, Charlie. 1980. CAD/CAM and Group Technology: The Answer to Systems Integration? *Industrial Engineer,* November, 66–73.

Kozmetsky, George, Michael D. Gill, Jr., and Raymond W. Smilor. 1985. *Financing and Managing Fast-Growth Companies: The Venture Capital Process.* Lexington, Mass.: Lexington Books.

Krouse, John K. 1980. CAD/CAM—Bridging the Gap from Design to Production. *Machine Design,* 12 June, 117–25.

———. 1981a. Sculptured Surfaces for CAD/CAM. *Machine Design,* 12 March, 115–120.

———. 1981b. Automated Drafting: The First Step to CAD/CAM. *Machine Design,* 21 May, 50–55.

———. 1981c. Computer Time-Sharing for CAD/CAM. *Machine Design,* 23 May, 57–64.

———. 1981d. Smart Robots for CAD/CAM. *Machine Design,* 25 June, 85–91.

———. 1981e. The Link Between CAD and CAM. *Machine Design,* 10 September, 111–15.

———. 1981f. Automated Factories: The Ultimate Union of CAD and CAM. *Machine Design,* 26 November, 54–60.

———. 1982a. Solid Models for Computer Graphics. *Machine Design,* 20 May, 50–55.

———. 1982b. *What Every Engineer Should Know About Computer-Aided-Design and Computer-Aided Manufacturing.* New York: Marcel Dekker.

Kunda, Gideon. 1992. *Engineering Culture.* Philadelphia: Temple University Press.

Latour, Bruno. 1987. *Science in Action: How to Follow Scientists and Engineers Through Society.* Cambridge, Mass.: Harvard University Press.

———. 1991. Technology is Society Made Durable. In *A Sociology of Monsters: Essays on Power, Technology and Domination,* edited by J. Law. London: Routledge and Kegan Paul.

Latour, Bruno, and Steve Woolgar. 1986 (1979). *Laboratory Life: The Construction of Scientific Facts.* 2nd ed. Princeton, N. J.: Princeton University Press.

Lave, Jean. 1990. Views of the Classroom: Implications for Math and Science Learning Research. In *Toward a Scientific Practice of Science Education,* edited by M. Gardner. Hillsdale, N. J.: L. Erlbaum Association.

———. 1988. *Cognition in Practice: Mind, Mathematics and Culture in Everyday Life.* Cambridge: Cambridge University Press.

Lave, Jean, and Etienne Wenger. 1991. *Situated Learning: Legitimate Peripheral Participation.* Cambridge, U.K.: Cambridge University Press.

Law, John. 1987a. The Structure of Sociotechnical Engineering: A Review of the New Sociology of Technology. *Sociological Review* 35:404–25.

———. 1987b. Technology and Heterogeneous Engineering: The Case of Potuguese Expansion. In *The Social Construction of Technological Systems: New Directions in the Sociology and History of Technology,* edited by Wiebe E. Bijker, Thomas P. Hughes, and Trevor J. Pinch. Cambridge, Mass.: The MIT Press.

———, ed. 1991. *A Sociology of Monsters: Essays on Power, Technology and Domination.* London: Routledge and Kegan Paul.

Law, John, and Michel Callon. 1992. The Life and Death of an Aircraft: A Network Analysis of Technical Change. In *Shaping Technology/Building Society,* edited by Wiebe E. Bijker. Cambridge, Mass.: The MIT Press.

Lee, Gloria L. 1989. Managing Change with CAD and CAD/CAM. *IEEE Transactions on Engineering Management* 36 (3):227–33.

Leontief, Wassily, and Faye Duchin. 1986. *The Future Impact of Automation on Workers.* New York: Oxford University Press.

Lerro, Joseph P., Jr. 1980. CAD/CAM System: More than an Automated Drafting Tool. *Design News,* 17 November.

———. 1981. CAD/CAM System: Start of the Productivity Revolution. *Design News,* 16 November, 46–65.

———. 1982. CAD/CAM Systems: Today and Tomorrow. *Design News,* 19 April, 90–98.

Leslie, Stuart W. 1983. *Boss Kettering.* New York: Columbia University Press.

Liker, Jeffrey K., and Mitchell Fleischer. 1989. Implementing Computer-Aided Design: The Transition of Nonuser. *IEEE Transactions on Engineering Management* 36 (3):180–90.

Liker, Jeffrey K., Mitchell Fleischer, and David Arnsdorf. 1992. Fulfilling the Promises of CAD. *Sloan Management Review,* Spring, 74–86.

Lucena, Juan. 1996. *Making Policy for Making Selves in Science and Technology: From Sputnik to Global Competition.* Ph.D. Dissertation. Graduate Program in Science and Technology Studies, Virginia Polytechnic Institute and State University, Blacksburg, Virginia.

Machover, Carol, and Robert E. Blauth, ed. 1980. *The CAD/CAM Handbook.* Bedford, Mass.: Computervision Corp.

MacKenzie, Donald. 1981. *Statistics in Britain 1865–1930: Social Construction of Scientific Knowledge.* Edinburgh: Edinburgh University Press.

———. 1990. *Inventing Accuracy: An Historical Sociology of Ballistic Missile Guidance.* Cambridge, Mass.: The MIT Press.

MacKenzie, Donald, and Judy Wajcman, eds. 1985. *The Social Shaping of Technology: How the Refrigerator Got Its Hum.* Milton Keynes: Open University Press.

Majchrzak, Ann, and Harold Salzman. 1989. Introduction to the Special Issue: Social and Organizational Dimensions of Computer-Aided Design. *IEEE Transactions on Engineering Management* 36 (3):174–79.

Mann, R. W., and S. A. Coons. 1965. Computer-Aided Design. *McGraw-Hill Yearbook Science and Technology.* New York: McGraw-Hill Book Company, Inc.

Manske, Fred, and Harald Wolf. 1989. Design Work in Change: Social Conditions and Results of CAD Use in Mechanical Engineering. *IEEE Transactions on Engineering Management* 36 (3):282–92.

Manufacturing Studies Board. 1988. *A Research Agenda for CIM.* Washington, D.C.: National Research Council.

Marcus, Alan I., and Howard B. Segal. 1989. *Technology in America: A Brief History.* San Diego, Calif: Harcourt Brace Jovanovich.

Marcus, George E., ed. 1995. *Technoscientific Imaginaries: Conversations, Profiles, and Memoirs.* Chicago and London: University of Chicago Press.

Marcuse, Herbert. 1991 (1964). *One Dimensional Man: Studies in the Ideology of Advanced Industrial Society.* Boston: Beacon Press.

Marshall, Philip. 1982. Do It Yourself CAD/CAM. *Machine Design,* 6 May, 74–79.

Martin, Emily. 1987. *The Woman in the Body: A Cultural Analysis of Reproduction.* Boston: Beacon Press.

———. 1992. The End of the Body? *American Ethnologist* 19(1):121–40.

———. 1994. *Flexible Bodies: Tracking Immunity in American Culture from the Days of Polio to the Age of AIDS.* Boston: Beacon Press.

Martin, Emily, Laury Oaks, Karen-Sue Taussig, and Ariane van der Straten. 1997. AIDS, Knowledge, and Discrimination in the Inner City: An Anthropological Analysis of Injection Drug Users. In *Cyborgs and Citadels: Anthropological Interventions in Emerging Sciences and Technologies,* edited by Gary Lee Downey and Joseph Dumit. Santa Fe, N. Mex.: The SAR Press.

McAdam, Doug, John D. McCarthy, and Mayer N. Zald, eds. 1996. *Comparative Perspectives on Social Movements: Political Opportunities, Mobilizing Structures, and Cultural Framings.* Cambridge, U.K.: Cambridge University Press.

MicroCAD News Staff. 1990. 2D Here to Stay. *MicroCAD News,* June, 24–25, 32.

Miller, Steven M. 1989. *Impacts of Industrial Robotics: Potential Effects on Labor and Costs within the Metalworking Industries.* Madison: University of Wisconsin Press.

Mumford, Lewis. 1963. *Technics and Civilization.* New York: Harcourt, Brace, and World.

———. 1970. *The Myth of the Machine.* New York: Harcourt, Brace, and World.

Murray, Fergus, and Steve Woolgar, eds. Forthcoming. *Critical Perspectives on Software Development.* Cambridge, Mass.: The MIT Press.

Nader, Laura, ed. 1996. *Naked Science: Anthropological Inquiry into Boundaries, Power, and Knowledge.* New York: Routledge.

National Aeronautics and Space Administration. 1992.

National Commission on Excellence in Education. 1983. *A Nation at Risk.* Washington, D.C.: U.S. Department of Education.

National Research Council. 1982. *Outlook for Science and Technology: The Next Five Years.* San Francisco: W.H. Freeman and Company.

———. 1985. *Engineering Education and Practice in the United States: Foundation of Our Techno-Economic Future.* Washington, D.C.: National Academy Press.

Nelkin, Dorothy, ed. 1992. *Controversy: The Politics of Technical Decisions.* Newbury Park, Calif.: Sage.

Nespor, Jan. 1994. *Knowledge in Motion: Space, Time, and Curriculum in Undergraduate Physics and Management.* London: Falmer.

New Allure of American Manufacturing, The. 1988. *New York Times,* 18 Dec., 30–31.

Noble, David F. 1984. *Forces of Production: A Social History of Industrial Automation.* New York: Knopf.

Nyhoff, Larry, and Sanford Leestma. 1992. *FORTRAN '77 for Engineers and Scientists.* New York: Macmillan.

Office of Technology Assessment. 1982. *Impacts of Technology on U.S. Cropland and Rangeland Productivity.* Washington, D.C.: U.S. Government Printing Office.

Ogburn, William F. 1945. *The Social Effects of Aviation.* Boston: Houghton Mifflin.

Ogburn, William F., with the assistance of S. C. Gilfillan. 1933. The Influence of Invention and Discovery. In *Recent Social Trends in the United States: Report of the President's Research Committee on Social Trends.* New York: McGraw-Hill.

Ogburn, William F., and F. Meyers Nimkoff. 1955. *Technology and the Changing Family.* Boston: Houghton Mifflin.

Pasmore, William, and John J. Sherwood, eds. 1978. *Sociotechnical Systems: A Sourcebook.* La Jolla, Calif.: University Associates.

Penley, Constance, and Andrew Ross, eds. 1991. *Technoculture.* Minneapolis: University of Minnesota Press.

Pfaffenberger, Bryan. 1988. The Social Meaning of the Personal Computer: Or, Why the Personal Computer Revolution Was No Revolution. *Anthropological Quarterly* 61(1):39–47.

———. 1990. *Democratizing Information: Online Databases and the Rise of End-User Searching.* Boston: G. K. Hall.

———. 1992. The Social Anthropology of Technology. *Annual Review of Anthropology* 21:491–516.

Pitt, Joseph, and E. Lugo, eds. 1991. *The Technology of Discovery and the Discovery of Technology: Proceedings of the 6th International Conference of the Society for Philosophy and Technology.* Blacksburg, V.I.: Society for Philosophy and Technology.

Plonski, Guilherme Ary. 1989. The Need to Reconceptualize CAD: The Case of Brazilian Engineering Consultancy Firms. *IEEE Transactions on Engineering Management* 36 (4): 293–99.

Port, Otis. 1986. High Tech to the Rescue. *Business Week,* 16 June, 100–03.

President's Commission on Industrial Competitiveness. 1985. *Global Competitiveness: The New Reality.* Washington, D.C.: U.S. Government Printing Office.

———. 1987. *The President's Competitiveness Initiative, Fact Sheet.* Washington, D.C.: The White House.

Rabinow, Paul. 1995. *PCR.* Chicago: The University of Chicago Press.

Ramo, Simon. 1980. *America's Technology Slip.* New York: Wiley.

Rapp, Rayna. 1993. Accounting for Amniocentesis. In *Knowledge, Power, and Practice: The Anthropology of Medicine and Everyday Life,* edited by Shirley Lindenbaum and Margaret Lock. Berkeley and Los Angeles: University of California Press.

———. 1997. Real-Time Fetus: The Role of the Sonogram in the Age of Monitored Reproduction. In *Cyborgs and Citadels: Anthopological Interventions in Emerging Sciences and Technologies,* edited by Gary Lee Downey and Joseph Dumit. Santa Fe, N. Mex.: The SAR Press.

Restivo, Sal. 1992. *Mathematics in Society and History: Sociological Inquiries.* Dordrecht and Boston: Kluwer Academic Publishers.

Rouse, Joseph. 1991. What Are Cultural Studies of Scientific Knowledge? *Configurations* 1(1):1–22.

———. 1996. *Engaging Science: How to Understand Its Practices Philosophically.* Ithaca: Cornell University Press.

Sager, Ira. 1983. CAD/CAM Systems. *Electronic News,* October, 26–27.

Salzman, Harold. 1989. Computer-Aided Design: Limitations in Automating Design and Drafting. *IEEE Transactions on Engineering Management* 36 (3):252–61.

Segal, Howard P. 1985. *Technological Utopianism in American Culture.* Chicago: University of Chicago Press.

———. 1994. *Future Imperfect: The Mixed Blessing of Technology in America.* Amherst: University of Massachusetts Press.

Seireg, Ali. 1981. The Computer and the Mechanical Engineer: A Coming of Age. *Mechanical Engineering,* November, 29–30.

Shaiken, Harley. 1984. *Work Transformed.* New York: Holt, Rinehart, and Winston.

Sharda, Ramesh, B. L. Golden, Edward A. Wasil, O. Balci, and W. Stewart, eds. 1989. *Impacts of Recent Computer Advances on Operations Research.* New York: Elsevier Press.

Simon, Richard L. 1982. CAD/CAM System: Foundation of Manufacturing Automation. *Design News,* 1 March, 34–44.

Sinclair, M. A., C. E. Siemieniuch, and P. A. John. 1989. A User-Centered Approach to Define High-Level Requirements for Next-Generation CAD Systems for Mechanical Engineering. *IEEE Transactions on Engineering Management* 36 (3):262–70.

Smith, George. 1985. The Dangers of Computer-Aided-Design. *Transactions of the American Society of Mechanical Engineers,* 85-WA/FE-9:1–7.

Sorensen, John H., Jon Soderstrom, Emily Copenhaver, Same Cornes, and Robert Bolin, eds. 1987. *Impacts of Hazardous Technology: The Psycho-Social Effects of Restarting TMI-1.* Albany: State University of New York Press.

Sørensen, Knut H. 1992. Toward a Feminized Technology? Gendered Values in the Construction of Technology. *Social Studies of Science* 22:5–51.

Star, Susan Leigh. 1990. Layered Space, Formal Representations, and Long-Distance Control: The Politics of Information. *Fundamenta Scientiae* 10(2):122–55.

Starr, Paul. 1982. *The Social Transformation of American Medicine.* New York: Basic Books.

Sterling, Michael W. 1983. *Manufacturing Is Not a Button on the Design Data Base.* CAD/CAM Industry Conference, September 26–28, Newport Beach, California. San Jose, Calif.: Dataquest Incorporated.

Stone, Alluquere Rosanne. 1995. *The War of Desire and Technology at the Close of the Mechanical Age.* Cambridge, Mass.: The MIT Press.

Suchman, Lucy. 1987. *Plans and Situated Actions: The Problem of Human-Machine Communication.* Cambridge, U.K.: Cambridge University Press.

Teicholz, E. 1984. Computer-Integrated Manufacturing. *Datamation,* March, 169–74.

Teschler, Leland. 1982. CAD Will Allow 'Anyone' to Design ICs. *Machine Design,* 7 October, 75–80.

Toffler, Alvin. 1970. *Future Shock.* New York: Random House.

———. 1980. *The Third Wave.* New York: Morrow.

Toumey, Christopher. 1994. *God's Own Scientists: Creationists in a Secular World.* New Brunswick, N. J.: Rutgers University Press.

———. 1996. *Conjuring Science.* New Brunswick, N. J.: Rutgers University Press.

Traweek, Sharon. 1988. *Beamtimes and Lifetimes.* Cambridge, Mass.: Harvard University Press.

———. 1992. Border Crossings: Narrative Strategies in Science Studies and Among Physicists in Tsukuba Science City, Japan. In *Science as Practice and Culture,* edited by Andrew Pickering. Chicago: University of Chicago Press.

———. 1993. An Introduction to Cultural, Gender, and Social Studies of Sciences and Technologies. *Culture, Medicine and Psychiatry (Special Issue: Biopolitics: The Anthropology of the New Genetics and Immunology)* 17:3–25.

———. 1995a. Bachigai [out of place] in Ibaraki: Tsukuba Science City, Japan. In *Technoscientific Imaginaries (Late Editions, vol. II),* edited by George Marcus. Chicago: University of Chicago Press.

———. 1995b. Bodies of Evidence: Law and Order, Sexy Machines, and the Erotics of Fieldwork among Physicists. In *Choreographing History,* edited by Susan Foster. Bloomington: Indiana University Press.

———. 1996a. Kokusaika (International Relations), Gaiatsu (Outside Pressure), and Bachigai (Being Out of Place). In *Naked Science: Anthropological Inquiry into Boundaries, Power, and Knowledge,* edited by Laura Nader. New York: Routledge.

———. 1996b. Unity, Dyads, Triads, Quads, and Complexity: Cultural Choreographies of Science. In *Social Text* (special issue edited by Stanley Aronowitz and Andrew Ross). Spring/Summer 129–40.

———. 1996c. When Eliza Doolittle studies 'enry 'iggins. In *Technoscience, Power, and Cyberculture: Implications and Strategies,* edited by Stanley Aronowitz, Barbara Marinsons, Michael Menser, and Jennifer Rich. New York: Routledge.

———. Forthcoming. Warning Signs: Acting on Images. In *Revisioning Women, Health, and Healing: Feminist, Cultural, and Technoscience Perspectives,* edited by Adele Clarke and Virginia Olesen. New York: Routledge.

Turkle, Sherry. 1984. *The Second Self: Computers and the Human Spirit.* New York: Simon and Schuster.

———. 1995. *Life on the Screen: Identity in the Age of the Internet.* New York: Simon and Schuster.

U.S. Congress. 1983. Partnerships and Collaboration as Competitiveness Tools. *Hearing before the Committee on Science, Space, and House of Representatives.* 103rd Cong., 1st session, 9 July. Washington, D.C.: U.S. Government Printing Office.

———. 1984. *Targeting the Process of Innovation: An Agenda for U.S. Technological Leadership and Industrial Competitiveness.* Washington, D.C.: Steering Committee, Task Force on High Technology Initiatives, House Republican Research Committee, U.S. House of Representatives.

———. 1986. *Economic Competitiveness: Promoting America's Living Standard.* Washington, D.C.: Senate Democratic Working Group on Economic Competitiveness, U.S. Senate.

U.S. General Accounting Office. 1991. SEMATECH's Efforts to Develop and Transfer Manufacturing Technology. *Fact Sheet for the Committee on Science, Space, and Technology, House of Representatives.* Washington, D.C.

U.S. International Trade Commission. 1984. *A Competitive Assessment of the U.S. Manufacturing Automation Equipment Industries.* June. Washington, D.C.: Industry Analysis Division, Office of Industry Assessment, Trade Information and Analysis, Assistant Secretary for Trade Development.

Wajcman, Judy. 1991. *Feminism Confronts Technology.* Cambridge, Mass.: Polity Press.

Walker, John. 1989. *The Autodesk File: Bits of History, Words of Experience.* 3rd ed. Thousand Oaks, Calif.: New Riders Publications.

Wampler, S. G., A. Myklebust, S. Jayaram, and P. Gelhausen. 1988. *Improving Aircraft Conceptual Design—A PHIGS Interactive Graphics Interface for ACSYNT.* AIAA-88–4481. AIAA/AHS/ASEE Aircraft Design, Systems and Operations Meeting, September 7–9, Atlanta, Ga. Washington, D.C.: American Institute of Aeronautics and Astronautics.

Webre, Philip. 1987. *The Benefits and Risks of Federal Funding for SEMATECH.* Washington, D.C.: U.S. Congress, Congressional Budget Office.

Williams, Robin, and David Edge. 1995. British Perspectives on the Social Shaping of Technology: A Review of Research. In *Similar Concerns, Different Styles?: Technology Studies in Western Europe,* edited by Tarja Cronberg and Knut H. Sorensen. Brussels, Belgium: European Commission.

Winner, Langdon. 1977. *Autonomous Technology: Technics-Out-Of-Control as a Theme in Political Thought.* Cambridge, Mass.: The MIT Press.

———. 1980. Do Artifacts Have Politics? *Daedalus* 109 (1):121–36.

———. 1986. *The Whale and the Reactor: A Search for Limits in an Age of High Technology.* Chicago: University of Chicago Press.

Woolgar, Steve. 1981. Interests and Explanation in the Social Study of Science. *Social Studies of Science* 11:365–94.

———. 1991. The Turn to Technology in Social Studies of Science. *Science, Technology, and Human Values* 16:20–50.

Zald, Mayer N., and John D. McCarthy. 1988 (1979). *The Dynamics of Social Movements: Resource Mobilization, Social Control, and Tactics.* Lanham, Md: University Press of America.

Index